D1270215

Dangerous Dreams

FRAMING FILM
The History & Art of Cinema

Frank Beaver, *General Editor*

Vol. 13

PETER LANG
New York · Washington, D.C./Baltimore · Bern
Frankfurt · Berlin · Brussels · Vienna · Oxford

JAN WHITT

Dangerous Dreams

Essays on American Film and Television

PETER LANG
New York · Washington, D.C./Baltimore · Bern
Frankfurt · Berlin · Brussels · Vienna · Oxford

Library of Congress Cataloging-in-Publication Data

Whitt, Jan.
Dangerous dreams: essays on American film and television / Jan Whitt.
pages cm. — (Framing film: the history and art of cinema; v. 13)
Includes bibliographical references and index.
1. Motion pictures—Social aspects—United States.
2. Television programs—Social aspects—United States. 3. Motion pictures
and literature—United States. I. Title.
PN1995.9.S6W52 791.430973—dc23 2013003322
ISBN 978-1-4331-1660-5 (hardcover)
ISBN 978-1-4539-1046-7 (e-book)

Bibliographic information published by **Die Deutsche Nationalbibliothek**.
Die Deutsche Nationalbibliothek lists this publication in the "Deutsche
Nationalbibliografie"; detailed bibliographic data is available
on the Internet at http://dnb.d-nb.de/.

Cover art: Courtesy of the Cabinet of American Illustration,
Prints & Photographs Division, Library of Congress, LC-DIG-ds-00873.

The paper in this book meets the guidelines for permanence and durability
of the Committee on Production Guidelines for Book Longevity
of the Council of Library Resources.

For
Andrew Calabrese

Contents

Acknowledgments

As part of "Framing Film: The History and Art of Cinema," a book series edited by Professor Emeritus Frank E. Beaver, *Dangerous Dreams: Essays on American Film and Television* owes its existence to Professor Beaver, to the Peter Lang Media and Communication book list, and to ongoing interest in the ways in which popular culture texts are drawn from and contribute to aesthetic, historical, psychoanalytic, semiological, and sociological studies. Having taught courses at the University of Michigan in communication and film and video studies, Professor Beaver is author of six books about motion pictures and is also a documentary film producer. Along with others whose work he has selected, I thank him for contributing his reputation and hard work to this important series.

Second, I thank the journal editors who gave permission for me to include previously published material in *Dangerous Dreams*. Listed by the most recent publication date, the edited and updated refereed articles include: "From the Wilderness into the Closet: *Brokeback Mountain* and the Lost American Dream." *Popular Culture Review* 19.1 (Winter 2008): 27–37; "When Fiction Becomes Reality: Authorial Voice in *The Door in the Floor*, *Secret Window*, and *Swimming Pool*." *Popular Culture Review* 17 (Summer 2006): 73–81; "What Happened to Celie and Idgie?: The 'Apparitional Lesbians' of American Film." *Studies in Popular Culture* 27.3 (April 2005): 43–57; *"Frank's Place:* Coming Home to a Place We'd Never Been Before." *Journal of Popular Film and Television* 33.2 (Summer 2005): 80–87 (Taylor & Francis Ltd., http://www.tandfonline.com); "Grits and Yokels Aplenty: Depictions of Southerners in Prime-Time Television." *Studies in Popular Culture* 19 (October 1996): 141–52; "A Legacy of Fear: Japan-Bashing in Contemporary American Film." *American Journalism* 13.3 (Summer 1996): 354–60; and "The 'Very Simplicity of the Thing': Edgar Allan Poe and the Murders He Wrote." *Clues* 15 (Spring/Summer 1994): 29–47; and "Displaced People and the Frailty of Words." *Popular Culture Review* 2 (July 1991): 59–69. "The 'Very Simplicity of the Thing'" also appeared in *The Detective in Fiction, Film, and Television*. Ed. Jerome P. Delamater and Ruth

Prigozy. Westport, Conn.: Greenwood, 1998. 111–21. It later was published as "Poe's Detective Tales Employ Both Critical Reasoning and Intuition" in a collection entitled *Readings on the Short Stories of Edgar Allan Poe*. Ed. Hayley Mitchell Haugen. San Diego: Greenhaven Press, 2001. 59–66.

Third, I appreciate the rights to publish an essay, "'American Life Is Rich in Lunacy': The Unsettling Social Commentary of *The Beverly Hillbillies*," which appeared as a chapter in a collection entitled *The Enduring Legacy of Old Southwest Humor*. Ed. Ed Piacentino. Baton Rouge: Louisiana State University Press, 2005. 229–47.

Fourth, I commend Willard D. (Wick) Rowland Jr., Ph.D., dean emeritus of the School of Journalism and Mass Communication at the University of Colorado at Boulder (1987–1999) and now president and CEO of Colorado Public Television (KBDI-TV/12). His foresight made it possible for an eclectic group of scholars—from humanities and social science disciplines as diverse as literary studies and political communication—to contribute their energies to journalism education and media studies. These scholars and a generation of undergraduate and graduate students are part of his rich legacy.

I dedicate the book to Andrew Calabrese, a colleague in the journalism and mass communication program at the University of Colorado at Boulder, whose interest in film studies and commitment to interdisciplinary inquiry have been a beacon to me and to others. Most especially, I thank Professor Calabrese for his quiet but steady support for equality and his devotion to research of particular interest to women and people of color. It is no surprise that his work on behalf of the disenfranchised has earned him so many lifelong friends.

No book is written in a vacuum. Without question, Baylor professors, including James Barcus, Robert Collmer, J.R. LeMaster, and Rachel and Andy Moore, and University of Denver scholars, including Eric Gould and Robert D. Richardson Jr., sparked my interest in film and literature and their compelling intersections. I thank these and other colleagues for their commitment to teaching, for their wisdom, and for their compassionate spirits.

Finally, as with every book project, I thank Elizabeth A. Skewes, a colleague and an author in her own right. Her editorial advice and formatting expertise are invaluable.

Introduction

In the documentary *Celluloid Closet* (1995), actress Susan Sarandon said films are "important—and they're dangerous—because we're the keeper of the dreams." Her statement about the role of the film industry and the impact of individual productions is difficult to discount. Those drawn to this study already are convinced of the significance and impact of film and television texts on American culture; therefore, this collection of essays simply underscores the obvious: visual media hold a powerful sway. In short, the influence of popular culture on attitudes about class, ethnicity, gender, politics, race, religion, and sexual orientation cannot be overstated.

Part of the impact of film and television images occurs, of course, because of the one-on-one engagement that film and television viewers experience with the text. Even if we screen a television situation comedy or sports event in our living rooms with 20 others present, the experience is quintessentially individual. We watch the screen—expecting to be affected—and the actors appear to perform for and talk directly to us. "You go into a little dark room and become incredibly vulnerable," said Sarandon. "On one hand, all your perspectives can be challenged—you could feel something you couldn't feel normally. It can encourage you to be the protagonist in your own life. On the other hand, it can completely misshape you."

Dangerous Dreams: Essays on American Film and Television is the culmination of research that began in 1990. The single-authored collection employs aesthetic, feminist, historical, Marxist, psychoanalytic, semiological, and sociological criticism to explore five decades of film and television texts that have captivated audiences. From *Ordinary People* (1980) to *Shutter Island* (2010) and from *The Beverly Hillbillies* (1962–1971) to *Men of a Certain Age* (2009–2011), the study is divided into four sections, each comprised of several chapters that explore the effects of narrative and visual texts. Sections include "The Influence of Literature on Film and Television"; "Portrayals of Class, Race, and Sexual Orientation"; "Portrayals of Class, Race, and Ethnicity"; and "Portrayals of Women in Film and Television."

Each section features first the most recent literary and media texts, followed by earlier ones with historical and sociological import.

The Influence of Literature on Film and Television

Section One features both the screenplays that were drawn from literature and the literature than enriches conversations about film and popular television programs. Instead of dealing with how a story is adapted into film in the tradition of studies such as *Now a Major Motion Picture: Film Adaptations of Literature and Drama* by Christine Geraghty, two of the chapters in Section One describe the original text and the film version without making aesthetic judgments. The other three chapters argue that themes inherent in literary classics such as short stories by Edgar Allan Poe and Flannery O'Connor or novels by Herman Melville, Robert Louis Stevenson, Thomas Hardy, and others inform the films that followed them and enrich the discussion of those films.

As noted, the chapters in each of four sections appear in reverse chronological order based upon the release dates of the films and television programs themselves. Section One includes both references to and in-depth analysis of films as diverse as *Shutter Island* (2010), *The Door in the Floor* (2004), *Secret Window* (2004), *Swimming Pool* (2003), *Dangerous Liaisons* (1988), *Masquerade* (1988), *Betrayed* (1988), *Criminal Law* (1988), *Black Widow* (1987), *Fatal Attraction* (1987), *No Way Out* (1987), *The Morning After* (1986), *Jagged Edge* (1985), *Betrayal* (1983), *Terms of Endearment* (1983), *Sophie's Choice* (1982), *Still of the Night* (1982), *On Golden Pond* (1981), and *Ordinary People* (1980). *Murder, She Wrote* (1984–1996) is the focus of the only chapter in the group that deals primarily with literature and television.

The first chapter, *"Shutter Island:* Martin Scorcese's Allegory of Despair," suggests that Martin Scorcese's 2010 film is not a horror film in the traditional sense. Instead, the dark and twisting hallways of a mental institution and the paths along the bluffs of the island represent the labyrinths of the human mind. With water that drips hauntingly on the stone walls of the hospital wards and an eerie light that illuminates the faces of those trapped within, *Shutter Island* elicits a different kind of terror.

Reminiscent of the endlessly twisting tunnels of Franz Kafka's *The Trial*, the dank catacombs of Edgar Allan Poe's "The Cask of Amontillado," and the evocative bell tower of Alfred Hitchcock's *Vertigo*, the images that characterize both the novel by Dennis Lehane and the film include barbed wire fences, a cemetery, jagged cliffs, and a Civil War fortress that stands

watch over the resplendent (and incongruous) flower gardens below. Drawing us into a microcosm of human cruelty and depravity, Scorcese creates an allegory of despair.

Although the film is drawn from a novel by the same name, the thematic center of the chapter that follows "*Shutter Island:* Martin Scorsese's Allegory of Despair" does not address the literature that inspired particular films but focuses upon the role of the narrative voice in the films themselves. Acknowledging that the intimate connection between authors and their works has always captivated readers, "When Fiction Becomes Reality: Authorial Voice in *The Door in the Floor, Secret Window,* and *Swimming Pool*" deals with the function of the imagination in storytelling, with the distinctions between genius and madness in the creative process, and with meta-fiction, or the way in which literary and visual texts about language and images comment upon themselves.

The three films in "When Fiction Becomes Reality" feature protagonists who have lost their way and who hope fiction will save them. Ted Cole (Jeff Bridges) considers himself "an entertainer of children," although his book *The Door in the Floor* is an exploration of the horrors that lie beneath us as we move unsuspectingly through life. Cole is dealing with the death of his sons and the dissolution of his marriage by escaping into alcohol, drawing, promiscuity, and writing. In the second film, *The Secret Window,* an accomplished writer named Morton Rainey (Johnny Depp) is accused of having plagiarized one of his stories, "Sowing Season." As he tries to unravel the mystery of authorship, he goes slowly mad. Finally, in *Swimming Pool,* Sarah Morton (Charlotte Rampling) struggles to produce a manuscript different from the mystery novel series that has earned her the respect of her publisher and her readers and ultimately blurs the lines between her own life and the lives of her characters.

The chapter in the section that deals with television is "The 'Very Simplicity of the Thing': Edgar Allan Poe, Jessica B. Fletcher, and *Murder, She Wrote,*" which explores similarities between Poe's detective stories and the formula behind the popular television show. The chapter identifies the central concern of Poe's semiologist C. Auguste Dupin and Jessica Fletcher (Angela Lansbury)—never to miss what Poe repeatedly calls in "The Purloined Letter" the "very simplicity of the thing." Also, each detective—although involved in an occupation that requires solitude—discusses each case with a close friend, thereby allowing the reader or viewer to keep pace with the discoveries; each detective compiles data after sorting through the accounts of multiple witnesses, irrelevant observations, and misleading signifiers; each detective is treated as if he or she were a bungler who—in spite of an established reputation—must earn the respect of the law enforcement

officials he or she seeks to help; and each detective attests repeatedly to his or her astute reading of people, who are the subtexts in the phenomenological nightmare of crimes and murders.

Poe's fantastical tales give way to the real life nightmares that afflicted the nation during the 1980s in "Changing Faces: Dr. Jekyll, Mr. Hyde, and Films of the 1980s." Faced with controversies involving Jim Bakker, Gary Hart, Oliver North, Jimmy Swaggart, and other military, political, and religious leaders, Americans were drawn to a succession of films that allowed them a temporary sense of control over their lives. Films featuring betrayal and human misperception either reassured moviegoers that they could spot fraud and deception when they encountered them or left them in a maelstrom of anxiety and doubt, mitigated by the fact that they were engaging fictional texts.

Films of the 1980s startled audiences by transforming and upending what they considered familiar. Both Flannery O'Connor and Vladimir Nabokov argue that one responsibility of an artist is to jolt readers into new understanding. "Changing Faces" focuses upon a literary prototype for duplicitous behavior—Robert Louis Stevenson's *The Strange Case of Dr. Jekyll and Mr. Hyde* (1886)—and alludes to tales about villains, seductresses, rogues, and tricksters from the Bible to early American literature to music videos and song lyrics.

The final chapter in this portion of the collection is "Displaced People and the Frailty of Words: Communication in *Ordinary People, On Golden Pond*, and *Terms of Endearment*." The longing for words that will do justice to one's feelings and beliefs too often remains unsatisfied, as we discover through a brief study of problematic dialogue in *Ordinary People* (1980), *On Golden Pond* (1981), and *Terms of Endearment* (1983). In the conversations central to these films, parents and children are unable to hear one another when, for example, one of them addresses core relational issues and the other talks about the mundane. The chapter deals with the fabric of human conversation and the longing for understanding and connection in these three representative and immensely popular films.

The title of the chapter alludes to a short story by Flannery O'Connor entitled "The Displaced Person," a tale about an immigrant, a landowner, and a priest, all of whom struggle to deal with the failure of communication and with inevitable misunderstandings within a fictional text. When the stakes of missed communication are high—as in parent-child or romantic relationships—the failure is especially excruciating. A young man and his mother strain to reach one another in *Ordinary People;* a young woman desperately tries to understand her critical and withholding father in *On Golden Pond;* and a young woman in *Terms of Endearment* must address the emotional

chasm that lies between her and her self-protective son, between her and her philandering husband, and between her and her overly protective mother.

Portrayals of Class, Race, and Sexual Orientation

The second portion of the collection includes chapters about depictions of class, race, and sexual orientation and an analysis of how differences between us are portrayed in popular film. Texts are as varied as *Flags of Our Fathers* (2006), *Letters from Iwo Jima* (2006), *Brokeback Mountain* (2005), *Rising Sun* (1993), *Come See the Paradise* (1991), *Fried Green Tomatoes* (1991), *Pacific Heights* (1990), *Ski Patrol* (1990), *Black Rain* (1989), *Gung Ho* (1986), *Karate Kid II* (1986), and *The Color Purple* (1985).

The first chapter, "Working Man Blues: Images of the Cowboy in American Film," relies upon literary, regional, and sociological scholarship about the American West and challenges popular myths. The cowboy is a national treasure, a stereotype both embraced and reviled. Filmmakers, authors, and songwriters glorify him and appear to celebrate what he represents: manual labor, the raising of cattle for human consumption, and rural life. There is much to admire. The cowboy works hard, is loyal to his friends, lives close to the land, and depends upon animals for his identity as well as his livelihood. He represents freedom and stands in stark opposition to a settled, domesticated life. However, his self-sufficiency depends upon the seasons, upon the availability of employment, and upon the financial stability of those who pay his wages. In short, the cowboy is often isolated and poor, facts that are too often obliterated in the national obsession with legends about men who brand and herd cattle, chase outlaws, shield women and children from harm, and wield Colt revolvers. Waylon Jennings and Willie Nelson are probably correct: mothers shouldn't let their babies grow up to be cowboys.

"Working Man Blues" emphasizes the labor that sustains the cowboy and the films that portray a more realistic—albeit still iconic—figure. Although it is impossible to discuss all of the films listed here, blue-collar cowboys appear prominently in these and other narratives: *Butch Cassidy and the Sundance Kid* (1969), *Midnight Cowboy* (1969), *Little Big Man* (1970), *The Outlaw Josey Wales* (1976), *Silverado* (1985), *The Milagro Beanfield War* (1988), *Young Guns* (1988), *Dances with Wolves* (1990), *Unforgiven* (1992), *Tombstone* (1993), *Legends of the Fall* (1994), and *Wyatt Earp* (1994). Others are *Lone Star* (1996), *The Missing* (2003), *Open Range* (2003), *An Unfinished Life* (2004), *The Three Burials of Melquiades Estrada* (2005), *The Assassination of Jesse James by the Coward Robert Ford* (2007), *3:10 to Yuma* (2007), *No Country for Old Men* (2007), *Appaloosa* (2008), and *True*

Grit (2010). Spanning five decades, these celebrated films have garnered numerous awards. Among them, *Dances with Wolves* was nominated for 12 Academy Awards and won seven; *Unforgiven* and *Brokeback Mountain* each were nominated for nine and won four.

The sheer number of films suggests that the Marlboro man is as much a part of the national psyche as Aunt Jemima and the Pillsbury Doughboy. Acknowledging the importance of the cowboy in American mythology, this study alludes to the romantic, realistic, and revisionist Westerns that have defined the American cowboy and analyzes two films that powerfully disrupt earlier portrayals—*Brokeback Mountain* (2005) and *No Country for Old Men* (2007). Directors such as Ang Lee and the Coen brothers, respectively, both challenge and reify portrayals of the blue-collar cowboy and provide new understanding of a historical and significant national icon.

The next two chapters employ queer theory to better understand the gay experience in America. One of the films is set in the American West and challenges prevailing myths about masculinity; the other is set in the Deep South and explores historical and prevailing images of women. With the release of *The Kids Are All Right* (2010), Hollywood screenwriters, producers, and directors renewed their interest in the gay issues that were addressed in the documentary *The Celluloid Closet* (1993) decades before. *The Celluloid Closet* concludes with a compelling analysis of the contributions made by landmark films such as *Philadelphia* (1993), which casts Tom Hanks as an attorney dealing with AIDS. "From the Wilderness into the Closet: *Brokeback Mountain* and the Lost American Dream" deals with a film and the short story from which it is drawn and argues that we do *Brokeback Mountain* a disservice by calling it "the gay cowboy film." Both Annie Proulx's short story and the screenplay by Larry McMurtry and Diana Ossana succeed for reasons that are largely unrelated to sexual orientation; in fact, class issues are equally as compelling for protagonists Jack Twist (Jake Gyllenhaal) and Ennis del Mar (Heath Ledger).

The short story and film succeed not only because they challenge preconceptions about gender identity but because they force us to contend with the fears and limitations that make our being able to choose a richer, more passionate, more imaginative life impossible. Chances for a rich, restorative, and expressive life in the Wyoming wilderness come to nothing; instead, in the final scene of the film one of the central characters stands silently in the closet of his trailer. *Brokeback Mountain* disturbs and unsettles us, not simply because it suggests that love between two men is as valid and as viable as love between a woman and a man but because it demands that we confront the lives we could have lived if we had crossed the invisible divides that separate us from ecstasy and the fulfillment of our deepest desires. Like

American literary classics such as F. Scott Fitzgerald's *The Great Gatsby*, *Brokeback Mountain* demands that we consider the societal paradigms that help us to define ourselves at the same time that they limit, constrain, and often immobilize us.

Like the chapters about the literature and culture of the American South included in Section Three ("'American Life Is Rich in Lunacy': The Unsettling Social Commentary of *The Beverly Hillbillies*" and "Grits and Yokels Aplenty: Depictions of Southerners in Prime-Time Television"),"What Happened to Celie and Idgie?: 'Apparitional Lesbians' in American Film" deals with the historical and literary legacy of a region starkly different from the rest of the United States. The chapter is appropriate for this section because it features lesbian figures whom readers met in novels by Alice Walker and Fannie Flagg but who had in the film versions (perhaps not so mysteriously) all but disappeared. Relying heavily upon ideas introduced by scholars such as John Howard and Terry Castle, "What Happened to Celie and Idgie?" deals with lesbian characters in *The Color Purple* and *Fried Green Tomatoes at the Whistle Stop Café* as they are portrayed in films by the same name. The chapter analyzes the relationships between Celie (Whoopi Goldberg) and Shug Avery (Margaret Avery) and Idgie (Mary Stuart Masterson) and Ruth Jamison (Mary-Louise Parker) and suggests ways that the screenwriters, producers, and directors transformed lesbian desire into friendships that were presumably more acceptable to the public. Substituting the romantic love in the novels with the near-platonic love in the films may ultimately, however, have made the subversive themes more obvious.

Following three chapters about the American West and the Deep South is "Litigating the Past: Portrayals of the Japanese in American Film," which addresses the legacy of World War II and United States internment camps and the impact of history on popular culture. It traces the hostility expressed by Japanese authors and politicians toward American workers and highlights responses by American filmmakers during the 1990s and beyond. Most recently, Clint Eastwood's *Flags of Our Fathers* and *Letters from Iwo Jima* again attempt to bridge the racial and ethnic divide. Misunderstandings and mistrust are inevitable in a society struggling to come to terms with the vestiges of World War II, the changing economic landscape, and the profound differences in customs between the two worlds. Films such as *Come See the Paradise*, *Karate Kid II*, and *Letters from Iwo Jima* are attempts to portray Japanese culture honestly, but they are only a beginning. In *Karate Kid II*, Noriyuki (Pat) Morita states: "Never stop war by taking part in one." The wounds from Pearl Harbor, Hiroshima, and Nagasaki remain.

Although only the final chapter in Section Two deals explicitly with race and ethnicity, the topic remains central to the third and fourth sections of *Dangerous Dreams*. In "Fatherhood, Fidelity, and Friendship: Owen Thoreau Jr. and *Men of a Certain Age*" and *"Frank's Place:* Coming Home to a Place We'd Never Been Before," for example, African-American and Latino issues again are addressed. Although issues of particular importance to gay audiences are central to the chapters about *The Color Purple*, *Fried Green Tomatoes*, and *Brokeback Mountain*, the fourth section of the collection addresses gender issues as they relate to straight women in chapters such as "The Lady Is (Still) a Tramp: Prime-Time Portrayals of Women Who Love Sex" and "From *Great Expectations* to *The Bachelor:* The Jilted Woman in Literature and Popular Culture." These chapters depend upon cultural icons in *The Golden Girls* (1985–1992), *Sex and the City* (1998–2004), *Desperate Housewives* (2004–2012), and other popular prime-time programming.

Portrayals of Class, Race, and Ethnicity

Section Three begins with "Fatherhood, Fidelity, and Friendship: Owen Thoreau Jr. and *Men of a Certain Age*" and *"Frank's Place:* Coming Home to a Place We'd Never Been Before," which feature African-American actors as fathers and business owners and which remained on the air only two years and one year, respectively. Along with "'American Life Is Rich in Lunacy': The Unsettling Social Commentary of *The Beverly Hillbillies*" and "Grits and Yokels Aplenty: Depictions of Southerners on Prime-Time Television," these chapters analyze the portrayal of middle- and working-class African Americans living in Southern California or New Orleans, poor whites transplanted from the Ozarks to Beverly Hills, and middle-class whites living in rural communities in the Deep South.

Men of a Certain Age (2009–2011) introduced three men nearing 50 in various stages of relationships and in pursuit of the American dream. One owns his business and is divorced and a father of two. Another is single and struggles with career choices. A third works for his father and deals with the demands of marriage and three young children. All rely upon one another and meet regularly; in this way, they mimic the friendships made famous by *The Golden Girls* and *Sex and the City*.

Owen Thoreau Jr. (Andre Braugher)—the heavyset African American whose father calls him "an embarrassment" but who is adored by his wife and children—is at the center of "Fatherhood, Fidelity, and Friendship." Relying heavily upon studies such as *The Myth of the Missing Black Father*,

edited by Roberta L. Coles and Charles Green, this chapter contributes to the section on gender images in television by dealing with men and issues of race and ethnicity in a contemporary dramedy.

The next chapter, too, celebrates a television show embraced by a small but loyal following. For those who loved *Frank's Place* (and who chased it determinedly when CBS entertainment executives moved it through six different time slots on four different nights), walking into the front door of Chez Louisiane was akin to coming home. The nostalgia for an unknown but familiar place so prevalent in Southern literature and culture is similar to the television audience's expectation that the setting for the show will provide a sense of coming home, a sense of being located and of feeling safe.

Frank's Place was no simplistic rendition of stereotypical American life, nor was it a challenge to racial stereotypes in the same way that *The Cosby Show* was. Rather than offering American viewers a peek into the living room of a family headed by a successful lawyer and a doctor, *Frank's Place* introduced class issues and demanded that a viewer leave behind all presumptions about the South, about New Orleans, and about the African-American community in a particular locale and engage social issues, a new television genre, a beautiful but unfamiliar setting, and a central character on a quest for understanding.

Two popular episodes of *The Beverly Hillbillies* (1962–71) place class issues at the center of the television program and of this study. One of the most critically despised and publicly acclaimed situation comedies in American television history, *The Beverly Hillbillies* features Jed Clampett (Buddy Ebsen) and his family in the first episode as they take their first airplane trip. The dislocation and fear that the Clampetts experience represent the way much of America approached technological development, increased industrialization, and economic materialism during the 1960s. In the second episode important to this study, Elly May (Donna Douglas) befriends creatures in the woods and embodies the instinctive sensitivity and strength with which she and Granny (Irene Ryan) respect the natural world and live in balance with it. When a scene that depicts the Clampetts' unfamiliarity with and distrust of technology collides with a scene that depicts Elly May's negotiation with wild "critters," what results is the central conflict and the primary didactic message of *The Beverly Hillbillies:* Those who live close to the land and who protect nature have a superior moral sensibility, a sensibility that is lost to those in the urban wasteland.

Although the phenomenal popularity of the situation comedy does not necessarily attest to its quality, it does suggest that *The Beverly Hillbillies* gripped the national imagination in a singular way. By focusing on roles played by Elly May Clampett and Granny, this chapter explores both the

primary theme of the situation comedy and its possible historical antecedents. It also argues that *The Beverly Hillbillies* is, in fact, part of a rich tradition of American comedy and social satire. Although *The Beverly Hillbillies* did not have the scathing satirical edge of "Li'l Abner," creator Paul Henning might well have agreed with cartoonist Al Capp when Capp said that he found humor "wherever there is lunacy, and American life is rich in lunacy everywhere you look" (Capp 104).

A second chapter, which reintroduces *The Beverly Hillbillies* but depends upon several other popular texts as well, is "Grits and Yokels Aplenty: Depictions of Southerners on Prime-Time Television." The chapter argues that many Americans of a certain generation can whistle the theme song to *The Andy Griffith Show*, as we remember Andy Taylor and son Opie (Ron Howard) strolling down a dirt road toward the ol' fishin' hole. We remember "New York is where I'd rather stay/ I get allergic smelling hay/ I just adore a penthouse view/ Darlin', I love you, but give me Park Avenue" from *Green Acres*. And we remember Uncle Joe, "he's a movin' kinda slow, at the Junction" *(Petticoat Junction)*.

From the introduction of "Li'l Abner" (1934) to country music variety shows to the ruralcoms of the 1960s to the present, the South has been portrayed as a reservoir of homely virtues, which includes a young hero or heroine facing initiation experiences (Opie Taylor, John-Boy Walton, etc.); a tendency toward the grotesque, a representation of those who appear foolish but who secretly safeguard the highest human principles; and an appreciation of the agrarian economy that makes poverty tolerable by focusing on human values forged in adversity.

Even while they ridiculed Georgia drawls, Americans came back week after week for another shot of Southern hospitality. The importance of community, family, and human values—traditionally associated with the best of the South—are central in programming from *The Andy Griffith Show* to *The Waltons* to *Evening Shade*. Images of Southerners fighting for populist agrarianism and against corporate greed; committed to family, community, the land, unions, and democracy; and living by the standards of individualism counteract the caricatures of buxom belles and stumbling bumpkins living awkwardly in the land of azaleas.

The fascination with the South continues with the revival of *Dallas* and the emergence of *Hart of Dixie*, which were renewed for at least a second season. After an unparalleled 14-year run that ended in 1991, *Dallas* was reincarnated in 2012 with several of the original cast members, and the battle for control of the energy industry and Southfork continues on TNT with J.R. Ewing (the late Larry Hagman), Bobby Ewing (Patrick Duffy), and Sue Ellen Ewing (Linda Gray) as heads of warring households. *Hart of Dixie*, which

premiered on CW in 2011, stars Rachel Bilson as Dr. Zoe Hart. The tough New Yorker finds herself working in a small clinic in Bluebell, Ala. As in *The Prince of Tides* and other films, life in the rural South is juxtaposed with life in the urban North, and viewers return for another heapin' helpin' of Southern hospitality.

Portrayals of Women in Film and Television

The final section of *Dangerous Dreams* begins with a discussion of women's issues at the heart of *The Bachelor*, *Desperate Housewives*, *The Golden Girls*, and *Sex and the City*. Books, articles, television programs, and films about an insatiable desire for companionship, sexual connection, and marriage continue to proliferate. Films that deal with the intricacies of marriage—such as *Father of the Bride* (1991), *Four Weddings and a Funeral* (1994), *My Best Friend's Wedding* (1997), *Runaway Bride* (1999), *An Ideal Husband* (1999), and *Sweet Home Alabama* (2002)—testify that the desire to live happily ever after is not likely to ebb. With a wink and a nod, we laugh at those in film or on the television screen who need someone too much— perhaps while asking ourselves what we might be missing.

Images of women who have been betrayed by their lovers, partners, and husbands have peppered literature and popular culture since the beginning of time. Although the word "jilted" customarily refers to a woman left on the day of her wedding, "From *Great Expectations* to *The Bachelor:* The Jilted Woman in Literature and Popular Culture" employs the term to describe any woman abandoned, betrayed, rejected, or sent home alone. In Katherine Anne Porter's "The Jilting of Granny Weatherall," the dying protagonist, floating between memory and the flesh-and-blood visitors at her bedside, remembers a lost love and refers to it as "something not given back" (74). *Great Expectations* by Charles Dickens and "A Rose for Emily" by William Faulkner join Porter's short story in a chapter that explores images of abandoned women. A woman left at the altar or abandoned by her husband or lover is a compelling cliché because loss and betrayal are universal experiences. In many popular and literary texts, the significance of this loss is tied to the historical dependence that women have had on men for financial security, cultural acceptance, children, and protection from an often hostile patriarchal system. It is also tied, though often secondarily, to a woman's genuine grief at the loss of a love that is ultimately unreciprocated.

"The Lady Is (Still) a Tramp: Prime-Time Portrayals of Women Who Love Sex" deals with several fictional characters who express their sexuality while being ridiculed by others. They include Abby Ewing (Donna Mills) of

Dallas and *Knot's Landing*, Blanche Devereaux (Rue McClanahan) of *The Golden Girls*, Jackie Harris (Laurie Metcalf) of *Roseanne*, Samantha Jones (Kim Cattrall) of *Sex and the City*, and Paige Matheson and Edie Britt (both played by Nicollette Sheridan) of *Knot's Landing* and *Desperate Housewives*, respectively. Because this study does not focus upon lesbians or women of color, it underscores the manner with which straight white women are caricatured when they disrupt suburbia (*Knot's Landing*, *The Golden Girls*, *Roseanne*, and *Desperate Housewives*), a ranch in Texas *(Dallas)*, or an urban community *(Sex and the City)* by coloring outside the lines.

"The Lady Is (Still) a Tramp" suggests that women who subvert unwritten heterosexual codes of conduct must be punished; in fact, their conniving and sometimes narcissistic behavior is the object of humor at the same time that it allows other characters in the television program to bask in a certain moral superiority. Viewers often find their own life choices reinforced by the fictional worlds they temporarily inhabit—unless, of course, they are viewers who identify with the ladies who are (still) tramps. It also argues that women who love sex are often the ones who are most unruly by society's standards; furthermore, although they may be objects of ridicule, they often use wit to retaliate against those who judge them.

The third and last chapter in Section Four deals with many of the same themes introduced in the first two chapters—but without even a hint of humor to dilute them. The protagonists in Stephen Daldry's *The Hours*—Laura Brown, Clarissa Vaughn, and Virginia Woolf—provide an opportunity to explore the challenges and struggles of women's lives across generations and continents. "'This Moment of June': Laura Brown, Clarissa Vaughn, Virginia Woolf, and *The Hours*" explores the role of the imagination in providing escape and respite from the real world and places the film into context by relying upon Woolf's *Mrs. Dalloway*, Edward Albee's *Who's Afraid of Virginia Woolf?* and Michael Cunningham's *The Hours*.

Clearly, *Dangerous Dreams* suggests the rich reservoir of texts in literature, film, and television studies, which by their very existence and popularity demand further research. As Susan Sarandon reminds us, film is "dangerous" because skilled actors, actresses, directors, producers, and writers unite to sustain a film industry that is "the keeper of the dreams." Television images are no less potent and are, perhaps, more readily available. Whether we go into what Sarandon calls "a little dark room" and enjoy a film or sit in our own living rooms alone or surrounded by family and friends, our engagement with film and television texts is personal and potent.

Dangerous Dreams celebrates the interconnectivity of film, literature, and television and does not suggest the supremacy of any of these texts. Films based on literature and films that explore the role of the narrator in

creating his or her own reality are at the heart of Section One. Section Two and Section Three address diversity of class, race, ethnicity, and sexual orientation in multiple popular films and television programs. Although Section Four includes texts reliant upon differences in class, race, ethnicity, and sexual orientation and refers to literature, it focuses primarily upon gender images in the first decade of a new century and hints at the creative possibilities that await just around the corner.

Section One

The Influence of Literature on Film and Television

Chapter One

Shutter Island:
Martin Scorsese's Allegory of Despair

Ominous clouds droop low over the ocean. An island rises out of the fog ahead. Winds slash trees and slam into the windows of Ashecliffe Hospital. Lavish lawns and bright gardens are juxtaposed with frozen corpses in a winter tableau. And dread is the mood of the day.

Although previews of *Shutter Island* depict spiral staircases, candlelight, mist, and other Gothic portents of doom, Martin Scorsese's 2010 film is not a horror film in the traditional sense. Instead, the dark and twisting hallways of a mental institution and the paths along the bluffs of the island represent the labyrinths of the human mind. With water that drips hauntingly on the stone walls of the hospital wards and an eerie light that illuminates the faces of those trapped within, *Shutter Island* elicits a different kind of terror.

The film and the book upon which it is based trade on dreams, hallucinations, and delusions. There are no vampires or rivers of blood on *Shutter Island*; instead, living people wander alone in ghostly silence. Author of *Gone, Baby, Gone* and *Mystic River*, Dennis Lehane has perfected a mood of gloom and apprehension. His 2003 novel *Shutter Island* is no different. "The dark trees on the other side of the wall had begun to sway and whisper" (68), he writes. Similar descriptions of nature as a menacing force permeate the film as well.

Reminiscent of the endlessly twisting tunnels of Franz Kafka's *The Trial*, the dank catacombs of Edgar Allan Poe's "The Cask of Amontillado," and the evocative bell tower of Alfred Hitchcock's *Vertigo*, the images that characterize both the novel and the film include barbed wire fences, a cemetery, jagged cliffs, and a Civil War fortress that stands watch over the resplendent (and incongruous) flower gardens below. Drawing us into a

microcosm of human cruelty and depravity, Scorsese creates an allegory of despair.

From our first glimpse of a ship's moving slowly toward the forbidding island to Dinah Washington's singing "This Bitter Earth" during the final credits, we understand that we have entered a baffling but self-contained and carefully choreographed universe. Washington's lyrics—"This bitter earth/ What a fruit it bears"—provide the thematic center for this strange new world. In his *Wall Street Journal* review, John Anderson notes "the film's ever-present cigarette smoke and mood of anxiety." Similarly, Roger Ebert describes the film with characteristic attention to its place among other narratives: "In its own way it's a haunted house movie, or make that a haunted castle or fortress."

Scorsese's allegory is a finely hewn narrative, and, in fact, effective storytelling lies at the heart of the film, as character after character tells his or her own somber tale. Throughout the novel, Lehane employs numerous synonyms for narrative, reminding us that—wisely or not—human beings are doomed to talk about themselves and their individual realities. Lehane writes about the "late-night boogeyman story" (252), the fairy tale that develops in a "boo-ga-boo-ga-boo-ga kind of way" (253), "tall tales" (286), "yarns" (286), "a handsomely mounted stage play" (348) and a "masquerade" (348). In the novel, protagonist Edward "Teddy" Daniels accuses his wife of having filled their children's heads with "dreams" and "fantasies" and of having taken them too often to the movies (354). In a film in which memory and the impossible borderland between truth and fiction are at stake, there are sure to be surprises.

Narratives of Sanity and Madness

Shutter Island is two films in one, and its startling twists encourage a second (and third) viewing. It is and is not about World War II, the Holocaust, and the dead victims and their oppressors at Dachau. It is and is not about the thin line between sanity and madness: "Sanity is not a choice," Dr. John Cawley (Ben Kingsley) tells Daniels.

The film is set in 1954 in the Boston Harbor Islands of Scorsese's imagination. Taking place in three days, *Shutter Island* opens with Daniels (Leonardo DiCaprio), a U.S. marshal, retching in a lavatory on a ship that carries him to his most recent assignment. Perhaps his nausea is related to seasickness; perhaps it is the result of something more sinister ("It's just water. It's a lot of water," Daniels says. "I just can't stomach the water"). Critic Anthony Rianone notes that in *Shutter Island*, "water is as dangerous as acid."

Anderson concurs: "The heaving water on Boston Harbor looks as welcoming as a grave."

The ocean, the waves, the rain, and the impenetrable fog are central to the plot. Unlike bodies of water in *Huckleberry Finn, A River Runs Through It*, or other masterpieces of American literature, water in *Shutter Island* is sinister. Instead of giving life, it threatens those who live on the island and hints at the trauma that torments Daniels. Water is often central to Daniels in his dreams and in his waking moments. Telling Daniels "I'm just bones in a box, Teddy," his wife turns to ashes in his arms as water runs off his hands. A mother drowns her three children after going for a "long swim in the lake."

Before long, we understand that in this fictional universe, little is as it appears and music and setting are nearly as important as character or plot. The ship captain—anxious to deposit his cargo before the impending storm engulfs the island—maroons us along with marshals Daniels and Chuck Aule (Mark Ruffalo). We are left with the doctors, guards, inmates, nurses, and orderlies who populate a seemingly corrupt mental institution at the height of the Cold War. As if the post-World War II anxiety, the uneasy relationship between the U.S. and Russia, and the proliferation of nuclear weapons aren't enough, we are witnesses to escalating debates about psycho-pharmaceutical drugs and surgical procedures that are used to treat the criminally insane.

A patient, Rachel Solando, is missing. She has escaped from her cell, although everyone agrees it is impossible for her to get past the guards or to survive outside the facility. Having relinquished their weapons, Daniels and Aule begin to interview doctors and patients and to search the wards and the rest of the island for her. But soon Scorsese makes it clear that all is not as it seems. Cawley tells Daniels that Solando created an "elaborate fictional structure" and gave all those on Shutter Island parts in the play she wrote. She enlisted others in her story in order to avoid facing the truth about her past. "The greatest obstacle to her recovery was her refusal to face what she had done," Cawley says to Daniels.

Unsurprisingly, Rachel Solando is not the only one who has created an intricate fiction, and we soon begin to understand how Daniels is connected to the escapee he has been assigned to locate. Driven mad by the traumatic events of war and by guilt for his complicity in the deaths of his wife and children, Daniels confronts his family in a dream. "You should have saved me," his daughter tells him. "You should have saved all of us." Later, covered in blood, Solando (played in this particular scene by Emily Mortimer) stands above three dead children who are lying at her feet. Daniels lifts one of the children, who is his daughter, and says, "I'm so sorry." Again, the child asks, "Why didn't you save me?" Slowly and with the atrophied movements of someone trapped in a dream, Daniels puts the body of his

daughter in the water with the other children. "See? Aren't they beautiful?" Solando says to him.

Like Solando, Daniels has reinvented reality in order to save himself. In the novel, Cawley tells Daniels, "You've created a dense, complex narrative structure in which you are the hero" (331). To cope with the unalterable pain of guilt and loss, Daniels has redefined himself as a brilliant, caring U.S. marshal and has displaced his darker side onto a character named Andrew Laeddis. As Daniels and Aule investigate odd occurrences on the island, Aule says cryptically, "Maybe we'll run into Andrew Laeddis." And later, Daniels says, "He's here. Laeddis. I can feel him."

The conclusion of the film resolves some mysteries and highlights others. As Daniels runs into a room in the lighthouse, gun drawn—ostensibly to put an end to lobotomies that he believes are taking place—he is drenched from swimming to the promontory. Cawley is alone in the room. In an allusion to Daniels' past, he says, "Why are you all wet, baby?" He then shows Daniels his intake form, and Daniels reads that in two years of treatment on the island, he has denied that the murder of his children and the death of his wife ever took place and has created "highly developed and fantastical narratives" about his life. In the novel, Lehane includes a lengthier report: "Patient is highly intelligent and highly delusional. Known proclivity for violence. Extremely agitated. Shows no remorse for his crime because his denial is such that no crime ever took place. Patient has created a series of highly developed and highly fantastical narratives which preclude, at this time, his facing the truth of his actions" (326).

We then learn that Daniels also has invented anagrams: His wife Dolores Chanal (Michelle Williams) is Rachel Solando. Edward Daniels is actually Andrew Laeddis. As we learn that Daniels has hidden his violent past from himself, we begin to understand that he in fact might not be allowed to leave. From the way Daniels describes his passion for his wife, we know the depths of his loss and his inability to deal with the manner in which she died. Throughout the film, Scorsese visually suggests the deep love Daniels has for his wife, but Lehane also powerfully evokes the torment of his separation from her as she sinks further and further into madness: He "wanted to ask her what sound a heart made when it broke from pleasure, when just the sight of someone filled you the way food, blood, and air never could, when you felt as if you'd been born for only one moment, and this, for whatever reason, was it" (242).

Little by little, we understand more about the convoluted but intriguing plot. Manic-depressive and suicidal, Chanal and Daniels had three children, Simon, Henry, and Rachel, according to the novel. As his wife sank into madness, Daniels ignored the severity of her condition, even after she set

their apartment on fire. Having moved the family to a lake house, Daniels returns from a trip one day in 1952, pours himself a drink, and goes outside to greet his family. Rising from a backyard swing, Chanal is drenched. "Baby. Why are you all wet?" Daniels asks. Seeing the bodies of his children in the water, Daniels throws himself into the lake. Lifting each of them, he screams his grief to the heavens and lays the bodies in a row and folds their arms. As Chanal begs him to set her free, Daniels then cradles his wife in his arms and shoots her. Later, in a rare moment of self-awareness, Daniels tells Cawley, "I killed them because I didn't get her help."

As Cawley talks with his most challenging patient, we learn that at one point during his treatment, Daniels acknowledged his guilt, and the doctors began to hope for a breakthrough; however, as Cawley explains, Daniels "reset." Throughout the carefully monitored role-play during his three days as a marshal, Daniels is again brought into consciousness of his past. However, as we witness his conversation with Aule, who is actually psychiatrist Lester Sheehan, Daniels drifts back into his other persona and calls Sheehan "Chuck." Sheehan nods to Cawley and Jeremiah Naehring (Max Von Sydow), indicating to them that the role-play therapy did not succeed. Although the words do not appear in the novel, Daniels then asks the man he believes to be his partner, "Which would be worse? To live as a monster? Or to die as a good man?"

A Microcosm of Human Violence

Scorsese's allegory is part thriller, part psychological drama, and part tormented love story. His analysis of human violence and of the ability of the mentally ill to deny their crimes by creating alter egos and writing their own stories is masterful. Dr. James Gilligan, author of *Violence: Reflections on a National Epidemic*, served as the psychiatric consultant on *Shutter Island*. An expert in dissociative identity disorder, Gilligan addresses the ways people avoid treatment by creating an imaginary world or meta-reality. According to Gilligan, in the final seconds of the film, Daniels chooses "symbolic suicide" by agreeing passively to a lobotomy.

However, horror reverberates far beyond Shutter Island. Even the inmates are terrified of what lies across the ocean, a reminder to viewers that madness has many forms. For example, one patient who killed her spouse with an ax tells the marshals she doesn't know what she would do if she were released, especially now that bombs can "reduce whole cities to ash." And later, as Daniels subdues a violent patient in Ward C, the man cries out: "I don't want to leave here. All right? I mean why would anybody want to? We

hear things here. About the outside world...Do you know how a hydrogen bomb works?...Get it?...Do you?"

Three other scenes suggest Scorsese's desire to make Shutter Island a microcosm of a dangerous and violent world. When he is invited to talk with Cawley and Naehring after he disembarks on the island, Aule asks if the music playing in the mansion is Brahms. Daniels responds, "No. It's Mahler." In the room with Cawley and Naehring, Daniels flashes back to his time as a soldier in Germany and to the suicide of a Nazi commander. The commander was playing Mahler as he slowly bled to death and as Allied troops outside faced the horrors of Dachau. Bodies were frozen to the ground—"too many to imagine," Daniels says. When prison guards were executed, Daniels tells Aule, "It wasn't warfare. It was murder."

In another scene, Daniels finds the woman he believes is Rachel Solando (played in this scene by Patricia Clarkson). She is hiding in a cave at the far reaches of the island and tells him she was never a patient but a psychiatrist. She calls the surgical procedures in use on the island "barbaric" and "unconscionable." She says the doctors are creating ghosts, people "who can't be interrogated because [they have] no memories to confess." "You can never take away all man's memories," Daniels says. "Never." He then asks her, "Who knows about this? On the island, I mean. Who?" "Everyone," she tells him. Solando talks about North Koreans, Nazis, Soviets, and Americans, all of whom prey upon one other and create chaos and death, she says. There is no "moral order" on the island—or anywhere else.

When Daniels leaves the cave, a menacing warden offers him a ride. The warden identifies with Daniels' violent nature and issues a short soliloquy as he drives: "God loves violence...Why else would there be so much of it? It's in us. It's what we are. We wage war, we burn sacrifices, and pillage and plunder and tear at the flesh of our brothers. And why? Because God gave us violence to wage in his honor." He ends their conversation by suggesting that he and Daniels are very much alike: "We've known each other for centuries."

Lehane placed his novel in the tradition of paranoid political thrillers and set out to create an unreliable narrator, and screenwriter Laeta Kalogridis honored his vision. Daniels is or isn't a marshal. Sheehan did or did not leave the island while the marshals searched for Solando. The lighthouse is either a sewage treatment plant or a hospital annex in which lobotomies are performed. Reality depends upon which story we believe: a U.S. marshal's tale of a missing patient or psychiatrist's tale of an intricate role-play designed to bring a patient back to his senses.

Naehring, who early in the film identifies Daniels and Aule as "men of violence," tells Daniels he has "outstanding" and "very impressive" defense mechanisms," but it is not until the end of the dark tale that we understand

what he means. Listing *Kudun*, *The Age of Innocence*, and *Raging Bull* as three other Scorsese films about "psychological or physical cruelty," Lawrence Toppman writes in the *Charlotte Observer* that the "consequences of violence" in *Shutter Island* are "inescapable guilt, fruitless denial, pathetic justification." Certainly, his assessment is true of Daniels, whose defenses prohibit him from integrating his two selves.

In his novel, Lehane explores the manner in which we write our own fictions and maintain what we need to believe about ourselves. "You surfaced without a history, then spent the blinks and yawns reassembling your past, shuffling the shards into chronological order before fortifying yourself for the present" (20), he writes. In the film, we realize that when Cawley describes Solando, he is talking not only about her but about Daniels and—to a lesser extent—all human beings who engage in self-delusion. Describing Solando, Cawley says, "To sustain the structure, she employs an elaborate narrative thread to her life that is completely fictitious" (50). But, of course, instead of simply describing one troubled woman, Cawley refers to us all.

Conclusion

In its first week, *Shutter Island* opened at #1 and netted $41 million. Still #1 during the second week, it earned $22.2 million. Like other Scorcese films starring DiCaprio *(Gangs of New York*, *The Aviator*, and *The Departed)*, *Shutter Island* is also a critical success. However, *Shutter Island* is unlike anything that came before. Anderson calls it Scorsese's "most enigmatic" film: *"Shutter Island* requires multiple viewings to be fully realized as a work of art. Its process is more important than its story, its structure more important than the almost perfunctory plot twists it perpetrates. It's a thriller, a crime story and a tortured psychological parable about collective guilt."

Anderson predicted that *Shutter Island* would have limited popular success, as much because of its topic as its meandering plot line: "It won't be a beloved movie. It will inspire doctoral dissertations." He celebrates Scorsese's having "turned a death camp into a frozen tableau of permanently lovely children," another suggestion that the dark tale might appeal to critics more than to the American public. "Not since *Raging Bull* has Mr. Scorsese so brazenly married brutality to beauty," he writes.

Certainly, *Shutter Island* is a contribution to film noir, but it is also a narrative that comments on the nature of storytelling. And if the story isn't compelling enough, Ebert argues that the film is notable for other reasons:

And that's what the movie is about: atmosphere, ominous portents, the erosion of Teddy's confidence, and even his identity. It's all done with flawless directorial command...

...This movie is all of a piece, even the parts that don't appear to fit...What if there were things about Cawley and his peculiar staff that were hidden? What if the movie lacks a reliable narrator? What if its point of view isn't omniscient but fragmented? Where can it all lead? What does it mean? We ask, and Teddy asks, too. (n.p.)

Shutter Island challenges our conclusions about mental illness as it introduces us to a Kafkaesque universe in which nothing is what it seems to be. What do the multiple narratives mean? Which characters may we trust? Why do we so readily privilege Daniels' version of reality? Ultimately, making sense of the macabre allegorical tale is as rewarding as it is challenging.

Works Cited

Anderson, John. "Scorsese Rules This 'Island.'" *Wall Street Journal*. 19 Feb. 2010. http://online.wsj.com/article.

Ebert, Roger. *"Shutter Island." Chicago Sun Times*. 17 Feb. 2010. http://rogerebert.suntimes.com/apps/pbcs.dlll/article?AID.

Lehane, Dennis. *"Shutter Island."* New York: HarperTorch, 2003.

Rainone, Anthony. "Island of No Return." *January Magazine*. http://january magazine.com/crfiction/shutterisland.html.

Shutter Island. Dir. Martin Scorsese. Paramount, 2010.

Toppman, Lawrence. *"Shutter* Yields Shudders—and Ideas." *Charlotte Observer*. 18 Feb. 2010. http://events.charlotteobserver.com/reviews/show/151425-review-shutter-island.

Chapter Two

When Fiction Becomes Reality: Authorial Voice in
The Door in the Floor, *Secret Window*, and *Swimming Pool*

The intimate connection between authors and their works has always capti-
vated readers. Where is the line between an artist and his or her creation?
Are there times when the line is invisible, when the real and the imaginative
become one? "When Fiction Becomes Reality: Authorial Voice in *The Door
in the Floor*, *Secret Window*, and *Swimming Pool*" deals with the role of the
imagination in storytelling, with the distinctions between genius and madness
in the creative process, and with meta-fiction, or the way in which literary
and visual texts about language and images comment upon themselves.

With varying degrees of success, three films—two of which are drawn
from literature—address the complexities of the authorial process and form
the basis for several conclusions about storytelling as a stay against chaos.
While creating characters and plots, novelists and screenwriters are also
authors of their own experiences and are often extraordinarily conscious of
how the narratives they create mimic the narratives they live. This study
addresses the self-consciousness of three fictional authors as they weave
experience into art.

The Door in the Floor (2004), *Secret Window* (2004), and *Swimming
Pool* (2003) feature protagonists who have lost their way and who hope
fiction will save them. Ted Cole (Jeff Bridges, *Seabiscuit* and *The Big
Lebowski*) considers himself "an entertainer of children," although his book
The Door in the Floor is an exploration of the horrors that lie beneath us as
we move unsuspectingly through life. Reviewer Arthur Lazere writes:

> The title of the film is also the title of one of Ted's books and it's a variation on
> one of the classic, central themes of children's literature—the frightening

unknowns hiding somewhere nearby, whether under a door in the floor or in
|Stephen| Sondheim's *Woods* or down Alice's rabbit hole. Children, the inno-
cents, must venture out into life with all its risky experiences, including
hurts and losses and disappointments and the mysteries of sexuality, too. (n.p.)

In *Secret Window*, an accomplished writer, Morton Rainey (Johnny Depp) is
accused of having plagiarized one of his stories, "Sowing Season"; as he tries
to unravel the mystery of authorship (and simultaneously regain control of
his life), he goes slowly mad. Finally, in *Swimming Pool*, Sarah Morton
(Charlotte Rampling) struggles to produce a manuscript different from the
mystery novel series that has earned her the respect of her publisher and her
readers. Hoping to impress her publisher, she leaves London and isolates
herself at his home in the Provencal town of Luberon and, through an
interplay of narratives (a diary, an unpublished manuscript, and her own text-
in-progress), finds her way both into a new genre and back to herself. She
succeeds by creating a narrative in which, as reviewer Michael Rechtshaffen
writes, the "line between reality and fantasy becomes increasingly smudged";
in fact, the line between her own life and the lives of her characters is blurred
as well.

Drawn from a 1998 novel by John Irving entitled *A Widow for One Year*,
The Door in the Floor deals with Ted and Marion Cole (Kim Basinger, *L.A.
Confidential*), who are dismantling their marriage after losing both their sons
in a car accident five years before. A.O. Scott argues in the *New York Times*
(July 14, 2004) that *The Door in the Floor* "may even belong in the rarefied
company of movies that are better than the books on which they are based"
|Two other Irving novels became successful films: *The World According to
Garp* (1983) and *The Cider House Rules* (1999)|. Separated and trading
residences in East Hampton in order to be available to their 4-year-old
daughter Ruth (Elle Fanning), the Coles employ storytelling as a way to
make meaning out of their shattered lives and as a way to keep the memory
of their sons Thomas and Timothy alive (In the novel, Marion Cole is also a
writer, and Ruth later becomes one).

A bright and articulate child, Ruth has become a receptacle for her par-
ents' stories, and she obsessively tells and retells the stories of her brothers to
those who will listen and demands that her parents chronicle the events
captured in the family photographs that adorn the house. Scott writes,
"Rather than help her parents move beyond their grief she traps them inside
it, and herself as well." Some of the most powerful moments in the film are
of Ruth as she stands on a chair in a darkened hallway, looking at the framed
photographs of young men who died before she was born and whispering
their stories to herself. Becoming anxious if the photographs are moved or

taken down, Ruth seems to realize that possessing the images and their respective narratives is a way to hold onto her dissolving family.

The photographs that decorate the hallways and bedrooms in the film are decontextualized by the child as she struggles to understand what happened to her brothers. Thomas and Timothy seem alive and energized in the photographs, but they are absent in real life and real time. The contrast terrifies Ruth, making her cry out on more than one occasion and ask if she, too, is going to die (Ruth, for example, drops one of the framed photographs and cuts her finger. As the doctor puts stitches in, she asks, "Am I going to die?" The answer, of course, is "No": The wound will heal. But the answer is also "Yes": Like her brothers, she, too, will one day die).

Overhearing one conversation between Ted Cole and Ruth, we learn how the boundaries between life and death have become confused for the child. We recognize the photographs and literature as her way to preserve what has been. Ruth asks her father about her brothers in an effort to understand where they have gone:

> **Ruth:** "'Dead' means they're broken?"
> **Ted:** "Well, their bodies are broken. Yes."
> **Ruth:** "And they're under the ground?"
> **Ted:** "Their bodies are. Yes."
> **Ruth:** "Tell me what 'dead' is."
> **Ted:** "When you look at the photographs of Thomas and Timothy, do you remember the stories of what they're doing?"
> **Ruth:** "Yes."
> **Ted:** "Well, Tom and Timmy are alive in your imagination."

Then, into the triangle of Ted, Marion, and Ruth Cole steps Eddie O'Hare (Jon Foster), a junior at Philips Exeter Academy. Like the central figure in coming-of-age films such as *Sophie's Choice*, O'Hare will most assuredly learn more from living with the Coles than he will from his job, correcting the punctuation in Ted Cole's newest story, "A Sound Like Someone Trying Not To Make a Sound." O'Hare's father, an English professor who remembers Thomas and Timothy Cole from their time at Exeter, wants his son to work as Ted Cole's apprentice, although ultimately O'Hare spends more time as Cole's driver (Cole had lost his license three months before for driving while drunk) than he does learning the craft of writing. The 16-year-old, who was hired by Ted Cole to spend the summer as his assistant, falls in love immediately with the sad, sensitive, maternal, perceptive, withholding Marion Cole, who picks him up at the ferry. He becomes their messenger and translator; rarely do Ted and Marion Cole

appear together in a scene, and O'Hare often serves as a conduit for infor-
mation.

While Marion Cole temporarily escapes the memory of her sons' violent
death—one son's leg was severed at the hip, and she picks up his shoe from
the wreckage without realizing the shoe is attached to his leg—her husband
finds refuge from her inability to engage with him and refuge from his own
grief by drawing and subsequently seducing women in the community. As
Irving explains in his novel, the models go through several stages—
innocence, modesty, degradation, and shame—that precede Ted Cole's
ultimate and inevitable abandonment of the women.

At the heart of the film is Ted Cole's children's tale *The Door in the
Floor*, which is illustrated with grotesque figures drawn with the ink from
squids. "And in the cabin there was a door in the floor," begins the harrowing
tale. "Children had come to visit for Christmas but had opened the door and
had disappeared down the hole." When a pregnant woman looks into the door
in the floor, we learn that she has "seen some things—things so horrible you
can't imagine them." Expecting a son, the woman fears that he will one day
open the door in the floor. She resolves her dilemma by vowing to tell him
never to open it. The boy, however, listening from the womb, "didn't know if
he wanted to be born into a world in which there *was* a door in the floor."

The "door in the floor," of course, is richly suggestive: It is the death of
two brothers in a car accident while they are joyously looking forward to a
ski vacation; it is Ted, a deeply sad man having sex with a series of wounded
women; it is the underside of a marriage going through its death throes; it is
the lost innocence of an Eddie O'Hare, who falls in love with and is aban-
doned by Marion; it is a child deserted emotionally (and later physically) by
her mother; and it is also the power of fiction to unleash itself on unwary
readers who have forgotten how treacherous is the world in which we live
and how fragile and temporary is this life.

Part of the difficulty of engaging the role of the writer on an *intellectual*
level in *The Door in the Floor* is that Ted Cole is not a sympathetic figure on
an *emotional* level. We remain detached from him through much of his story.
Ted Cole is "in many ways, monstrous, using his charm and talent the way he
uses sex and drink, as a defense against both intimacy and guilt," Scott
suggests. Although Ted Cole has admitted to delivering Eddie to his wife
because he looks so much like his son Thomas, he is brutal with his young
assistant. He critiques the story Eddie brought with him at the first of the
summer, telling him that "it isn't really a story." He calls the boy's first effort
"an emotional outburst" and a "collection of personal anecdotes that don't
really add up to much." Arguing that writing involves "a certain manipula-
tion," Ted Cole tells O'Hare that "everything in fiction is a tool—pain,

betrayal, even death. These are like different colors on a painter's palette and you need to use them." Telling O'Hare to describe specific smells and tastes and to use details that "create whole scenes in a reader's mind," Ted Cole argues that fiction should prepare readers for the ending but then surprise them. Later in the film, O'Hare dares to tell Ted Cole that his wife has left him and that he can't imagine she would go to New York. Cole replies, "You don't *have* an imagination, Eddie."

The limited role of critics is addressed when Ted Cole meets a student at a book signing and learns that she wrote her freshman English term paper on *The Door in the Floor*. Flirting with her, Ted Cole asks her the title of her paper, and she replies, "An Analysis of the Atavistic Symbols of Fear in *The Door in the Floor*." She tells him that myths and fairy tales are "full of images like magic doors and children disappearing and people being so frightened their hair turns white overnight." She tells him that for the unborn child, the door in the floor could even be the vagina. Ted Cole, hiding his amusement, asks her how long the paper was. The young woman tells him it was 28 pages, not counting the bibliography.

This scene is a reminder of the way in which we separate ourselves from fiction through criticism, when we have missed the point of the literature itself because we are emotionally incapable of engaging it. Rather than analyzing "symbols of fear" in the narrative, we should account for our own fear of pain, betrayal, and, of course, mortality. Doing so would not require 28 pages, but it would be a more honest response to the unsettling potential of fiction.

O'Hare's moment of epiphany comes not as he edits Ted Cole's prose or as he sleeps with Marion Cole. Instead, it occurs as he stands beside Ruth at a frame shop and demands the return of a broken photograph that was to be repaired but is overdue. When the shop owner (Donna Murphy) asks him to calm down and write out his complaint, O'Hare writes: "I have been sleeping with Mrs. Cole this summer. I estimate we have made love 60 times. Ted Cole has been |sleeping with Mrs. Vaughn|." Amazed, the shop owner says, "The Vaughns of Gin Lane?...Please go on." O'Hare obliges her and writes: "Marion is taking the pictures with her, every one of them, except the one you have here in the shop. When Ruth goes home, both her mother and all the pictures will be gone. Her dead brothers and her mother will be gone." After delivering the repaired photograph to O'Hare, the woman asks him, "Is Marion leaving you, too?" (Earlier in the day, O'Hare told Marion Cole that he loved her. She replied, "So long, Eddie." Her response is without malice, but also without empathy.) O'Hare must confront his own irretrievable loss and acknowledge his own broken heart. He is not a character in the Coles's

story: He is deeply wounded and will never again be the boy he was when he stepped off the ferry.

Ruth has an even more unsettling discovery to make as she gazes at the picture hooks that now pepper the walls in her house: "Where are all the other pictures?" Ruth asks O'Hare. "Why would Mommy do that?" Ted Cole's questions mirror his daughter's: "What kind of mother doesn't even try to get custody of her daughter?" and later, "What kind of mother leaves her daughter?" he asks.

The climax of the film *The Door in the Floor*, written and directed by Tod Williams, occurs when Ted Cole enters O'Hare's room on his last night in the Cole house. Startled, O'Hare turns on the lamp beside his bed. Cole says, quietly, "Turn off the light, Eddie. This story's better in the dark." Cole then tells O'Hare about his sons, 17 and 15, who were sitting in the front seat of the family car with Cole and his wife in the back. Caught in a snowstorm and preparing to turn left, the family's car is cut in half by a snowplow: The driver couldn't see them in the "wet, thick snow" that blanketed the rear window and tail lights. Thomas was killed by the steering column; Timothy bled to death in the ambulance. Remembering how his wife reached for Timothy's shoe on the floorboard of the car, Cole said, "I couldn't move. I couldn't even speak." As he leaves the room, Cole tells O'Hare: "And that is the end of the story."

And that *is* the end of the story. The story marks the end of a marriage; the end of Marion Cole's ability to function in the world around her; the end of Eddie O'Hare's innocence; the end of any possibility that the Coles would be able to parent Ruth, who is the child they would have in their one last, vain attempt to save themselves; and the end of *The Door in the Floor*, in which the boy not yet born will most assuredly open the door and see the horrors that turned his mother's hair white. It is also the end of the film, as the camera moves from the empty, pictureless hallway to the new gardener helping Ruth trim a hedge to Ted playing squash by himself before opening a door in the floor of the court and lowering himself into it. But the death of the two boys and our participation in the narrative is not the end of *our* story. The film has manipulated us, surprised us, as Ted Cole would say, but our lives are another narrative entirely, and we have our own photographs and our own endings.

In *Secret Window*, written by David Koepp *(Panic Room)*, it is, again, both a marriage and a mind that unravel. Taken from a short story by Stephen King entitled "Secret Window, Secret Garden," the film opens with Mort Rainey leaving a motel in which his wife Amy Rainey (Maria Bello) and Ted Milner (Timothy Hutton) are making love. As the wipers thump across the windshield and snow falls, Rainey argues with himself: "Don't go back. Do

not go back there." The cacophony of voices begins, but we do not yet understand its significance. We learn later that Rainey's voices are evidence of separate identities that are beginning to manifest themselves as he goes slowly and privately insane. He ignores his own warning, takes a key from the front desk, enters the couple's room, points a gun at them, screams, and leaves.

Six months later Rainey is sitting in his cabin on the coast of New York. He is accosted by a man who introduces himself as John Shooter (John Turturro) and is accused of having stolen his story: "When two writers show up at the same story, it's all about who wrote the words first," Shooter says. "Wouldn't you say that's true?" This statement is, of course, as compelling as the way in which stories—however disconcerting—give a frame to our existence. In Shooter's statement lies an acknowledgement that no story is uniquely ours, although its expression might be. Shooter tells Rainey he wrote the story seven years before and asks, "How in the hell did a big money scribbling asshole like you get down to a little shit-splat town in Mississippi and steal my goddam story?"

Before the viewer learns the answer, Rainey's dog Chico will be killed; the home he shared with Amy in Riverdale, N.Y., will burn down; and a detective and townsperson will be killed. As Amy (and the viewer) understand for the first time the extent of Rainey's madness, the word "Shooter" ("Shoot Her") becomes clear moments before she and her lover are killed. It is John Shooter who demands that Mort Rainey "fix the story." To "fix" the story, Amy and Ted must die. The end of the story reads: "I know I can do it, [he] said, helping himself to another ear of corn from the steaming bowl. I'm sure that in time her death will be a mystery, even to me."

As in *Swimming Pool*, mirrors in *Secret Window* suggest the differences between real life and fiction, between sanity and madness. Characters tell Rainey, "I don't think you're really all that well" and "You really don't look well at all." But Rainey continues his dialogue with himself, even when Shooter tells him that if he's wrong about the author of his story, he'll turn himself over to authorities: "Then I'd turn myself in. But I'd take care of myself before a trial, Mr. Rainey, because if things turn out that way then I suppose I am crazy. And that kind of crazy man has no reason or excuse to live."

The relationship between authors and their characters is hinted at when the voices take over Mort Rainey's mind. One voice says, "There is no John Shooter. There never has been. You invented him." Rainey yells back: "Leave me alone!" The voice says, "You are alone." Wearing John Shooter's 10-gallon hat, Rainey gazes at himself in the mirror and asks, "What is happening to me?" To save himself, Rainey tells Shooter, "You don't exist."

Shooter answers: "I exist, Mr. Rainey. I exist because you made me. You thought me up. Gave me my name. Told me everything you wanted me to do. I did them things so you wouldn't have to."

Writers create characters who do "them things" so they don't have to. They live vicariously through their creations and allow their readers to do so as well. Where an author takes us may or may not be where we want to go. Like the unborn boy in the book *The Door in the Floor*, do we really want to be born into a world in which there *is* a door in the floor? Do we really want literature to take us there?

In *Swimming Pool*, mystery writer Sarah Morton and the object of her invention, Julie (Ludivine Sagnier), weave a tale that suggests a more hopeful role for the imagination. Although Julie's murder of Franck (Jean-Marie Lamour) must occur in order to help Morton develop a riveting story, the murder is not "real," and Morton can return to London and to her publisher with a published copy of a very different kind of book than she had written before.

Directed by Francois Ozon *(8 Women* and *Under the Sand)*, *Swimming Pool* suggests that whatever happens in literature is more alive than what happens in life, that the joy of creation dwarfs other human pleasures. Morton, a tight, controlled, unhappy, bored woman who drinks whiskey in the morning and eats yogurt during the day, creates Julie, an unrestrained, loud, disrespectful, voluptuous young woman with full breasts and an insatiable appetite for sex with several undeserving partners. By doing so, she sets herself free, personally and professionally.

The swimming pool is as transparent as the characters are hidden. Throughout the film, we see Morton in a series of mirrors that offer multiple, identical images. We watch Morton as she writes about her participation in her own story. The mirror (and Morton's story) offer infinite reflections and infinite narrative possibilities. Referring to her publisher John Bosload (Charles Dance), Morton tells Julie, "When someone keeps an entire part of their lives secret from you, it's fascinating and frightening." Using Julie's diary, which she steals from her backpack; a manuscript allegedly written by Julie's late mother; and her own text, Morton creates Julie, and the young woman sacrifices herself to give Morton a provocative murder mystery and a "love story with a happy ending."

The relationship between Morton and Julie deepens, until Julie, wracked with despair over the murder of Franck, throws herself at Morton, calling her "mother," which, of course, she is, since Julie is Morton's fictional creation. Fearing that Morton had left and "abandoned" her, Julie is reassured by Morton's affection for her and wants Morton to be absolved of her role in covering up Franck's death:

Julie: "Sarah, there's something you forgot to burn."
Morton: "What's that?"
Julie: "Your book. It could be used as evidence."
Morton: "Did you read it?"
Julie: "No, but I just can imagine."
Morton: "Well, stop imagining. Get yourself to bed. We have work to do tomorrow."

When we learn that Julie exists (John has a daughter named "Julie") but that the Julie of the film is an imaginary person, we understand how much more immediate and real a fictional character can be than the actual, public one. We also hear in Morton's words "Well, stop imagining" the authority of the writer as she takes back the story from her formidable character. That authority is reinforced when Julie tells Morton, "I've come to say goodbye," and Morton replies, "It's possibly for the best." In the final scene with Julie, we watch part of the action through a mirror. Julie gives Morton her mother's novel, saying, "Perhaps if I give you these pages today you will bring her back to life. So if they inspire you, take them—steal them—they're yours."

When Bosload reads and rejects Morton's manuscript ("Where's the action? Where are the plot twists?"), Morton tells him, "I think this is the finest piece of work I've done in a bloody long time." She then shows him the manuscript in book form, revealing that she secretly published the narrative he rejected. He asks, "Why couldn't you have told me?" She responds by reminding him about the secrets he kept from her: "There were a few things you couldn't tell me." She tells him to give the signed copy to his daughter, whom she sees for the first time as she leaves his office.

The film ends with Morton watching Julie swim. As she comes out of the pool, Morton waves. The Julie of her novel (and her very real interior life) is replaced momentarily by the newly available image of Bosload's real daughter, then superseded by the fictional one. Morton's expression suggests a genuine affection for her creation, her child.

The role of narrative as a shaper of meaning is reinforced in all three films. As Ruth looks at the empty hallway of her house and remembers the stories of her largely absent family—associating those stories with photographs that no longer hang on the walls—the role of storytelling and memory as frames of human experience become clear. In *Secret Window*, Mort Rainey is driven mad by the secrets that lie beneath his own door in the floor. He loses his mind (and his wife) at the same time that he loses his ability to write and to coherently frame his experience; although he considers the end of the story John Shooter wrote "perfect," it is instead an indicator of madness, not genius. Staring at the screen of his laptop and eating the corn

that grew in the garden where his wife is buried, Rainey can no longer write the short stories that gave him a reason for being. There is no superintending narrative, no frame, no order.

It is Sarah Morton of *Swimming Pool* who endures and prevails, rediscovering her muse and creating a novel that gains her more recognition than the formulaic mysteries for which she had become known. Morton lives her story, inventing characters to whom she becomes attached. In doing so, she connects fiction and "real" life, making sense of the latter. Ozon is masterful in reminding the viewer that Morton's dreaming and writing are the connecting threads linking the imaginary with the real; in one particularly effective scene, Morton sits in a chair at the bottom left-hand corner of the screen: The camera moves slowly toward her, eclipsing Julie and Franck as they dance in the upper right-hand portion of the frame. Her characters invite her into "their" story, but she reappropriates the narrative before going upstairs to sleep and to dream. Unlike Ted Cole and Mort Rainey, Morton enjoys her revitalized literary success and finds solace and purpose in her novel *Swimming Pool*.

Works Cited

The Door in the Floor. Dir. Tod Williams. Universal Studios, 2004.
Irving, John. *A Widow for One Year*. New York: Ballantine Books, 1999.
Lazere, Arthur. *The Door in the Floor* (2004). 1 July 2003. http://www.culturevulture.net. 1 Jan. 2005.
Rechtshaffen, Michael. "*Swimming Pool*." 19 May 2003. http://www.hollywoodreporter.com. 1 Jan. 2005.
Scott, A.O. "An Idol Who's Deeply in Love With His Own Feet of Clay." 2 July 2003. http://www.nytimes.com/200407/14/movies. 1 Jan. 2005.
Secret Window. Dir. David Koepp. Columbia Pictures, 2004.
Swimming Pool. Dir. Francois Ozon. Universal Studios, 2003.

Chapter Three

The "Very Simplicity of the Thing": Edgar Allan Poe, Jessica B. Fletcher, and *Murder, She Wrote*

Edgar Allan Poe (1809–1849) left the world a collection of poems, essays, tales of terror, and detective fiction, all dedicated to the belief that art must appeal both to reason and to emotion. It is in Poe's three detective stories, however, that Poe best defends the interdependence of logic and intuition in reaching what he unabashedly calls "truth." In a poem Poe wrote when he was about 20, "Sonnet to Science," he reveals an early cynicism about the ascendancy of technological development:

> Science! true daughter of Old Time thou art!
> Who alterest all things with thy peering eyes.
> Why preyest thou thus upon the poet's heart,
> Vulture, whose wings are dull realities?
> How should he love thee? or how deem thee wise,
> Who wouldst not leave him in his wandering
> To seek for treasure in the jewelled skies,
> Albeit he soared with an undaunted wing?
> Has thou not dragged Diana from her car?
> And driven the Hamadryad from the wood
> To seek a shelter in some happier star?
> Has thou not torn the Naiad from her flood,
> The Elfin from the green grass, and from me
> The summer dream beneath the tamarind tree? (771–72)

The disciple of Samuel Taylor Coleridge (1772–1834) and the contemporary of Nathaniel Hawthorne (1804–1864), Poe was part of a worthy tradition that suspected science of draining the life and emotion from art by trying to

eradicate mystery from the earth (Poe, therefore, accuses Science of dragging
Diana from her "car"—the moon—symbol of mystery or inconstancy).

Matthew Arnold (1822–1888) also was a contemporary of Poe's who
espoused a fear of excessive rationality adopted at the expense of faith and
poetry in the modern world. In his famous essay "The Study of Poetry,"
Arnold wrote of poetry as a force that would complete the role of science in
transforming the earth:

> More and more mankind will discover that we have to turn to poetry to interpret life
> for us, to console us, to sustain us. Without poetry, our science will appear incom-
> plete; and most of what now passes with us for religion and philosophy will be re-
> placed by poetry. Science, I say, will appear incomplete without it. (306)

Arnold also noted the importance of "regularity, uniformity, precision, [and]
balance" in writing and in decisions, but he warned against the "exclusive
attention to these qualities" because of the "repression and silencing of
poetry" (321) that might result. Poetry, obviously, is more to Arnold than
verse; for him it was a power capable of unifying humankind as he believed
religion once had done.

Although Poe might have been especially devoted to Coleridge and con-
nected philosophically to Arnold, one also must recognize his link to at least
one of his contemporaries in America: Nathaniel Hawthorne. Certainly the
spirit of the times in both Britain and America involved a reverence for
science and a fear that humankind had lost its spiritual center. In a series of
short stories and novels reminiscent of *Frankenstein* (1817) by Mary Woll-
stonecraft Shelley (1797–1851), Hawthorne analyzes the role of the scientist
and physician too devoted to factual analysis. The theme runs through
"Rappaccini's Daughter," "The Birth-Mark," *The Scarlet Letter,* and other
works and testifies to Hawthorne's fear of the possibilities of a mind separat-
ed from the heart. The most damning description of the man of science
occurs in the first paragraph of "The Birth-Mark":

> In the latter part of the last century, there lived a man of science—an eminent profi-
> cient in every branch of natural philosophy—who not long before our story opens,
> had made experience of a spiritual affinity, more attractive than any chemical one.
> He had...persuaded a beautiful woman to become his wife. In those days, when the
> comparatively recent discovery of electricity, and other kindred mysteries of nature,
> seemed to open paths into the region of miracle, it was not unusual for the love of
> science to rival the love of woman, in its depth and absorbing energy. (1289)

At the end of the tale, the man devoted "too unreservedly to scientific
studies" kills his wife while attempting to remove a blemish from her face in

a vain search for perfection and for a symbol of "man's ultimate control over nature" (1289).

Poe proposes later in his career that the analytical perspective of mathematics and the physical sciences is limited, and in C. Auguste Dupin he unites the critical powers of reasoning and the perception and energy of the heart. Like Samuel Taylor Coleridge and William Wordsworth (1770–1850), Poe struggled not to treat scientific discovery as arrogant bluff but to balance it with the longings of the human spirit. Coleridge writes in Chapter One of *Biographia Literaria* that while he was a student he learned that "poetry, even that of the loftiest and, seemingly, that of the wildest odes, had a logic of its own as severe as that of science; and more difficult, because more subtle, more complex, and dependent on more, and more fugitive, causes" (387). In Chapter Four, he pays tribute to the "union of deep feeling with profound thought" (394), as does Wordsworth in the "Preface to the *Lyrical Ballads*":

> The knowledge both of the poet and the man of science is pleasure; but the knowledge of the one cleaves to us as a necessary part of our existence, our natural and unalienable inheritance; the other is a personal and individual acquisition, slow to come to us, and by no habitual and direct sympathy connecting us with our fellow-beings. The man of science seeks truth as a remote and unknown benefactor; he cherishes and loves it in his solitude: the poet, singing a song in which all human beings join with him, rejoices in the presence of truth as our visible friend and hourly companion. Poetry is the breath and finer spirit of all knowledge; it is the impassioned expression which is in the countenance of all science...Poetry is the first and last of all knowledge—it is as immortal as the heart of man. (166–67)

Poe remained in sympathy with Coleridge and Wordsworth as he wrote "The Purloined Letter," "The Murders in the Rue Morgue," and "The Mystery of Marie Roget (A Sequel to 'The Murders in the Rue Morgue')." He leaves the cerebral Parisian police acting from habit and past experience, while his famous detective solves the cases as much through an understanding of the human spirit as through a detached analysis of data.

The influence of Poe's detective fiction on American mystery writers has been well documented, but the relationship between Dupin and the detectives of popular culture depicted in a television series such as *Columbo* [1971–1978 (NBC), 1989–2003 (ABC)] or *Murder, She Wrote* (1984–1996) is not as extensive. Through an examination of *Murder, She Wrote*, this study reveals several important similarities between the philosophy behind Poe's three short stories and the formula that drives the creators of *Murder, She Wrote*. Most important, the study identifies the central concern of Dupin and Jessica Fletcher: never to miss what Poe terms the "very simplicity of the

thing" ("The Purloined Letter," 126) in the midst of the complexities of the case. Other similarities include:

1) the fact that each detective, although involved in an occupation that requires solitude, discusses each case with a close friend, thereby allowing the reader or viewer to keep pace with the discoveries;
2) the fact that each detective compiles data after sorting through the accounts of multiple witnesses replete with details, irrelevant observations, and misleading signifiers;
3) the fact that each detective is treated as if he or she were a bungler who— in spite of an established reputation—must earn the respect of the law enforcement officials he or she seeks to help; and
4) the fact that each detective attests repeatedly to his or her astute reading of people, who are the subtexts in the phenomenological nightmare of crimes and murders.

The Methods of C. Auguste Dupin

In one of Poe's most popular stories, "The Purloined Letter," the narrator discusses the two previous cases that his friend Dupin solved: "The Murders in the Rue Morgue" and "The Mystery of Marie Roget." A visit by the prefect of the Parisian police activates the plot, as Dupin is immediately set up as superior to his guest. The narrator tells the reader that the Prefect has the unfortunate habit of ridiculing what he cannot understand. The Prefect, he says, "had a fashion of calling every thing 'odd' that was beyond his comprehension, and thus lived amid an absolute legion of 'oddities'" (125). These oddities create for the Prefect an impenetrable jungle in which he struggles and fails to make sense of the sign system. Coming to Dupin for help in recovering a stolen letter, the Prefect admits to his failure without understanding that the cause is his lack of self-perception:

> "The fact is, we have all been a good deal puzzled because the affair *is* so simple, and yet baffles us altogether."
> "Perhaps it is the very simplicity of the thing which puts you at fault," said my friend.
> "What nonsense you *do* talk!" replied the Prefect, laughing heartily.
> "Perhaps mystery is a little *too* plain," said Dupin.
> "Oh, good heavens! who ever heard of such an idea?"
> "A little *too* self-evident."
> "Ha! ha! ha!—ha! ha! ha!—ho! ho! ho!" roared our visitor, profoundly amused, "oh, Dupin, you will be the death of me yet!" (126)

Poe reveals the Prefect's Achilles heel through short sections of dramatic monologue, in which the official reveals more about himself than he intends. Discussing the man who took a letter that contains secrets dangerous to a high-ranking government official, the Prefect assesses his opponent by saying, "Not *altogether* a fool, but then he's a poet, which I take to be only one remove from a fool." The reader thereby understands that the Prefect operates with only half of his capacities; the reader then may choose to identify with Dupin, who confesses in an ironically self-deprecating way that he himself is "guilty of certain doggerel" (128).

The Prefect and the Parisian police searched the thief's apartment for the letter and are now at a loss, although they are certain they have the right man. To the narrator, Dupin explains that the measures the Prefect used "were good in their kind, and well executed; their defect lay in their being inapplicable to the case, and to the man" (131): "A certain set of highly ingenious resources are, with the Prefect, a sort of Procrustean bed, to which he then forcibly adapts his designs. But he perpetually errs by being too deep or too shallow, for the matter in hand; and many a schoolboy is a better reasoner than he" (131). Dupin then tells his friend two parables, the first involving a young boy who wins consistently in a game of marbles. The boy reads the faces of his opponents, reasons, observes, trusts experience—and wins, a feat that his acquaintances attribute to luck. Lacking these abilities, the Prefect is crippled, Dupin suggests. He implicates the Prefect when he describes a group of people who operate from custom alone:

> They consider only their *own* ideas of ingenuity; and, in searching for anything hidden, advert only to the modes in which *they* would have hidden it. They are right in this much—that their own ingenuity is a faithful representative of that of *the mass;* but when the cunning of the individual felon is diverse in character from their own, the felon foils them, of course. This always happens when it is above their own, and very usually when it is below. They have no variation of principle in their investigations; at best, when urged by some unusual emergency—by some extraordinary reward—they extend or exaggerate their old modes of *practice*, without touching their principles. (133)

In a second parable later in "The Purloined Letter," Dupin describes what he calls "a game of puzzles which is played upon a map" (133). In this game, "over-largely lettered signs and placards of the street" escape "observation by dint of being excessively obvious" (136). Through both short narratives, Dupin makes clear to his listener the failure of the Prefect to investigate the nature of the man he seeks to trap, an investigation that is at root a poetic enterprise.

In "The Purloined Letter," Dupin eventually combines the quantitative skills of the mathematician (respected in the culture) with the qualitative powers of the poet (assumed to be the fool) and finds the stolen letter in the Minister's apartment. The limitations of the mathematical approach are revealed when Dupin says:

> There are numerous other mathematical truths which are only truths within the limits of *relation*. But the mathematician argues, from his *finite truths*, through habit, as if they were of an absolutely general applicability—as the world indeed imagines them to be. (134)

By opening scientific premises to the scrutiny of the poetic mind, Dupin testifies to the importance of the two powers working in tandem. By practicing what he preaches, Dupin at last sees a rack with "five or six visiting cards and a solitary letter" in the Minister's home. "This last was much soiled and crumpled," Poe writes of the letter. "It was torn nearly in two, across the middle—as if a design, in the first instance, to tear it entirely up as worthless, had been altered, or stayed, in the second" (136). The detective finds the letter because he knows the Parisian police have checked every hidden corner on the premises; he deduces that the letter must be in plain sight. In the end he spots the letter by realizing that a soiled and torn letter is antithetical to the Minister's own character, since he is by nature compulsively clean and organized: "The *radicalness* of these differences, which was excessive, the dirt; the soiled and torn condition of the paper, so inconsistent with the *true* methodical habits" (137) of the Minister alerted Dupin. Not only does Dupin gain the 50,000 francs offered by the Prefect for helping to solve the case, but he gains the respect of the police force and the pleasure of having outsmarted the Minister, to whom he sends a personal message by replacing the letter he has retrieved with a letter resembling it.

In "The Murders in the Rue Morgue," Poe holds consistently to the motivating philosophy of his earlier two detective sagas. Once again, the necessity of the analytical mind working with intuition is established early. The world, says Dupin, believes that the powers of calculation are at odds with powers of the imagination and that they can barely coexist. However, Dupin passionately declares that in spite of the historical precedent for separating the analytical from the imaginative, invention and creation are part and parcel of successful mathematical and scientific processes. Quite simply, Dupin argues, mathematical and scientific methods are at heart intuitive. In short, the gift of the poet, Dupin believes, is the ability to observe deeply and intuitively and thereby to remember with detail and specificity.

Using these powers, Dupin finds the unlikely killer of Madama L'Espanaye and her daughter, Mademoiselle Camille L'Espanaye: an Ourang-Outang from the East Indian Islands. The ape had been brought to Europe by a sailor who lost the animal and disappeared after the crime, afraid of his own responsibility in the brutal deaths. Another man has been wrongly accused of the murders, and Dupin sets a trap to find the sailor, reassures him of his innocence if he testifies, and thereby frees the accused. "Murders in the Rue Morgue," which Dupin calls a "riddle," reinforces "The Purloined Letter" by implicating those who cannot see what is too obvious. Dupin said, "It appears to me that this mystery is considered insoluble, for the very reason which should cause it to be regarded as easy of solution—I mean for the *outré* character of its features" (14). Criticizing a Frenchman for his short-sightedness, Dupin tells the narrator: "He impaired his vision by holding the object too close. He might see, perhaps one or two points with unusual clearness, but in so doing he, necessarily, lost sight of the matter as a whole. Thus there is such a thing as being too profound. Truth is not always in a well" (13).

For the semiologist who equates a detective and his or her clues with a reader exploring the signs in a text, "The Murders in the Rue Morgue" and "The Mystery of Marie Roget" are especially rich. In "The Murders in the Rue Morgue," data are accumulated through interviews with multiple witnesses who speak several languages: Italian, English, Spanish, French, and others. The linguistic labyrinth overwhelms the police, since descriptions conflict with one another and facts seem shadowed by the varied perceptions, some of which *must* be wrong. The difference in the languages themselves makes even the cognates problematic, and the nuances and semantic puzzles testify to the basic unreliability of language itself. In "The Mystery of Marie Roget," the same artistic effect is gained through the use of multiple newspaper stories in which selected facts are revealed. Dupin must solve both cases by gleaning information from accounts by witnesses and from published newspaper articles without being swayed and without missing the implications of those very accounts and stories. All three cases require that Dupin read varied texts (the Minister's apartment, the Minister himself, the Prefect, the police accounts of the crimes, the newspaper stories, etc.).

In "The Mystery of Marie Roget," Mary Cecilia Rogers of New York is murdered and her body found floating in a river. The case remains unsolved, and Dupin has only newspaper accounts with which to work. Again, the central problem Dupin discovers in the coverage of others is their failure to reconcile the "most rigidly exact in science" (what he terms the "Calculus of Probabilities") with the "shadow and spirituality" of the "most intangible" (28) aspects of the case. Inverting his previous method in "The Purloined

Letter" and "The Murders in the Rue Morgue," Dupin solves the crime, saying to the narrator:

> I need scarcely tell you...that this is a far more intricate case than that of the Rue Morgue, from which it differs in one important respect. This is an *ordinary*, although an atrocious instance of crime. There is nothing peculiarly *outré* about it. You will observe that, for this reason, the mystery has been considered easy, when, for this reason, it should have been considered difficult, of solution. (37)

Discovering that the murder was committed by a single person instead of a gang as earlier believed, "the Chevalier's analytical abilities acquired for him the credit of intuition" (28), Poe writes. Dupin analyzes the nature of the gang and explains how the murder must have been committed by a single person who would have had to resort to dragging the body and leaving behind some of the evidence. He then analyzes the nature of the murderer himself, deduces his means of escape, and discusses his findings with the narrator.

In all three stories, Dupin attests to the value of the scientific method wedded to the discernment of the human heart; to the value of close observation connected with an understanding of others; the value of perseverance in the face of ridicule and doubt; and to the value of not remaining a slave to one's own favorite approach, an approach that may require modification during another case.

The Methods of Jessica B. Fletcher

The first similarity between the detective in *Murder, She Wrote* and Dupin is the reliance of each on a friend or colleague with whom to discuss the facts of the case. Because both must reveal new discoveries that take place in an internal stream of consciousness, a narrator or friend standing in as listener is necessary organically. The reader or viewer must rely on spoken language as well as reconstructed scenes for understanding. In four episodes of *Murder, She Wrote*—all of which are representative of the series—Jessica B. Fletcher (Angela Lansbury) keeps the viewer up to date by talking to the local sheriff or doctor if she is in her hometown, Cabot Cove, Maine; or she relies on a relationship with an accused but ever innocent person, a former friend, a new acquaintance, etc., if she is traveling before or during the commission of the crime.

Second, Fletcher functions as a semiologist in the tradition of Dupin. While rarely wrestling with the stationary text of a witness' recorded account

or a published newspaper story—as Dupin does—Fletcher often reconstructs the scene via speculation and reads the fluid texts—people—available to her. A physician, who has been a long-time friend of Fletcher's in Cabot Cove tells a state health department official in "Keep the Home Fires Burning" that Fletcher is "the most observant person I know." In "Powder Keg," Fletcher argues against the guilt of an accused murderer during a conversation with the father of the dead man, Ed Bonner. In the scene she attests to her ability to read those around her. She speaks in the following excerpt about Matthew Burns, accused of the murder:

> **Fletcher:** "But don't you think—I mean—if he's as much of a coward as you think he is, don't you think it's more likely he would have fired a gun from ambush?"
>
> **Bonner:** "Are you an expert in killing?"
>
> **Fletcher:** "No. But I think I know something about people."

Unusually astute readings of those involved in the case make Jessica Fletcher a reliable translator of the event.

The third similarity between Poe's creation of C. Auguste Dupin and the creation of Jessica Fletcher by Peter S. Fischer, Richard Levinson, and William Link is the necessity for the detectives to prove their worth to a skeptical person in power. Even when those in power are attacked by others and supported by the detective, their arrogance clouds their vision. For example, in "Powder Keg," a small Alabama community erupts when a town bully is killed at a local bar called "Kelso's." The town sheriff, a black man, is besieged by residents who do not trust his handling of the case. One resident speaks the mind of the community when he calls the sheriff a "colored college boy." Andy Crane, a friend of the deceased, later adds, "All I see is a colored boy shakin' behind that badge." Even in this atmosphere, the sheriff is loathe to accept the knowledge and support that Fletcher offers. In the other episodes, Fletcher must win over sheriffs, police, administrators, and others. Since the show is a series and not a serial, many of the characters change from week to week. With no time to characterize each participant in the case, the creators of *Murder, She Wrote* illustrate the importance of each character through the function in the community; they are identified by their roles as waitresses, cooks, owners of diners, sheriffs, professors, club owners, etc.

Just as Dupin is respected and praised only by the friend to whom he tells his story (since others associate him with being a magician but rarely praise his clearly superior observation skills), Fletcher must solve cases because of the pure joy she gains in doing so, not because she is paid or appreciated.

When the plot evolves in Cabot Cove, Fletcher can expect support from long-time friends and the sheriff (Tom Bosley). But in "Keep the Home Fires Burning," for example, a state health department official, Margot Perry, comes to Cabot Cove to investigate a death at the Joshua Peabody Inn on the outskirts of town. She has no role in solving the murder; in fact, she leaves the episode before the murderer is apprehended. Her work is complete when she understands that motive, not restaurant health standards, is at issue. Her reason for existing in the fictional world of the script is to challenge the courteous, mild-mannered authority of Jessica Fletcher. Fletcher's interest in the case is supported by friends because she, too, ate in the restaurant on the day of the death, but Perry repeatedly ridicules her methods of investigation. To solve the cases in *Murder, She Wrote*, Fletcher often must discredit the person in control and wrest authority from him or her.

Occasionally, Fletcher is supported by what is perceived as the lower echelon of the community. In "Who Killed J.B. Fletcher?" a large portrait of Fletcher adorns the wall of a resident's home. The woman is a club member of the J.B. Fletcher Literary Society in a small town called Bremerton. When one of the residents assumes Jessica Fletcher's identity in order to solve a local mystery, she is killed as she inadvertently stumbles onto a murder. A headline in the *Bremerton Gazette* ("Mystery Writer Killed") alerts Fletcher that something is afoot. Going to the town to interview the friends of the murdered woman, Fletcher discovers the club formed in her honor. The homemakers who constitute its membership use their part-time positions and the reputations of their husbands to glean information for Fletcher. In finding the killer of their friend Marge Allen, they also uncover an insurance scam and the murder of a respected Bremerton resident. Proud of their achievement, the women hail Fletcher as their inspiration.

In every episode, Fletcher is the superintending narrator, the omniscient, perceptive humanist who not only brings order to the community she is in but also provides lessons about the value of compassion in dealing with one's fellows. In "Keep the Home Fires Burning," Fletcher notices that Harrison Fraser grieves more about the death of his friend than the illness of his wife after the two are poisoned while eating at the Joshua Peabody Inn. Fletcher eventually accuses his wife, Wilhemina, of murdering her lunch companion, a woman involved emotionally with Harrison Fraser. Wilhemina Fraser put poison in a jar of the restaurant's famous strawberry preserves, ate a small amount to make herself sick and remove herself from suspicion, and killed the woman. The jar is accidentally passed from table to table, and several other diners become ill. Fletcher reconstructs the scene, eliminates local residents and visitors from the list of suspects, and traps Wilhemina Fraser through an accurate reading of her character and the sorrow of her husband.

Jessica Fletcher never fails. When she befriends a character, that character will prove his or her worth and innocence in the end. When someone is rude to Fletcher or treats her with condescension, the viewer is assured that the person is worthless. In the universe of *Murder, She Wrote*, the predictable formula reassures the viewer of the possibility of order in a postmodern world and of the importance of emotion as a balance for the technical expertise involved in processing clues. Fletcher never misses the obvious or the hidden, and she constantly revises her strategy to avoid relying too heavily on previously effective methods. For example, in "Who Killed J.B. Fletcher?" a prominent resident of Bremerton is killed. The police, led by Sheriff J.T. Tanner, are unable to ascertain the scene of the crime. Fletcher suggests that the murder occurred in his own basement; she tells Tanner she believes the murderer stepped out from behind the stairs and shot him in the back as he walked toward a cabinet in the basement. Tanner, following the formula in *Murder, She Wrote*, is hostile to Fletcher's ready analysis:

> **Tanner:** "Well, that's a tidy scenario, Mrs. Fletcher. Unfortunately, it's not backed up by any physical evidence."
> **Fletcher:** "Well, maybe we're overlooking something. I mean, something obvious—something in plain sight."

Fletcher finds the physical evidence—blood spattered on the basement light bulb that is invisible when the light is on—and the sheriff acknowledges Fletcher as the better sleuth. Accused early in the episode of being too nosy, Fletcher admits, smiling, "It's a character flaw. I'm curious about everything." Fletcher is not only curious; she is accurate. When she announces that one of the suspects is not the right "type," the viewer can turn his or her attention elsewhere.

Fletcher, like Dupin, does not allow her analytical skills to overwhelm her instincts. She balances head with heart. Further, she never loses sight of the obvious, the "something in plain sight," that baffles the law enforcement officials involved in the case. Just as Dupin found the purloined letter by studying the character of the Minister carefully, Fletcher approaches the players in her cases as the complex signifying systems they are. Just as Dupin pays homage to the "very simplicity of the thing" in his investigations of the crime scene, Fletcher finds evidence others overlook as being too obvious. Both detectives must prove their worth to those in authority—much as other television detectives such as Lieutenant Frank Columbo must do—and both are unaffected by the judgments of others. Finally, each shares with the audience his or her techniques via conversations with a friend or a colleague, thereby increasing the pleasure of the reader or viewer by allowing

familiarity and identification with that person. Edgar Allan Poe, master storyteller, provided the detective of Cabot Cove with a worthy predecessor indeed.

Works Cited

Arnold, Matthew. "The Study of Poetry." *Poetry and Criticism of Matthew Arnold*. Ed. A. Dwight Culler. Boston: Houghton Mifflin, 1961. 306–27.

Coleridge, Samuel Taylor. From *Biographia Literaria*. *The Norton Anthology of English Literature*. Vol. 2. 5th edition. Ed. M.H. Abrams and others. New York: W.W. Norton, 1986. 386–405.

Hawthorne, Nathaniel. "The Birth-Mark." *The Norton Anthology of American Literature*. Vol. B. 6th ed. Ed. Nina Baym and others. New York: Norton, 2003. 1289–1300.

Poe, Edgar Allan. "The Murders in the Rue Morgue." *Complete Stories and Poems of Edgar Allan Poe*. New York: Doubleday, 1984. 2–26.

———. "The Mystery of Marie Roget." *Complete Stories and Poems of Edgar Allan Poe*. New York: Doubleday, 1984. 27–63.

———. "The Purloined Letter." *Complete Stories and Poems of Edgar Allan Poe*. New York: Doubleday, 1984. 125–38.

———."Sonnet—to Science." *Complete Stories and Poems of Edgar Allan Poe*. New York: Doubleday, 1984. 771–72.

Wordsworth, William. From "Preface to the *Lyrical Ballads*." *The Norton Anthology of English Literature*. Vol. 2. 5th ed. Ed. M.H. Abrams and others. New York: W.W. Norton, 1986. 157–70.

Chapter Four

Changing Faces:
Dr. Jekyll, Mr. Hyde, and Films of the 1980s

The 1980s were littered with the broken reputations of those who fell from national grace. Americans watched as Oliver North, accused of deceiving the country about the Iran-Contra scandal, became a hero with fan clubs from the Midwest to the Deep South to the West Coast; they became familiar with the trial of Jim Bakker, who was convicted of breaking tax laws and who bilked viewers of Praise the Lord (PTL) out of millions; and they saw televangelist Jimmy Swaggart weep with remorse and address charges of immorality. Americans dropped off their children at day care centers staffed by people they hoped they could trust; they listened to reports of government spokespeople claiming that it was safe to eat most fruits and vegetables and to live in the shadow of a nuclear plant; and they read statistics claiming that most rape victims know their assailants.

In the midst of the decade of distrust, Americans fled to theaters to see a succession of films that allowed them a temporary sense of control over their lives. While Americans lost their confidence in their ability to determine the moral character of national figures like Gary Hart, they turned to themes of betrayal and tested loyalty in the popular arts to, perhaps, reassure them that they could spot fraud and deception when they encountered them. Films of the decade mesh themes of betrayal and the failure of perception with what writers and critics often have identified as the highest purpose of art: to startle the reader or viewer with the familiar. In her famous essay, "The Fiction Writer and His Country," Flannery O'Connor says that a writer must "make [one's] vision apparent by shock—to the hard of hearing you shout, and for the almost-blind you draw large and startling figures" (34). Vladimir Nabokov, likewise, emphasized the artist's responsibility to jolt the reader or

viewer: "This, then, is the highest, the plastic part of literature: to embody character, thought or emotion in some act or attitude that shall be remarkably striking to the mind's eye" (25).

Nothing is more striking or startling than the characters in 1980s films such as *Still of the Night* (1982), *Sophie's Choice* (1982), *Betrayal* (1983), *Jagged Edge* (1985), *The Morning After* (1986), *Black Widow* (1987), *No Way Out* (1987), and a battery of 1988 films such as *Dangerous Liaisons*, *Masquerade*, *Betrayed*, and *Criminal Law*. Films that followed—including *Music Box* (1989), starring Jessica Lange, and *Bad Influence* (1990), starring Rob Lowe, also deal with the con artist and human duplicity and promised a continued interest in these particular themes into the 1990s.

The films in this study may be grouped into four categories: 1) plots in which a rogue is taught a lesson and alters his or her ways, usually after much suffering and often only before an untimely death; 2) plots in which an immoral and vicious character persists in wreaking violence and havoc and must be stopped (usually killed); 3) plots in which the inner worth of a person long suspected of evil is revealed to the viewer and, thankfully, the main character; and 4) plots in which the trickster escapes pursuit and asserts that evil (or at least deception) will triumph. The prototype for the plots of contemporary films about changing faces is *The Strange Case of Dr. Jekyll and Mr. Hyde* (1886) by Robert Louis Stevenson. More than a precursor of the modern mystery tale, the novel also epitomizes a theme that has obsessed the reading public since the early days of American literature.

Ever obsessed with the villain, the seductress, the rogue, and the trickster, American audiences are never more captivated with evil than when a character is both cruel and cryptic. From the Bible to early American literature to contemporary music videos and song lyrics, we engage texts in which forces of good and evil clash, but we feel vindicated only if the knaves get their due. One of the most representative myths, of course, is the biblical story of Jesus, who is betrayed by Judas Iscariot:

> Now the betrayer had arranged a signal with them: "The one I kiss is the man; arrest him."
> Going at once to Jesus, Judas said, "Greetings, Rabbi!" and kissed him.
> Jesus replied, "Friend, do what you came for." (Matt. xxvi.48–50)

Justification, more difficult to achieve in life, is gained when Judas, "seized with remorse" (Matt. xxvii.3), hangs himself. In Acts, biblical writers are even more graphic: "With the reward he got for his wickedness, Judas bought a field; there he fell headlong, his body burst open and all his intestines spilled out" (Acts i.18). Scripture, though an early expression of the human

desire that the meek could inherit their due, is only the starting point in the study of themes of betrayal and dual personalities.

Two of the most effective warnings against the sinister confidant appear in 19th-century American literature; both Nathaniel Hawthorne's *The Scarlet Letter* and Herman Melville's often ignored novel *The Confidence-Man: His Masquerade* draw heavily on the Bible. In *The Scarlet Letter*, Arthur Dimmesdale, a minister who has fathered a child by Hestern Prynne, is befriended by a dark and brooding physician, Roger Chillingworth. Eventually freed from Chillingworth's clutches, the Rev. Dimmesdale says of his cunning adversary: "He has violated, in cold blood, the sanctity of a human heart" (186). Melville portrays Christ himself as a con artist who dons disguises in order to trick both his enemies and his friends in *The Confidence-Man*. Alluding to the New Testament, which urges the followers of Christ to strengthen their confidence in their savior, Melville creates a microcosm aboard the steamer Fidele (the Faithful) and allows travelers to be duped by the greatest fraud of them all. Asking in succession, "Is he or is he not, what he seems to be?" (36), those who populate the novel give way to his charms one by one. The theological implications of Melville's piece are not under scrutiny here; we must, however, understand the significance of the ironies in the text and even the subtitle, *The Confidence-Man: His Masquerade*.

Rock videos, such as "Thriller" by Michael Jackson and "The Wall" by Pink Floyd, emphasize seemingly trustworthy individuals who change before one's eyes. Song lyrics from musicals such as "Sweeney Todd" portray demons "prowling everywhere" and demons that will "charm you with a smile/ For a while" ("Not While I'm Around" by Stephen Sondheim). Contemporary media re-enact that which the society most seems to fear: the individual allowed into the deepest emotional sanctuary who will then betray or fool the unsuspecting.

The Strange Case of Dr. Jekyll and Mr. Hyde

The novel that best depicts the formula for deception employed by modern filmmakers is *The Strange Case of Dr. Jekyll and Mr. Hyde*. In the novel, Robert Louis Stevenson explores the trials and eventual annihilation of Henry Jekyll, a London physician and chemist, through the perspective of several characters, primarily Mr. Utterson. The portrait of Jekyll is in Vladimir Nabokov's words certainly one "striking to the mind's eye." In the introduction to the novel, Nabokov reveals the Danish origins of the names of the primary character(s), Dr. Jekyll and Mr. Hyde. "Hyde," he writes, comes from the Anglo-Saxon "hyd," which means "hide" or a "haven." "Jekyll"

comes from the word "Jokulle," which means an "icicle" (9). Both names, of course, reverberate with meaning, for Hyde hides his monstrosity as best he can, he hides in an apartment Stevenson locates in a "district of some city in a nightmare" (62), Hyde and Jekyll unsuccessfully hide Hyde's crimes, and Jekyll hides for a time from his dual nature. Jekyll, too, lives down to his name, as an icy, detached physician akin to Roger Chillingworth, as he concocts a potion that will alter his nature and as he wallows in Chillingworth's greatest sin, pride.

The centrally important line in *The Strange Case of Dr. Jekyll and Mr. Hyde* for purposes of this film study is a description of Dr. Jekyll as his friend, Dr. Hastie Lanyon, watches him change into Mr. Hyde: "His face became suddenly black and the features seemed to melt and alter" (101). How reassuring it would be if faces literally changed into something we could recognize as evil. Nabokov records in his introduction the ironic connection between Stevenson's own life and his creation of Dr. Jekyll. In Samoa in 1894, Stevenson died from a blood vessel that burst in his brain: "He went down to the cellar to fetch a bottle of his favorite burgundy," writes Nabokov, "uncorked it in the kitchen, and suddenly cried out to his wife: what's the matter with me, what is this strangeness, has my face changed?— and fell on the floor" (34). Nabokov repeats the line, "What, has my face changed?" as he refers to what Stevenson describes in his novel as "Satan's signature upon a face" (52)—the mark of Cain on Hyde. Who, as a child, has not been startled or frightened by the face of someone familiar and trusted, who alters his or her expression unexpectedly and without explanation? Stevenson and others play upon that universal fear and need—the need to have the people close to us behave consistently with our expectations and desires. Fortunately, as Richard Enfield observes in a conversation with Utterson, Hyde is recognizable as evil:

> There is something wrong with his appearance; something displeasing, something downright detestable. I never saw a man I so disliked, and yet I scarce know why. He must be deformed somewhere; he gives a strong feeling of deformity, although I couldn't specify the point. He's an extraordinary looking man, and yet I really can name nothing out of the way. (43–44)

Stevenson describes Hyde as "pale and dwarfish":

> [Hyde] gave an impression of deformity without any nameable malformation, he had a displeasing smile, he had borne himself to the lawyer with a sort of murderous mixture of timidity and boldness, and he spoke with a husky, whispering and somewhat broken voice. (52)

Dr. Jekyll looks down from a window in his home to converse with two of his trusted friends. He seems happy and safe, when suddenly, his face changes: The "words were hardly uttered, before the smile was struck out of his face and succeeded by an expression of such abject terror and despair, as froze the very blood of the two gentlemen below" (77). What has caused the change in his features? Obsessed with the "duplicity of life" (103) and "man's dual nature" (104), Dr. Jekyll has made a fatal discovery: "With every day, and from both sides of my intelligence, the moral and the intellectual, I thus drew steadily nearer to that truth, by whose partial discovery I have been doomed to such a dreadful shipwreck: that man is not truly one, but truly two" (104). Later in the tale, Jekyll expresses what he calls "horror of my other self" (122), a horror we shall find mirrored in film, and Jekyll literally changes faces:

> I began to be aware of a change in the temper of my thoughts, a greater boldness, a contempt of danger, a solution of the bonds of obligation. I looked down; my clothes hung formlessly on my shrunken limbs; the hand that lay on my knee was corded and hairy. I was once more Edward Hyde. A moment before I had been safe of all men's respect, wealthy, beloved—the cloth laying for me in the dining-room at home; and now I was the common quarry of mankind, hunted, houseless, a known murderer, thrall to the gallows. (118-19)

"Without bowels of mercy" (49), Hyde tramples a child and then kills Sir Danvers Carew, a local nobleman, with unusual brutality:

> The old gentleman took a step back, with the air of one very much surprised and a trifle hurt; and at that Mr. Hyde broke out of all bounds and clubbed him to the earth. And next moment, with ape-like fury, he was trampling his victim under foot and hailing down a storm of blows, under which the bones were audibly shattered and the body jumped upon the roadway. At the horror of these sights and sounds, the maid fainted. (60)

The irony here, which Stevenson may or may not have intended, is that apes do not demonstrate the kind of unprovoked rage exhibited by Mr. Hyde. Only—as we shall see in a study of modern film—do humans.

Films of Initiation

The first category of films involves a plot in which a duplicitous or cruel person learns something essential about himself or herself at great cost. Often, the initiation is paid for by his or her death or the death of someone

important to him or to her. Films from the 1980s that meet this criterion include *Dangerous Liaisons* and *Masquerade*. In *Dangerous Liaisons* (1988), a film based on an often-banned 1782 novel *Les Liaisons Dangereuses*, the Viscount of Valmont (John Malkovich) is challenged to a love duel by the Marquise of Merteuil (Glenn Close); before the contest of power is over, Valmont has fallen in love with the woman he was challenged to seduce, Madame de Tourvel (Michelle Pfeiffer). His feelings and her predicament eventually cause their deaths. In *Masquerade*, Tim Whalen (Rob Lowe) falls in love with Olivia Lawrence (Meg Tilly) in a scam to take her money; in the end, he dies a death intended for her, and she understands for the first time his commitment to her.

The brutality of *Dangerous Liaisons* is subtle though immediately evident in the first scene in which the Marquise baits Valmont with "love and revenge, two of your favorites." She reminds Valmont that his intended lover believes in God and virtue and the sanctity of marriage. He agrees but responds, "I want the excitement of watching her betray everything that's most important." As the two lean toward each other and plot their vengeance, their voices take on the "hissing intake of breath" (50) Stevenson attributes to Hyde. One also remembers Stevenson's warning that Hyde "enjoys the inflicting of pain" (24). The Marquise promises to sleep with Valmont if he accomplishes his cruel mission. Much to his surprise, Valmont ultimately falls in love with the Madame de Tourvel, and the Marquise, who secretly is attracted to him, is devastated. Eventually, the two declare war on each other when the Marquise refuses to keep her end of the bargain, and Valmont dies in a duel she arranges. Degraded and weeping, the Marquise sits alone in her dressing room, symbolically removing her mask as she takes off her makeup. As Valmont dies, he tells his adversary to take a message to Madame de Tourvel: "Tell her love was the only real happiness that I have ever known." The theme of the film is uttered by the conniving Marquise, who says, "Illusions, of course, are by their nature sweet," while reality proves to be torment. When the illusions die, so does the hope of the contestants.

In *Masquerade*, Tim Whalen teams up with a former high school friend of Olivia Lawrence's and with her stepfather in a plan to kill her and take her money. Whalen argues with her stepfather about the necessity of killing her, and when her stepfather breaks into the house one night to attack her, Whalen kills him. Lawrence claims she killed him, and Whalen sets up his alibi. After numerous twists and turns, Whalen and Lawrence marry, she becomes pregnant, and Whalen finds he cannot hurt her. Mike McGill, the high school friend, plans to kill Lawrence aboard a boat before a sailing trip, but when Whalen races to the dock to warn her, crying, "Olivia, get off the boat!" he is himself killed in the propane explosion. In the end, standing in the graveyard,

an attorney tells Lawrence, "He loved you, Olivia. However it started, he came to love you."

The triumph of love over cruelty and immorality is evident in both films, but one can hardly call the conclusion optimistic; in both films, the characters pay for their newly found compassion and empathy for another with their lives. However, both Valmont and Whalen look into their dark side and would say with Dr. Jekyll, "This, too, was myself" (108).

Films of Murder and Destruction

In the second set of films *(Jagged Edge, Fatal Attraction, Betrayed, Black Widow,* and *Criminal Law),* a vicious character wreaks violence on his or her fellows and must be stopped—killed or imprisoned—in the end. This category is most closely linked to the formula of *The Strange Case of Dr. Jekyll and Mr. Hyde,* although Hyde is "restrained" only by illness and not by forces from outside himself. In three of the films, *Jagged Edge, Betrayed,* and *Criminal Law,* the deceiver is male; in two, female.

Jagged Edge opens with the brutal death of Page Lofton Forrester, wife of *San Francisco Times* editor Jack Forrester, who is then charged with his wife's murder. Teddy Barnes (Glenn Close) steps in as his reluctant attorney and, much against her will, falls in love with him. Thomas Krasny (Peter Coyote), the district attorney prosecuting the case, believes in Forrester's ability to deceive. When asked, "Do you really think he could have done that to his own wife?" he replies that Forrester committed the crimes in precisely such a way as to make it look like a "Charlie Manson did it."

But in spite of such warnings, point of view is masterful in the film, as the viewer sees Forrester despondent and alone after his wife's death, throwing her ashes (along with roses) into the sea. Nonetheless, the dual nature of humankind is obvious from the beginning, as Barnes's perceptive abilities (and ours) are called into question. Barnes talks with a colleague, who says, "What if he passes the polygraph test? How are you going to know if he's lying to you?" She responds confidently, as do we all, "I'll know." He says, "A guy like him? You'll never know." After Forrester passes the polygraph, Barnes's assistant tells her that the "machine loves him." Then the assistant says, "He's telling the truth—or, he's the kind of ice cube even the machine can't melt."

A psychiatrist called in to advise the defense attorney tells Barnes that Forrester is not psychopathic but that he is manipulative. Yet the audience is set up to hope with Barnes that her opening statement in the trial is true: "He is an innocent man unjustly accused." We then wait to watch her prove it.

Barnes's objectivity is called into question soon after by her colleague, Sam Ransom (Robert Loggia), who tells her, "He killed her." Barnes later tells him, "Sam. He didn't do it." "Yeah?" he says. "Is that your head talking or another part of your anatomy?" During the trial, Krasny claims Forrester planned the murder for 18 months: "He is not a psychopath. He is an ice man. He is a monster."

Found innocent by the jury, Forrester sleeps with Barnes at his opulent home; she wakes to sunlight and chirping birds in a reconstituted Garden of Eden. Looking in the closet for clean sheets, Barnes finds a typewriter that was used to type notes giving her tips about the murder. Her reaction is much like Utterson's in *The Strange Case of Dr. Jekyll and Mr. Hyde* when he sees the weapon Hyde used to kill Carew: "When the stick was laid before him, he could doubt no longer; broken and battered as it was, he recognized it for one that he had himself presented many years before to Henry Jekyll" (61). Since Forrester cannot be tried again for the same crime, Barnes does not call the police. She flees, locks herself in her house, showers, and refuses to take his calls. As Forrester breaks into her house and creeps into her bedroom, Barnes says softly, "I need to see your face, Jack. I could have loved...." She shoots him with a gun she has hidden under the covers when the masked man, carrying a knife and rope, moves toward her without speaking. Sam, suspecting something is wrong, arrives and removes the mask. Forrester dies, and the mask takes on a symbolic significance as Barnes sees him realistically for the first time.

Betrayed, too, opens with a murder, this time the murder of a Jewish talk show host known for his candor and barely suppressed rage. Sent to investigate those whom the government believes to be guilty is a federal agent, Catherine Weaver (Debra Winger). As in *Jagged Edge*, where Forrester's position, wealth, seeming sincerity, and tearful reaction to his wife's death are placed in direct contrast to those warning Barnes of Forrester's ability to deceive, *Betrayed* sets Midwestern culture (with its families, farms, "USA" baseball caps, and churches) against the suspicion that some of the residents "go hunting," a euphemism for chasing blacks in the woods and shooting them with semi-automatic weapons. The whites, assisted by dogs, give the blacks 30 seconds and 10 bullets and make statements such as "gonna get some black stuff" and "coon in a trap." The murders are in horrible contrast to the simple country life portrayed in the film. When a grandmother says, "There's filth and trash everywhere," she means blacks and Jews. When the local minister preaches, "Our schools can teach that we came from apes but can't each we are created by God," the viewer must understand that being "created by God" is a distinction reserved for whites, the chosen people.

However, as Weaver tracks down the murderers, she understands the ironies in the lives of the farm community residents and she realizes the irony in her own life as well: she, too, is not what she seems. Love soon enters the plot in *Betrayed* when Weaver begins to fall in love with Gary Simmons, a farmer who adores his two children and seems moral and compassionate. His words after a "hunt" shake Weaver to the soul: "Just a nigger. Don't make too much out of it. There's plenty more where he came from." She continues her pursuit of the members of the Zionist Occupation Government (ZOG), a group dedicated to ridding the country of Jews and blacks. In the end, Weaver must kill Simmons and leave the FBI in order to regain her own integrity and to eliminate the part of her that could love a man capable of racism and murder.

In the unfocused and plodding *Criminal Law*, the words of Friedrich Nietzsche precede the film: "Whoever fights monsters should see to it that in the process he does not become a monster. And when you look too long into an abyss, the abyss also looks into you." After Dr. Lanyon of *The Strange Case of Dr. Jekyll and Mr. Hyde* looks into Dr. Jekyll's face when he drinks the potion that will transform him, Lanyon is never the same again. In *Criminal Law*, Ben Chase (Gary Oldman) believes his old college friend incapable of the rape and mutilation of a woman. He defends his friend in court, and when he learns his friend is guilty, his faith in his own judgment is shaken forever. For both Lanyon and Chase, association with evil calls their own self-righteousness into question.

Films with women as detached and vicious killers are *Black Widow* and *Fatal Attraction*. In *Fatal Attraction*, Alexandra Forrest (Glenn Close) meets Dan Gallagher (Michael Douglas) and becomes obsessed with him. Married, he has a weekend affair with her before she begins a series of bizarre acts guaranteed to preserve monogamy: she rips his shirt, kicks him, slits her wrists, tells him she's pregnant, pours acid on his car, kills the family pet, kidnaps his daughter, and breaks into the house to kill his wife. Gallagher's stereotypical happy life—with a wife and daughter whom he adores and a new house complete with a white picket fence—intensifies the viewer's horror at: 1) the underlying violence of which Forrest is capable and 2) Gallagher's inability to remain faithful to Beth (Anne Archer).

Of course, Forrest is killed, as is the alluring enchantress-murderer of *Black Widow*, Catherine (Theresa Russell). Seductive and beautiful, Catherine murders her wealthy husbands and inherits their money. Alexandra (Debra Winger) is again a federal investigator who must confront her own masquerade as she pursues a woman engaged in an illegal one. Brought under Catherine's spell, Alexandra must ask herself why she, too, is obsessed with the black widow. Giving Catherine a spider pin on her most recent

wedding, Alexandra is startled to hear Catherine say, "Black widow. She mates and she kills. Your question is: Does she love? It's impossible to answer that unless you live in her world. Such an intriguing gift." The suggestion of lesbianism is intensified when Catherine kisses Alexandra on the mouth at the wedding reception, but the film skirts the issue of sexual orientation and honesty with oneself and plays instead upon Catherine's ability to seduce those around her. Caught in the end in dependable Hollywood fashion, Catherine goes to jail, and Alexandra walks out into the sunlight.

Films of Individual Vindication

Those identified as evil or potentially evil early in a film often are vindicated later, as the person who suspects them initially later discovers they are trustworthy. Films in this third category are *Still of the Night, Sophie's Choice,* and *The Morning After*.

In *Still of the Night,* Meryl Streep plays Brooke Reynolds, an art curator accused of murdering a man with whom she had an affair. The film opens with the discovery of his body, and flashbacks involve sessions between the man and his psychiatrist, Sam Rice (Roy Scheider). Reynolds is a lovely, flustered, and frightened woman, whose eyes mingle pain and innocence. Warning her son about the mystery woman he has described to her, Rice's mother (Jessica Tandy) says: "We're probably dealing with a woman who on the surface seems childlike and innocent, but underneath is capable of extreme violence." Heeding his mother's words, Rice flinches when Reynolds approaches him in her office; she realizes he is enamored of her but does not trust her. In the end, the real murderer is apprehended, Rice saves Reynolds' life, and the mother is proven wrong.

In *The Morning After,* the viewer deals with a similar plot, in which Alex Sternbergen (Jane Fonda) awakens to find herself in bed with a corpse. Turner Kendall (Jeff Bridges), an ex-policeman, ultimately saves her from her husband, a man who has set her up to protect an heiress he plans to marry. When the film came out on video, promoters enticed prospective viewers with the slogan: "Nothing is as it seems," and that reminder bears even more notice in an analysis of *Sophie's Choice*.

In a decidedly more noteworthy film, *Sophie's Choice,* William Styron's novel is turned into a screenplay by Alan J. Pakula. In the film, Stingo (Peter MacNicol) travels to Brooklyn and sets up an office in a boardinghouse and begins to write an American novel. One night he meets a couple named Sophie and Nathan and hears Nathan verbally abusing Sophie on the stairwell

before leaving the house. Sophie immediately says to Stingo: "I'm very sorry. That's not the way he really is, you know." What follows are days of dancing, laughter and carnivals, as Stingo is jolted out of the age of innocence and learns that cruelty and madness often lurk beneath a smile. As Jekyll says in Stevenson's novel, "My devil had been long caged, he came out roaring" (115). Remembering Nathan's voice raised against Sophie, Stingo says, "Suddenly, I shivered violently." Capable of emotional and physical brutality, Nathan nonetheless once rescued Sophie, a Polish survivor of Auschwitz, when she, exhausted and malnourished, collapsed in a library. Tending tenderly to her as the two read Emily Dickinson poetry and shared an apartment, Nathan won her love. So warm and loving is he when sane that Sophie continually comes to his rescue after his explosions of rage: "But, you know, you don't understand Nathan. You don't know," she tells Stingo. Stingo learns from Nathan's brother that Nathan was "born the perfect child" but that he is a chronic liar, a paranoid schizophrenic, and a drug user. Ultimately, Stingo cannot save the people he loves, and Nathan and Sophie commit suicide. Having grown into a writer with a message, Stingo crosses the Brooklyn Bridge and ends his "voyage of discovery," weeping for the "butchered, betrayed, and martyred children of the earth."

The Triumph of Evil

The final category in the review of 1980s films involves a main character who is so intelligent and deceptive that he or she escapes detection and continues to deceive others. Two very different films comprise the section: one is a Soviet-American spy thriller, and the other is a sensitive, understated screenplay written by dramatist Harold Pinter.

In the first film, *No Way Out*, Kevin Costner plays Tom Farrell, an American war hero who seduces Susan Atwell (Sean Young) at a party and lures her away from her lover, Secretary of Defense David Brice (Gene Hackman). Although he is married, Brice supports Atwell financially and demands an exclusive relationship. Brice learns of her infidelity, and with a "Listen, damn it. I pay the rent," throws her against a railing. The railing breaks, and she plummets to the floor and dies. Brice then must place the blame on someone else; he and his chief adviser elect a Soviet spy already sought by their office. Brice begins seeking the KGB agent in earnest, hoping to find and kill the agent before he can deny that he killed Brice's girlfriend. Because the office needs a front man, Brice and the aide select Naval Commander Farrell. Farrell learns that Atwell is dead while looking in a file in Brice's office and crumbles in grief when out of Brice's view.

The audience sympathizes with Farrell throughout the film, hoping he will evade his pursuers, avenge the death of Atwell, and implicate Brice. The final scene, however, shows Farrell talking with Soviet agents in Russian. The viewer then knows Farrell is the missing KGB agent but is never sure if he loved Atwell or fooled her, since he was assigned to seduce her and learn more about Brice. Were his actions throughout the film designed to implicate Brice, or was he merely protecting himself? Farrell escapes, Brice is caught, and the plot remains unresolved, perhaps a more realistic ending than identifying someone as purely good or consummately evil. Certainly, this film is more true to the Jekyll-Hyde formula, in which elements of trust and deception are commingled in one person.

In Pinter's *Betrayal*, deception occurs in a triangle, with Jerry (Jeremy Irons) and Emma (Patricia Hodge) carrying on an affair for seven years under the nose of Robert (Ben Kingsley), Emma's husband and Jerry's best friend. The film begins in the present and moves backwards in one- and two-year intervals to the day when the two first confess attraction for one another. The confusion of the three (Jerry's wife is never introduced) is symbolized by an interchange between Robert and Jerry in which Jerry learns that Robert has known about him and Emma for some time; the dialogue is typical of Pinter's style, as the two struggle to understand, repeating themselves and confusing each other:

> **Robert:** "She didn't tell me about you and her last night. She told me about you and her four years ago. I thought you knew."
> **Jerry:** "Knew what?"
> **Robert:** "That I knew. That I've known for years—I thought you knew that."

Much of the dialogue is cold and ruthless, as evidenced by Robert as he seeks to force Emma to tell him the truth about her affair. After seeing a letter from Jerry addressed to her, Robert says: "What do you think of Jerry as a letter writer? You're trembling. Are you cold?...Well, we're still close friends...He wasn't best man at our wedding, was he?...Was there any message for me in his letter?" Emma responds carefully, "No message." Robert smiles brutally and says, "No message? Not even his love?" She replies, "We're lovers." He moves in for the kill: "Ah, yes. I thought it might be something like that, something along those lines." Robert then says, "I've always liked Jerry. To be honest, I've always liked him rather more than I've liked you."

The cost of dishonesty and miscommunication lies at the heart of the film. Pinter peppers the script with references to truth: the phrase "to be

honest," when no one is; the description of a minor character as a "brutally honest squash player"; the memory of a conversation between the two couples about a novel that is "dishonest," etc. The theme of the film is the failed communication that results from their inability to be honest; that failure is captured in Jerry's plaintive, "What are you talking about?" In one of Pinter's brilliant uses of irony, Emma and Jerry even talk about faithfulness to one another, when both are betraying their spouses. Very drunk and a little in love, Jerry says to Emma late in the film that if she refuses him, she will be "banishing" him "to the land where the Prince of Emptiness reigns." Pinter and the audience know, of course, that the couples—trapped in their own selfishness and inability to commit themselves—already live there.

Reflections of Cultural and Personal Fears

The concentration of films about deception in one decade testifies to our need to discern the truth about each other. *No Way Out* is frustrating, for we are duped as we watch the film in the same way we are duped in life. In *Jagged Edge*, we are at least prepared for the possibility that Jack Forrester may be a murderer, even though—if the film succeeds—we hope with his love-struck attorney that he is not.

Television Westerns, situation comedies, and other genre prevail because conflict is resolved in an expected way and in an allotted period of time, when the incidents of our days are much less reassuring. In *The Strange Case of Dr. Jekyll and Mr. Hyde*, we are at least assured that Mr. Hyde is dying and can no longer wreak his rage upon the world. We also know that his evil nature results from a potion that concentrated the evil already present in Dr. Jekyll, and we reassure ourselves that evil is rarely that potent. We also are reassured by the fact that Hyde is as physically repulsive as he is; we are not as sure that we can identify evil when it is masked by a visage as attractive as Catherine's in *Black Widow* or as seductive as Alex Forrest's in *Fatal Attraction* or as charismatic as Jack Forrester's in *Jagged Edge*. Melville writes in *The Confidence-Man* that the appearance of truth can destroy and that ignorance is no excuse for blunders. The difficulty of maintaining compassion in the face of distrust is illustrated by the following dialogue between two acquaintances in *The Confidence-Man:*

> "He's a rascal," I say.
> "But why not, friend, put as charitable a construction as one can upon the poor fellow?" said the soldier-like Methodist, with increased difficulty maintaining a

pacific demeanor towards one whose own asperity seemed so little to entitle him to it: "he looks honest, don't he?"

"Looks are one thing, and facts are another," snapped out the other perversely. (20)

In short, the films in "Changing Faces" allow us to discover if our heroes on the screen and our perception of them are to be trusted. Outside the darkened theater, we are less sure of ourselves.

Works Cited

Hawthorne, Nathaniel. *The Scarlet Letter*. New York: New American Library, 1959.

Melville, Herman. *The Confidence-Man: His Masquerade*. New York: New American Library, 1954.

O'Connor, Flannery. *Mystery and Manners*. Ed. Sally and Robert Fitzgerald. New York: Farrar, Straus, & Giroux, 1969.

Stevenson, Robert Louis. *The Strange Case of Dr. Jekyll and Mr. Hyde*. New York: New American Library, 1987.

Chapter Five

Displaced People and the Frailty of Words: Communication in *Ordinary People, On Golden Pond,* and *Terms of Endearment*

Films about difficult parent-child relationships often rely upon a series of semiological puzzles, as the characters who solve the riddles gain love and self-awareness and those who fail to solve them face estrangement and self-doubt. The viewer often confronts post-Deconstructionist dialogue in which language can be simultaneously unreliable and richly suggestive. To some extent, the failure of communication lies in the nature of the tools we all employ. As T.S. Eliot writes in "Burnt Norton" *(The Four Quartets):*

> Words strain,
> Crack and sometimes break, under the burden,
> Under the tension, slip, slide, perish,
> Decay with imprecision, will not stay in place,
> Will not stay still. (1)

For all of its rich possibilities, human language is flawed, as anyone who has struggled to communicate his or her deepest feelings can attest. In "Existenzphilosophie," Karl Jaspers writes, "No urge seemed stronger to me than that for communication with others. If the never-completed movement of communication succeeds with but a single human being, everything is achieved" (173). In a discussion of the poetics of language, Gérard Genette writes that the "'perfect' or 'supreme' language does not exist, or if it exists, it is elsewhere; perhaps the 'good language' is always that of our neighbors" (2). Poetry, he says, exists only to "repair and compensate" for the defects in language: "If a language were perfect, poetry would have no reason for

being, since it would have nothing to repair. Language itself would be a poem and poetry would be everywhere..." (3).

The longing for words that will do justice to one's feelings and beliefs remains unsatisfied, as we shall discover through a brief study of problematic dialogue in the award-winning films *Ordinary People* (1980), *On Golden Pond* (1981), and *Terms of Endearment* (1983). Engaged in conversations, parents and children are unable to hear one another when one of them addresses core relational issues and the other talks about the mundane. The study focuses on the fabric of human conversation and the longing for understanding and connection in these three representative films.

From 1980 to 1987, numerous reviews and scholarly studies about the three films dealt with everything from family psychology to family disintegration to the patriarchal crisis to the directing talents of Robert Redford in *Ordinary People;* from child abuse to cancer to mother-daughter relationships in *Terms of Endearment;* and from mortality to the significance of the backflip as a symbol in *On Golden Pond*. Only a few articles addressed the structure of the films and fewer yet analyzed dialogue.

In a particularly incisive study of structure, Robert T. Eberwein discusses the ghost motif in *Ordinary People*, focusing on the Halloween trick-or-treat scene and the incident during which Beth is startled by Conrad as she sits in Buck's old bedroom. By dealing with these film situations, Eberwein engages one of the concerns of this article—the failure of communication between Beth (Mary Tyler Moore) and Conrad (Timothy Hutton). "Now he stands outside the door," writes Eberwein, "having come apparently out of nowhere while Beth engages in her communion with the dead" (4). Although Beth communes with her dead son, she has lost touch with her living one.

The title of this study, "Displaced People and the Frailty of Words," alludes to a short story by Flannery O'Connor entitled "The Displaced Person," a tale about an immigrant named Guizac. As in all O'Connor stories, the plot is not the point. O'Connor is concerned in "The Displaced Person" with the failure of communication, the inevitable misunderstandings that will never be unraveled within the fictional text. The central example of this failure in the story involves a conversation between Mrs. McIntyre, Guizac's employer, and the local priest. While they talk, the priest is startled by the beauty of several peacocks, which symbolized for O'Connor the resplendent nature of Christ:

> The old man didn't seem to hear her. His attention was fixed on the cock who was taking minute steps backward, his head against the spread tail. "The Transfiguration," he murmured.

> She had no idea what he was talking about. "Mr. Guizac didn't have to come here in the first place," she said, giving him a hard look.
>
> The cock lowered his tail and began to pick grass.
>
> "He didn't have to come in the first place," she repeated, emphasizing each word.
>
> The old man smiled absently. "He came to redeem us," he said. (239–40)

The dialogue, which results only in confusion for both Mrs. McIntyre and the priest, relies on the ambiguous pronoun "he": he "didn't have to come here," says Mrs. McIntyre, meaning Mr. Guizac (not understanding that according to Catholic doctrine, Christ, too, "didn't have to come here" or choose a martyr's life). He "came to redeem us" refers both to Christ and, as a reader learns later in "The Displaced Person," to Guizac himself.

When Guizac eventually dies violently, Mrs. McIntyre is so deeply affected that she ultimately loses her farm. The immigrant and the prophet from Nazareth are both outcasts, but the two who profess to know them best (Mrs. McIntyre and the priest, respectively) are oblivious to the revelation. A man in awe appears "idiotic" to Mrs. McIntyre; Mrs. McIntyre's lack of compassion and distrust of others are revealed in her labeling Guizac an "extra" person in her world. The priest, who speaks only to himself about the significance of the life of Christ and his transfiguration, has no desire to connect with Mrs. McIntyre (beyond "blandly" reaching for her hand). O'Connor tells the reader directly that Mrs. McIntyre "had no idea what he was talking about." Later, the dialogue between them becomes more adversarial:

> "For," he was saying, as if he spoke of something that had happened yesterday in town, "when God sent his Only Begotten Son, Jesus Christ Our Lord"—he slightly bowed his head—"as a Redeemer to mankind, He. . ."
>
> "Father Flynn!" she said in a voice that made him jump. "I want to talk to you about something serious!"
>
> The skin under the old man's right eye flinched.
>
> "As far as I'm concerned," she glared at him fiercely, "Christ was just another D.P." (243)

Committed to a belief in the holiness of Christ, the priest can no longer avoid the raw unconcern Mrs. McIntyre feels for the displaced of the world. The semiological puzzle is to some extent solved when the two realize they are interested in different things, but the two speakers remain isolated and estranged from one another.

Popular films with expert screenplays contain many such encounters and use dramatic monologue masterfully. When the stakes of missed communication are high, as in parent-child or romantic relationships, the failure is

especially excruciating. In an essay entitled "The Museum's Furnace," Eugenio Donato acknowledges the "dream and hope of a total, finite, rational domain" of human wisdom but says that all must "come to realize that not only is knowledge as a given totality unavailable," but "any act of totalization is by definition incomplete, infinite, and everywhere marked by accident, chance, and randomness" (7). In the flawed kingdom of film, failures and limitations are represented by human interaction, revealed in dialogue. Through pivotal conversations in which family members are unable to hear one another, one person often addresses core relational issues while the other talks of the mundane. For example, the priest and Mrs. McIntyre in "The Displaced Person" sound a great deal like Conrad and his mother in *Ordinary People* as they strain to talk to one another in the back yard of their plush suburban home.

Ordinary People

Beth sees Conrad huddled outside on a lawn chair. In an uncharacteristic effort to reach out to her son, Beth goes outside and tells him to put on a sweater. Conrad tells her how much he would like a pet; she interrupts and tells him how much trouble a neighbor's dog is. Reduced to rage that his mother does not understand his need for something to belong to him, Conrad shouts over his mother's voice, and when she continues talking, he begins to bark. She looks at him stoically and calmly tells him to put on his sweater if he plans to stay outside. Moments later, Conrad follows his mother into the dining room where she is setting the table for dinner. "Can I help?" he asks quietly. Beth tells him to go upstairs and clean out his closet. His heart in his hands, Conrad says, "Mom." The phone rings. Beth answers it, saying, "No, no. I'm not doing anything. Just getting ready for dinner." Conrad leaves silently.

Eberwein notes that Beth is "not the heavy" in the film, as she is considered by many critics. He refers to the anguish that communication causes for both Beth and Conrad: "They end up talking over each other's statements, and Conrad barks. Beth goes back into the house; her effort at being pleasant has failed, for Conrad has been *emotionally* cold to her in the chilly scene and rebuffed the only kind of warmth she is capable of extending to him" (8). Similar failure to communicate occurs when the two pass in the hall at home:

> **Beth:** "I didn't play golf today. It was too cold."
> **Conrad:** "How was your golf game?"
> **Beth:** "I didn't play."

Conrad: "Oh, it did get colder today."
Beth: "No, I mean for the year, it's colder."

It is no accident, of course, that Conrad is reading *Jude the Obscure* by Thomas Hardy in his English class. The displaced Jude Fawley finds human relationships obscure and suffers a series of losses. Hardy writes of Jude's continuing disappointments: "Events did not rhyme quite as he had thought. Nature's logic was too horrid for him to care for" (9). This despair is reflected in Conrad's own life. Those around him—especially his mother—are mysteries, and his feelings of isolation and rejection are unclear even to him. In dismay, Conrad turns to a psychiatrist, who he hopes can master the hidden text of his life. The young man's cry, "We just don't connect!" summarizes his relationship with his mother, but it also is the theme and semiological center of the script by Alvin Sargent.

On Golden Pond

In *On Golden Pond*, the relationship between Chelsea (Jane Fonda) and her father Norman Thayer (Henry Fonda) is symbolized by a provocative semantic war during a seemingly innocent game of Parcheesi. Chelsea equates her father's need to win the board game with his enjoyment of beating others in word games, games that have cost her the intimacy she craves. Unlike Mrs. McIntyre and Guizac, Norman and Chelsea eventually understand that they are no longer talking about an outside person or event but about their own relationship:

Norman: "Chelsea doesn't like playing games…We don't know why. Probably doesn't like losing."
Chelsea: "I tend to panic when the competition gets too intense…What I'd like to know is why you enjoy playing games.
Norman: "Huh?"
Chelsea: "You seem to like beating people. I wonder why."
Norman: "What's that supposed to mean?"
Chelsea: "Nothing."

Evident throughout the film is Chelsea's anguished longing for connection with her father, sometimes hidden, sometimes expressed in jealousy or rage, sometimes acknowledged in embarrassment. By refusing to visit her father for long periods of time, Chelsea uses silence to express her pain. When Norman connects with Billy, the son of Chelsea's boyfriend, Chelsea

says her father should have "traded [her] in" for a son. That jealousy some-
times is linked with anger: "I've been answering to Norman all my life,"
Chelsea tells Ethel Thayer (Katharine Hepburn), her mother. "It makes me so
mad. Even when I'm 3,000 miles away and I don't even see him, I'm still
answering to him." Chelsea also expresses her isolation and frustration in
occasional embarrassed confessions of inadequacy: "I act like a big person
everywhere else," Chelsea says. "I'm in charge of Los Angeles, and I come
here and I feel like a little fat girl." Norman's inability to express his love for
his daughter is mirrored in Chelsea's behavior toward him. As Ethel tells
Chelsea, "But darling, you're wrong about your dad. He does care. He cares
deeply. He's just an absolute muck about telling anyone." Without Ethel's
facilitating the relationship between Norman and Chelsea, their longing to
connect might never have been enough. After Chelsea and her father reach a
reconciliation because of Ethel's help, subtle shifts in language once again
illustrate the temporary transformation of the relationship. As Chelsea leaves,
she says shyly, "Well. Good-bye. Norman…Dad."

In all three films, characters who are 1) trapped by the inherent unrelia-
bility of language as well as 2) enraged by their own inability to meet another
family member on common ground remain frustrated and unsure about how
to make their feelings clear. Expecting more from themselves, they feel more
and more inadequate. It is Conrad of *Ordinary People* who best expresses
this inadequacy: "I kept thinking John Boy would have said something about
the way he felt." The reference to the perfect son depicted in the long-
running family drama *The Waltons* (1971–1981) indicates the insurmounta-
ble chasm between Conrad's desire to verbalize his pain and his mother's
inability to hear him.

Terms of Endearment

In *Terms of Endearment*, the stakes are even higher, as Emma Greenway
(Debra Winger) and her mother (Shirley MacLaine) struggle to communicate
after Emma is diagnosed with terminal cancer. Aurora Greenway is obses-
sively involved with her daughter from the moment we see her crawl into
Emma's crib and make her cry (in order to reassure herself that Emma is still
breathing). Emma's father dies, and Aurora alienates Emma's friends ("Sure
would be nice to have a mother somebody liked," Emma tells her friend
Patsy) and eventually refuses to attend Emma's wedding because she
disapproves of Emma's choice of a husband.

One of the first examples of the difficulty the two have in addressing
central issues between them occurs when Emma and her husband Flap

Horton (Jeff Daniels) move from Houston to Des Moines. As the family hugs farewell, Aurora clings to her daughter. Emma says, "That's the first time I stopped hugging first. I like that." Aurora replies, "Get yourself a decent maternity dress." Emma's disappointment lies behind her eyes as she says, "You had to get one in, didn't you?"

In the cancer ward with each new treatment failing, Emma and her mother are alone. The desperate desire to connect is evident as each of them tries to stabilize the alternately troubled and tender relationship between them. Aurora tells her daughter that she and Garrett Breedlove (Jack Nicholson) are romantically involved again:

Aurora: "And you know what?"
Emma: "What?"
Aurora: "I got up the nerve to tell him I loved him. You know what his reaction was? Emma?"
Emma: "I don't give a shit, Mom. I'm sick. Not everything has something to do with you. I've got a lot to figure out."
Aurora: "I just don't want to fight anymore."
Emma: "What do you mean? When do we fight?"
Aurora: "When do we fight? You amaze me! I always think of us as fighting."
Emma: "That's because you're never satisfied with me."

Aurora doesn't reassure Emma, but she is there when Emma wakes briefly, moves her fingers slowly to wave good-bye, and dies. Loneliness and loss overwhelm Aurora, as she hugs Flap and cries, "My sweet little girl...There's nothing harder."

Conclusion

No stranger to isolation and emptiness, Jaspers explains in "Existenzphilosophie" why the human desire to "say" is so intense. He writes:

> The emptiness caused by dissatisfaction with mere achievement and the helplessness that results when the channels of relation break down have brought forth a loneliness of soul such as never existed before, a loneliness that hides itself, that seeks relief in vain in the erotic or the irrational until it leads eventually to a deep comprehension of the importance of establishing communication between man and man. (10)

What Jaspers calls the "act of mutual discovery" (11) occurs only in communication, and he believes (like Saul Bellow in *Mr. Sammler's Planet)* that the individual is not born human but gains humanity through community, through what he calls "communication with another self-being" (12).

The sophisticated semiological tangles of *Ordinary People, On Golden Pond,* and *Terms of Endearment* are not lost on modern filmmakers, critics, or reviewers. Although they do not explain the gaps in meaning using terms such as "sign," "signifier," or "signified," art still imitates life, and most of us have felt the fear of losing something or someone because of an inability to articulate our need clearly. The very tools we choose are flawed.

While this may be true, language also is suggestive and rich and allows for multiple levels of meaning simultaneously. In "From Work to Text," Roland Barthes reminds us that the "logic that governs the Text is not comprehensive (seeking to define 'what the work means') but metonymic." Making "associations, contiguities, and cross-references coincides with a liberation of symbolic energy" (13), he states.

Through a complex interchange between "revelation and concealment" (14), terms introduced by Wolfgang Iser, symbols come to life in our discourse. Although Conrad and his mother fail to understand one another, he and his father express their love with intensity and vulnerability in the final scene of *Ordinary People.* Chelsea and Norman Thayer have their moments of connection in *On Golden Pond,* and Emma dies knowing she is adored by her mother in *Terms of Endearment.* As an argument for continuing the effort to talk genuinely with one another, Eberwein writes of the characters in *Ordinary People:* "In a world where we seem to be in the grip of circumstance, where people let us down, and where our anger prevents us from forgiving, love seems to be all we have" (15).

The titles of the films themselves promise rich undercurrents of meaning and remind the viewer of the potential magic of language. In *Terms of Endearment,* for example, James L. Brooks intends the viewer to understand both the concept of "terms" as words or messages and "terms" as conditions. With the latter, the viewer encounters the insidious, implied, and secret terms on which our love for one another often is based. The title *Ordinary People* sets up the ironic possibility that while the characters may be representative, they will be unordinary in their interaction. In *On Golden Pond,* "golden" signifies Norman Thayer's 80th birthday, the pond beside which the family gathers, and the yellow-orange hues of the late afternoon. In all three films, language claims the power to challenge and reassure, but it reserves the right never to be taken for granted.

Works Cited

Barthes, Roland. "From Work to Text." *Texual Strategies: Perspectives in Post-Structuralist Criticism*. Ed. Josué V. Harari. New York: Cornell University Press, 1979. 73–81.

Donato, Eugenio. "The Museum's Furnace: Notes Toward a Contextual Reading of Bouvard and Pécuchet." *Textual Strategies: Perspectives in Post-Structuralist Criticism*. Ed. Josué V. Harari. New York: Cornell University Press, 1979. 213–38.

Eberwein, Robert T. "The Structure of *Ordinary People*." *Literature and Film Quarterly* 11.1 (1983): 9–15.

Eliot, T.S. "Burnt Norton." *The Four Quartets. Collected Poems* (1909–1962). New York: Harcourt Brace, 1991. 175–81.

Genette, Gérard. "Valéry and the Poetics of Language." *Textual Strategies: Perspectives in Post-Structuralist Criticism*. Ed. Josué V. Harari. New York: Cornell University Press, 1979. 359–73.

Hardy, Thomas. *Jude the Obscure*. New York: W.W. Norton, 1978.

Iser, Wolfgang. "Interaction Between Text and Reader." *The Reader in the Text: Essays on Audience and Interpretation*. Ed. Susan R. Suleiman and Inge Crosman. Princeton, N.J.: Princeton University Press, 1980. 106–19.

Jaspers, Karl. "Existenzphilosophie." *Existentialism from Dostoevsky to Sartre*. Ed. Walter Kaufman. New York: New American Library, 1975. 158–232.

O'Connor, Flannery. "The Displaced Person." *A Good Man Is Hard to Find and Other Stories*. 1948. New York: Harvest, 1955. 196–252.

Section Two

Portrayals of Class, Race, and Sexual Orientation

Chapter Six

Working Man Blues:
Images of the Cowboy in American Film

Whether they are cacti, deserted gas stations, dusty roads, motels, rusted pick-up trucks, or tumbleweeds, images of the American West cast a powerful spell. The most potent of these images—the American cowboy—dominates the landscape, as he sits on his horse in silhouette against a sunset backdrop of yellow and orange flame.

The cowboy in Western film and literature evolved from stories about medieval English knights and, later, the Spanish *vaqueros*, who herded cattle from Mexico into what is now California, New Mexico, and Texas. Although the cowboy has his roots in other centuries and cultures, he remains one of the quintessential symbols of courage, hardiness, masculinity, and national pride in contemporary America.

The cowboy is more than a historical figure and more than the idealized hero who dominates television programs such as *Bonanza* (1959–1973) and *Gunsmoke* (1955–1975) and classic films from *Shane* (1953) to *3:10 to Yuma* (2007). The cowboy is a national treasure, a stereotype both embraced and reviled. Filmmakers, authors, and songwriters glorify him and appear to celebrate what he represents: manual labor, the raising of cattle for human consumption, and rural life.

There is much to admire. The cowboy works hard, is loyal to his friends, lives close to the land, and depends upon animals for his identity as well as his livelihood. He represents freedom and stands in stark opposition to a settled, domesticated life. However, his self-sufficiency depends upon the seasons, upon the availability of employment, and upon the financial stability of those who pay his wages. In short, the cowboy is often isolated and poor, facts that are too often obliterated in the national obsession with the legend

about men who brand and herd cattle, chase outlaws, shield women and children from harm, and wield Colt revolvers. Waylon Jennings and Willie Nelson are probably correct: mothers shouldn't let their babies grow up to be cowboys.

This study emphasizes the labor that defines the blue-collar cowboy and the films that portray a more realistic—albeit still iconic—figure. Although it is impossible to discuss all of the films listed here, blue-collar cowboys appear prominently in these and other narratives: *Butch Cassidy and the Sundance Kid* (1969), *Midnight Cowboy* (1969), *Little Big Man* (1970), *The Outlaw Josey Wales* (1976), *Silverado* (1985), *The Milagro Beanfield War* (1988), *Young Guns* (1988), *Dances with Wolves* (1990), *Unforgiven* (1992), *Tombstone* (1993), *Legends of the Fall* (1994), and *Wyatt Earp* (1994). Others are *Lone Star* (1996), *The Missing* (2003), *Open Range* (2003), *An Unfinished Life* (2004), *The Three Burials of Melquiades Estrada* (2005), *The Assassination of Jesse James by the Coward Robert Ford* (2007), *3:10 to Yuma* (2007), *No Country for Old Men* (2007), and *Appaloosa* (2008). Spanning five decades, these celebrated films have garnered numerous awards. Among them, *Dances with Wolves* was nominated for 12 Academy Awards and won seven; *Unforgiven* and *Brokeback Mountain* each were nominated for nine and won four.

The sheer number of films suggests that the Marlboro man is as much a part of the national psyche as Aunt Jemima and the Pillsbury Doughboy. Acknowledging the importance of the cowboy in American mythology, this study alludes to the romantic, realistic, and revisionist Westerns that have defined the American cowboy and analyzes two films that powerfully disrupt earlier portrayals—*Brokeback Mountain* (2005) and *No Country for Old Men* (2007). Directors such as Ang Lee and the Coen brothers, respectively, both challenge and reify portrayals of the blue-collar cowboy and provide new understanding of a historical and significant national icon.

The American Cowboy in Film

From the silent film era to the "Golden Age of the Western" (1946–1962) to Academy Award winners for "Best Picture"—*Dances with Wolves* (1990), *Unforgiven* (1992), and *No Country for Old Men* (2007)—the cowboy is perhaps the best-known symbol of masculinity in America. Also, as William Indick writes of the Western narrative in *The Psychology of the Western: How the American Psyche Plays Out on Screen,* "no other distinct national mythology has risen to take its place" (3).

Since the 1960s, however, romanticism gradually has given way to realism and revisionist narratives and to portraits of the cowboy as a "darker, more conflicted" figure, "shaded with psychological torment and internal conflict" (Indick 2). Nonetheless, fans of the cowboy rarely consider his status in society or express anything but enthusiasm for his courage and tenacity. Just as a rising body count in a traditional Western film is an accepted part of the genre, the danger and poverty a cowboy face are simply assumed. Songs such as "Workin' Man Blues" by Merle Haggard address the penniless state of those who perform manual labor on behalf of others, but blue-collar cowboys rarely are included among descriptions of farmers, factory workers, sharecroppers, and other laborers during the 19th and 20th centuries. Focusing on cowboys as day laborers—who survived on $1 a day and worked for food and the shelter of a bunkhouse at night—undercuts the iconic image familiar to American audiences.

The economic status of cowboys may help to explain why they are portrayed so often as young men who are "prematurely old." As James Poniewozik writes about U.S. Marshal Raylan Givens (Timothy Olyphant), the central character in the television hit *Justified*, "Like many a western hero, there's something strong and tired about him at the same time" (54). Resembling warriors of the Old Testament, cowboys are charged with conquering the land, establishing order, and enforcing the law (Indick 14), although they often have no visible means of support—unless they take temporary positions as lawmen or try (and usually fail) as farmers. David Lusted links the portrayal of the cowboy to class distinctions in the country at large: "The hero may be classed or classless, a representative of bourgeois refinement or working class aspiration, and even an impossible ideal of a classless American future" (47).

Because the cowboy symbolizes the work ethic of the American laborer, Western films become what Indick calls "a deliberate and an unconscious expression of American ideals, hopes, fears, and anxieties" (5). In more recent films, such as *Unforgiven*, the cowboy is featured as someone who—because of emotional, financial, or societal obstacles—is unable to achieve his goals. In the Clint Eastwood classic, for example, the Schofield Kid is "nearsighted, unable to see things for what they are, and unable to see what lies in front of him if he continues on his reckless path" (54), Indick writes. Although the Kid eventually renounces the dangerous path he has chosen, he initially represents a new generation of gun-slinging cowboys.

In spite of questionable values that characters such as the Schofield Kid embody, the cowboy still represents something essential for American audiences. For example, he provides what Indick calls a "critical awareness of their own imminent doom": "Western heroes teach us how to live with

honor and how to face death with courage and integrity" (59). Historically, cowboys introduce priorities as varied as "honor and redemption" and "vengeance and violence" (Indick 60). In his more evil incarnations, the cowboy points toward a "dark passage into the netherworld" and embodies the "mark of Cain" from biblical lore, his "hands stained with the sin of blood" (Indick 60).

The Blue-Collar Cowboy in the Realistic Western

Established categories of Western films—epic, romance, dystopian, elegiac, classical, realistic, and revisionist—are helpful in a study that includes so many examples. However, a realistic film might include at least one romantic figure; a realistic film might also challenge accepted notions about the colonization of the American West and become in part a revisionist film. Two 2007 films that fall into the borderland between categories are *The Assassination of Jesse James by the Coward Robert Ford* and *3:10 to Yuma*. Both realistic, they also deconstruct Western legends.

Set in the 1880s, *The Assassination of Jesse James by the Coward Robert Ford* features Robert Ford (Casey Affleck) as an aspiring gunfighter in love with the idea of fame and initially devoted to Jesse James (Brad Pitt). Based on a novel by Ron Hansen, the film describes the James Gang and the 25 bank, stage, and train robberies they executed between 1867 and 1881. "I honestly believe I'm destined for great things," announces Robert Ford, who longs to be featured as a gunslinger in one of the "nickel books" that were popular during the time. Keeping a "little museum" on members of the gang, Ford tells others, "I've also got an appetite for greater things." Directed by Andrew Dominik, the film juxtaposes those who lead a hardscrabble life and those who want to steal their way into fame and wealth. Although he is tortured by much of the violence he has perpetrated, Jesse James remains defiant in the face of railroad owners and others who oppose him: "They've got their company rules and I've got my mean streak and that's the way we get things done around here."

Based on a short story by Elmore Leonard, *3:10 to Yuma* also refers to dime novels and tall tales about gunslingers. When outlaw Ben Wade (Russell Crowe) and Dan Evans (Christian Bale) collide, so do two ways of life and two value systems. Although he lost his leg during the Civil War, Evans is the epitome of courage and righteous anger. Being forced to sell his land to a railroad, he says, "You got no right to do what you done. Hear me?

That's my land." When gunshots disperse his cattle, he tells Wade, "They're all I got. I need em' back."

Filmed in New Mexico and directed by James Mangold, *3:10 to Yuma* is rich with references to cowboys and blue-collar values. For example, Evans explains to his wife Alice (Gretchen Mol) why he has agreed to accept $200 to transport Wade to a rail station where he will be taken to a Yuma prison. "Now I'm tired," he says. "I am tired of watching my boys go hungry. I'm tired of the way they look at me. I'm tired of the way that you don't. I've been standing on one leg for three damn years, waiting for God to do me a favor. And he ain't listening." Throughout the morality play, Evans adheres to his values and ultimately transforms those around him.

Appaloosa (2008) is another realistic Western with a didactic message and a notable cast. Directed by Ed Harris and based on a novel by Robert B. Parker, *Appaloosa* is a tale of two blue-collar cowboys who choose law enforcement as a way to make a living. At its heart is male friendship and loyalty. In *Appaloosa*, Marshal Virgil Cole (Viggo Mortensen) and Deputy Everett Hitch (Ed Harris) settle in the New Mexico Territory in 1882, and, as is true for most Western films, the land becomes a character in the narrative, requiring much from those who choose to live there. Throughout the film, Cole and Hitch address the meaning of life, the certainty of death, and the role of emotion in their lives. "Life has a way of making the foreseeable that which never happens and the unforeseeable that which your life becomes," Hitch says.

The Blue-Collar Cowboy in Revisionist Films

The definition of "revisionism" in film is contested, although generally the phrase suggests inclusive narratives that acknowledge the convergence of African Americans, American Indians, Asians, Mexicans, women of all races and ethnicities, and gay men and lesbians in the history of the West. However, a film such as *Unforgiven* also might be considered "revisionist" in its deliberate attempt to undercut Western stereotypes.

What Stephen McVeigh calls the "traditionally mythic and moodily introspective" (75) Westerns of the 1950s gave way to the "postmodern Western" (203)—*Unforgiven*. In *Unforgiven* (1992), Clint Eastwood, the epitome of the unflinching hero, both bids farewell to his career as an actor in Westerns and critiques the mythology of cowboy culture. As director of the dark and violent film, Eastwood systematically undercuts the tall tales and legends that define the Western itself; redefines womanhood and chivalry;

creates heroic figures who are haunted by killing and who dream of worms that crawl out of human skulls; and highlights anti-intellectualism (Little Bill ridicules the publication "Duke of Death" by calling it the "Duck of Death," for example).

In *Unforgiven*, Eastwood questions men whose greatness is defined by their riding and shooting ability and critiques the blue-collar hired hand who turns gunslinger. The violence in *Unforgiven* is relentless: a young cowboy dies slowly from a wound in his stomach, and a sadistic sheriff flogs a black man to death. Protagonists Ned Logan (Morgan Freeman) and Will Munny (Eastwood) are aging heroes: They still sleep near the campfire, but their conversation centers upon how much they miss their beds. Known for his violent exploits, Munny now is inept with handling hogs; can't mount his horse; and can't shoot straight. Struggling to believe he has become the kind of man his late wife wanted him to be, he protests too much: "I ain't no crazy killing fool," "I'm just a fella now," and "I ain't like that no more," he says. He corrects his son for swearing; however, he leaves his children for two weeks to fend for themselves and murders without remorse. His reasons for following the Schofield Kid (Jaimz Woolvett) and avenging the mutilation of a prostitute remain suspect. Does he want justice, money, or adventure? Or is being a gun for hire simply a habit he never broke?

Like other Westerns, the apocalyptic *Unforgiven* is didactic. Eastwood tips his hat to the genre that made him famous and portrays a man who understands the cost of murder while continuing to perpetrate it. "It's a hell of a thing, killin' a man," Munny tells the Schofield Kid. "Take away all he's got, and all he's ever gonna have." When the Kid reassures him that the men they killed were guilty and "had it comin'," Munny responds, "We all have it comin', Kid." Admitting that he has "killed just about everything that walks or crawls at one time or another," Munny recognizes but cannot control his baser instincts. "I've always been lucky when it comes to killin' folks," he says. Although Little Bill (Gene Hackman) appears to be more diabolically cruel than Munny, neither he nor Munny makes a connection between the suffering he causes and his own day of reckoning. Before Munny shoots him, Little Bill moans, "I don't deserve this—to die like this—I was building a house."

Set in Big Whiskey, Wyoming, *Unforgiven* won "Best Picture," "Best Director," and "Best Supporting Actor" (Hackman) because of its insightful commentary on the genre of the American Western itself. "The avowedly revisionist stance of the movie gives it a sense of elegiacism," writes McVeigh. "The mourning of the loss of frontier mythology that underlies the movie represents an unquestionably knowing revision of the genre" (204).

As an "epitaph" (204) for the Western, he says, *Unforgiven* teaches that "violence begets violence" in a "continuous cycle" (206).

One of the revisionist films that highlights the role of Mexicans and Spaniards in the settlement of the American West is *Lone Star* (1996). Three sheriffs, Sam Deeds (Chris Cooper), Buddy Deeds (Matthew McConaughey), and Charlie Wade (Kris Kristofferson), represent the changing attitudes in several generations of law enforcement. Focusing on a murder that occurred 40 years before, *Lone Star* illuminates Anglo, black, Latino, and Native American perspectives on equality and fairness. Pilar Cruz (Elizabeth Peña), Mercedes Cruz (Miriam Colon), and Eladio Cruz (Gilbert R. Cuellar Jr.) deal with complex issues such as immigration and poverty. An African-American bar owner, Otis Payne (Ron Canada), summarizes the central thesis in a film devoted to issues of race, ethnicity, and family when he says, "Blood only means what you let it."

Both realistic and revisionist, *An Unfinished Life* (2004) features three main characters coping as best they can with their hardscrabble lives and with the death of someone they love. Einar Gilkyson (Robert Redford), Mitch Bradley (Morgan Freeman), and Jean Gilkyson (Jennifer Lopez) mourn Griffin Gilkyson, who died in a car accident. His wife Jean was driving when she fell asleep, and her father-in-law blames her for the wreck. Years later, accompanied by her daughter and fleeing an abusive relationship, Jean seeks refuge with her father-in-law and his friend Mitch. Directed by Lasse Hallström, *An Unfinished Life* highlights the place of women in the West, the longing of men such as Mitch to be cowboys, and the inability of an older man to work a ranch after the death of his son. Mauled by a bear and dealing with continual pain, Mitch teaches Einar about forgiveness and hope. He tells Einar he can't watch him "mourn for a life you think you should have had": "There are people everywhere who think they've got dealt a bad hand, Einar," he says.

Also a tale of forgiveness, *The Missing* (2003), directed by Ron Howard, is set in 1885 New Mexico. A healer who struggles to support her daughters Lily (Evan Rachel Wood) and Dot (Jenna Boyd), Maggie Gilkeson (Cate Blanchett) is estranged from her father, Samuel Jones (Tommy Lee Jones). When he offers to help her rescue her kidnapped daughter, she says: "What you're doin', you're doin' for your own soul." Based on the novel *The Last Ride* by Thomas Eidson, *The Missing* highlights the role of women who helped to settle the American West and who also herded cattle, rode horses, and used weapons to defend themselves and others.

Tommy Lee Jones directs and stars in another revisionist film, *The Three Burials of Melquiades Estrada* (2005), set in a Texas border town. Pete Perkins (Jones) befriends Melquiades Estrada, a ranch hand. When Estrada is

shot by U.S. Border Patrolman Mike Norton (Barry Pepper), Perkins begins a pilgrimage that transforms both him and Norton. Based upon Guillermo Arriaga's script, "The Three Burials of Melquiades Estrada" is reminiscent of Sam Peckinpah's *Bring Me the Head of Alfredo Garcia* (1974), *Lone Star* (1996), and The Border Trilogy by Cormac McCarthy (220), according to McVeigh. What McVeigh calls a "picaresque tale of revenge and redemption" (220) is also a morality play that reframes the traditional Western.

The Blue-Collar Cowboy in the Romantic Western

If the point of the narrative is adventure and if good prevails over evil, then a Western film often is categorized as "romantic." Blue-collar cowboys are central to several representative films in this genre.

One of the most popular is *Silverado* (1985), which is both a romantic and revisionist Western. When Emmett (Scott Glenn) and Paden (Kevin Kline) defend a black man in a saloon in Turley, they make a friend for life. The bartender calls Mal (Danny Glover) a "nigger," and without investigating the conflict, Sheriff John Langston (John Cleese) banishes Mal from town. Mal, who is a talented marksman, then saves the lives of Emmett and Paden and begins to educate them and others about discrimination. In a conversation with Emmett's brother Jake (Kevin Costner), Jake asks him where he has been living. "Chicago," Mal replies. "Workin' in the slaughterhouses." Excited, Jake shouts: "Chicago? You've been to Chicago? Was it wonderful?" "No," Mal responds, quietly and purposefully.

In addition to issues of race and ethnicity, the rollicking romance also addresses women and their contributions to building the frontier. Paden tells Hannah (Rosanna Arquette) that she's lovely, and Hannah tells him that other men have been attracted by her beauty. "They're drawn to me by that, but it never lasts," she says. "Why?" asks Paden incredulously. "Because they don't like what I want," she tells him. "I want to build something. Make things grow. That takes hard work. A lifetime of it. That's not why a man comes to a pretty woman. After a while I won't be so pretty. But this land will be."

Directed by Lawrence Kasdan and set in New Mexico, *Silverado* exhibits a romantic optimism that sets it apart from other films in this study. The good guys win, and there is never any confusion about who they are and what they want. The tone of the film is exemplified by Stella (Linda Hunt), a bartender who befriends Paden. "The world is what you make of it, friend," she says. "If it doesn't fit, you make alterations."

Another popular example of the romantic genre is *Young Guns* (1988), which stars Emilio Estevez as William H. Bonney, and is set in Cerrillos, N.M., in 1878. Other popular cast members include Kiefer Sutherland (Doc Scurlock), Lou Diamond Phillips (Chavez y Chavez), Charlie Sheen (Dick Brewer), Dermot Mulroney ("Dirty Steve" Stephens), and Casey Siemaszko (Charley Bowder). Directed by Christopher Cain, *Young Guns* features boys who are taken off the streets, fed, and educated and who then work for their benefactor, John Tunstall (Terence Stamp). *Young Guns* and its sequel celebrate the rough-and-ready, nearly penniless cowboy. For example, Scurlock says without any sense of irony, "This country needs a hero," and sets out to become one.

Legends of the Fall (1994) is rarely included in lists of romantic Westerns because it is essentially a tragedy; furthermore, it is not included in lists of films that deal with blue-collar laborers because it features a wealthy landowner. However, it merits mention here because *Legends of the Fall* elevates the heroic virtues common to the romantic Western and features three sons, two of whom represent opposite ends of the economic continuum. Tristan Ludlow (Brad Pitt) does not renounce his father's wealth, but for many years he works as a bootlegger, a rancher, and a sailor. His brother Alfred Ludlow (Aidan Quinn) is a businessman and politician. Directed by Edward Zwick and based upon a novella by Jim Harrison, the film attaches a higher moral sensibility to those who engage in hard labor.

None of the realistic, revisionist, or romantic films briefly cited in this study rivals *Brokeback Mountain* (2005) or *No Country for Old Men* (2007), which challenge the themes and plot lines of traditional Western films in stark and transforming ways.

Brokeback Mountain (2005)

The plight of the blue-collar cowboy is nowhere more evident than in Ang Lee's *Brokeback Mountain*, which, as it challenged established definitions of masculinity and heteronormativity in the American West, also addressed issues of class in rural Wyoming in 1963.

Based on Annie Proulx's short story, the film script by Larry McMurtry and Diana Ossana introduces Jack Twist and Ennis del Mar, who are notable not only because of their emotional need for and physical attraction to one another but because of their determination to gain property and ascend to the middle class.

Economic limitations impede both 19-year-old men, who have little education and few job skills. Author of *On Brokeback Mountain: Meditations*

about Masculinity, Fear, and Love in the Story and the Film, Eric Patterson
focuses primarily on the men's sexual orientation during a time when
conformity to established attitudes and traditions prevailed. But Patterson
also addresses the class issues that thwart Jack and Ennis:

> Ennis has grown up even poorer than Jack...The movie emphasizes Ennis's poverty
> even more than does the story; it's clear from the text that when they meet both he
> and Jack have trucks, but in the movie, Ennis hitchhikes into Signal to get to the
> Farm and Ranch Employment Agency trailer, one change of clothes in a paper gro-
> cery sack. Jack's pickup is a junker that keeps breaking down, but Ennis is on foot.
> (2)

Although Patterson's central concern is the manner in which the protago-
nists struggle to understand their love for one another, he also addresses the
class struggle implicit in the film and the way in which bisexual and gay men
often ostracize men of lower income levels. Class issues divide men, Patter-
son argues, even though men are perceived to control the majority of the
nation's wealth. Discussing the allure of the middle class, he writes:

> For every poor boy who makes it, whose ship eventually really does come in, allow-
> ing him to claim to belong to the middle class, there are many others in America
> who never do, though the dream of success continues to dangle in front of them,
> keeping them working hard for other men in the hope that someday they'll make it
> after all. (3)

Ironically, even though the gay community might disparage men of the
lower class, they emulate how they dress, perhaps because they consider the
attire rugged and masculine. Patterson writes that gay men often appropriate
"strongly masculine styles": The preferred look is "based in part on the
modes of self-presentation among working class American men—including
rural Westerners—with boots, jeans, flannel shirts, and facial hair, celebrat-
ing the masculine appearance that the dominant culture naively assumed
excluded the possibility of same-sex attraction" (62).

Although middle- and upper-class gay men might want to dress like blue-
collar cowboys, they do not want to live without the accoutrements they
enjoy. Patterson suggests that the "supposed sexual prowess of working-class
men that had particular appeal to many middle-class men" (62) became
fashionable, although gay working-class men and some gay men of color
continue to experience the gay community as "inhospitable" (xxvi). The
suggestion that a disenfranchised community ostracizes others—practicing
the very discrimination that adversely affects them—is troubling. "Despite
the idealization of a working-class 'look,' urban gay society continued to be

marked by prejudice against men from rural and working-class backgrounds and men who did manual and service jobs" (62), Patterson says.

In addition to Western clothing, gay men appreciate other aspects of the cowboy image. For example, those who live off the land may "betray a distrust and a dislike of authority" (106). Furthermore, the cowboy hero is far from perfect: he is sometimes violent, often drinks to excess, curses, and sleeps with women without necessarily committing to them (106). Although Patterson doesn't suggest that gay men are violent, drink too much, curse, or take sexual involvement lightly, he does seem to think that, historically, the cowboy has symbolized independence and rebellion.

Also, the solitary life led by cowboys in popular culture and their "lack of domestic ties" appeal to gay men, Patterson says. However, he cautions that a "cowboy's independence, self-reliance, and self-control" and his "aggressive, competitive attitude" hurt his chances to build a supportive community. Patterson argues that cowboy culture—which involves "many poor men working hard on their own...tends to divide men from each other and to prevent collective action" (107). Specifically, the "stoicism and silence" (107) of a John Wayne figure can isolate men—whether they are gay or straight.

In his analysis of *Brokeback Mountain*, Patterson emphasizes the efforts Jack and Ennis make to earn money ranching while they battle the elements. They do not fear hard work. They don't want to live in trailers or remain poor and under someone else's control. Their dreams include buying and managing a ranch and providing for others. Patterson understands that media create and sustain the image of the blue-collar cowboy and that the everyday reality of their lives was and remains far different from the legend. They do manual work for bosses who may not respect them, and their independence comes at the price of a home and family. He writes:

> Also, the life of the "cowboy," as he exists in literature and film, with his freedom to roam the frontier and to defend white settlers, is very different from the actual experience of the men who did the hard, poorly paid work of tending cattle in the West for those who controlled the cattle industry in the decades following the Civil War. Rather than being shaped by lone adventurers on horseback, the development of the West was shaped by those with capital to invest. (108)

As noted in the essay that follows, "From the Wilderness into the Closet: *Brokeback Mountain* and the Lost American Dream," *Brokeback Mountain* juxtaposes the wilderness with settled communities, wild animals with civilized townspeople, the poor with the privileged, the uneducated with the intellectually elite, women with men, rural life with city life, the innocent

with the corrupt, and gays, lesbians, and bisexuals with their heterosexual
family members, neighbors, and friends. Although the text challenges what
we think we know about sexual orientation, it also depicts the struggle
between what is expected and what is possible, between what we long for
and what we actualize, between what we dream and what is.

Brokeback Mountain shares with other Western films a portrayal of mas-
culinity, cowboys as central characters, and a regional setting. It also shares
with *Midnight Cowboy, Butch Cassidy and the Sundance Kid, Unforgiven,*
and other Westerns that rely upon *bildungsroman* an understanding of how
fated we are, how limited by the places and people we know, how devastated
by our own fear. Richard Corliss calls the film "slow and studied": "The
movie is heartbreaking because it shows the hearts of two strong men—and
their women—in the long process of breaking" (62).

Jack Twist and Ennis del Mar struggle with class issues and dream of
owning a ranch together. For Ennis in the final scene of *Brokeback Moun-
tain*, the future is a window looking out onto an open field. A treasured
postcard of the past that is taped to the inside of his closet door reminds us
that the possibility of a life lived large under the wide Wyoming sky has
ended in isolation and despair. Sexual relationships between men in the
American West are difficult to chronicle or quantify, but Proulx's revisionist
narrative affirms that men cared deeply for and relied upon one another.

No Country for Old Men (2007)

Another film that undercuts the traditional Western is *No Country for Old
Men*. Winner of Academy Awards for "Best Picture," "Best Director," Best
Writing," and "Best Supporting Actor" (Javier Bardem), it has been called an
allegory, a comedy, film noir, a horror film, and a Western. Narrated by Ed
Tom Lee (Tommy Lee Jones) through stream of consciousness, *No Country
for Old Men* is a dark description of the evil that permeates our lives and an
argument for compassion and positive intervention in the lives of others. As
Dennis Cutchins writes, "*No Country for Old Men* may be a reverie on evil,
but it is also an explanation for the necessity of grace and charity and the
importance of agency" (169). The absence of a musical score makes the
dialogue and the action sequences even more portentous.

Considering himself an "instrument" of some dark purpose, Anton Chi-
gurh (Javier Bardem) pursues Llewelyn Moss (Josh Brolin), who came upon
a drug deal gone bad and appropriated a briefcase full of cash. During
Chigurh's pursuit, he kills several people, sometimes without apparent
motive and always without pleasure. Numerous scholars comment on

Chigurh and his role in *No Country for Old Men*. For example, Linda Woodson describes Chigurh as an "instrument of determined consequence" (7) who "exists outside of moral responsibility altogether" (8). Jim Welsh writes that Chigurh exhibits "behavior governed by a code that has its own cryptic logic, making him an apparently unbending agent of a fatality that itself seems irrational" (80). Another scholar, John Cant, writes that Chigurh believes his judgment to be "absolute":

> He is indomitable, all-seeing, and entirely without humor or sexuality. He kills without emotion, men and women alike. Drug runners, other hit men, policemen, motel desk clerks, corporate executives, someone who insults him in a bar, motorists encountered by chance—all are one to him. The only way to survive an encounter with him is by the toss of a coin—in other words, by chance. (55)

In both the novel by Cormac McCarthy and the film, Chigurh subjects two people to a coin toss: the winner keeps his life; the loser dies. In a film that deals starkly with the ways in which chance determines much of our lives, the coin tosses are revelatory and terrifying. In the first scene, Chigurh stops at a gas station in the middle of West Texas. Behind the counter is an older gentleman (Gene Jones), who is polite to a fault. Having never confronted the personification of evil, he muddles through his conversation with Chigurh as best he can:

Chigurh: "What's the most you ever lost in a coin toss?"
Station owner: "Sir?"
Chigurh: "The most you ever lost in a coin toss?"
Station owner: "Oh, I don't know. Couldn't say."
Chigurh: "Call it."
Station owner: "Call it? For what?"
Chigurh: "Just call it."
Station owner: "Well, we need to know what we're calling it for here."
Chigurh: "You need to call it. I can't call it for you. It wouldn't be fair."
Station owner: "I didn't put nothing up."
Chigurh: "Yes, you did. You've been putting it up your whole life. You just didn't know it. You know what date is on this coin?"
Station owner: "No."
Chigurh: "It's 1958. It's been traveling twenty-two years to get here. Now it's here and it's heads or tails. Now, you have to call it."
Station owner: "Now, I need to know what I stand to win."
Chigurh: "Everything. You stand to win everything. Call it."

After the man flips the coin and calls it correctly, Chigurh stops him from putting the coin in the cash register or in his pocket:

Chigurh: "Don't put it in your pocket. It's your lucky quarter."
Station owner: "Where do you want me to put it?"
Chigurh: "Anywhere not in your pocket—where it will get mixed in with the others and will become just a coin...which it is."

Chigurh recognizes that the coin is just a coin, but he invests both the coin and the coin toss with meaning. He behaves as though he has been chosen by God for a special mission (It is this behavior that leads numerous critics to compare Chigurh to The Misfit in Flannery O'Connor's "A Good Man Is Hard to Find"). Later in the film, he visits Carla Jean Moss (Kelly Macdonald) and asks her to flip a coin. "The coin don't have no say," Carla Jean tells him. "It's just you." "Well, I got here the same way the coin did," says Chigurh, cryptically, suggesting that everything in life is a matter of chance and that he is powerless against his own destiny.

Chigurh's antithesis is Ed Tom Bell, a thoughtful man too often belittled by critics who find his homespun wisdom simplistic. Woodson contrasts how the two treat birds in the novel: "Bell gently moves the dead redtail hawk out of traffic so that its body won't be desecrated further." Chigurh, on the other hand, "seeing a large white bird, shoots at it to test his silencer" (10).

Ed Tom Bell is an Everyman, whose fears represent those of the reading and viewing audience. He wonders about the role chance plays in human life. As he and his deputy come upon another of Chigurh's victims, his deputy says, "Wasnt what the old boy had in mind when he left Dallas I dont reckon, was it?" "No...I'd guess it was about the farthest thing from his mind" (69), Bell responds. Bell's reminiscence introduces the novel and the film. In the film, he talks about the mystery of evil let loose in the world:

> He kilt a fourteen-year-old girl. Papers said it was a crime of passion but he told me there wasn't any passion to it. Told me that he'd been planning to kill somebody for about as long as he could remember. Said that if they turned him out he'd do it again. Said he knew he was going to hell. "Be there in about fifteen minutes." I don't know what to make of that. I surely don't. The crime you see now, it's hard to even take its measure. It's not that I'm afraid of it. I always knew you had to be willing to die to even do this job. But, I don't want to push my chips forward and go out and meet something I don't understand.

Coming to the end of his career, the sheriff tries to understand the meaning of life and the purpose of his dedicated career. Realizing he is overmatched by the evil embodied in Chigurh, he questions the very nature of human violence:

> I read the papers ever mornin. Mostly I suppose just to try and figure out what might be headed this way. Not that I've done all that good a job at headin it off. It keeps gettin harder. Here a while back they was two boys run into one another...And then they set out together travelin around the country killin people. I forget how many they did kill. Now what are the chances of a thing like that? Them two had never laid eyes on one another. There cant be that many of em. I dont think. Well, we dont know. Here the other day they was a woman put her baby in a trash compactor. Who would think of such a thing? (40)

In another rumination, Ed Tom Bell reads a story about a couple that tortured and murdered people:

> What I was sayin the other day about the papers. Here last week they found this couple out in California they would rent out rooms to old people and then kill em and bury em in the yard and cash their social security checks. They'd torture em first, I dont know why. Maybe their television was broke. Now here's what the papers had to say about that. I quote from the papers. Said: Neighbors were alerted when a man run from the premises wearin only a dogcollar. You cant make up such a thing as that. I dare you to even try. (124)

During one of his social commentaries, Ed Tom Bell critiques the behavior of young people, suggesting that a loss of manners in the society is the beginning of the end: "It starts when you begin to overlook bad manners. Any time you quit hearin Sir and Mam the end is pretty much in sight" (304). Woodson suggests that for Sheriff Bell, the "absence of manners in our world represents the placing of self-interest before the feelings of others" (8).

Set in Albuquerque, Las Vegas, Mexico, Santa Fe, and Texas in 1980, *No Country for Old Men* is the 12th film by Joel and Ethan Coen. Central to the film is Llewellyn Moss, whose dead-end life in a trailer in West Texas compels him to put himself and his wife at risk. Stealing the money sets the plot into motion and dooms him.

Like *Unforgiven*, *No Country for Old Men* parodies the traditional Western, but the comparison ends there. According to Robert Jarrett, Chigurh is the "symbol of a postmodern American apocalypse" (71), which puts *No Country for Old Men* into a category of Western cinema all its own. As Pat Tyrer and Pat Nickell write:

> The three central characters, Ed Tom Bell, Llewelyn Moss, and Anton Chigurh, seem to be remnants of the Old West. Each man represents a watered-down version of a familiar Western character: the local lawman who maintains order and dispenses justice; the opportunistic, but basically solid citizen who succumbs to temptation; and the outlaw who lives by his gun. However, in both novel and film these contemporary western characters have faded into shadows of their original forms. (86)

Tyrer and Nickell suggest that Ed Tom Bell's words at the end of the film also deconstruct Western mythology, arguing that his statements are "colored by his own subconscious recognition that the myth of a heroic West has been exposed as a dream" (91).

Conclusion

The rocky cliffs, open skies, and heroic figures of the Western film insure the ongoing success of the genre. As filmmakers both undercut and reify iconic cowboys, villainous landowners, formidable outlaws, and damsels in distress, films set in the American West continue to entertain and provoke audiences here and abroad. And if the past is any guide, the blue-collar cowboy will remain, and his poverty will fade into the desert landscape, no more and no less relevant than a tumbleweed. But as Paul Varner reminds us, "Real cowboys of old were low-paid, migrant agricultural laborers" (58).

In *Kill the Cowboy: A Battle of Mythology in the New West*, Sharman Apt Russell deconstructs some of the legends the Western film has made popular. Most importantly, she reminds us that the work cowboys do is not glamorous or lucrative. "So few Americans want the lonely job of herding cattle or sheep at $800 a month, plus room and board, that foreign workers are hired to fill the shortage" (2), she writes. In addition to the overwhelming poverty they face, cowboys are not as carefree and independent as traditional narratives suggest, nor do they necessarily live closer to animals, the land, or other people. Russell writes:

> Cowboys are intimate with wildlife in the sense that they must control its activity and growth. They are intimate with the horses they break and castrate. They are intimate with the cows they protect in order to market. They are intimate with the land they seek to tame. Theirs—critics say—is the intimacy of oppression. (4)

Engaging in what Russell calls the life of the "branding iron, whip, and spur" (149) is not financially rewarding, nor is it necessarily emotionally fulfilling. Even in the 21st century, it is a brutal and dangerous existence. Because of the lack of water and the often substandard grazing land, the 11

major Western states produce only 20 percent of the nation's beef (6), Russell writes, making the work of raising cows and moving them to slaughterhouses physically demanding and less-than-lucrative work.

From the knights of medieval times to the Spanish *vaqueros* to Llewellyn Moss, Will Munny, and Jack Twist, images of blue-collar cowboys change and remain constant. As Indick writes:

> The old motifs of Western expansionism, alcoholism, violence, and racism are giving way to stories about gay cowboys *(Brokeback Mountain)* and independent single mothers *(The Missing)*. Nevertheless, the archetypal themes that the Western setting represents—independence, isolationism, and individualism—remain the primary forces behind the genre. (195)

These "primary forces" endure, and the image of a lone cowboy facing dust storms, rushing rivers, hostile outlaws, and stampedes shows no signs of vanishing.

The fact that cowboys were uneducated, poorly paid, and rarely chased outlaws or carried firearms is for some less important than the enjoyment the legends provide. However, it is worth remembering that the fictions we tell ourselves are innocuous only if we remember the truth behind them. As Annie Proulx said about two of her favorite characters, Jack Twist and Ennis del Mar, "both wanted to be cowboys, be part of the Great Western Myth, but it didn't work out that way" ("Getting Movied," 130).

Works Cited

Appaloosa. Dir. Ed Harris. New Line Cinema, 2008.

The Assassination of Jesse James by the Coward Robert Ford. Dir. Andrew Dominik. Warner Bros., 2007.

Brokeback Mountain. Dir. Ang Lee. Focus Features, 2005.

Cant, John. "Oedipus Rests: Mimesis and Allegory in *No Country for Old Men*." *No Country for Old Men: From Novel to Film*. Ed. Lynnea Chapman King, Rick Wallach, and Jim Welsh. Lanham, Md.: Scarecrow, 2009. 46–59.

Corliss, Richard. "How the West Was Won Over." *Time*. 30 Jan. 2006: 60–63.

Cutchins, Dennis. "Grace and Moss's End in *No Country for Old Men*." *No Country for Old Men: From Novel to Film*. Ed. Lynnea Chapman King, Rick Wallach, and Jim Welsh. Lanham, Md.: Scarecrow, 2009. 155–72.

"Getting Movied." *Brokeback Mountain: Story to Screenplay*. By Annie Proulx, Larry McMurtry, and Diana Ossana. New York: Scribner, 2005. 129–38.

Indick, William. *The Psychology of the Western: How the American Psyche Plays Out on Screen*. Jefferson, N.C.: McFarland, 2008.

Jarrett, Robert. "Genre, Voice, and Ethos: McCarthy's Perverse 'Thriller.'" *No Country for Old Men: From Novel to Film*. Ed. Lynnea Chapman King, Rick Wallach, and Jim Welsh. Lanham, Md.: Scarecrow, 2009. 60–72.

King, Lynnea Chapman, Rick Wallach, and Jim Welsh, ed. *No Country for Old Men: From Novel to Film*. Lanham, Md.: Scarecrow, 2009.

Legends of the Fall. Dir. Edward Zwick. TriStar Pictures, 1994.

Lone Star. Dir. John Sayles. Columbia Pictures, 1996.

Lusted, David. *The Western*. New York: Pearson Longman, 2003.

McCarthy, Cormac. *No Country for Old Men*. New York: Alfred A. Knopf, 2008.

McVeigh, Stephen. *The American Western*. Edinburgh: Edinburgh University Press, 2007.

The Missing. Dir. Ron Howard. Columbia Pictures, 2003.

No Country for Old Men. Dir. Joel Coen and Ethan Coen. Miramax, 2007.

Patterson, Eric. *On Brokeback Mountain: Meditations about Masculinity, Fear, and Love in the Story and the Film*. Lanham, Md.: Lexington Books, 2008.

Poniewozik, James. "Lone Gunman." *Time*. 15 March 2010: 54.

Russell, Sharman Apt. *Kill the Cowboy: A Battle of Mythology in the New West*. New York: Addison-Wesley, 1993.

Silverado. Dir. Lawrence Kasdan. Columbia Pictures, 1985.

The Three Burials of Melquiades Estrada. Dir. Tommy Lee Jones. EuropaCorp, 2005.

3:10 to Yuma. Dir. James Mangold. Lionsgate, 2007.

Turner, Ralph Lamar, and Robert J. Higgs. *The Cowboy Way: The Western Leader in Film, 1945–1995*. Westport, Conn.: Greenwood, 1999.

Tyrer, Pat, and Pat Nickell. "'Of what is past, or passing, or to come': Characters as Relics in *No Country for Old Men*." *No Country for Old Men: From Novel to Film*. Ed. Lynnea Chapman King, Rick Wallach, and Jim Welsh. Lanham, Md.: Scarecrow, 2009. 86–94.

An Unfinished Life. Dir. Lasse Hallström. Miramax, 2004.

Unforgiven. Dir. Clint Eastwood. Warner Bros., 1992.

Varner, Paul. *Historical Dictionary of Westerns in Cinema*. Lanham, Md.: Scarecrow, 2008.

Welsh, Jim. "Borderline Evil: The Dark Side of Byzantium in *No Country* for *Old Men*, Novel and Film." *No Country for Old Men: From Novel to Film*. Ed. Lynnea Chapman King, Rick Wallach, and Jim Welsh. Lanham, Md.: Scarecrow, 2009. 73–85.

Woodson, Linda. "'You are the battleground': Materiality, Moral Responsibility, and Determinism in *No Country for Old Men*." *No Country for Old Men: From Novel to Film*. Ed. Lynnea Chapman King, Rick Wallach, and Jim Welsh. Lanham, Md.: Scarecrow, 2009. 1–12.

Young Guns. Dir. Christopher Cain. 20th Century Fox, 1988.

Chapter Seven

From the Wilderness into the Closet:
Brokeback Mountain and the Lost American Dream

In the film *Brokeback Mountain*, Ennis Del Mar (Heath Ledger) tells Jack Twist (Jake Gyllenhaal), "I ain't queer." Twist responds, "Me neither." With those faltering but defiant words begins a pilgrimage into an internal wilderness at least as terrifying, as uncharted, and as destabilizing as the one initiated by early explorers of the American West. Like the medieval quests upon which much of Western literature is based, this particular epic journey for self-knowledge will end in paralyzing loss.

Overwhelmingly, viewers and readers who have engaged the film and the short story from which it is drawn have interpreted the texts primarily as challenges to heterosexual norms. While they are correct in doing so, the texts succeed for reasons that are largely unrelated to sexual orientation. They succeed not only because they challenge preconceptions about gender identity but because they force us to contend with the fears and limitations that make our being able to choose a richer, more passionate, more imaginative life impossible. The possibility of a rich, restorative, and expressive life spent in the Wyoming wilderness comes to nothing; instead, in the final scene of the film one of the central characters stands silently in the closet of his trailer.

Set in Texas and Wyoming and shot in Alberta, *Brokeback Mountain* is a tale propelled by contradictions, oxymorons, paradoxes, and oppositions. Drawn from Annie Proulx's short story by the same name, *Brokeback Mountain* juxtaposes the wilderness with settled communities, wild animals with civilized townspeople, the poor with the privileged, the uneducated with the intellectually elite, women with men, rural life with city life, the innocent with the corrupt, and, yes, gays, lesbians, and bisexuals with their

heterosexual family members, neighbors, and friends. However, the landscape of *Brokeback Mountain* is endlessly suggestive, and its heteronormativity is but one stop on the journey. Although the text does, in fact, challenge what we think we know about sexual orientation, it more importantly becomes the site of a struggle between what is expected and what is possible, between what we long for and what we actualize, between what we dream and what is.

If considering how we prevent ourselves from achieving what we most desire is not unsettling enough, *Brokeback Mountain* goes beyond even that, suggesting that we have a responsibility to ask ourselves why we make decisions that provide safety, security, familiarity, and responsibility even when they deprive us of joy. Viewers and readers don't have to be gay, lesbian, or bisexual in order to recognize the miles that separate life in a dingy kitchen—with clothes left in heaps on the floor, with a sink full of dirty dishes, and with weeping children demanding attention—from joyous fulfillment. In a particularly powerful scene in the film, Jack and Ennis leave stultifying domesticity behind and leap from a ledge into icy waters, shouting, intimately connected, and fully alive.

Jack fantasizes about a "sweet life" and tells Ennis, "You know, it could be like this—just like this—always." In this simple statement, we engage universal themes of need and longing and desire. When Ennis responds by saying that there is "no way" two men can live together and then utters the now-famous line—"If you can't fix it, Jack, you've got to stand it"—readers and viewers must contend with whether the situation cannot be "fixed" or whether Ennis lacks the will or the template to "fix" it (and whether we lack that will or template, too). That Ennis' life experience has not prepared him for the possibility of loving a man—that the cultural discourse has not given him language for his desire—makes choosing Jack impossible for him to imagine. But the choice is not impossible, joy is not forbidden, and life does not have to end in a trailer on the edge of the dream.

The open, verdant Western landscape of *Brokeback Mountain* stands in stark contrast to the apartments and strip malls and bars of the town in which Ennis and Alma (Michelle Williams) make their life together. Brokeback Mountain looms, mythic and majestic and impenetrable, a 14-hour drive and a universe away from rodeos and a Texas ranch where Jack and Lureen (Anne Hathaway) are raising their son.

The film disturbs and unsettles us, not simply because it suggests that love between two men is as rich and as viable as love between a woman and a man but because it demands that we confront the lives we could have lived if we had crossed the invisible divides that separate us from ecstasy and the fulfillment of our deepest desires. *Brokeback Mountain* demands that we

consider the societal paradigms that help us to define ourselves at the same time that they limit, constrain, and immobilize us.

The tragedy of the tale is not that Jack is dead—killed as he changed a tire or murdered by those who despised him for being gay. The tragedy of *Brokeback Mountain* is not death but a long life lived cautiously and guardedly. The tragedy is not having lost one's life but having wasted it. Although set across the continent from the Long Island Sound, *Brokeback Mountain* evokes thoughts of the "last and greatest of all human dreams" and "the transitory enchanted moment" (182) of *The Great Gatsby*. By doing so, *Brokeback Mountain* becomes reminiscent of classic American narratives about profound and enduring loss.

Inevitably, the film has been analyzed for its portrayal of love and sexual expression between two men; lauded for its cinematic accomplishments; celebrated for the universal themes that it addresses; and analyzed for its vision and revision of the mythology of the West. In fact, all of these critical approaches enrich a study of the lost American dream in *Brokeback Mountain* by reminding us that love and passion are not restricted to heterosexual couples; that a film about two men in love can be compelling and artful; that a text fails or succeeds because of the emotions it evokes; and that unreliable stereotypes of the vanished West include not only savage Native Americans and kind-hearted prostitutes but cowboys without emotion and without an ability to express themselves through language and through touch.

The Portrayal of Same-Sex Love

Reviews that followed the release of *Brokeback Mountain* sometimes highlighted the homophobia of journalists and editors. In a statement without support and without context, Sean Smith writes in a review about the Academy Awards published in the March 6, 2006, issue of *Newsweek* that *Brokeback Mountain* "could get a boost if it wins Sunday night, but for some Americans, it seems a same-sex love story is still too much, no matter how many trophies it wins" (8). And under a photo of Ledger and Gyllenhaal in the Jan. 30, 2006, issue of *Time* magazine is the following phrase: "exactly the type of scene most straight guys usually don't want to see" (60). What follows the phrase is an analysis of gay themes in *Brokeback Mountain* entitled "How the West Was Won Over."

Even if we allow for editors who need to find a clever phrase to captivate readers ("How the West Was Won Over") and if we allow for the straight men in America who might not want to see two straight actors portraying

same-sex desire, it still bears asking: Why would one of the nation's top-selling news magazines suggest that a photo of two men fully dressed and standing close together is "exactly the type of scene" that heterosexual men would find offensive? Why would the editor then add "most straight guys," as though she or he has conducted a reliable poll? And, finally, why would the editor include the qualifier "usually?" Are there "unusual" times during which straight men might be open to a narrative about same-sex love?

In the phrase "exactly the type of scene most straight guys usually don't want to see" lies the first topic of importance to this study: Are "straight guys" presumed to be homophobic? Are they expected to be homophobic and therefore considered unlikely to attend *Brokeback Mountain* either alone or with a group of other "straight guys"? Are they both homophobic and expected to be homophobic? Is it true that most men who attended the film in the company of women are more open to the idea of same-sex desire, as some critics suggest? The answer to these questions must be, "We don't know," followed immediately with the acknowledgment that *Brokeback Mountain* enjoyed significant box office success and critical acclaim in spite of contemporary stereotypes about gay and heterosexual men.

Certainly, *Brokeback Mountain* is not the only successful and widely distributed "gay film." *The Crying Game* (1992) netted $63 million; *Philadelphia* (1993) netted $77 million and earned Tom Hanks his first Oscar; *The Birdcage* (1996) netted $124 million. William Hurt won "Best Actor" for his portrayal of a gay prisoner in *Kiss of the Spider Woman* (1985) and Hilary Swank won her first Academy Award for her portrayal of a transsexual character in *Boys Don't Cry* (1999).

According to *USA Today*, by Feb. 12, 2006, more than 12 million Americans had seen *Brokeback Mountain*, and the film had taken in $72 million. *Brokeback Mountain* led other films released in 2006 with eight Academy Award nominations and was widely regarded as the favorite to win the Oscars for "Best Picture" and "Best Director." The film also earned more than the other films nominated for "Best Picture" in 2006: During the month before the Academy Awards, *Crash* had earned $53.4 million; *Munich*, $45.4 million; *Good Night, and Good Luck*, $29.3 million; and *Capote*, $22.1 million (2A).

Certainly, box office and critical successes are not the only measures of a film's impact. Some critics suggest that the import of *Brokeback Mountain* actually will be determined individually—in private living rooms during private screenings. Poignantly enough, one such person is Judy Shepard, mother of murdered college student Matthew Shepard. Shortly before his 1998 death, Matthew gave his mother a copy of the story that inspired the film. She suggested that when viewers could rent *Brokeback Mountain* and

view it alone, they would understand its message: "I think they'll see it how I see it," Shepard said, "as a story that's trying to say that you can't help who you fall in love with. If it opens just a few eyes to that, then it's done a good thing" (Bowles 2A). Both the Gay and Lesbian Alliance Against Defamation (GLAAD) and the Human Rights Campaign, organizations that advocate equality for all people, seem to agree with her. GLAAD provided an online resource guide to accompany the film, and through press releases and other efforts, the HRC widely encouraged small group discussion of the issues in the film. (The importance of the film to conversations about gay rights is suggested by the fact that director Ang Lee won an "Equality Award" from the HRC in New York in the spring of 2006.)

For some, focusing on the controversy the film was certain to ignite was largely a marketing ploy. In "Backbreaking Bid to Create a Controversy" (Dec. 28, 2005), Neil G. Giuliano, the former mayor of Tempe, Ariz., and the president of GLAAD, argues that Americans are much more open to the idea of same-sex love than stories about the release of *Brokeback Mountain* indicated. In the article published by *The Arizona Republic*, he writes:

> Boy, how we love a story that divides. So in addition to the near unanimous ac-
> claim this movie has received, we're encouraged by the nation's leading newspapers
> and television news outlets to ponder, "Is America ready for this film?"
> Was America "ready" for *Guess Who's Coming to Dinner* or *Philadelphia?*
> Why does America need to be ready for any film? It's a movie, not a mandate. If you
> want to see an original, powerful and emotionally authentic love story, go see it. If
> not, go shopping. (n.p.)

Whether *Brokeback Mountain* will have lasting impact on attitudes about gay, lesbian, bisexual, and transgender people in America is impossible to know, of course. In an article published in *USA Today*, Scott Bowles writes: "The film is the punch line of jokes, the subject of Internet parodies and the front-runner for the Oscars on March 5. Oprah plugged the gay-cowboy drama on her show. Howard Stern gave it a thumbs up. 'Have you seen *Brokeback?*' has become a dinner-party Rorschach test of gay tolerance." In addition to Bowles's suggestion that whether one does or does not see the film is a "test of gay tolerance," the subhead of the article—entitled *"Broke-back Mountain:* Milestone or Movie of the Moment?"—is, "Film's success signals shift in attitudes toward gays—or maybe it's just marketing" (1).

But the focus of this study is not whether the film grossed more than oth-er films it competed against or whether it altered the cultural landscape in New York City or Dubuque, Iowa. Instead, this study deals with the fact that one reason a dream can be lost—one reason Ennis was unable to break out of his emotional and intellectual prison—is that the film *Brokeback Mountain* is

still a phenomenon; that passionate, sexual love between men is still consid-
ered an anomaly; and that sex between two heterosexual actors is treated by
at least one editor as "exactly the type of scene most straight guys usually
don't want to see."

In "A Picture of Two Americas in *Brokeback Mountain*," Stephen
Hunter writes, "It's hard to argue that the movie constitutes any kind of
threat, or pro-gay propaganda. For one thing, there's too much authentic pain
in it, it's too bloody sad." At the same time, though, he argues that Lee
speaks "louder with images than most of his ideological opponents do in
words." Clearly, the second sentence undercuts the first by suggesting that
the film is a loaded love story—a story about genuine affection that serves a
political purpose and advances the cause of gay-rights groups and of the
LGBT community itself. Although Hunter celebrates being gay by associat-
ing it with a river ("It's a great torrent of nature, which cannot be controlled
and which provides sustenance, nurture, satisfaction, joy"), he also claims the
film is "cruel to family": "It seems to think family is a bourgeois delusion."

The problem with these conflicting contentions is that, of course, the film
is not the enemy of heterosexual life in America, any more than gay, lesbian,
bisexual, and transgender people are. In fact, Jack longs to live with Ennis, to
be near his mother and father, and to work a ranch, but this desire—rooted in
tradition and American family values—is denied to him. The dream Jack
loses is one that sustains heterosexual couples who rarely have to think about
the privilege of living with one another, of rearing children, of filing taxes
jointly, of demonstrating affection toward one another publicly, etc. Hunter is
closer to the truth of *Brokeback Mountain* when he says that Jack and Ennis
are forced to "genuflect before the stations of the cross of heterosexual
culture: marriage, family, responsibility." It is not that they don't want what
heterosexual couples take for granted; instead, they are forced to validate a
way of life others seek to deny to them.

The film doesn't ridicule heterosexual privilege by juxtaposing sounds of
crying children and unkempt houses with the freedom of the wilderness, but
the conflicting images force a primarily heterosexual audience to consider the
fulfillment implicit in being able to live in a way consistent with who they
are and whom they love. While it is true that the images of heterosexual life
in *Brokeback Mountain* are "impoverished, constrained, dysfuctional" and
that, too often, "family life, home life, breeder life" serve "as a gestalt of
impoverishment and stark, comfortless angularity," as Hunter argues, it is
heterosexual life that is considered normal. And it is heterosexuals who often
deny to gay, lesbian, bisexual, and transgender people the rights they covet,
passing state laws that prevent some of their family members, neighbors, co-
workers, and others from marrying legally, from adopting children, and from

enjoying a relationship sanctioned by law. Jack and Ennis are prevented by both their own decisions and by societal constraints from realizing the full promise of their love for one another. They seek the wilderness because it allows them to express their passion; what they leave behind temporarily are the vestiges of unhappy heterosexual family life.

The Cultural Legacy of the Film

If homophobia and a lack of understanding of marginalized people help to explain adverse reaction to *Brokeback Mountain* and help to prevent Ennis and Jack from pursuing a life together, it is reasonable to argue that the more often sympathetic portrayals exist in popular culture and elsewhere, the more likely that attitudes will change. "In three-time Oscar winner *Brokeback Mountain*, Ennis Del Mar and Jack Twist fall in love in the wide open spaces of Wyoming," reads the introduction to "The Director's Cut," an interview with Lee *(Crouching Tiger, Hidden Dragon* and *Sense and Sensibility)* published in *Equality: News about GLBT America.* "Their quiet, simple story moved audiences in theaters everywhere and soon exploded into one big cultural conversation" (6).

Part of the reason for the "big cultural conversation" is the talent of the director; the ability of writers Larry McMurtry and Diana Ossana; and the understated but intense performance by Ledger *(10 Things I Hate About You, The Patriot, A Knight's Tale, Lords of Dogtown,* and *Monster's Ball),* a performance lauded by critics such as Belinda Luscombe in the Nov. 28, 2005, *Time* magazine review entitled "Heath Turns It Around." Gyllenhaal and Michelle Williams *(Dawson's Creek)* also received accolades for their roles.

Although *Crash* beat *Brokeback Mountain* for "Best Picture" on Oscar night, *Brokeback Mountain* won "Best Director," "Best Adapted Screenplay," and "Best Original Score." [Other winners that night were Reese Witherspoon ("Best Actress," *Walk the Line);* Philip Seymour Hoffman ("Best Actor," *Capote);* George Clooney ("Best Supporting Actor," *Syriana);* and Rachel Weisz ("Best Supporting Actress," *The Constant Gardener).*] Although *Brokeback Mountain* did not win in all eight of the categories for which it was nominated, the competition among actors was especially strong. In addition to its three Academy Awards, *Brokeback Mountain* also garnered seven Golden Globe nominations during a year when 19 million viewers were estimated to have tuned in. In that venue, *Brokeback Mountain* won for "Best Picture," "Best Director," and "Best Screenplay."

And, finally, the talent behind *Brokeback Mountain* suggests that writers are less concerned about taking on themes that might alienate the public. In addition to Lee, Proulx *(Shipping News)* and McMurtry *(Lonesome Dove)*, both winners of Pulitzer Prizes, were involved with the project. Proulx's story "Brokeback Mountain" first appeared in *The New Yorker* in 1997. It is included in a collection entitled *Close Range: Wyoming Stories* and has been published independently by Scribner. In addition to *Shipping News*, Proulx is author of four novels including *Postcards* and the short story collections *Heart Songs* and *Bad Dirt*. McMurtry has garnered 26 Oscar nominations for film adaptations of his work—including those for *Hud*, *The Last Picture Show*, and *Terms of Endearment*.

One of the themes addressed by the film is the pain of being disenfranchised and of struggling to remain closeted in order to be a part of a community—in this case a heterosexual community that identifies itself as much by who is excluded as it does by who is accepted into its circle. In "The Director's Cut" (subtitled *"Brokeback's* Ang Lee on Jack, Ennis...and Other Outsiders"), Lee explains his commitment to the project and his identification with the central characters by saying, "I think it is very easy for me to identify with outsiders or minorities—that is who I've been all my life. My parents followed the Nationalist Party to Taiwan when their family was executed in China. We were outsiders in Taiwan. Then I came to the States, of course, as an outsider."

The film portrays the two central characters as noble, a characteristic that most assuredly comes from their isolation and the stoic way with which they deal with it. Hired to spend the summer of 1963 on Wyoming's Brokeback Mountain tending sheep, Jack and Ennis are unable to redefine themselves enough to function in the restrictive society in which they have always lived. Both, writes Hunter, are "ranch-bred, horse-proud, sinewy, resourceful, brave, tough, industrious, poorly educated." While this tough cowboy image is certainly one they strive to maintain, the stereotype has its cost: they are stymied as much by their internalized homophobia as they are by the hyper-masculine, heterosexual, family-oriented rural West that surrounds them.

Brokeback Mountain becomes a meta-Western, a film that, in fact, makes viewers reconsider their preconceptions about life in the American West. *Brokeback Mountain* is, as Luscombe writes, an "elegiac western" (66), but it falls into a category far different from the John Wayne classics. Similar to *Midnight Cowboy, Butch Cassidy and the Sundance Kid* and *Unforgiven* in its unflinching critique of Western mythologies, *Brokeback Mountain* is a revisionist film that up-ends the wide-open spaces that are as much a part of the Western genre as cattle rustling. It leaves one hero dead and another

standing in two closets—one in his lover's childhood home and the other in his own trailer.

The film is decidedly a revisionist text, one that forces viewers to question their assumptions about the West, about "real men," about cowboys and ranchers, about small town life, about sexual orientation, and about family life. "Talk about revisionist westerns!" writes Richard Schickel. *"Brokeback Mountain* is, as far as one can tell, the first movie to trace the course of a homosexual relationship between a pair of saddle tramps, doing so in considerable—if discreetly visualized—detail, from first idyllic rapture to angry rupture some 20 years later" (68). Also, because McMurtry wrote the adaptation, *Brokeback Mountain* "focuses, as some of his fiction does, on the modern, anti-romantic West, a place of trailer parks and honky-tonks, of small, thwarted hopes, wrangling wranglers and sweet dreams betrayed by raw reality" (68). Schickel considers the film flawed but celebrates its "assault on Western mythology, its discovery of a subversive sexual honesty in an unexpected locale" (68).

"Queer Eye for the Big Sky," the teaser on the cover of the Jan. 13, 2006, issue of *The Chronicle Review*, is both humorous and suggestive. There are, ultimately, no big skies in this fictional Wyoming. Two men who have conquered their environment—surviving bears, storms, poverty, the elements, etc.—are vanquished by their own forbidden desires. "Queer Eye for the Big Sky" introduces an article by Colin R. Johnson entitled "Rural Space: Queer America's Final Frontier." While probably not in actuality its "final frontier," rural America is admittedly for many one of the least likely places for two men to fall in love and seek to build a life and a home together. An assistant professor of gender studies, history, and American studies, Johnson writes:

> Especially in the wake of Matthew Shepard's brutal murder in 1998 in Laramie, Wyo., but also in light of the poignant sadness at the core of other queer landscape films like *My Own Private Idaho* (1991) and *Boys Don't Cry* (1999), the kind of big-sky rural vistas that Lee captures quite superbly on screen have tended to engender feelings of exposure and vulnerability in lesbians and gay men more than freedom and openness, two symptoms of affective privilege that heterosexual Americans have traditionally felt in connection to the great outdoors though rarely regarded as privilege per se.
> *Brokeback Mountain* refigures that aesthetic association in some important ways. In the story certainly but in the film especially, it is the openness of the landscape that signals a temporary opening in the heteronormative constraints of American masculinity. By contrast, it is the cramped and claustrophobic domestic spaces of Ennis Del Mar's and Jack Twist's marital homes that signal the intrusion of homophobia's stark realities, not to mention a necessary illicitness about same-sex intimacy and desire that comes at the expense of women, namely their wives. Similarly,

it's the deafening silence that Lee's film associates with open spaces that seems to point to the site where intimacy's potential might be realized. Talk, by contrast, maps its very limitations. (B15)

Both the short story and the film are—at their center—about what Luscombe calls "the circumscription of dreams about how fate and our choices make the life we have much smaller than the one we had hoped for" (70). To some extent, a prohibitive, constraining, traditional society is at fault; to some extent, responsibility lies with human beings who underestimate their own agency. In spite of what may have occurred to Jack Twist and what did most certainly occur to Matthew Shepard, being gay does not necessarily end in death or despair. That Jack can see the potential in his relationship with Ennis and that he has the will to actualize it are both a blessing and a curse. He is blessed with passion and courage, but he loves someone who is immobilized and who cannot imagine a life with his lover. Proulx's short story highlights the differences between Jack and Ennis, making Jack somewhat of a visionary and Ennis a man afraid of his own desires. "Jack, in his dark camp, saw Ennis as night fire, a red spark on the huge black mass of mountain" (9), writes Proulx. For Jack, Ennis is the "red spark" on the "huge black mass of mountain" that is his life. For Ennis, though, the relationship is not restorative or hopeful, but terrifying: "As they descended the slope Ennis felt he was in a slow-motion, but headlong, irreversible fall" (17). Moving toward one's "red spark" and fearing an "irreversible fall" are decidedly different reactions to falling in love. "I'm stuck with what I got, caught in my own loop" (29), says Ennis. Meanwhile, Jack, rejected and desperate, says:

Tell you what, we could a had a good life together, a fuckin real good life. You wouldn't do it, Ennis, so what we got now is Brokeback Mountain. Everthing built on that. It's all we got, boy, fuckin all, so I hope you know that if you don't never know the rest...You got no fuckin idea how bad it gets. I'm not you. I can't make it on a couple a high-altitude fucks once or twice a year. You're too much for me, Ennis, you son of a whoreson bitch. I wish I knew how to quit you. (42)

That they cannot "quit" one another is both their salvation—a testament to the power of their attachment—and their ultimate damnation.

Although they do not share a vision of their future, the men agree on the mysterious power of their love and desire for one another. Ennis tells Jack: "Took me about a year a figure out it was that I shouldn't a let you out a my sights. Too late then by a long, long while" (26). Later, he says, "But if you can't fix it you got a stand it. Shit. I been lookin at people on the street. This happen a other people? What the hell do they do?" (30). Jack, too, recognizes the intensity of their attraction to one another: "This ain't no little thing that's

happenin here" (30), he says. And later in the story, Proulx writes, "Jack said he was doing all right but he missed Ennis bad enough sometimes to make him whip babies" (38). The two know that their time together is special and finite: "One thing never changed: the brilliant charge of their infrequent couplings was darkened by the sense of time flying, never enough time, never enough" (39).

What *Brokeback Mountain* shares with other Western films is the selection of cowboys as central characters, the portrayal of masculinity, the decision to locate the action in a particular geographical region, etc. However, perhaps more importantly, it shares with timeless Western classics an understanding of how fated we are, how limited by the places and people we know, how devastated by our own fear. Even so, I would argue that *Brokeback Mountain* may have more in common with *The Great Gatsby* than it does with other classics of the American West. Like *The Great Gatsby*, *Brokeback Mountain* is about an impossible—or at least unactualized— dream. Richard Corliss calls the film "slow and studied": "The movie is heartbreaking because it shows the hearts of two strong men—and their women—in the long process of breaking" (62).

The lost and abandoned dream drives the plot, a plot that depends upon internal action and barely uttered emotion. And it is the lost and abandoned dream that places *Brokeback Mountain* in the company of American films about thwarted hopes, whether those films are set in the American West or not. As F. Scott Fitzgerald writes about Jay Gatsby, "His dream must have seemed so close that he could hardly fail to grasp it." But the dream eluded Gatsby, and Fitzgerald ends his novel with the now-famous line: "So we beat on, boats against the current, borne back ceaselessly into the past" (182). For Ennis in the final scene of *Brokeback Mountain*, the future is a window looking out onto an empty field—and a treasured postcard of the past taped to the inside of his closet door. The possibility of a life lived large under the wide Wyoming sky ends instead in the confining isolation of a trailer.

Works Cited

Bowles, Scott. *"Brokeback Mountain:* Milestone or Movie of the Moment?" *USA Today*. 22 Feb. 2006: 1A–2A.
Corliss, Richard. "How the West Was Won Over." *Time*. 30 Jan. 2006: 60–63.
Fitzgerald, F. Scott. *The Great Gatsby*. New York: Scribner, 1953.
Giuliano, Neil G. "Backbreaking Bid to Create a Controversy." *The Arizona Republic*. 28 Dec. 2005. <http://glaad.org> 29 Dec. 2005.

Hughes, Janice. "The Director's Cut: *Brokeback's* Ang Lee on Jack, Ennis...
and Other Outsiders." *Equality: News about GLBT America* (Spring
2006): 6–7, 9.

Hunter, Stephen. "A Picture of Two Americas in *Brokeback Mountain.*"
Washington Post 2 Feb. 2006. <http://www.washingtonpost.com> 3 Feb.
2006.

Johnson, Colin R. "Rural Space: Queer America's Final Frontier." *The
Chronicle Review*. 13 Jan. 2006: B15–B16.

Luscombe, Belinda. "Heath Turns It Around." *Time*. 28 Nov. 2005: 66–68,
70.

Proulx, Annie. *Brokeback Mountain*. New York: Scribner, 2005.

Smith, Sean. *"Brokeback:* No Hump." *Newsweek*. 6 March 2006: 8.

Chapter Eight

What Happened to Celie and Idgie?: "Apparitional Lesbians" in American Film

Southern literature enthusiasts who attended the films *The Color Purple* (1985) and *Fried Green Tomatoes* (1991) could not help but wonder what had happened to the two central characters. The lesbians whom they had met in the novels had (perhaps not so mysteriously) disappeared. Relying heavily upon ideas introduced by scholars such as John Howard and Terry Castle, this study deals with the transformation of Celie in *The Color Purple* and Idgie Threadgoode in *Fried Green Tomatoes at the Whistle Stop Café* into their film versions; it also analyzes the relationships between Celie and Shug Avery and Idgie and Ruth Jamison and suggests ways that the screenwriters, producers, and directors transformed lesbian desire into friendships that were presumably more acceptable to the public. It also argues that by doing so, they actually may have made subversive themes more obvious.

The purpose of the study is to combine autobiography, lesbian criticism, regional studies, and textual analysis in order to evaluate the contemporary ability of the American public to deal with images of gays and lesbians in mainstream film. Although films such as *Kissing Jessica Stein* (2002) present out lesbians and occasionally appear in mainstream theaters, they have not gained the accolades afforded to *The Color Purple*, which boasted 11 Academy Award nominations, and *Fried Green Tomatoes*, which garnered two. Making the lesbian relationships in *The Color Purple* and *Fried Green Tomatoes* more ambiguous than they were in the novels may have helped to make the films palatable for heterosexual audiences, although we may never know what the reaction would have been had directors Steven Spielberg and Jon Avnet, respectively, acknowledged that the lesbian characters shared not only supportive friendships but sexual relationships. In her book

The Apparitional Lesbian: Female Homosexuality and Modern Culture,
Terry Castle addresses the absence of visibly lesbian protagonists in Ameri-
can film: "The lesbian is never with us, it seems, but always somewhere else:
in the shadows, in the margins, hidden from history, out of sight, out of
mind" (2), Castle writes.

If the filmmakers' decision to omit the sexual relationships of the cen-
tral characters helped to make *The Color Purple* and *Fried Green Tomatoes*
more successful, however, that fact is hardly reassuring to gay and lesbian
moviegoers who long for positive representations, who want to see their lives
portrayed accurately and compassionately on film, and who hope that films
about gays and lesbians will be widely distributed and knowledgeably
reviewed. In a Jan. 10, 1992, review of *Fried Green Tomatoes* published in
the *Washington Post*, Rita Kempley goes to the heart of the matter: "In
Fannie Flagg's novel *Fried Green Tomatoes at the Whistle Stop Café*, Idgie
and Ruth shared a love that dares not speak its name. But in this movie by
Risky Business producer Jon Avnet, they are not lesbians, just really, really
good friends. And Idgie just happens to be fond of brogans. Avnet, debuting
as a director, isn't about to let these heroines out of the closet and into the
mainstream." She argues that with Flagg's consent, Avnet turned the film
into a "parable of platonic devotion." She then writes, "In doing so, he might
also have assured the movie's stars the wider audience they deserve."

Like Kempley, Jennifer Ross Church agues in "The Balancing Act of
Fried Green Tomatoes" that the filmmakers managed to make palatable
numerous subversive themes: "It's a story about a tomboy's life of playing
poker and drinking, defying the Ku Klux Klan, recapturing her lesbian lover
from a violent marriage, and murdering and cannibalizing the husband. How
could a movie that treats these controversial issues be considered family
entertainment, and how could it push to the number one position in video
rentals in February 1993?" Her answer?: "It's a story about two pairs of
women finding strength and solace in their strong friendships" (193). *Fried
Green Tomatoes* in film and video grossed more than $42 million in the year
following its release (193), according to Church, who clearly suggests that
the filmmakers were successful in normalizing the provocative issues in the
film. Like the film, the novel suggests that same-sex love may be "little more
than a youthful crush or a sexual experimenting to be outgrown with child-
hood" (195), Church argues.

Other critics acknowledge that lesbian desire is present between the char-
acters in both *The Color Purple* and *Fried Green Tomatoes*, but at minimum
the relationships are left ambiguous enough for audiences to interpret them in
whatever ways they choose. Roger Ebert states in a Dec. 20, 1985, review of
The Color Purple that "the relationship between Shug and Celie is a good

deal toned down from the book," and in a Jan. 10, 1992, review of *Fried Green Tomatoes*, writes, "It's pretty clear that Idgie is a lesbian, and fairly clear that she and Ruth are a couple." James Berardinelli suggests in an online review that the relationship between Idgie and Ruth is deliberately "left ambiguous."

Depicting friendship between women—even the intense friendships exhibited by characters in films such as *Julia* (1977), *The Turning Point* (1977), *Steel Magnolias* (1989) and *Thelma and Louise* (1991)—is failsafe. Scholar Jeff Berglund argues that "friendship is invoked as the culminating explanation of Idgie and Ruth's relationship" (144–45) in the film *Fried Green Tomatoes*. He documents the reactions of actress Mary-Louise Parker, who plays Ruth Jamison; Flagg, who co-wrote the script; and Avnet, the director, to the virtual omission of lesbian desire in the film. According to Berglund, Parker believes same-sex desire in the film is so obvious that mainstream audiences will understand it; Flagg says the book is a "story about love and friendship" and that "sexuality is unimportant"; and Avnet echoes Flagg, saying, "The sexuality had no interest for me" (146–47).

As we will see throughout this study, it is lesbian critics who provide the context for understanding the novels *The Color Purple* and *Fried Green Tomatoes*—and the films drawn from them—as lesbian texts. Lesbian criticism also acknowledges the encoding present in the texts and makes it possible to understand the subversive themes that may be drawn even from the ambiguous lesbian relationships in the films. In "What Is Lesbian Literature? Forming a Historical Canon," Lillian Faderman argues that *The Color Purple* "takes as its emotional center the nurturing, loving, and specifically sexual relationship between Celie and Shug." She adds, "For Celie, the relationship remains erotically charged to the end of the novel and represents the only satisfactory sexual experience of her life. Do the absence of the word *lesbian*, the oblivion to the existence of a lesbian subculture, and the author's putative heterosexuality mandate that we cannot consider such a work lesbian literature?" Faderman's answer, of course, is "no," and, as we will see, the answer remains the same for the film drawn from the novel. In spite of the near-annihilation of lesbian themes in the award-winning film, *The Color Purple* may suggest as much as it obfuscates. In both *The Color Purple* and *Fried Green Tomatoes*, what is omitted may be more important (and more suggestive) than what is clearly depicted on the screen.

Regional studies provide the most important critical framework for an analysis of the novels and films. It is not incidental that Alice Walker and Fannie Flagg were born in Georgia and Alabama, respectively, or that the novels and films are set in the Deep South. Although recreated by William Faulkner, Harper Lee, Eudora Welty, and others as being predominantly

conservative, Protestant, and rural, the American South is most accurately described as a land of compelling contradiction. In *Carryin' On in the Lesbian and Gay South*, Howard explains his title by referring to a cliché often employed in the South: "Ya'll better stop that carryin' on" (1). Defining "carryin' on" as "stepping over some perceived line of propriety" (2), Howard argues that for gays and lesbians in the South, "carryin' on" should be redefined as "to get through, to resist, to endure." He argues persuasively that reifying stereotypes of the American South as a land of particular intolerance perpetuates what he considers to be a dangerous belief in national innocence. If racism, misogyny, and intolerance of lesbians and gays can be located conveniently in the South, he suggests, the rest of the country can avoid looking at itself too closely.

Howard and other scholars whose work appears in the collection argue that residents of the South are not necessarily more intolerant than they are in other regions of the country and that stereotyping the South serves primarily to let the rest of the nation off the hook. Howard acknowledges that the South has a "dangerous intellectual history, a tradition that forwards selected notions of the past as widely shared values": "'Southern heritage' frequently amounts to a mythologized, planter-class world imbued with racism and misogyny. These concepts are rarely identified as conservative, white male, heterosexist constructs" (5) that are pervasive in other regions of the United States, Howard writes. Donna Jo Smith, whose essay "Queering the South: Constructions of Southern/Queer Identity" appears in Howard's collection, connects the grotesque characters that abound in Southern literature and the myths of Southern eccentricity with the reality of "queers" who live and work in the region:

> When combined, these stereotypes tend to conflict or conflate, depending on per-spective. For some, the notion of a "southern queer" is an oxymoron, conjuring up images of a drag queen with a pickup truck and gun rack or of a dyke with big hair and Birkenstocks. For others, the term "southern queer" is redundant: Since the South is already an aberration, what is a southern queer but deviance multi-plied?...Even the most cursory attention to current events, however, suggests that queers are made the target of hate crimes everywhere, and that hateful rhetoric to-ward queers is not only spewed by southern politicians. (370, 381)

Although Howard and Smith are correct that prejudice against gays and lesbians is part of a national—not simply a regional—sensibility, the promi-nence of conservative Christianity, reified attitudes about the nuclear family, definitions of masculinity and femininity, and other cultural ideas have made coming out in the South a daunting process. Determining whether living openly as a lesbian or gay person is more difficult in the South than in other

regions of the country is not the purpose of this study. It is important, however, to recognize that the image of the Southern "queer" remains a compelling and recurring image in modern novels by writers such as Carson McCullers *(The Heart Is a Lonely Hunter, The Ballad of the Sad Café,* and *Reflections in a Golden Eye)* and in contemporary nonfiction by writers such as John Berendt *(Midnight in the Garden of Good and Evil)* and that creating a character who is more "queer" than others in the "queer" South would provide a particular symbolic energy in works by Walker, Flagg, and other Southern writers.

Some lesbian and gay writers in the South are able to parody the society that contributes to their sense of estrangement. In her hilariously bawdy semi-autobiography about growing up in the South, Florence King discusses what it was like to come of age and to understand her sexual orientation during a time when patriarchy and heterosexual privilege were synonymous with Southern living. It is interesting to note that when King reviewed the novel *Fried Green Tomatoes,* she appreciated Flagg's humor and celebrated her portrayal of the South: "Watch out for Fannie Flagg," King wrote. "When I walked into the Whistle Stop Café she fractured my funny bone, drained by tear ducts, and stole my heart" ("Reader's Guide," n.p.). King employs her own brand of humor in *Confessions of a Failed Southern Lady* (1985) to describe the impossible expectations women face in the Land of Southern Belles, and her description is important as one considers the cultural landscapes of *The Color Purple* and *Fried Green Tomatoes:*

> [Granny] was a frustrated ladysmith and I was her last chance. Mama had defeated her but she kept the anvil hot for me and began hammering and firing with a strength born of desperation from the day I entered the world until the day she left it.
>
> This is the story of my years on her anvil. Whether she succeeded in making a lady out of me is for you to decide, but I will say one thing in my own favor before we begin.
>
> No matter which sex I went to bed with, I never smoked on the street. (x)

Protected to some extent by her scathing satire, King tells readers, "Whether or not I went crazy is impossible to say; a maniac could hide in my family as a leaf can hide in the forest" (42). This reference to the eccentricities of families in the South cannot camouflage the alienation and longing King felt while growing up in a place in which every woman inevitably topples from her pedestal. Aware of the impossible demands imposed upon young women, King never became used to what she calls the "exquisite balance between hatred and hospitality" (219) in the South. Rejecting heterosexuality as the norm, she suggests that she adhered to as many of the

prevailing cultural mandates as she could: Although she slept with both men and women, for example, she refused, metaphorically, to smoke on the street.

Nonetheless, whether or not a writer turns to humor for relief, the underlying pain remains; an awareness of the consequences of being different fuels much of the fiction produced by Southern writers such as Walker and Flagg. As Alabama writer Mab Segrest, editor of a collection entitled *My Mama's Dead Squirrel: Lesbian Essays on Southern Culture*, suggests, it would be incorrect to say that disenfranchised people do not have a particular sensitivity to difference and its consequences. In an article entitled "Lines I Dare to Write: Lesbian Writing in the South," Segrest addresses the effects of cultural attitudes on gays and lesbians, including herself, directly: "I am not saying that all kinds of people are not lonely. But, as a lesbian, I know that we are lonelier than we have to be and that structures of society separate us unnecessarily" (55). Although Walker treats the effects of being different with great seriousness and Flagg undercuts the theme of alienation with humor, both writers understand alienation and employ it effectively, albeit in starkly different ways. In *Fried Green Tomatoes*, Buddy Jr., who loses his arm after being hit by a train, participates in a funeral for his arm and is then affectionately called "Stump" by the townspeople. Like Idgie and others, he is different but accepted. In *The Color Purple*, Celie, who is black, less physically attractive than Shug, and drawn to women, does not fare as well as Buddy Jr. Raped by her stepfather, beaten by her husband, abused by her stepchildren, and separated from her children and her sister, Celie must deal with far more than her sexual orientation.

The alienation experienced by gays and lesbians and people of color in any geographical region is especially pronounced when society seems to ignore their very existence. If films such as *The Color Purple* and *Fried Green Tomatoes* are made palatable to American filmgoers because the lesbian protagonist is not portrayed as a sexual being, what does that indicate? Castle argues that the lesbian figure in classic literature and popular culture virtually disappears: "Nowhere has the work of ghosting been carried on more intensely than in the realm of literature and popular fantasy. Western writing over the centuries is from one angle a kind of derealization machine: insert the lesbian and watch her disappear" (6). Castle's work also helps to explain the intensity of the interest in sexual orientation that runs through scholarship about the novels *The Color Purple* and *Fried Green Tomatoes* and the films that followed. She argues that "the very frequency with which the lesbian has been 'apparitionalized' in the Western imagination also testifies to her peculiar cultural power": "Only something very palpable—at a deeper level—has the capacity to 'haunt' us so thoroughly" (7).

The decisions by directors Steven Spielberg in *The Color Purple* and John Avnet in *Fried Green Tomatoes* to erase lesbian sexual desire would be of interest to Castle and other critics who concern themselves with "apparitional lesbians" and the ways in which they all but vanish from contemporary film. Castle's research supersedes regionalism and addresses her long-term concern that the lesbian is "a kind of 'ghost effect' in the cinema world of modern life: elusive, vaporous, difficult to spot—even when she is there, in plain view, mortal and magnificent, at the center of the screen" (2). Andrea Weiss notes in *Vampires and Violets: Lesbians in Film* that "lesbian images in the cinema have been and continue to be virtually invisible. Hollywood cinema, especially, needs to repress lesbianism in order to give free rein to its endless variations on heterosexual romance" (1). And finally, in "Theorizing Lesbian: Writing—A Love Letter," Elizabeth Meese asks, "Why is it that the lesbian seems like a shadow—a shadow with/in woman, with/in writing?" (70). Meese reminds us that the process of identifying lesbian writers and lesbian texts is a daunting, albeit essential task. Meese defines "lesbian" as "a word written in invisible ink, readable when held up to a flame and self-consuming, a disappearing trick before my eyes where the letters appear and fade into the paper on which they were written" (83).

If, as lesbian critics suggest, lesbian characters in popular culture are ghosts and shadows whose lives are written in invisible ink, is it reasonable to expect that Celie and Idgie should have been more visible as lesbians? It would seem, for example, that Walker and Flagg, who both had sexual relationships with women, would argue for their characters to be clearly drawn in the films created from their books. However, in addition to the producers, screenwriters, and directors, authors themselves are sometimes not involved in writing the script, as was the case with Walker, or are themselves uncomfortable with their own sexual orientation, as was Flagg.

Since so many scholars find it important to locate an author's own sexual identity, it would be both arrogant and cavalier to dismiss a study of the lives of Alice Walker and Fannie Flagg as a basis for their work. This is true in particular because characters may be at least partially autobiographical. Although this may be the case with Walker's portrayal of Celie and Shug or Flagg's portrayal of Idgie and Ruth, the characters are not drawn from the lives of their creators as directly as they are in other Southern novels, for example, Mick Kelly as a mirror of Carson McCullers in *The Heart Is a Lonely Hunter* or Scout as a reflection of Harper Lee in *To Kill a Mockingbird*.

Although placing too much emphasis on an author's life and self-revelation defeats the purpose of this study, it is true that the lives of Walker and Flagg are replete with evidence of their own interest in issues of sexual

orientation. In *The Same River Twice: Honoring the Difficult* (1996), Walker describes the loss of her mother, the loss of an important relationship with a man, her battle with depression, and her realization that she is bisexual. In *Rita Will* (1997), Rita Mae Brown refers to her relationship with Flagg in chapters entitled "18th Century-Fox," "A Rolls-Royce and Love," "The Eternal Triangle," "The Booby Prize," and "Gypsyfoot." Although unwilling to acknowledge her sexuality publicly, Flagg engaged in sexual relationships with women.

In *The Same River Twice: Honoring the Difficult*, which was written a decade after *The Color Purple* became a film, Walker concedes that the film did not replicate her vision of her characters: "It was clear that Shug is, like me, bisexual. That Celie is a lesbian. Do I regret that my version of the book was not filmed? I have accepted that it wasn't" (35). After Walker wrote *The Color Purple*, she was "'accused' of being a lesbian, as if respecting and honoring women automatically discredited anything a woman might say" (22), Walker writes. Walker did argue strongly with Spielberg about allowing the kiss between Celie and Shug. She writes of wanting her mother, a fundamentalist Christian opposed to lesbianism, to understand that Celie and Shug were in love: "I did not want her to miss the love between women in *The Color Purple*. And so I lobbied for a kiss" (167). Later, she writes:

> It was important to me that Celie and Shug be portrayed as the lovers they are in *The Color Purple*. It took a bit of gentle insistence...simply to include "the kiss," chaste and soon over as it is. However I was aware, because Quincy Jones sent copies of some of the letters he received, that there were people in the black community who adamantly opposed any display of sexual affection between Celie and Shug. There were also editorials in black newspapers condemning such behavior. Incredibly, love between women was considered analogous to drug addiction and violence.
>
> I knew the passion of Celie and Shug's relationship would be sacrificed when, on the day "the kiss" was shot, Quincy reassured me that Steven had shot it "five or six" different ways, all of them "tasteful." (219)

In a letter Walker includes in *The Same River Twice*, a lesbian wrote to her after the film was released and is quoted as saying: "As a lesbian, I'm also disappointed that Celie and Shug are not portrayed as lovers...The love, affection and sensuality that the two women share is what makes Celie come alive, learn to value herself. She did not receive that from any man in her life. How can that be ignored?" (250).

Although Flagg thought the portrayal of Idgie and Ruth was consistent between the novel and the book, Rita Mae Brown, author of *Rubyfruit Jungle* and a series of books that include mystery novels, attributes Flagg's assessment to her homophobia. Brown claims in *Rita Will: Memoir of a Literary*

Rabble-Rouser, that she was with Flagg at a café that served as the basis for *Fried Green Tomatoes at the Whistle Stop Café*, that Flagg's aunt who ran the café lived with another woman, and that Flagg told her she did not want to write a lesbian novel. Brown, who calls Flagg "one of the great loves of my life" (303), describes the event:

> Fannie drove me out to the Iron Café, frequented by the railroad workers. Bill Neal's sister, Iggy, having battled the bottle herself (ran in the family), helped the railroad drunks dry out. She lived with another woman. The two women were kind but tough. Fannie always believed her aunt was a lesbian. As the good woman and her companion had been dead many years, I had no opportunity to form my own opinion.
>
> We poked, prodded and talked about how to frame the story. Fannie didn't want to write a lesbian book. What a surprise. But her aunt's story was a great story. I told her she could soft-pedal it. Just write the women as she remembered them. I helped her with the structure.
>
> This was the novel that eventually became *Fried Green Tomatoes at the Whistle Stop Café*. (325)

Although Brown writes that she "wanted to spend the rest of [her] life with Fannie" (323), Flagg eventually left the relationship. Brown faults her only for her internalized homophobia: "Fannie and I were never seen together publicly. She had a holy horror of anyone thinking she was a lesbian. Why in God's name did she fall in love with me?" (315). It is not difficult, then, to understand why—as a co-screenwriter for *Fried Green Tomatoes*—Flagg would be reluctant to define two of her main characters as lesbian.

As is obvious from Brown's chronicle of the origin of *Fried Green Tomatoes*, one of the challenges of lesbian criticism is to identify a "lesbian text" even when the author herself refuses to acknowledge that there are lesbian characters or themes. A scholar's definition of "lesbian" will necessarily determine the texts she or he identifies as "lesbian texts," and it is unlikely that either the definition of "lesbian" or the identified "lesbian texts" will please everyone. With the exception of what Bonnie Zimmerman calls "the growing body of literature written from an explicit lesbian perspective since the development of a lesbian political movement, it is likely that many will disagree with various identifications of 'lesbian texts'" (41), she writes. Is a lesbian text created only by a lesbian? Might a lesbian text be created by a bisexual or straight woman who describes lesbians in her work? Could a text have overtones identified as "lesbian" by readers or viewers without the creator's conscious knowledge? Might a "lesbian text" be written by a man? Finally, as in Flagg's case, could a "lesbian text" be written by a woman who is ambivalent about her own sexual orientation? If she is uncomfortable with

her sexuality and claims she has not created a lesbian character, do critics have a right to identify her character as a lesbian in spite of her protests? The answer to the last question—notably in the case of the film *Fried Green Tomatoes*—is a resounding "yes."

Zimmerman correctly states that a lesbian critic necessarily "begins with the establishment of the lesbian text: the creation of language out of silence" (41). Furthermore, fictional characters may deal with their sexual identities and intrigue us for the very reason they intrigue the authors themselves: They are on a quest to understand themselves and to build relationships in a world hostile to difference. Lesbian criticism relies upon the premise that gay, lesbian, and bisexual writers throughout history have been silenced and that they often write in the shadows and in the margins. Some of them may be exploring their own boundaries as they write. Others may be clear on their sexual orientation and the importance of sexual identity in their work but may employ encoding to protect themselves from criticism, to make their work more marketable, or to allow themselves a creative space in which to come to terms with who they are.

Identifying the sexual orientation of authors, producers, screenwriters, and directors ostensibly may seem to strengthen or weaken a gay or lesbian reading of a text, but, in fact, it is not—and it must not be—the deciding factor. As Zimmerman reminds us, "Literary interpretation will, of course, be supported by historical and biographical evidence, but perhaps lesbian critics should borrow a few insights from textual criticism. If a text lends itself to a lesbian reading, then no amount of biographical 'proof' ought to be necessary to establish it as a lesbian text" (39). When scholars discuss Walker and Flagg and their work, it is essential to remember that, as Zimmerman writes, "the problem of definition is exacerbated by the problem of silence": "One of the most pervasive themes in lesbian criticism is that woman-identified writers, silenced by a homophobic and misogynistic society, have been forced to adopt coded and obscure language and internal censorship" (40).

Furthermore, when dealing with woman-identified authors and their work, scholars should not overlook the possibility that they were not deliberately either hiding their sexual orientation or encoding their message; it is quite possible that the writers were actively questioning their own boundaries while creating characters who challenged theirs. Karla Jay and Joanne Glasgow suggest in the introduction to their collection entitled *Lesbian Texts and Contexts: Radical Revisions* that "problems of 'encoded' language remain and make especially difficult the analysis of all these texts written from a lesbian sensibility that was covered over, masked, or hidden from disapproving or simply uncomprehending eyes" (7).

Mainstream movie audiences might decipher some of the encoding afforded them in *The Color Purple* and *Fried Green Tomatoes*, but to do so they might also rely too heavily upon stereotypes of lesbians and gays. If, for example, they understand that Celie and Idgie are gay because they wear clothes traditionally understood to be "masculine," they are, in fact, being discriminatory. Through cultural conditioning, we learn accepted ways of dress and self-expression; audiences might or might not understand that lesbians and gays often play with those artificial and constructed boundaries. Ruth and Shug are no less "lesbian" than Idgie and Celie because they wear "feminine" attire. Like Mick Kelly in *The Heart Is a Lonely Hunter*, Frankie in *The Member of the Wedding*, Scout Finch in *To Kill a Mockingbird*, and other female characters in Southern fiction and film, Idgie refuses to wear clothing considered suitable for girls. As we have seen in our review of the impact of the literature and culture of the South on Walker and Flagg, a female character in the South might choose to wear pants and men's shirts as a clear and visible sign that she has rejected the expectations of those around her. She may be saying loudly that she is not a Southern belle and that she refuses to adhere to traditional female roles. Is she necessarily a lesbian?

Ironically, although adopting a style of dress does not identify a woman as lesbian, in the film version of *Fried Green Tomatoes*, Idgie's attire is one of the most reliable cues for the heterosexual audience, since Idgie and Ruth are rarely identified as lesbians through their expressions of physical intimacy, their building of a home together, or their rearing of Buddy Jr. Jane Rule's description of Radclyffe Hall, author of *Well of Loneliness* (1928), is appropriate here: "She wore men's jackets and ties, had a short haircut, and in all manners was gallantly masculine. When she was criticized for calling such attention to herself, she explained that dress was simply an expression of nature, which she could not change, one of the honest ways she faced her inversion" (*Lesbian Images*, 52; *Lure*, 247). However, even though Idgie is a lesbian and chooses to wear pants, suspenders, ties, and vests, it is still possible for members of the audience to refer to Idgie as a "tomboy" and avoid dealing with her lesbianism entirely. It would be far more honest to allow Celie and Shug and Idgie and Ruth to express their love for one another in ways that would identify them as individuals in committed relationships.

In "Heterosexual Plots and Lesbian Subtexts: Toward a Theory of Lesbian Narrative Space," Marilyn R. Farwell argues that a lesbian text inevitably undercuts heterosexuality and conventional notions of normalcy: "The point in the narrative where this deconstruction begins is what I would call lesbian narrative space. It happens most often when two women seek another kind of relationship than that which is prescribed in the patriarchal structures, and

when it occurs in the narrative, it can cast a different light on the rest of the novel, even on those portions that seem to affirm heterosexual patterns" (98). Identifying and understanding the significance of the "lesbian narrative space" in *The Color Purple* and *Fried Green Tomatoes*, of course, is the challenge of this and other studies. One way to locate that space in the novels and films important in this study is to examine the language used to describe the relationships between Celie and Shug and Idgie and Ruth in the films *The Color Purple* and *Fried Green Tomatoes*, respectively. In fact, the words the women speak to one another clearly support the fact that they are in love with one another. The encoding occurs, it seems to me, in the way the women gaze at one another and the way their limited physical contact is framed in the films.

In *The Color Purple*, Walker describes both Celie's enchantment with Shug Avery and her lack of sexual interest in her husband. It might be possible for heterosexual audiences to argue that Celie loved Shug because Shug was kind to her and that she was uninterested in sexual relations with her husband because she was not in love with him and had never chosen marriage. However, it is clear that Celie falls in love at first sight, without any sense that Shug will care for her. "Shug Avery was a woman," Walker writes, "the most beautiful woman I ever saw. She more pretty then my mama. She bout ten thousand times more prettier then me...An now when I dream, I dream of Shug Avery. She be dress to kill, whirling and laughing" (16).

After Celie meets Shug, her feelings are intensified, and she responds quite obviously to Shug's physical presence: "First time I got the full sight of Shug Avery long black body with it black plum nipples, look like her mouth, I thought I had turned into a man...I wash her body, it feel like I'm praying. My hands tremble and my breath short" (53). Since Celie doesn't know any other lesbians, the only way she can contextualize her feelings for Shug is by identifying with men. When she listens to Shug sing at the juke joint, she says, "All the men got they eyes glued to Shug's bosom. I got my eyes glued there too. I feel my nipples harden under my dress. My little button sort of perk up too" (82).

There is no encoding in Walker's book: Celie is sexually aroused by and falling in love with her husband's long-time mistress. She has no interest in sex with men. Of Shug, she says, "I git the coffee and light her cigarette. She wearing a long white gown and her thin black hand stretching out of it to hold the white cigarette looks just right...If I don't watch out I'll have hold of her hand, tasting her fingers in my mouth" (55). Of Albert, she says, "Mr. _____ clam on top of me, do his business, in ten minutes us both sleep.

Only time I feel something stirring down there is when I think bout Shug" (68).

In the films, it is perhaps the kiss between the women that best identifies Celie and Shug and Idgie and Ruth as lesbian. In the novel *The Color Purple*, however, the kiss leads to a sexual relationship. Walker writes:

> She say, I love you, Miss Celie. And then she haul off and kiss me on the mouth.
> *Um*, she say, like she surprise. I kiss her back, say, *um*, too. Us kiss and kiss till us can't hardly kiss no more. Then us touch each other
> I don't know nothing bout it, I say to Shug.
> I don't know much, she say.
> Then I feels something real soft and wet on my breast. (109)

In the film, the sexual relationship is less clear, although the film is true to the novel in its portrayal of Celie's attraction to Shug Avery (Margaret Avery). In the screenplay written by Menno Meyjes, Celie (Whoopi Goldberg) thinks about Shug while she has sex with Albert (Danny Glover): "And then I think about that pretty woman in the picture. I know what he doin' to me, he done to her. And maybe she like it." After Shug comes to Celie's home to recover, Celie walks in on Shug in the bath. Shug asks, "What you starin' at? Never seen a naked woman before?" Celie is mesmerized by Shug and, kneeling beside the bathtub, brushes her hair.

Shug writes a song, "Miss Celie's Blues," and performs it for Celie as a tribute to her kindness: "Sister, you been on my mind/ Oh, sister, we're two of a kind/ So sister, I'm keeping my eyes on you...I'm somethin'/ I hope you think that you're somethin', too." While singing, she holds Celie's hand as Celie looks up shyly at her. Although a gay audience would understand the gaze between the women, a straight audience might hear "sister" in the song and respond only to the kindness Shug is showing Celie by singling her out in the song.

Later in the film, the two dance and look into mirrors together; the scenes melt into one in which Shug tells Celie, "I think you're beautiful" and kisses her cheek, her forehead, her other cheek, and her mouth. Celie, embarrassed, pulls away and covers her mouth but then kisses Shug on the mouth tenderly. Shug kisses Celie hard, and the camera pans to their hands on each other's shoulders. The viewer has no idea whether or not the two sleep together or whether Shug's feelings for Celie go beyond sisterhood and a desire to help Celie feel good about herself and her body. After the kiss, Celie says, "Shug like honey. And now I's just like a bee. I's follows her everywhere. Wanna go where she go. What it like for her? And why she sometime get so

sad...just like me." The sexual attraction fades into an identification with
Shug and a desire to be less alone.

Given Fannie Flagg's alleged statement to Rita Mae Brown that she
didn't want to write a lesbian novel, an understanding of *Fried Green
Tomatoes* and the film that followed it becomes more problematic. Encoding
occurs in both the novel and film, although I would argue that the novel
makes the lesbian relationship between Idgie and Ruth (and perhaps between
Idgie and Eva) more obvious. Describing lesbian desire as a "crush" both
minimizes it and creates confusion for heterosexual audiences: One might
assume that many men and women have had same-sex crushes without those
"crushes" being sexually actualized. When Idgie's mother realizes that her
daughter has strong feelings for Ruth, she announces to her family, "Now,
children, your sister has a crush, and I don't want one person to laugh at her"
(81); later in the novel, she calls Ruth Idgie's "sweet companion" (199).
Idgie has been transformed by her feelings for Ruth to the extent that, as
Flagg writes, "Even Sipsey razzed her. She'd see Idgie by herself and say,
'That ol' love bug done bit Idgie'" (82).

Flagg doesn't sexualize the relationship between Idgie and Ruth in the
novel, although a lesbian or gay reader would understand that the two have a
relationship that goes beyond a supportive friendship. When Ruth puts her
arms around Idgie and says, "Oh Idgie, I'm not mad at you. It's just that I
don't know what I'd do if anything ever happened to you. I really don't,"
Flagg tells the reader, "Idgie's heart started pounding so hard it almost
knocked her over" (86). Idgie's feeling for Ruth is more than friendship.
Flagg's description of Ruth's response also appears to be more than the
response of a friend:

> It's funny, most people can be around someone and then gradually begin to
> love them and never know exactly when it happened; but Ruth knew the very second
> it happened to her. When Idgie had grinned at her and tried to hand her that jar of
> honey, all these feelings that she had been trying to hold back came flooding through
> her, and it was at that second in time that she knew she loved Idgie with all her
> heart...
>
> And now, a month later, it was because she loved her so much that she had to
> leave. Idgie was a sixteen-year-old kid with a crush and couldn't possibly understand
> what she was saying. She had no idea when she was begging Ruth to stay and live
> with them what she was asking; but Ruth knew, and she realized she had to get
> away.
>
> She had no idea why she wanted to be with Idgie more than anybody else on
> this earth, but she did. She had prayed about it, she had cried about it... (88)

What does Ruth know that Idgie doesn't know? It is quite apparent that Ruth
fears she is responding to Idgie as a mature, sexual, passionate woman

would, and because Idgie is younger, Ruth is concerned about the impact of her desire for Idgie. When she tells Idgie that she will marry Frank Bennett, Idgie says, "You don't love him...You love me...you know you do" (90). She is equating their relationship with the relationship between a woman and a man, perhaps making it even more likely that Ruth will leave. After Ruth goes, she thinks of Idgie often. Flagg writes, "But sometimes, in the middle of a crowd or alone at night, she never knew when it was going to happen, Idgie would suddenly come to mind, and she would want to see her so bad that the pain of longing for her sometimes took her breath away" (194).

In many ways, including narrative structure, *Fried Green Tomatoes* is faithful to the novel it is based upon, but it stops short of allowing the two central characters to experience a sexual relationship; in fact, as a framing device, the film balances the relationship between Idgie and Ruth with that of Ninny Threadgoode (Jessica Tandy) and Evelyn Couch (Kathy Bates). According to Church, the film relies on the "safe rubric of friendship" (199): "The framing narrative of the building friendship between the middle-aged Evelyn and the elderly Mrs. Threadgoode stabilizes and normalizes the ambiguous but more potentially subversive stories of Ruth and Idgie" (200), she writes. Berglund goes a step further in "'The Secret's in the Sauce': Dismembering Normativity in *Fried Green Tomatoes*" and argues that the film entirely "secrets the lesbian desire evoked in the novel" (132).

Unlike in the novel, Idgie (Mary Stuart Masterson) meets Ruth (Mary-Louise Parker) when Ruth is her brother's girlfriend. This allows the filmmakers to establish Ruth as a straight woman and Idgie as a tomboy who so adores her older brother that she even dresses like him. The promotional material that accompanies the video released in 1992 reads, "It's the story of a friendship that defied all obstacles, a devotion that couldn't be broken." The problem, of course, is that the relationship transcended a friendship between women; in fact, Idgie and Ruth establish a committed relationship and raise Ruth's son together. In the screenplay by Fannie Flagg and Carol Sobieski, Idgie plays poker, drinks, smokes, and charms bees (and Ruth). At the River Club, Ruth kisses Idgie on the cheek while they sit by the lake, but the kiss is not sexualized. When Idgie drives the second time to Valdosta, Ga., to see how Ruth is faring with Frank Bennett, Ruth says, "Idgie Thread-goode. How are ya? You look so...so grown up. All the guys must be wild about you. Tell me...Do you have a fella yet?" Even though she is miserable in her abusive marriage, Ruth expects that Idgie will follow the tenets of Southern life and marry.

When Ruth's mother dies and Ruth sends Idgie the obituary, she includes a well-known passage from the book of Ruth: "Whither thou goest, I will go; whither thou lodgest, I will lodge. Thy people shall be my people." Idgie

brings Ruth home with her, and the movie audience—many of whom have heard the passage from the book of Ruth uttered at heterosexual wedding ceremonies—might assume the two are a couple. However, when Ruth is asked in court why a "respectable Christian woman" would leave her husband and go to live with Idgie, Ruth replies, "She's the best friend I've ever had and I love her." It is this kind of deconstruction that leaves the relationship ambiguous, protects Flagg from questions about her own sexuality, and, presumably, helps to guarantee the popularity of the film among mainstream audiences.

Lesbian critics do not advocate locating a gay or lesbian writer and scouring his or her work for lesbian or gay themes, nor do they revel in collecting works they can call "lesbian fiction," even when an out gay or lesbian writer introduces a decidedly gay or lesbian character. Teresa de Lauretis writes in "Queer Theory: Lesbian and Gay Sexualities" that she has no desire to "correct the historical record through locating great homosexuals in the past in order to reconstruct their effaced stories," nor does she want to "retrieve the events and actors elided by official history." Instead, she said she struggles to reveal the "processes and operations that produced those elisions, those constructed silences" (xiii). It is the unmasking of the society and the process that allows a silenced writer to speak that make rich the exploration of gay and lesbian themes. Castle, although concerned with the conspicuous absence of the lesbian figure in literature, herself stops short of dogmatically identifying "lesbian" fiction. Instead, she asks a series of questions: "Is a 'lesbian novel' simply any narrative depicting sexual relations between women?...Would a lesbian novel be a novel, then, written by a lesbian?...'A novel written by a lesbian depicting sexual relations between women' might come closer, but relies too heavily on the opacities of biography and eros, and lacks a certain psychic and political specificity" (67).

There is no doubt that the novels *The Color Purple* and *Fried Green Tomatoes* and the films drawn from them are rich for lesbian readers and viewers and are emblematic of larger debates in lesbian studies. It is appropriate here to reintroduce Zimmerman's reminder that lesbian writers sometimes write and even live in the margins:

> The critic will need to consider whether a lesbian text is one written by a lesbian (and if so, how do we determine who is a lesbian?); one written about lesbians (which might be by a heterosexual woman or by a man); or one that expresses a lesbian "vision" (which has yet to be satisfactorily described). But, despite the problems raised by definition, silence, and coding, and absence of tradition, lesbian critics have begun to develop a critical stance. Often this stance involves peering into shadows, into the spaces between words, into what has been unspoken and barely imagined. (41)

Perhaps Catharine R. Stimpson's definition of the lesbian writer—a definition she calls "conservative and severely literal"—must suffice until the voices of other writers and critics are included as lesbian studies continues to mature and to become more widely embraced. In "Zero Degree Deviancy: The Lesbian Novel in English," Stimpson writes:

> [The lesbian writer] is a woman who finds other women erotically attractive and gratifying. Of course a lesbian is more than her body, more than her flesh, but lesbianism partakes of the body, partakes of the flesh. That carnality distinguishes it from gestures of political sympathy with homosexuals and from affectionate friendships in which women enjoy each other, support each other, and commingle a sense of identity and well-being. (364)

The final word in this study belongs to Lori J. Kenschaft, whose article "Homoerotics and Human Connections: Reading Carson McCullers 'As a Lesbian,'" suggests another important way to deal with female characters when they have been made "apparitional lesbians" in American popular culture. Kenschaft argues persuasively that even if the text, the characters, the author, and the reader are not lesbian, "reading with the hypothesis that any or all might be reveals new ways of reading these texts" (231). These "new ways" can be rich, indeed, and they are long overdue.

Works Cited

Berardinelli, James. *"Fried Green Tomatoes."* 1992. http://moviewreviews.colossus.net.

Berglund, Jeff. "'The Secret's in the Sauce': Dismembering Normativity in *Fried Green Tomatoes." Camera Obscura* 42 (September 1999): 124–59.

Brown, Rita Mae. *Rita Will: Memoir of a Literary Rabble-Rouser.* New York: Bantam Books, 1997.

Castle, Terry. *The Apparitional Lesbian: Female Homosexuality and Modern Culture.* New York: Columbia University Press, 1993.

Church, Jennifer Ross. "The Balancing Act of *Fried Green Tomatoes." Vision/Re-Vision: Adapting Contemporary American Fiction by Women to Film.* Ed. Barbara Tepa Lupack. Bowling Green, Ohio: Bowling Green State University Popular Press, 1996.

DeLauretis, Teresa. "Introduction." "Queer Theory: Lesbian and Gay Sexualities." *Differences* 3.2 (Summer 1991): iii–xviii.

Ebert, Roger. *"The Color Purple."* 20 Dec. 1985. www.suntimes.com.

―――. *"Fried Green Tomatoes."* 10 Jan. 1992. www.suntimes.com.

Faderman, Lillian. "What Is Lesbian Literature? Forming a Historical Canon." *Professions of Desire: Lesbian and Gay Studies in Literature.* Ed. George E. Haggerty and Bonnie Zimmerman. New York: The Modern Language Association of America, 1995.

Farwell, Marilyn R. "Heterosexual Plots and Lesbian Subtexts: Toward a Theory of Lesbian Narrative Space." *Lesbian Texts and Contexts: Radical Revisions.* New York: New York University Press, 1990.

Flagg, Fannie. *Fried Green Tomatoes at the Whistle Stop Café.* New York: Fawcett Columbine, 1987.

―――. "Reader's Guide." *Fried Green Tomatoes and the Whistle Stop Café.* By Fannie Flagg. New York: Fawcett Columbine, 1987. n.p.

Howard, John, ed. *Carryin' On in the Lesbian and Gay South.* New York: New York University Press, 1997.

Jay, Karla, and Joanne Glasgow, ed. *Lesbian Texts and Contexts: Radical Revisions.* New York: New York University Press, 1990.

Kempley, Rita. *"Fried Green Tomatoes."* 10 Jan. 1992. www.washington post.com.

Kenschaft, Lori J. "Homoerotics and Human Connections: Reading Carson McCullers 'As a Lesbian.'" *Critical Essays on Carson McCullers.* Ed. Beverly Lyon Clark and Melvin J. Friedman. New York: G.K. Hall, 1996.

King, Florence. *Confessions of a Failed Southern Lady.* New York: Bantam Books, 1985.

Meese, Elizabeth. "Theorizing Lesbian: Writing—A Love Letter." *Lesbian Texts and Contexts: Radical Revisions.* New York: New York University Press, 1990.

Roof, Judith. *The Lure of Knowledge: Lesbian Sexuality and Theory.* New York: Columbia University Press, 1991.

Rule, Jane. *Lesbian Images.* Trumansburg, N.Y.: Crossing Press, 1975.

Segrest, Mab. "Lines I Dare to Write: Lesbian Writing in the South." *Southern Exposure* 9.2 (Summer 1981): 53–55, 57–62.

Smith, Donna Jo. "Queering the South: Constructions of Southern/Queer Identity." *Carryin' On in the Lesbian and Gay South.* Ed. John Howard. New York: New York University Press, 1997.

Stimpson, Catharine R. "Zero Degree Deviancy: The Lesbian Novel in English." *Critical Inquiry* 8.2 (Winter 1981): 363–79.

Walker, Alice. *The Color Purple.* New York: Washington Square Books, 1982.

―――. *The Same River Twice: Honoring the Difficult.* New York: Scribner, 1996.

Weiss, Andrea. *Vampires and Violets: Lesbians in Film*. New York: Penguin, 1992.

Zimmerman, Bonnie. "What Has Never Been: An Overview of Lesbian Feminist Criticism." *Sexual Practice, Textual Theory: Lesbian Cultural Criticism*. Cambridge: Blackwell, 1993.

Chapter Nine

Litigating the Past:
Portrayals of the Japanese in American Film

History is an experiment in vantage point. American high school students study the Dec. 7, 1941, attack on Pearl Harbor, while American journalists localize the event for each anniversary of the bombing. In the "Land of the Rising Sun," Japanese students and journalists focus on the 1945 bombings that killed between 70,000 and 80,000 in Hiroshima and 40,000 more in Nagasaki. Teachers in both countries worry about historical amnesia and the inclination of people to forget what is too painful to remember.

During the Pearl Harbor attack, 353 Japanese bombers, torpedo bombers, and fighters wiped out one-half of the United States Navy in moments. That day 2,400 Americans were killed, and 1,200 more were wounded. Although fewer and fewer American veterans and citizens who lived through the attack remain to tell their stories, oral histories and interviews keep their memories alive in archives, documentaries, magazines, and newspapers.

Since Aug. 15, 1945, when Japan surrendered unconditionally, the debate has continued: Were the bombs dropped on Hiroshima and Nagasaki necessary? Would Japan have surrendered without them? How many more American lives would have been lost if President Harry S. Truman had not chosen to drop the bombs? Did American officials know via Swedish and Swiss diplomats that Japan was ready to surrender before the bombs fell?

Addressing these questions is not the purpose of this essay. However, in order to understand the American films written and produced since World War II, there must be an acknowledgement that American, Japanese-American, and Japanese people continue to make sense of an inheritance of

fear and hatred very much a part of their present lives. When Japan's parliament marked the 50th anniversary of Pearl Harbor in 1991, its members expressed regret for Japanese aggression during World War II but did not apologize for Japan's attack on Pearl Harbor. On the 46th anniversary of the Aug. 6, 1945, bombing of his city, Hiroshima Mayor Takashi Hiraoka offered an apology for the hardships Japan caused its Asian and Pacific neighbors, but not its Western one. In the United States during the same year, former President George Bush said he would not apologize for the bombings of Nagasaki or Hiroshima.

But in March 2011, a 9.0-magnitude earthquake, a tsunami, and aftershocks devastated Japan and seriously damaged several nuclear plants. Radiation was detected as far away as California and Washington state. The United States and the rest of the international community responded generously and with great compassion, providing everything from money, to expertise about the repair and maintenance of nuclear facilities, to bottled water.

The shared crisis illustrates that the wounds from World War II are healing, although a history of antagonism remains. Distrust between Japan and the United States lives on in the popular culture of both nations. In a column about Michael Crichton's Japanese-bashing 1992 bestseller *Rising Sun*, George F. Will says of the novelist, "He should write less fiction until he has read more history" (82). The hostility that divides historians, journalists, novelists, and politicians of both countries is nowhere more apparent than in films as varied as *Gung Ho* (1986), *Karate Kid II* (1986), *Black Rain* (1989), *Pacific Heights* (1990), *Ski Patrol* (1990), and *Rising Sun* (1993), which belittle the Japanese and reveal a renewed fear of Japan since its emergence as an economic power.

More contemporary films such as *Flags of Our Fathers* (2006) and *Letters from Iwo Jima* (2006), directed by Clint Eastwood, provide a richer portrayal of the complexities of cultural diversity and the impact of war. In *Letters from Iwo Jima*, for example, General Tadamichi Kuribayashi (Ken Watanabe), who sacrificed himself to protect an island of rock and ash from American "invaders," once lived in America and grieves the loss of the friends he left behind. Courageous, he insists on eating the same rations as his soldiers. Knowing that the Japanese navy is destroyed and the air force deployed to Tokyo, Kuribayashi says to his weary and desperate men, "Do not expect to return home alive," but he reassures them by saying, "I will always be in front of you."

According to Eugene Franklin Wong, American filmmakers depict the Japanese as the most aggressive group of Asians and overemphasize the "big-power expectations" (xx) of Japan. In his book on Asians in American film,

Wong says portrayals of the Japanese and other Asians are usually negative and include erotic scenes between white males and Asian females (rarely between Asian males and white females). He argues that Asians are depicted as heathens and as expendable soldiers and laborers.

Even *Come See the Paradise* (1991)—a sensitive story about three generations of Japanese Americans during a time of international horror and despair—is told through the eyes of a white male hero. Although the film combines drama with attention to facts, it should not replace the screening of documentaries that allow those who endured the war and life in the internment camps to tell their stories.

Documentary films about the Japanese-American internment are an essential source of information about World War II and its aftermath. A few of these films include *Japanese Relocation* (1942), *A Challenge to Democracy* (1943), *Topaz* (1945), *Manzanar* (1972), *Unfinished Business* (1985), *Beyond Barbed Wire* (1997), *Days of Waiting* (1990), *Something Wrong Within* (1994), *Children of the Camps* (1999), *Rabbit in the Moon* (1999), *Conscience and the Constitution* (2000), *Forsaken Fields* (2001), *In Time of War* (2004), *The Cats of Mirikitani* (2006), *From a Silk Cocoon* (2006), *Pilgrimage* (2006), *Camp Amache: The Story of an American Tragedy* (2007), *Passing Poston* (2008), and *Toyo's Camera* (2009). Although not a documentary, another film tells the story of four children who befriend a Japanese soldier and alienate their families and community. It is entitled *I'll Remember April* (1999).

Come See the Paradise (1991)

Fortunately, recent generations learn about prejudice against Japanese Americans more from textbooks than from open hostility toward Asians in their neighborhoods and workplaces; however, the vestiges of fear and distrust are rooted in significant events that are part of our collective history. During World War II, for example, 126,000 Japanese Americans were living in the United States (93,000 of them in California). Of those, two-thirds were American-born citizens ("nisei") and one-third were foreign born ("issei") and were not eligible for naturalization.

More than 112,000 were sent to "relocation centers," prison camps with armed guards and barbed wire fences. They were not officially charged with any crime and were not freed in large numbers until 1944. Historians since have accused those who instituted the camps of depriving citizens of their constitutional rights; others have defended the camps as an effective way to protect the Japanese from angry Americans; still others have interpreted the

camps as a necessary evil during wartime. The effect of the relocation camps on Japanese Americans is analyzed in *Come See the Paradise*, written and directed by Alan Parker *(Mississippi Burning)*.

Come See the Paradise begins in Brooklyn and shifts to Little Tokyo in Los Angeles in 1936. The film stars Dennis Quaid as Jack McGurn, a projectionist working in a Japanese theater. Jack falls in love with Lily Kawamura (Tamlyn Tomita), whose father runs the theater. During their first awkward moments together, Jack discovers the effect of U.S. policies governing citizenship. Lily tells him that her father is not allowed to own his business ("He's Japanese. It's against the law."), and Jack asks if it's because he failed to become a citizen. Lily tells Jack that her father's becoming a citizen also was prohibited. "I didn't know that," Jack says. Lily responds, "Not many people do."

Lily's father tells the two to stay away from each other and makes it clear that his daughter will not marry outside of her race. Jack tries to reason with Lily's father. In a particularly dramatic scene, Jack tells him that he will work harder to become successful but that he senses he will never be good enough: "What I can never be—not ever—is Japanese. But I couldn't love Lily more," he says. Lily's father walks away without responding.

Jack and Lily marry in Seattle, since Japanese are not allowed to marry non-Japanese in California. Told in flashback, *Come See the Paradise* juxtaposes the American land of plenty with the deprivation and sadness of Jack and Lily's child. Affectionately called "Mini" (Elizabeth Gilliam), the child struggles to live as half-Japanese, half-Caucasian in a nation at war with her grandparents' homeland. The most dramatic moments in the film deal with her determination to come to terms with the cultural attitude in the United States during the early 1940s.

Come See the Paradise is an attempt to portray realistically several generations of Japanese Americans during a period of global conflict. Other films—such as *Gung Ho, Karate Kid II, Black Rain, Pacific Heights*, and *Ski Patrol*—depict the Japanese stereotypically—often as the object of racist humor.

Gung Ho (1986) and Karate Kid II (1986)

The fear of Japanese economic power has been depicted in television and film. Angry at what they consider the separatism, superiority, nationalism, and wealth of the Japanese, Americans have protested Japan's failure to pay enough for the Gulf War; have protested the Japanese purchase of ski resorts, golf courses in Arizona and Hawaii, and tourist concessions in Yosemite

National Park; and have ridiculed Japanese dominance in the automobile market.

In a 1990 *Newsweek* article entitled "Japan Circles the Wagons: Detroit's Family-Car Franchise Is Under Attack," reporters Frank Washington and Bill Powell claim that the "rollout" of family-size autos from Japan "is but the latest in the unprecedented blitz of new models coming from the Japanese automakers, placing excruciating competitive pressure on Detroit's Big Three at a time when the American market is contracting." The article continues:

> There is no longer any place for Detroit to hide. Japanese manufacturers, once known only for their small, sprightly gas tipplers, are now a force in virtually every segment of the U.S. auto market. "They have come full circle," says Chris Cedergren, an analyst with J.D. Power in Agoura Hills, California. "The Japanese have moved dramatically upscale with their product lines, while keeping a major presence at the entry level"...the reality for Detroit is that there is not a market segment at which the Japanese companies have taken aim and seriously misfired. And the new models like the Accord wagon are aimed straight for the heart. (44)

When *Gung Ho* appeared, the Japanese economy was vibrant, largely because of its successful auto industry. In the film, Japanese and American cultural philosophies collide in the most incendiary arena of all: an automobile factory in Hadleyville, Penn. The Japanese buy the faltering American company and plan to increase production drastically in the first year. But before the Assan Motors American Division can improve, the Japanese must learn respect for individuality (a worker's need for family, leisure, etc.), and the Americans must learn to sacrifice personal desire for the good of the company as a whole.

Throughout *Gung Ho*, American workers ridicule chopsticks, group exercise, meditation, personal cleanliness, and Japanese food. They call the Japanese the "Rice-a-Roni Patrol," "Yokahama Mamas," and the "whalekillers," and one American worker spits out a seaweed snack in his boss's office when he discovers what it is.

Japanese management wants each person to feel responsible for the product and to be able to conduct a variety of jobs; the Americans want to specialize and are interested in individual benefits and salaries. When Hunt Stevenson (Michael Keaton) suggests to a Japanese supervisor that he "just put everybody back where they belong," one of Stevenson's friends, Buster (George Wendt), snaps, "He belongs in Japan."

In the film, American workers personalize comparisons between their way of doing things and the Japanese auto industry's way. In the shadow of the fact that at the time, production by Japanese automakers was 40 percent

higher than that of American automakers, the following dialogue occurs. In this scene, a Japanese manager finds a defect in a car and is horrified:

> **American worker:** "Oh, that's something for the dealer to worry about. You know, every car can't be perfect."
> **Japanese boss:** "In Japan, if there is defect, worker is ashamed. He stays night to fix. In Japan, our goal is zero percent defect."
> **American worker:** "How'd you slip by?"

The Japanese workers, whose English sounds like that of the Native Americans ridiculed in early Western films, respond in kind. When a wheel rolls off a car model in a design meeting, the Japanese laugh and say, "American car."

To no one's surprise, Assan Motors begins to fail in Hadleyville, and the racial hatred affects everyone where it hurts most: financially. The Japanese threaten to shut down the plant unless American workers can rally and produce 15,000 automobiles in record time. In a speech to his fellow automakers, Stevenson says that the American workers don't want the truth—they want only to think they're the best. "The great American do-or-die spirit! But they've got it," he says of the Japanese. What follows this new understanding is the production of 14,994 cars, a renewed contract for Assan Motors, and a mutual respect that the American viewer is led to believe will prevail in years to come.

Kazihiro (Gedde Watanabe) and Stevenson become friends in *Gung Ho*, and their relationship is the only testimony to real understanding between the cultures. Late in the film, we learn that Stevenson has influenced Kazihiro when the Japanese automaker tells his lonely wife, "We work too damn hard...Our friends, our families should be our lives. We are killing ourselves." Earlier, when his wife complained that American fathers spend more time with their children than Japanese men do, he snapped, "Yeah. Because their work sucks."

The ridicule the Japanese express for American culture and attitudes is often justified, but it, too, stands in the way of a melding of cultures. Kazihiro, in one of the best comic moments in the film, says to his children: "No more MTV. No more Twisted Sister...Read a book!...No! No more Jimmy Dean. No more Hawaiian Punch. No more Green Giant Frozen Niblets!" In another moment of anger—a rare emotion for Kazihiro—he says, "Everyone in this country thinks they're special. Nobody wants to be part of a team. They're all too busy getting personalized license plates."

Although the 1986 film is an important statement about the need for the Japanese and American workers to learn from one another, the goal is profits, not mutual understanding, and most of the comic moments in the film are at

the expense of the Japanese. After all, the target movie audience is Caucasian, and the chopsticks, seaweed, and broken English of the Japanese arrogantly buying American companies are accepted objects of ridicule during the 1980s.

Fortunately, another film in 1986 does a better job of focusing on the community spirit, self-sacrifice, and quiet understanding of the culture it depicts. In spite of its enslavement to stereotypes, *Karate Kid II* emphasizes tradition, reverence for one's elders, forgiveness, and deep love as elements of Japanese culture worth imitating.

The most poignant analysis of the cost of cultural misunderstanding and competition comes when Miyagi (Noriyuki Morita) and Daniel (Ralph Macchio) travel to Okinawa when Miyagi's father dies. The two see children laughing and playing in the streets, and Daniel says pensively of the war, "It must have been terrible here — 15,000 Americans killed in...10 days." Miyagi responds quietly, "Yeah. And 150,000 Okinawan and Japanese. Why are we all so stupid?" After turning his back on the bitter turmoil of his own life and relationships, Miyagi says: "Never stop war by taking part in one." Such a philosophy is in direct opposition to the kind of racial stereotyping and viciousness we see in American films such as *Ski Patrol* and *Pacific Heights*.

Ski Patrol (1990) and *Pacific Heights* (1990)

Some American films such as *Ski Patrol* and *Pacific Heights* introduce the Japanese only as peripheral characters, good for a laugh in segments infused with racial stereotypes. In *Ski Patrol*, a group of Japanese tourists is shown briefly on the ski slope. The group is speaking Japanese animatedly and frenetically; they snap pictures of the Americans who come swishing past without understanding what is occurring. While they watch childishly, they take photos with instamatics and giggle. Certainly, no one in the film is portrayed as intelligent, but the humor here is apparently rooted in the inability of the Japanese to understand what is going on around them and in the inversion of a symbol (a sophisticated Nikon camera replaced with an instamatic).

In *Pacific Heights*, a young couple buys their first home, a large gray-and-white Victorian house with two rentals in San Francisco. The two put their savings into the downpayment and get a home equity loan for the improvements. They then commit themselves to doing the renovations themselves. The couple Patty Parker (Melanie Griffith) and Drake Goodman (Matthew Modine) — rent the two apartments, one to a Japanese couple and

one to a maniacal man driving a black Porsche. What happens to the deranged Carter Hayes (Michael Keaton) is not of interest here, but the portrayal of the Japanese couple is.

Toshio and Mira Watanabe (Mako and Nabu McCarthy, respectively) are shown in stereotypical Japanese activities: he, for example, spends his early morning hours in the pouring rain practicing karate on the deck. When the two suffer electrical trouble, an invasion of roaches, hammering in the dead of night, etc., they move out.

Again, the representation of the Japanese in *Pacific Heights* is brief and is the only comic element in what is billed as a suspense thriller. The Watanabes are characteristically polite but express themselves in frenetic mannerisms and with poor English. In short, in *Pacific Heights*, otherness is funny.

Black Rain (1989)

The most troubling film in this essay is *Black Rain*, in which two American policemen fly to Japan and teach the Tokyo police department how to catch criminals and how to show humility. Once again, although the attitudes of the Americans change minimally in the film—Nick (Michael Douglas) develops a friendship with a Japanese policeman—the comic moments in the suspense drama are bought at the expense of the Japanese: "I just hope we have a Nip in this building who speaks fuckin' English," says Nick. The line is designed to draw immediate and sustained applause and laughter from the audience, an audience that is ready to see Nick stir things up in true Terminator style.

Nick and Charlie (Andy Garcia) are members of the New York Police Department chosen to escort a member of the Japanese mafia ("Yahuza") to Osaka for trial. Even though Nick and Charlie are in Japan because they accidentally release their prisoner, the Japanese are portrayed as more inept and foolish than they. Even the Japanese policeman who befriends Nick and ultimately helps him confront the Japanese mafia is shown to be inferior. He ultimately thanks Nick for having taught him how to launch out on his own in solving a case without fear of his superiors.

The arrogance that characterizes Nick throughout the film is particularly grating as he confronts the Japanese chief of police. "All right," he says, "you assign us a cop who speaks English, knows his way around the streets, and can find his ass with two hands." The chief courteously gives him one of the top officers. Nick and Charlie respond sarcastically, saying, "It's been a gas, Chief. Sayonara."

Writers Craig Bolotin and Warren Lewis may be suggesting that the Japanese deserve the lesson that comes their way because they, too, are arrogant. Nick's friend tells him, "Perhaps you should think less of yourself and more with the group...Music and movies are all America is good for...We make the machines. We build the future." Meanwhile, Nick does exactly what he should in relying only on himself and challenging the system—an alien notion to the Japanese in *Black Rain*.

The central thematic action in *Black Rain* involves a war between two leaders, Sato (Yusaku Matsuda) and Sugai (Tomisaburo Wakayama), and a counterfeiting ring. The title of the film comes from a statement by Sugai, who tells Nick that his family was nearly destroyed in World War II:

> I was 10 when the B-29 came. My family lived underground for three days. When we came up, the city was gone. Then the heat brought rain—black rain—you made the rain black—and shoved your values down our throat. We forgot who we were. You created Sato—and thousands like him.

Sugai later tells Nick that he is "bound by duty and honor." In another jab at American values, he adds, "If you had time, I would explain what that means."

The theme of *Black Rain* is not that the best of both worlds mesh and allow the police to accomplish their task. The message is that even the worst in one American (arrogance, boorishness, disrespect for differences, and ignorance of other cultural values) can transform an inferior investigative system peopled by inferior people. Because Sato is responsible for having killed Charlie, Nick talks Sugai into letting him arrest Sato. He does capture the mobster and is honored in a special ceremony by the Japanese police.

Nick emerges as a brutal American who has alienated his friends and lost his wife because of his insensitivity, but even he can show the Japanese a thing or two. And American audiences are programmed to appreciate the rugged individual who may be gruff and unrepentant but who is monomaniacal in accomplishing a task.

Rising Sun (1993)

Rising Sun is no more historically accurate than *Black Rain*, and it exploits similar stereotypes. Michael Crichton's 1992 bestseller by the same name was a "paranoid polemic masquerading as a murder mystery," said David Ansen of *Newsweek*. He adds:

> The polemic—an alarmist wake-up call warning America that we are losing the business war with Japan—had an unfortunate tendency to turn the Japanese into an omnipotent, ominous, and faceless "they." Crichton's portrait of these shadowy power brokers, secretly pulling the strings of virtually every American institution, indulged in sweeping racial generalizations. (55)

George F. Will joined the crusade against the novel in 1992 when he wrote that it "overflows with anti-Japanese passion, a peculiar blend of fear and loathing and admiration." Will notes that the film *Rising Sun* is "not a harmless cartoon." He says, "We have seen such stuff before, with Jews treated as the Japanese now are." Of portrayals of the Jews and the Japanese in popular culture, Will writes, "They wield power behind impenetrable mists of subterfuge, manipulating the media and financial institutions, and controlling, like marionettes on wings of money, corrupted politicians and pliable intellectuals" (82).

However, other critics such as Ralph Novak of *People* claim that Crichton's novel was "falsely condemned" as Japan-bashing and that the film is a "model of equanimity," barring what Novak calls the references to "Japanese men's predilection for tall, blond American women" (17). Novak fails to note the good guy-bad guy divisions, with John Conner (Sean Connery) and his sidekick Web Smith (Wesley Snipes) as the heroes and Cary-Hiroyuki Tagawa (Eddie Sakamura) as the militant, arrogant, immoral culprit.

The effects of popular culture often are not as direct as the battery of shootings and assaults that followed the release of the film *Boyz N the Hood* in 1991, or the child who set fire to his home after watching *Beavis and Butthead* in 1993, or the teens who lay in the middle of the street to imitate a scene from *The Program* in 1993. But the reinforcement of the stereotypes of the Japanese—as people who move only when told to, who worship the organization, who deprive their families and friends of affection and time, who speak English poorly, and who remain committed to economic takeover—can only further alienate the societies from each other.

Letters from Iwo Jima (2006)

Two celebrated films address the residual misunderstandings and mistrust between America and Japan since World War II, the changing global economic picture, and the profound differences between Japanese and American culture. In 2006, director Clint Eastwood released *Flags of Our Fathers*, which tells the stories of those who raised the flag on Mount Suribachi on the

island of Iwo Jima. *Flags of Our Fathers* was followed a few months later by *Letters from Iwo Jima*.

As chronicles of horrific violence and despair, the films nonetheless share a bleak and haunting beauty. A.O. Scott of the *New York Times* joins the majority of film critics who consider *Letters from Iwo Jima* the better of the two films; however, he argues that *Flags of Our Fathers* and *Letters from Iwo Jima* "enrich each other, and together achieve an extraordinary completeness."

Iwo Jima is 700 miles south of the Japanese mainland, and when the Allies targeted it, the Japanese understood that Tokyo was next. Following five weeks of war, Associated Press photographer Joe Rosenthal took a photo of a flag raised by U.S. Marines at the top of Mount Suribachi—and the rest is quite literally history.

As *Flags of Our Fathers* documents, after the photograph appeared, three surviving flag raisers toured the country to make speeches and help sell war bonds. Treated as heroes, Ira Hayes (Adam Beach), John "Doc" Bradley (Ryan Phillippe), and Rene Gagnon (Jesse Bradford) faced their experiences in different ways. The men saw each other for the last time at the 1954 United States Marine Corps War Memorial dedication.

For 35 days beginning Feb. 19, 1945, American and Japanese combatants turned Iwo Jima into a charred wasteland. At the end of the battle, more than 6,800 United States troops—out of the 70,000 Marines who invaded—and at least 20,000 Japanese soldiers lay dead (sources differ on the number of Japanese killed, with some historians suggesting more than 21,000 lost their lives). Approximately 22,000 American troops were injured. "I feel terrible for both sides in that war and in all wars," Eastwood said when the films were released. "A lot of innocent people get sacrificed. It's not about winning or losing, but mostly about the interrupted lives of young people. These men deserve to be seen, and heard" (McCurry).

Certainly, Eastwood's words help to position both *Flags of Our Fathers* and *Letters from Iwo Jima* in a cultural universe far removed from the manufacturing plant in *Gung Ho*. *Letters from Iwo Jima* introduces viewers to a heroic commander who reassures his soldiers by saying, "I will always be in front of you," and to a baker who is torn away from his pregnant wife and forced into service on a forsaken island. Both of the men are told they will not survive, and only one does.

A story crafted by Iris Yamashita and Paul Haggis *(Crash, Flags of Our Fathers,* and *Million Dollar Baby), Letters from Iwo Jima* highlights young Japanese soldiers and reveals a military system in which dying honorably is more important than living well. Stephanie Zacharek says the film seeks to "humanize these soldiers, showing them as inexperienced young men who

loved their families, who were under orders from their superiors to fight viciously, and who were victims of a culture in which dying honorably was considered far more important than preserving life." For example, Private First Class Saigo (Kazunari Ninomiya), devotes himself to Lt. Gen. Tadamichi Kuribayashi (Ken Watanabe) as Japan tries to defend an island without adequate ammunition, air support, manpower, or weaponry.

Letters from Iwo Jima refers to several hundred letters that anthropologists unearthed in 2005, letters that gave voice to the thousands of Japanese dead. The soldiers who wrote to their family members and friends knew they would perish on the island, and their words provided filmmakers with their perspective. In "The Other Side of the Story," Ty Burr of the *Boston Globe* writes:

> There's a moment in *Letters from Iwo Jima* where the profundity of what Clint Eastwood is doing blindsides you with a wallop. The Japanese general Tadamichi Kuribayashi...emerges from a cave during the fifth day of the epic World War II battle and spies, a mile or so away, a handful of ant-like figures raising a US flag on Mount Suribachi. It's glimpsed on the right side of the screen for a wobbly second and then it's gone: One of the iconic images of the 20th century, viewed through the wrong end of history's telescope. (n.p.)

Appropriately, Eastwood employs a "monochromatic" technique to emphasize the dreary terrain and the desperation of the soldiers trapped on Iwo Jima. "This may be intended as an homage to older World War II movies or it may be an attempt at a pseudo-documentary approach," writes James Berardinelli.

Letters from Iwo Jima is a cinematic and historical tour de force. The arid, bleak, rocky setting underscores the emptiness and exhaustion of both the American and Japanese forces. The invasion of a rugged island featured in both *Flags of Our Fathers* and *Letters from Iwo Jima* might end in victory for the United States, but it will cost nearly 30,000 soldiers their lives. The film, which Burr describes as "eloquent, bloody, and daringly simple," "examines notions of wartime glory as closely as *Flags of Our Fathers* dissected heroism."

Scott describes *Letters from Iwo Jima* as "harrowing" and "contemplative" and argues that it both replicates familiar themes in war films ("victory against the odds, brotherhood under fire, sacrifice for a noble cause") and undercuts them. *Letters from Iwo Jima*, Scott writes, "adheres to some of the conventions of the genre even as it quietly dismantles them": "It is, unapologetically and even humbly, true to the durable tenets of the war-movie tradition, but it is also utterly original, even radical in its methods and insights."

Iwo Jima, the ghastly five-by-two-mile island dotted with scraggly, denuded trees, becomes the microcosm of a war without end. In a haze of smoke and shadows, Eastwood portrays the humanity of the Japanese as they treat a wounded soldier from Oklahoma and their inhumanity as they deliberately target U.S. medical personnel. Likewise, Eastwood portrays the humanity of the American troops as they capture Saigo alive and their inhumanity as they shoot two surrendering Japanese soldiers at point blank range. One of the soldiers holds his white flag as he dies.

In the end, viewers are left with stark images of a U.S. Marine named Sam, whose letter from his mother reminds his Japanese captors of their own families, and of Private Shimizu (Ryo Kase), who was banished to Iwo Jima because he refused to shoot a barking dog that was beloved by its family. *Flags of Our Fathers* and *Letters from Iwo Jima* commemorate two wars — one between Sam and Shimizu and those they represent and the other between two nations separated by culture, history, and language.

Today, the U.S. and Japan struggle to remake and maintain their relationship without forgetting the lessons of a dark and menacing time. The 1980s gave the American public *Gung Ho* and *Black Rain*, and although history remains an experiment in perspective, *Flags of Our Fathers* and *Letters from Iwo Jima* offer hope that filmmakers again may contribute to a richer, more nuanced global conversation.

Works Cited

Ansen, David. "Cross-Cultural Crime Story: Sean and Wesley vs. Japan Inc." *Newsweek* (2 Aug. 1993): 55.

Berardinelli, James. *"Letters from Iwo Jima."* 2006. http://www.reelviews. net/movies/l/letters_iwo.html.

Burr, Ty. "The Other Side of the Story." 12 Jan. 2007. http://articles. boston.com/2007-01-12.

Letters from Iwo Jima. Dir. Clint Eastwood. Warner Bros., 2006.

McCurry, Justin. "Eastwood Attacks Japan War Myths." 27 May 2006. *The Observer.* http://www.guardian.co.uk/world/2006/may/28/film.japan. 15 July 2012.

Novak, Ralph. *"Rising Sun."* *People* (2 Aug. 1993): 17.

Scott, A.O. "Blurring the Line in the Bleak Sands of Iwo Jima." 20 Dec. 2006. *The New York Times.* 11 Jan. 2012.

Tyler, Josh. *"Letters from Iwo Jima."* n.d. *Cinema Blend.* http://www. cinemablend.com. 11 Jan. 2012.

Washington, Frank, and Bill Powell. "Japan Circles the Wagons." *Newsweek* (24 Dec. 1990): 44.

Will, George F. "Shadow World?" *Newsweek* (4 May 1992): 82.

Wong, Eugene Franklin. *On Visual Media Racism: Asians in the American Motion Pictures*. New York: Arno Press, 1978.

Zacharek, Stephanie. *"Letters from Iwo Jima." Salon Arts and Entertainment*. 20 Dec. 2006. http://www.salon.com/2006/12/20. 11 Jan. 2012.

Section Three

Portrayals of Class, Race, and Ethnicity

Chapter Ten

Fatherhood, Fidelity, and Friendship:
Owen Thoreau Jr. and *Men of a Certain Age*

Three men awaken, one to a lonely hotel room, one to his lover, and one to a little boy dressed as Hulk Hogan. Yelling and bounding up and down, the young superhero shoots green plastic balls at his father.

"Go out of this room," the father says to him, firmly.

"Mommy said to get up because you gotta go exercise," the boy replies.

"Don't you shoot that thing," the exhausted man threatens, as a green ball knocks a lamp off the bedside table and shatters it.

Although he is not Cliff Huxtable of *The Cosby Show* (1984–1992), Owen Thoreau Jr. (Andre Braugher) is a realistic version of a middle-class African-American father living in a Southern California suburb. He adores his wife, reacts calmly and affectionately to his children, and has a complicated and often difficult relationship with his own father—for whom he works. As one of the *Men of a Certain Age*, Owen Thoreau Jr. also takes his friendships seriously, and unlike Clair and Cliff Huxtable, he devotes a significant amount of on-screen time to friendships outside the home.

Patient and compassionate by nature, Owen Thoreau Jr. never wavers from his responsibility to his family, his friends, and his work. Each day, he silently recommits himself to the challenges that confront him. He does not consider himself heroic; he is simply a man who understands his obligations and who cares deeply about the people who rely upon him. Unlike Cliff Huxtable, Thoreau Jr. does not manage the household with pithy one-liners and rarely solves family problems during the allotted time frame.

In short, Owen Thoreau Jr.'s children do not always delight him, his father does not jovially join the family for dinner, his wife struggles

unsuccessfully to re-enter the work force, and he rarely resorts to physical comedy. A diabetic, Owen Thoreau Jr. struggles to adhere to his diet and is the usually good-natured object of humor related to his love of food. In "You Gonna Do That the Rest of Your Life?" his son Jamie (Kwesi Boakye) worries about his father's weight and his health. Even his wife Melissa Thoreau (Lisa Gay Hamilton) cautions him, "Big man, slow down." Jamie videotapes Owen Thoreau Jr. sneaking ice cream from the refrigerator, and Melissa explains the behavior to her husband: "He's afraid his father is going to die." Owen Thoreau Jr. is not perfect: home renovations go awry, he sneaks food in the middle of the night, he worries about having a wife who works outside the home, and he struggles to keep up with his friends on morning hikes.

Well known for his role in *Gideon's Trumpet* and *Homicide: Life on the Street* (he won a 1998 Emmy Award for "Outstanding Lead Actor in a Drama Series" for his portrayal of Frank Pembleton), Braugher portrays a faithful father and loyal friend on *Men of a Certain Age*. The television series, which first aired on Dec. 7, 2009, was canceled after its second season. Before its cancellation, it drew 5.4 million viewers, becoming the most-watched series launch of 2009 on cable among adults 25-54.

The pilot ("Let It Go"), which featured Owen Thoreau Jr. with friends Terry (Scott Bakula) and Joe (Ray Romano) at Norm's Diner, promised viewers a very different kind of American male bonding. Each week, the Beach Boys classic "When I Grow Up (To Be a Man)" invited viewers into another episode about fatherhood, fidelity, and friendship among men who exercise together, take weekend trips, and meet over lunch to share the news of their lives.

From Cliff Huxtable to Owen Thoreau Jr.

The short-lived dramedy about the challenges, fears, and joys of middle-aged men gave television viewers a realistic portrait of an African-American man who works hard, cares deeply about those around him, struggles to compete in a male-dominated Chevrolet dealership, and expresses his emotions. *"Men of a Certain Age* is not violent, exciting or fast paced, but the series has a quiet charm of its own: it is a believable, sharply observed portrait of ordinary men who, through all-too-common bad breaks and missteps, feel that they are backsliding," writes Allesandra Stanley in "Pals at a Certain Stage." Stanley calls Owen Thoreau Jr. "a grumpy father to kids who don't listen and a cranky husband to a calm, competent, good-looking wife who loves him, sleep apnea and all."

Created and co-written by Ray Romano and Mike Royce, the first season of *Men of a Certain Age* featured Owen Thoreau Jr. with his family, although his wife and children all but disappeared in season two. When *Men of a Certain Age* premiered, Tom Shales wrote in the *Washington Post* that the television program had "a lot to do with dreams once dreamed," and this nostalgia had as much to do with having children and dealing with primary relationships as it did with success in the workplace. Shales suggested that much of the charm of *Men of a Certain Age* revolved around Owen and Melissa Thoreau. "Hamilton and Braugher achieve a sweet working rhythm together," Shales wrote, and "you can see what this husband and wife see in each other and how that sustains them." Calling the show "bittersweet, poignant and wise," Shales added, "It's not just a series, but something of a tonic."

In addition to his relationship with his wife, Owen Thoreau Jr. deals almost daily with his father (Richard Gant), a self-reliant, proud man who does not want his son to see his failures. A former NBA star, he postures and swaggers, and his detachment from his son makes intimacy impossible. With characteristic patience, Owen Thoreau Jr. simply tries to wait him out.

When Owen Thoreau Jr.'s father selects someone else to be sales manager at his Chevrolet dealership, Thoreau Jr. protests calmly: "My numbers are as good as anybody else's," he says. "Daddy, I work my ass off around here." His father counters, blaming him for "coming in that door all late," for taking long lunches, and for leaving early. He tells him that he needs "a face for the company," suggesting that Owen Thoreau Jr. will never be that image. As his anger escalates, Thoreau Sr. accuses his son of being "sloppy," of "breathing hard just walking from the car," and of "shooting up at your desk with your needle," a cruel reference to his son's struggle with diabetes. Eventually, Thoreau Sr. levels his most vicious attack: "Son, you are an embarrassment." Left in his father's office alone, Thoreau Jr. covers his mouth, loses his composure, and weeps silently.

But Owen Thoreau Jr.'s relationship with his father does not define him, and his friends and family are deeply devoted to him. On a hike with his friends, he suffers a diabetic seizure, and those who love him race to his side. At the hospital, his sons climb onto his hospital bed, and a bandage with a Hulk Hogan logo adorns his broken nose. He admits to hating his job at the dealership. Telling his wife he's 48 and is "not going back to that place," his wife tells him, "Listen. You gotta keep working." She reminds him that they have a new baby, that they must pay for the private schools their sons attend, and that they are renovating the house. "You just have to keep on workin', honey," she teases him. "You work. And we grow old together. And we're

happy. Cuz we have money." Conceding the wisdom in her argument, Owen Thoreau Jr. tells her good-naturedly, "I'm the Hulk."

The episodes entitled "Let It Go" and "Mind's Eye" document the courage and resilence of Owen Thoreau Jr. as they chronicle his return to work after the painful encounter with his father. He knocks a colleague into a potted plant to get to a customer first—as his father gazes down at the showroom from his second-floor office window. Having accepted the smallest demo on the lot—a car too small for a baby seat and his sons' sports gear—Owen Thoreau Jr. must deal with further humiliation when his wife goes behind his back to ask his father to give him a car suitable for the family. Eventually, he negotiates a new car and drives home proudly in a Corvette convertible. Melissa and Owen laugh as they acknowledge the symbolism behind the sports car. They keep the car for only a day but agree that they deserve to enjoy it and the freedom it represents. The next day, Owen Thoreau Jr. arrives home in a family sedan.

In addition to maintaining a work ethic, Owen Thoreau Jr. is principled and loyal to his friends. In "The New Guy," he stands up for his friend Joe, whose former wife is in a new relationship. After protecting his friend from information that will hurt him, he begins to worry about his own primary relationship. Insecure, he returns home and walks into the backyard garden where his wife is working. "Hey, sexy," she says to him. "People are screwed up," Owen tells her. "Not us," she says, kissing him. "Not yet," he responds, darkly. "Not ever," she tells him. "You hear me? Not ever."

Other episodes portray Owen Thoreau Jr. in stressful situations at home and at the office. In "Powerless," for example, Owen Thoreau Jr. and his family wake to a house without electricity because of a problem with their extensive renovation. Thinking the problem will be addressed quickly, Melissa asks her husband to pick up a movie on the way home because she is tired of their sons and is "about to strangle those two." Already exhausted, Owen Thoreau Jr. leaves for work and begins to realize that his contractor's code violations will not be easy to address.

Because Thoreau Jr. cannot deal with bureaucratic mazes efficiently, the family must move in with Owen Thoreau Sr., who competes with his grandchildren while playing cards and makes everyone miserable. At the end of the episode, Thoreau Jr. visits the Department of Building and Safety and through persistance is able to persuade an employee to turn his electricity back on. Thoreau Jr. simply asks him, "You got a father?" He explains what his life is like in his father's house, and the employee softens. In the next scene, Owen Thoreau is standing outside the department with the song "Rocky" playing in the background. Viewers can identify with his daily challenges and vicariously celebrate his perseverance.

Home life may be difficult, but Owen Thoreau Jr.'s office is no less challenging. In "Father's Fraternity," a colleague, Marcus (Brian J. White), becomes Thoreau Sr.'s favorite employee and stands next to him in a local television ad. One morning, as Owen and Melissa awaken and begin to make love, the commercial airs. Stunned, they watch and forget what they were doing. "My father ruined some perfectly good sex this morning," Thoreau Jr. says. Marcus calls him "Junior O" at work, and the rivalry continues through several episodes. Eventually, of course, Thoreau Jr. gains his father's confidence and is made owner of the dealership, although the second season makes it clear that Thoreau Sr. still is capable of cruelty; in fact, he sells the dealership, and his son has to fight to regain it. Little by little, Owen Thoreau Jr. better understands his father and seems to acknowledge his complicity in the family dynamic. For example, in "Back in the Shit," Thoreau Jr. tells his father, "I always had my own dream…I ended up inside one of yours."

The Critical Assessment

Men of a Certain Age was occasionally brilliant, sometimes flawed. Critics and viewers struggled to categorize it, especially with comedic actor Ray Romano, famous for *Everybody Loves Raymond*, at the helm. In a Dec. 7, 2009, review, Alan Sepinwall compared the dramedy to "an older, testosterone-infused version of *Sex and the City*." Some critics celebrated its edgy comedy, others its character-driven plots, others its images of masculinity—that included drinking beer and watching basketball. However, *Men of a Certain Age* focused almost entirely on the escapades of gentle men who made mistakes but tried to do no harm.

Other critics weighed in: On Dec. 4, 2009, Barry Garron called *Men of a Certain Age* a "bold, honest drama," Brian Lowry said the show possessed the "understated tone of a French comedy," Rob Owen called it "pathos-tinged," and in "Trio's Take on Midlife Is No Laughing Matter," Matthew Gilbert called it a "probing, occasionally bleak drama." In "TNT Has a Winning Drama in *Men of a Certain Age*" (Dec. 7, 2009), David Zurawik writes, "What a wise, wry and touching new series—and so many things to like." Somewhat whimsically, Tim Goodman states in "TNT's 'Men' Gets It Right—So Far" that the unusal prime-time program was "an introspective, more nuanced and slightly more depressing look at how hard it is to accept that you may not be what you wanted to be by the time you're a lot older than you thought you'd be."

Interestingly, some of the most insightful observations are those by women, including Nancy Franklin in "Sad Men: Comedy Comes of Age on

TNT" (Dec. 14, 2009) and Nancy Dewolf Smith in "The Mirror Has Three Faces." The title song, Franklin writes, "plays over a montage of old home movies of little boys doing classic little-boy things and going through rites of passage: bicycling, running under the sprinker, wearing superhero capes, teasing girls, throwing mortarboards in the air": "The last shot is of a boy throwing a balsa-wood airplane up into the air," she writes, "and the joy and momentum—the sense of aliveness—expressed in the thrust of his arm as it launches the plane are almost heartbreaking." Describing Joe, who owns a party supplies store, Franklin continues:

> One night, outside his store, Joe looks up at a big promotional balloon figure with a smiling face. It's just a balloon, but with the wind whipping it around in the light of the parking lot it looks threatening. What *Men of a Certain Age* illustrates is that when you reach that certain age life gets scary all over again. (n.p.)

Nancy Dewolf Smith praises *Men of a Certain Age* as a show "that doesn't patronize us with nonsense, but simply says, over and over, in ways that can bring tears both of sorrow and of laughter: When it comes to living, we are all in the same rocking boat."

Some critics saw the show as a eulogy to youth and lost dreams, and several are especially interested in Andre Braugher's character. In their December 2009 reviews, Ken Tucker says *Men of a Certain Age* suggests that "adulthood has turned out to be a bummer," and Lesley Smith focuses upon Thoreau Jr. and his "most unheroic of roles." Lesley Smith describes the character as "crushed between his domineering father and a family lifestyle he cannot afford, locked in a job where he makes not-quite-enough money only by persuading people to spend far more than they can possibly afford."

A few critics understand that Thoreau Jr. is an allegorical figure. Lesley Smith addresses the anger that "haunts the prosperous middle classes of the West, where plenty is never enough and contentment's a forgotten art." Although the critique is powerful, it is overwrought and detracts from the lighthearted charm of *Men of a Certain Age*, as three friends without role models make their way as we all do—with both confidence and despair. Reviewer Peter Swanson also focuses upon Thoreau Jr., calling Braugher's "the strongest performance in the show, playing a man who's trying to figure out how much unhappiness he can endure to guarantee himself an okay life." Swanson considers Thoreau Jr. representative, too, this time a symbol of the "bleakness of modern American life." In "*Men of a Certain Age* Gets It Right" (Feb. 21, 2010), Tim Goodman, states: "Braugher's nakedness is brave." He adds:

There are more melancholy and plaintive moments than humor—acerbic or otherwise. When you think it will leaven or undercut the tough emotions and veer somewhere safe or familiar, it doesn't. The series has more of an interior, existential aspect than anyone had a right to expect. (n.p.)

Owen Thoreau Jr. and African-American Fatherhood

Men of a Certain Age does not concern itself with issues of race and ethnicity, and the three friends are refreshingly colorblind. However, Thoreau Jr. and his extended family provide a positive and compelling look into a fully functional, happy African-American family with the same concerns as others who choose to build a life in suburbia. Perhaps without intending to do so, *Men of a Certain Age* counters the stereotype of the absent African-American father in much the same way that *The Cosby Show* did—with subtlety and quiet grace.

In a foreword to *Faith of Our Fathers: African-American Men Reflect on Fatherhood*, Alvin F. Poussaint, who served as a consultant on *The Cosby Show*, argues that black men continue to struggle with societal expectations and stereotypes. "No matter how high black men climb, they must still battle the traditional stereotypes and negative images of black masculinity, one of which is the demeaning public perception that they often fail in their fathering role" (xiv), he writes. Arguing that "media images have dealt unfair and damaging blows to the black father's status," Poussaint writes that the portrayal of "irresponsible, out-of-wedlock and/or absent, hustling fathers who avoid gainful employment and sexually exploit women is widespread" (xiv). Given that the divorce rate among blacks is twice that of whites and that, as recently as 1996, the poverty rate of blacks was 34 percent to 12 percent for whites, Poussaint suggests that "unemployed black men with low self esteem are easily seduced into believing that manhood is gained by 'making' babies rather than by raising them" (xix).

The editors of *Black Fathers in Contemporary American Society: Strengths, Weaknesses, and Strategies for Change* focus upon marriage as an important institution instead of specifially addressing African-American fatherhood. They argue strongly that marriage and intact family units provide children with better opportunities: "For an entire rising generation of young African Americans, including the growing numbers who will have attended college, the absence of a stable marriage may be the most important barrier keeping them from entering the middle and upper classes" (167), they write. According to their 2000 study, by age 30, 80 percent of white women but

only 45 percent of black women have married. Their data suggest that marriage provides more financial security for women and children.

Other studies focus specifically on African-American fathers and continue the discussion about which home environments provide the most financial and social stability for children. *The Myth of the Missing Black Father* features essays such as "'My Kids and Wife Have Been My Life': Married African American Fathers Staying the Course" and includes topics such as poverty and parenting, biracial children, single custodial fathers, African-American men rearing children in violent neighborhoods, and fathers on parole or on probation. In their introduction, editors Roberta L. Coles and Charles Green write:

> The black male. A demographic. A sociological construct. A media caricature. A crime statistic. Aside from rage or lust, he is seldom seen as an emotionally embodied person. Rarely a father. Indeed, if one judged by popular and academic coverage, one might think the term "black fatherhood" an oxymoron. (3)

According to the editors, in 2000, "only 16 percent of African American households were married couples with children, the lowest of all racial groups in America."

To no one's surprise, authors and editors are deeply divided about the progress black men are making as parents and providers. Editors of *Black Fathers: An Invisible Presence in America* employ words such as "absent," "missing," "nonresidential," "noncustodial," "unavailable," "nonmarried," "irresponsible," and "immature" to describe perceptions of African-American fathers. However, in a much more optimistic study of black fatherhood, Aaronette M. White includes a chapter entitled "Sweet Daddy: Nurturing Interactions with Children" in *Ain't I a Feminist?: African American Men Speak Out on Fatherhood, Friendship, Forgiveness, and Freedom*. In the chapter, she writes:

> Although no single way of being a father will work for all men, African American men have come to represent the most negative ones. Historical, economic, and sociocultural factors complicate the efforts of African American fathers who are trying to engage actively and responsibly in their children's lives. However, those who defy the odds are largely missing from contemporary discourse and literature on fatherhood. (156)

White writes persuasively about the poor, working class, and middle-class families who are less able to afford options that make child-rearing easier for "privileged professionals" (173). She argues that the men in her study—both

gay and straight African Americans—are "redefining fatherhood" and are embracing "gender-neutral parenting" and a "violence-free home" (173).

Conclusion

The portrait of the African-American father in American television history is a shallow one. In spite of the successful miniseries *Roots* (1977) and *The Cosby Show* (1984–1992), there are few portrayals of black men in stable and compassionate roles as caregivers for children, although it is also true that Cliff Huxtable's relationship with his children transcends class and race and ethnicity. His playful and deeply affectionate interaction with his children models fatherhood for us all. In "Bill Cosby: America's Father," Anne Chan acknowledges that Bill Cosby as Cliff Huxtable is the "enduring icon of the ideal American father" (125). Cosby's popular book *Fatherhood* (1992) added to the fame he enjoyed with "The Cosby Show," a television phenomenon that drew as many as 60 million viewers and was rated number one for eight seasons. Cliff and Clair Huxtable, an upper middle-class couple with five children (Sondra, Denise, Theo, Vanessa, and Rudy), lived happily in their New York brownstone, managing two full-time careers with humor and affection. They were a "loving, healthy, intact nuclear Black family" (126), writes Chan.

Before *The Cosby Show*, black men were featured on *Benson, Different Strokes, Good Times, The Jeffersons,* and *What's Happening,* but the focus of the situation comedies was not on the commitment African-American men made to their families. Cliff Huxtable changed all that: With his "sensitivity, good humor, openness, caring, confidence, and gentleness," Cosby "gave the Huxtable father an endearing humanness by depicting a Dad who sometimes made mistakes and who was at other times less than enthralled with his children," Chan writes. "Overturning the stereotype of the hypersexualized, wanton Black man, the show depicted a loving Black man who was a supremely faithful, loving, trustworthy, and dependable husband" (132).

No description better suits Owen Thoreau Jr., who adores his wife and loves his children but who does not always find home life joyful or even fulfilling. Thinking of himself as Hulk Hogan has its pluses and minuses, and waking to a disobedient and destructive son is not his life's dream. However, *Men of a Certain Age* allows the audience a glimpse into the pleasures of the average life, the reassurances of routine. Friends since college, Joe, Owen, and Terry are 40-somethings reaching for the stars and fearful that the best of life is past.

The first season of *Men of a Certain Age* shimmers—in large part because Owen and Melissa Thoreau embody parenthood at its best and worst. The second season continues the storylines of the three protagonists but begins to lose its focus by introducing too many ancillary characters. The audience cannot care deeply about all of Joe's employees, his golf mentor, his girlfriends, his bookie, and his ex-wife and her on-again, off-again relationships. Owen Thoreau Jr.'s relationship with his wife and children during season one was far more interesting than the Chevrolet dealership and its financial crises. With a few exceptions—including "Same As the Old Boss" in which Melissa announces, "I want to go back to work," and "The Great Escape" in which Owen and Melissa fantasize about selling the dealership and pursuing their dreams—the second season rarely provides glimpses into the life of the younger Thoreau and his family. Writers miss an opportunity to address the successes and failures of Owen Thoreau Jr. and the relationship he is building with his sons, who also are growing up to be men.

Featuring marriage and its benefits and challenges might have made *Men of a Certain Age* more popular among both men and women. Running out of adventures for Terry, the character who prides himself on his sexual exploits, the writers introduce a woman whom viewers (and Terry) want to know better. However, he resumes his excursions into superficial relationships and diminishes the dramatic potential of this important connection.

Certainly, lyrics in the theme song—"Will I love my wife/ For the rest of my life?"—and Carole King's "Will You Still Love Me Tomorrow?" that plays in the background during one episode suggest the centrality of heterosexual love, courtship, and marriage in the television series. Dealing seriously with Melissa Thoreau's desire not to be the mother who "fills her day worrying about the kids eating magnets" would resonate for many married women approaching 50, but Melissa and her ongoing relationship with Owen fade into black in the last episode of what would be the second and final season.

Men of a Certain Age illustrates the pitfalls and potentials of dramedies in American television history. Like *Frank's Place*, it briefly intrigues critics but loses its viewer base. Unlike *The Cosby Show*, it dissipates its focus by featuring too many characters. And unlike *Sex and the City*, where four women become essential to each other's happiness, *Men of a Certain Age* fails to convince viewers that hikes and lunches are significant bonding experiences for three men who clearly depend upon one another. In spite of its failures, however, *Men of a Certain Age* continues the quest to feature male friendships during prime-time television—in no small part because of its successful portrayal of a flawed African-American man who defines himself as a father and husband.

Works Cited

Chan, Anne. "Bill Cosby: America's Father." *Black Fathers: An Invisible Presence in America.* Ed. Michael E. Connor and Joseph L. White. Mahwah, N.J.: Lawrence Erlbaum, 2006. 125–43.

Clayton, Obie, Ronald B. Mincy, and David Blankenhorn, eds. *Black Fathers in Contemporary American Society: Strengths, Weaknesses, and Strategies for Change.* New York: Russell Sage Foundation, 2003.

Coles, Roberta L., and Charles Green, ed. *The Myth of the Missing Black Father.* New York: Columbia University Press, 2010.

Connor, Michael E., and Joseph L. White. "Introduction." *Black Fathers: An Invisible Presence in America.* Mahwah, N.J.: Lawrence Erlbaum, 2006. ix–xiv.

Franklin, Nancy. "Sad Men: Comedy Comes of Age on TNT." 14 Dec. 2009. http://www.newyorker.com/arts/critics/television/2009/12/14/091214. 17 May 2010.

Garron, Barry. *"Men of a Certain Age."* 4 Dec. 2009. http://hollywood reporter. 17 May 2010.

Gilbert, Matthew. "Trio's Take on Midlife Is No Laughing Matter." 7 Dec. 2009. http://www.boston.com/ae/tv/articles/2009/12/07. 17 May 2010.

Goodman, Tim. *"Men of a Certain Age* Gets It Right." 21 Feb. 2010. http://www.chron.com. 17 May 2010.

———. "TNT's *Men* Gets It Right—So Far." 7 Dec. 2009. http://www.sfgate.com. 17 May 2010.

Lowry, Brian. *"Men of a Certain Age."* 4 Dec. 2009. http://www.variety.com/review. 17 May 2010.

Owen, Rob. "Tuned In: *Men of a Certain Age."* 6 Dec. 2009. http://www.post-gazette.com. 17 May 2010.

Poussaint, Alvin F. "Foreword." *Faith of Our Fathers: African-American Men Reflect on Fatherhood.* Ed. Andre C. Willis. New York: Dutton, 1996. xiii–xx.

Sepinwall, Alan. *"Men of a Certain Age* Review." 7 Dec. 2009. http://www.nj.com/entertainment/tv/index.ssf. 17 May 2010.

Shales, Tom. "TNT's Truly Adult Fare." 7 Dec. 2009. http://www.washingtonpost.com. 17 May 2010.

Smith, Lesley. *"Men of a Certain Age:* Series Premiere." 7 Dec. 2009. http://www.popmatters.com. 17 May 2010.

Smith, Nancy Dewolf. "The Mirror Has Three Faces." 4 Dec. 2009. http://online.wsj.com. 17 May 2010.

Stanley, Alessandra. "Pals at a Certain Stage: Post-Salad, Pre-Grumpy." 7 Dec. 2009. http://nytimes.com/2009/12/07/arts/television. 17 May 2010.

Swanson, Peter. *"Men of a Certain Age:* Season One." 7 Dec. 2009. http://www.slantmagazine.com. 17 May 2010.

Tucker, Ken. *"Men of a Certain Age* (2009)." 2 Dec. 2009. http://www. ew.com. 17 May 2010.

White, Aaronette M. "Sweet Daddy: Nurturing Interactions with Children." *Ain't I a Feminist?: African American Men Speak Out on Fatherhood, Friendship, Forgiveness, and Freedom.* Ed. Aaronette M. White. Albany, N.Y.: State University of New York Press, 2008. 156–74.

Zurawi, David. "TNT Has a Winning Drama in *Men of a Certain Age.*" 7 Dec. 2009. http://weblogs.baltimoresun.com/entertainment/zontv/2009.

Chapter Eleven

Frank's Place:
Coming Home to a Place We'd Never Been Before

In "Rocky Mountain High," singer-songwriter John Denver celebrates the
longing and the epiphany of a 27-year-old who sees the vast beauty of the
Colorado wilderness for the first time: "He was born in the summer of his
27th year/ Coming home to a place he'd never been before/ He left yesterday
behind him/ You might say he's born again/ You might say he's found a key
for every door..." A song, a novel, a television program, a mountaintop, and
other markers identify and transform us individually and collectively. They
become a part of our understanding of ourselves, and, once appropriated,
make us believe that we hardly remember a time before we heard that song,
read that short story, watched that situation comedy, or saw that skyline.

For those who loved *Frank's Place* (and who chased it determinedly
when CBS entertainment executives moved it through six different time slots
on four different nights), walking into the front door of Chez Louisiane was
akin to coming home. In "A Clean, Well-Lighted Place," Ernest Hemingway
writes about a café as a microcosm of the world in which people gather to
feel connected to one another. Television viewers continue to visit *Cheers*,
which features a quirky cast in a Boston bar, because it remains a place
where "everybody knows your name." Then there is *Frank's Place*, featuring
a restaurant that welcomed television viewers as they listened to Louis
Armstrong's theme song: "Do you know what it means to miss New Orle-
ans?/ And miss it each night and day?/ I know I'm not wrong,/ The feeling's
getting stronger/ The longer I stay away."

The nostalgia for an unknown but familiar place so prevalent in Southern literature and culture is similar to the television audience's expectation that the setting for the show will provide a sense of coming home, a sense of being located and of feeling safe. *Frank's Place* belongs with other prime-time programs such as *I'll Fly Away* and *My So-Called Life* that were lauded by critics and enjoyed by a group of loyal viewers but were cancelled by the networks. Hot, steamy New Orleans—where the locals move as slowly as molasses in the dead of summer and gather at night year-round to hear jazz and rhythm and blues—also accounts for some of the appeal of *Frank's Place*.

Although it was on the air only a season, the critical successes, artistic innovations, and social impact of *Frank's Place* make it worthy of inclusion in a collection about African Americans and their contributions to television. As sociologist Herman Gray notes in *Watching Race: Television and the Struggle for "Blackness,"* *Frank's Place* "momentarily transformed and occasionally challenged dominant representations of black Americans in commercial network television" (118–119). The show was no simplistic rendition of stereotypical American life, nor was it a challenge to racial stereotypes in the same way that *The Cosby Show* was. Rather than offering American viewers a peek into the living room of a family headed by a successful lawyer and doctor, *Frank's Place* introduced class issues and demanded that a viewer leave behind all presumptions about the South, about New Orleans, and about the African-American community in a particular locale and engage social issues, a new television genre, a beautiful but unfamiliar setting, and a central character on a quest for understanding.

Although most regular viewers feel a connection to the setting, time, characters, and storyline of their favorite shows, *Frank's Place* demanded more than simple identification. In fact, as I will argue, the show both alienated and reassured viewers, who were drawn into the warm restaurant but were simultaneously challenged by the social issues the program addressed. Wasn't a prime-time situation comedy supposed to entertain, to make us laugh, to reinforce the status quo? Why was *Frank's Place* so decentering? Furthermore, the restaurant and surrounding neighborhood were familiar because of the authenticity of the human relationships that were portrayed, but they were foreign to those viewers largely unfamiliar with a working class African-American community in an exotic, multicultural city in the Deep South. This study deals with the power of reminiscence and one's ability to "remember" a place one has never visited; with the challenges of engaging the social issues, the blend of comedy and drama, the setting, and the central point of view in *Frank's Place;* and with the show's precipitous demise.

The Creation of *Frank's Place*

Frank's Place aired on CBS from 1987–88 and featured Frank Parrish (Tim Reid), a professor of Italian Renaissance history from Boston who inherited from his estranged father a New Orleans restaurant. More than 45 percent of the cast and crew were African Americans. Co-executive producers Reid and Hugh Wilson (Wilson was also writer and director for the show) had worked together on *WKRP in Cincinnati* and had become friends. Both were Southerners. Reid graduated from Norfolk (Va.) State University in his hometown and moved to Chicago after graduation to work for DuPont. Later, after working briefly with an anti-drug program, Reid moved to Los Angeles, where he studied acting before being cast as Venus Flytrap in *WKRP in Cincinnati*. The concept for *Frank's Place* was developed by Wilson, Reid, and Kim LeMasters, then head of entertainment for CBS, but the network failed to treat the program as the co-executive producers had hoped it would: "Both Wilson and Reid claim that, eventually, even their own mothers could no longer find the show on the schedule" (4), write Richard Campbell and Jimmie L. Reeves in "Television Authors: The Case of Hugh Wilson."

Like oral historians, Wilson and Reid interviewed members of the African-American community in New Orleans, creating authenticity and credibility in their rendering of a restaurant in that city. Modeled after Chez Helene, an African American-owned restaurant in New Orleans, Chez Louisiane itself is vintage New Orleans. Wilson and Reid dined in numerous restaurants in the city during a visit in March 1987. One night, they found Chez Helene, which has been on North Robertson Street since 1964, and read a menu featuring crawfish etouffee and gumbo and oyster stew. They met owner-and-chef Austin Leslie and knew they had hit gold. "Its down-home atmosphere is what we thought *Frank's Place* should have," said Reid in "Host," a feature published in *People Weekly* in 1988. "We didn't want the sparkle or shiny décor; when you go there you feel like you're at home" (n.p.).

The co-producers successfully transmogrified the reality of African-American life in their creation of a fictional restaurant and its surrounding community. Gray praises the show for its representation: "The aspirations, pressures, joys, and troubles of waiters, cooks, and regular folk were represented with integrity rather than with the derision, exaggeration, and marginalization that too often are found in other television representations of blacks and working-class people" (121), he writes. Reid himself argues that the show captured a part of life that was familiar to him but foreign to most American viewers. In "Just Folks: From the Music to the Mortician, *Frank's Place* Captures the Real New Orleans" by Mark Christensen, Reid is quoted as saying, "This is reality, whether you like this format or not...This is about

working people. We're dealing with an aspect of black culture most people don't even know exists. I come from that culture. I didn't speak to a white man socially until I finished college" (37).

The show starred Miss Marie (Frances E. Williams), a waitress; Big Arthur (Tony Burton), the chef; Shorty La Roux (Don Yesso), a chef's assistant; Anna-May (Francesca P. Roberts), a waitress; Tiger Shepin (Charles Lampkin), the bartender; Cool Charles (William Thomas Jr.), assistant bartender; Bertha Griffin-Lamour (Virginia Capers), funeral home director; Bertha Griffin-Lamour's daughter Hanna Griffin (Daphne Maxwell Reid); Reverend Deal (Lincoln Kilpatrick); and Bubba Weisberger (Robert Harper), a lawyer. Cast members, including Reid's wife Daphne Maxwell Reid, were carefully selected to represent the locals whom Wilson and Reid met during their time in New Orleans. Having met a beautiful mortician during their trip, the two agreed that Maxwell Reid would be a perfect choice to play that character. Maxwell and Reid had begun dating in 1980 in Los Angeles, where *WKRP in Cincinnati* was filmed, although they had met almost a decade earlier in Chicago. (According to Aldore Collier in an *Ebony* article entitled "Hollywood's Hottest Couple," when Maxwell first met Reid, dressed in "plaid pants with his wing-tipped shoes," she considered him, in her words, "just plain weird" (70), although she later clearly changed her mind.) In addition to performing opposite Reid in *Frank's Place*, Maxwell Reid also performed with him in several segments of *WKRP in Cincinnati* and in 16 episodes of *Simon and Simon*.

The 22 episodes that follow the pilot—some of which suggest a dominant theme that sets the show apart from its contemporaries—are entitled: "Frank Returns"; "Frank Takes Charge"; "The Bridge"; "Frank Joins a Club"; "Eligible Bachelor"; "Disengaged"; "Cool and the Gang" (two episodes); "Reverend Gets His Flock"; "I.O.U"; "Food Fight," also known as "Fighting Chefs"; "Season's Greetings"; "The Bum Out Front"; "Dueling Voodoo"; "Where's Ed?"; "Night Business"; "Shorty's Belle"; "Frank's Place, the Movie"; "Cultural Exchange"; "The Recruiting Game"; and "The King of Wall Street." In addition to Wilson's and Reid's courage in representing authentic African-American life in New Orleans, many of the episodes listed here support what Bernard Timberg and David Barker consider a primary contribution of *Frank's Place:* the manner in which it dealt with what they term "social power," or, more specifically, ownership, tradition, family connections, business interests, the art of persuasion, and the skills that are valuable to a particular society ("Interpreting," 24).

The Challenges of *Frank's Place:* Social issues

The typical storyline of *Frank's Place* was one that could—without warn-ing—dislocate the viewer, no matter what his or her racial or ethnic identity, sexual orientation, religious preference, or family situation. The plot chal-lenged some viewers to deal more deeply with their preconceptions and stereotypes. For others, it was an uncomfortable pilgrimage through a prime-time situation comedy, what had been until then a familiar and predictable television genre.

In one of the most effective episodes, for example, Frank Parrish (Tim Reid) asks the bartender, "Is this all the business we get around here at night?" As critics Reeves and Campbell write in "Misplacing *Frank's Place:* Do You Know What It Means to Miss New Orleans?": "In Tiger's answer, we learn along with Frank the basic temporal, economic and racial rules that organize this story world" (47). Tiger responds by saying, "Uh-huh. Except on Saturday night and sometimes Friday. You see, these are all working people down here in our neighborhood. They don't go out to dinner on weeknights. And white people are afraid to come down here after dark."

In another equally memorable scene, Parrish is invited to join a club of African-American professionals. He is honored and proud until Anna-May, one of his employees, shows him a brown paper bag and contrasts its brown tone with Parrish's darker skin color. He then understands that those who extended him the invitation to join are using him to challenge what television reviewer Lucy Liggett calls the "light-skin bias" of some of the club's members.

As a white viewer seduced by the stylistic innovations and lush setting of *Frank's Place,* I was often placed outside the otherwise welcoming sphere of the show and had to evaluate my own position in, identification with, and loyalty to the group of white people "afraid to come down here after dark." For me, and presumably for other viewers, *Frank's Place* was an important reminder that a love for aesthetics could not replace self-awareness and could not mask the reality of a world in which we both do and do not belong. Reeves and Campbell, ardent fans of the show, acknowledge the importance of being invited in and simultaneously left out of a fictional universe when they write, "In recognizing the truth of Tiger's words, viewers are asked to reconsider the meaning of their own class positions and the consequences of their own attitudes regarding race and class" ("Misplacing," 47).

The best and worst characteristic about *Frank's Place* was that, as Gray also says, "the series was distinguished by its explicit recognition and presentation of the habits, practices, manners, nuances, and outlooks of black Americans located in New Orleans" (119). It therefore required that viewers

step out of their familiar ways of ordering the world and "negotiate the world of *Frank's Place* through the experiences of black subjects" (120), Gray adds. A comfortable enough practice for those who readily engage other ways of being and knowing in literature and other texts, the demand may have been too much for American television viewers who had settled into a predictable set of expectations reinforced by American television programming.

Because "the show is not simply didactic nor does it merely offer a voyeuristic tour of black experiences that disempowers or exoticizes black subjects" (120), as Gray writes, *Frank's Place* was not everyone's cup of "dramedy," a combination of comedy and drama. "*Frank's Place* required its audience to engage directly the issue of cultural difference," Gray writes. "The show also demanded competence, patience, and engagement to produce pleasure and maintain interest. The narrative structure, thematic approach and cinematic look of the show disturbed the normal television experience. Given the institutional and market structure of commercial network television at the time, *Frank's Place* may have required too much work; it may have asked too much of an audience for which African American culture remained a fuzzy and distant experience" (125).

The Challenges of *Frank's Place:* Setting

For some of us, the extent and intensity of the desire to visit *Frank's Place* came as a surprise. Viewers of a particular generation—who grew up whistling with Andy and Opie Taylor as they trudged down a dirt road to an ol' fishin' hole near Mayberry—were sure to be surprised by *Frank's Place*. And yet I and others of various racial and ethnic groups tuned in weekly to hear Louis Armstrong sing "Do You Know What It Means to Miss New Orleans?" as photographs of New Orleans flowed past on the television screen like pages in a treasured family album. The "visual montage" that opens the show, writes Gray, was characterized by "sepia-toned stills of New Orleans life" that included "scenes of riverboats, the Mississippi River, Louis Armstrong, the Preservation Hall Jazz Band, the French Quarter, and Congo Square" (120). The setting and the painstaking production techniques were bait enough for viewers to visit Chez Louisiane.

The food, language, setting, dress, and music of New Orleans were faithfully represented in *Frank's Place*. In "Just Folks," Wilson is quoted as saying, "Everybody likes generalizations, and I think I've got one. New Orleans is about food, music, whiskey and death. Not necessarily in that order" (37). Blues, jazz, rhythm and blues—African-American popular

musical forms—added to the sense that the viewer had stepped into a realistic although perhaps unfamiliar world. During the show, African-American musicians such as Louis Armstrong, Slam Stewart, B.B. King, Muddy Waters, and Dizzy Gillespie were acknowledged as cultural heroes in the way African-American musicians often were celebrated during their guest appearances on *The Cosby Show*. The music of *Frank's Place* was, as Joe Moorehouse writes in "Black Music and Television: A Critical Look at *Frank's Place*," "a motif, a subtext, even a character" (41). Moorehouse even describes the resident jukebox as being "like a wise old man who consoles, supports, mocks, passes judgment, and otherwise comments on the inhabitants of the bar and their actions" (43). Examples of songs that gave *Frank's Place* its distinctive quality include those unfamiliar to viewers who listened to Contemporary Hits Radio (CHR), including "Old Time Zydeco" by Rockin' Dopsie and "You Act Sick When Your Man is Home" by Boozoo Chavis.

In spite of its reliance on a sense of place, *Frank's Place* was not an armchair tour of New Orleans. It dealt with social issues that de-centered both the characters and the viewers. Drug abuse, the recruitment of African Americans in sports, voodoo, homelessness, and other topics reminded the viewers that this was not your average situation comedy. As Timberg and Barker note in "Interpreting Television: A Closer Look at the Cinematic Codes in *Frank's Place*," "The denizens of *Frank's Place*—cooks, waiters, waitresses, and regular customers—characteristically become onlookers to the main action of each episode, which centers on the problem or crisis brought in from the outside world" (20).

The importance of a show set in the Deep South cannot be minimized, although it is difficult to know if its setting contributed to viewership in other regions or not. Horace M. Newcomb writes in "The Sense of Place in *Frank's Place*": "The South is a place, charged with meaning. It is a matrix of contradiction, a pattern of paradox. The region has its own shaded markers, its internal distinctions. Highland and lowland, tidewater and coastal plain, hill country and delta, swamp and piney woods, are inflected in terms of accent and dress, architecture and crop, hunter and hunted, and, most significantly, class and race" (32).

Although the setting added to the richness and mythology of the show, much of the country knew little about African-American culture, Southern culture, or New Orleans life. For this reason and others, according to several critics, the show may have demanded too much of its viewers. As noted earlier, Wilson, who worked in civil rights before becoming a television writer, and Reid were Southerners; they were determined to replicate the African-American community they encountered in New Orleans. Having

been born in Coral Gables, Fla.; having attended the University of Florida in Gainesville; and understanding the complexities and contradictions of the Deep South, Wilson wanted to portray his region positively. "Offended by TV's *Dukes of Hazzard* treatment of things southern, Wilson was determined to create a more authentic vision of his native region" ("Television Authors," 9), write Campbell and Reeves.

If one believes media critics such as Timberg and Barker, then Reid and Wilson succeeded: "Together, cinematography and score establish the tone and feel of *Frank's Place*. They place it, particularly at the beginning and end of the show, in a sort of mythical time and space—a mythical New Orleans" (23). But did the decision to locate the show in New Orleans make it even less possible for a viewer in California or Nebraska or Connecticut to identify with the people, the customs, and the symbolic system of *Frank's Place?*

Viewers had to confront the cultural and sociological differences addressed by the show, usually with the same awkwardness and sense of dislocation often experienced by the characters themselves. For some, the effort was a worthwhile challenge; for others, too much frustration. As Gray writes, *Frank's Place* "illustrated the hegemonic strategies of containment operating in the commercial television system. Thus, although it challenged conventional aesthetic and generic boundaries and offered new ways to represent aspects of black life in the United States, *Frank's Place* did not survive in the high-stakes world of commercial popularity" (125). In addition to dislocating some viewers, the plot line presented its own challenges, as did the shifting central point of view. "The characteristic narrative structure of *Frank's Place*," write Timberg and Barker, "is a play within a play, which we, as viewers, witness along with the more immediate audience in the restaurant" (20). Avoiding the neat conclusion at the end of most situation comedies familiar to American audiences, *Frank's Place* most often ended "on a pause, a moment of reflection" (21), they write.

The Challenges of *Frank's Place:* "Dramedy"

Frank's Place claimed a home within several familiar television legacies at the same time that it challenged traditional genres. There are television shows in which co-workers become at least as important as family members (*Cheers, The Mary Tyler Moore Show, Murphy Brown, M*A*S*H*, and others). There are shows that feature African-American actors (*Good Times, The Jeffersons, A Different World, Sanford and Son, The Cosby Show*, and others). There are dramas with African Americans in primary roles such as

I'll Fly Away and others too numerous to list. There are television shows with unresolved endings *(Thirtysomething, Dallas, Knot's Landing, Dynasty,* and others).

There also are "dramedies"—shows that rely upon a blend of comedy and drama with few plot resolutions—such as *The Wonder Years, Soap,* and *Mary Hartman, Mary Hartman.* Unfortunately, "dramedies" such as *Buffalo Bill, Hooperman,* and *The Days and Nights of Molly Dodd* represented less successful examples of the genre, and *Frank's Place* suffered by association. Mimi White writes in "What's the Difference?: *Frank's Place* in Television" that "dramedy" appeared in the 1980s, "combined the half-hour situation comedy format with a range of dramatic (even melodramatic) plots," and "usually included some degree of play with narrative conventions, including the use of voiceover narration and narrative intertitles, episodic and frag-mented sequences of action, degrees of open-endedness and indefinite closure, the absence of a laugh or applause track, and so on" (85). Although, as White notes, "the very label 'dramedy' signified situation comedy *with a difference"* (86), the genre rarely succeeded.

However, despite its similarities to established television programs, *Frank's Place* unapologetically carved out its own niche. "Socially and esthetically," Gray writes, "the distinctive character of *Frank's Place* derived from a variety of historical, generic, and aesthetic elements: situation come-dy, the workplace family, American racial memory, shows about region and location, and the tradition of black situation comedy" (118). The show possessed an almost documentary quality, a direct result of Wilson's and Reid's determination to recreate the authentic and myriad African-American customs and behavior in New Orleans and Wilson's determination to "revive that great American dead art form, the short story, and think of ourselves as short story writers" (55).

In spite of its challenges for viewers, *Frank's Place* must not be consid-ered a failed attempt to mimic a questionable genre. Receiving more than its share of critical acclaim, its blend of comedy and drama placed it with *The Wonder Years* and other "dramedies" that were adeptly produced by those who created a microcosm of America and engaged social issues. In 1987 *Frank's Place* won the Television Critics Association award for "Outstand-ing Comedy Series." In 1988, one episode, "The Bridge," won Emmy awards for best writing in a comedy series (writer and co-executive producer Hugh Wilson) and outstanding guest performance in a comedy series (Beah Richards). Reid took home a 1988 NAACP "Image Award." "Critically, *Frank's Place* received rave reviews," writes Gray. "It was hailed by televi-sion critics and the public as innovative and refreshing television" (117).

The Challenges of *Frank's Place:* Point of View

One of the "innovative and refreshing" components of *Frank's Place* was the central character himself. However, because Parrish represented what Gray calls the "critique and strategies for change" (125) in the portrayal of African Americans on television, some viewers had trouble finding a familiar and reliable lens through which to view events in the show. Unlike male protagonists in everything from *Father Knows Best* to *Leave It to Beaver* to *The Dick Van Dyke Show* to *The Andy Griffith Show* to *All in the Family* to *The Wonder Years* to *The Cosby Show*, Parrish was a seeker without a definitive narrative voice. Although Timberg and Barker identify Parrish as the "show's organizing sensibility" and "overarching presence" (20), he, like the viewer, was on a pilgrimage, sometimes sure-footed but often without a compass.

At the heart of Parrish's phenomenological quest is the need to make meaning out of a complex system of signs and symbols in his new home. Through his semiological journey, he struggles to find what Wallace Stevens calls a "blesed rage for order" ("The Idea of Order at Key West"). Newcomb captures the significance of Parrish's pilgrimage when he writes, "The Chez is *Frank's* place because he inherited it. But not one of these rooms will be Frank's *place* until he learns its meanings" (35). Although the viewer might see and interpret the setting through Parrish's eyes, Parrish, too, is struggling to understand the sign system in the place in which he finds himself.

This complex narrative point of view, in and of itself, may suggest one reason *Frank's Place* held onto some of the viewers it seduced and lost others. As Newcomb writes, "The paradoxical sense of comfort in being guided, as it were, by a stranger in a strange land is fundamental to the structure of television narrative" (35). As Reid himself notes in an interview with *American Film*, "Frank Parrish was a delight but he was out of it, and I played him that way, a guy who didn't know his tail from a banjo" (25). This description of the character he played underscores the opinion of Reeves and Campbell when they call events in Parrish's life from week to week "tragicomical experiences" ("Misplacing," 46). Reid's struggles to understand his environment and to relate to those around him were both familiar and unsettling for viewers who were more accustomed to a central protagonist who was a confident interpreter of the world.

For me, *Frank's Place* succeeds at least partially because of the vulnerability and hopeful expectation of its protagonist, attributes that characterize its viewers as well. Parrish was a compelling central character because he was a kind of Everyman. Through the inviting setting, "the initial otherness of New Orleans is quickly recast as warm familiarity and familiality," White writes. "It is not really different at all, but provides the title character with

surroundings where he can finally secure his identity in a proto-familial structure. This contrasts sharply with his life in Boston, as he loses his (long worked for) university teaching position, his girlfriend, his car and his apartment in short order" (88). Like most of us, Parrish was estranged from people he loved, was struggling to connect meaningfully with others, and was trying to create a stable identity and to succeed in the workplace.

Identifying with Parrish requires that the viewer see deeply into his persona. Reeves and Campbell are correct to focus on the significance of the microcosmic setting within Chez Louisiane, within the larger world of New Orleans, within the Deep South, and, ultimately, within America. They focus, too, appropriately enough, on the room in which Parrish lives alone, a room that is as symbolic as the restaurant itself: "Located upstairs, over the restaurant, the apartment was home to Parrish's father until he suffered a fatal stroke. In this intimate space, we come to share the dreams and despair of the internal Parrish—and we are invited to take communion in his anguish: the anguish of a man held prisoner by his father's property who lives involuntarily in his father's place" (47). He lives "involuntarily" in his father's apartment, and, perhaps also involuntarily, as his father's replacement in the wider world of the living.

The Cancellation of *Frank's Place*

The final episode of *Frank's Place* aired Oct. 1, 1989, although Black Entertainment Television (BET) began broadcasting it again in January 1990. The show's demise is attributed to various factors, including the expense of production, as well as other failures by CBS to support the show. An episode of *Frank's Place*, according to Gray, cost $650,000 to produce because of the lighting, innovative camera work, editing techniques, original music, etc. (116). Another estimate by Reeves and Campbell is between $600,00 and $630,000, versus a typical episode of *The Cosby Show* or *Family Ties* that might cost $500,000 to $550,000 ("Misplacing," 53).

Production costs were not the only reason *Frank's Place* went off the air. Reeves and Campbell quote Reid as saying that one of the problems with television is that writers and producers "will not venture into history" ("Misplacing," 51) and address issues of race and ethnicity with courage. For White and others, the show suggested concerns about future television portrayals of race and ethnicity: "The central question remains whether, and how, a prime time television series can incorporate multicultural perspectives without reducing multiculturalism to a process of generating differences in order to collapse them into universalistic categories that deny difference"

(90). But in an interview in *American Film* in 1990, Reid focused not on how *Frank's Place* collapsed difference but how it was too different from other series in its genre to succeed—not with critics or viewers—but with network owners and programmers. "There is a tremendous void, I think, in the creative leadership of network television right now," he said. "You've just got a bunch of yuppies developing comedy. All they know about comedy is *The Brady Bunch* and *Leave It to Beaver*...that's what they were reared on. And they come up with these inane, shallow premises that, after the first episode, have nowhere to go. So when you come in with something like *Frank's Place*, it's very frightening" (22). Reeves and Campbell blame the viewing public at least as much as they blame CBS executives:

> Clearly, not enough middle-class, white folks watched or even knew about the program. Unlike *Cosby* which is essentially a show about class—a show supportive of both white and black middle-class values, and therefore safer and less threatening—*Frank's Place* is a show that was supremely about region and race. The show often filtered what it is to live in mainstream America through the viewpoints of folks who live in the margins—in a black working class section of New Orleans. ("Misplacing," 57)

LeMasters expressed the CBS corporate perspective on the demise of *Frank's Place* when he said, *"Frank's Place* embodied every element of excellence that a programmer would want to see in a television show. Unfortunately, the viewing audience simply failed to respond to it" ("Misplacing," 45). It's true that *Frank's Place* premiered well in September 1987 with a 14.9 rating and a 25 percent share. It is also true that in its final airing in October 1988, it was ranked among the week's lowest-rated network shows with a 5.6 rating and a 10 percent share. But the network line is too simple and ignores its own role in moving the show and refusing to support it financially until it built a viewer base.

Conclusion

Critics have kept *Frank's Place* alive with a wistfulness rarely evident in reminiscences about other television programs. It's as though they're writing about lost friends, lost treehouses, lost tree-lined neighborhoods, lost childhoods, lost rooms in vacant houses. In the same way that *Frank's Place* producers experimented with camera angles, narrative, lighting, and music, critics become poets as they try to describe what the loss of the show represents. Timberg and Barker are a case in point: Describing the "soft-color ambience" of *Frank's Place*, they write, "It suggests that when we are in the

restaurant we are in a special place, a place of warmth, humanity, and quirkiness where wonderful, strange things may happen" (23).

Others, like Gray, are more clinical—without ever underestimating the contributions of the show. Gray writes that *Frank's Place* helped to "construct and represent the complexity and diversity of African American life" by "stretching and recoding the conventions of situation comedy": *Frank's Place* "achieved this departure precisely because African American culture and black American subjectivity were central to the show's content, aesthetic organization, setting, narrative, characters, and assumptions" (113). The show achieved an "affirmative stance through its complex treatments of social class, gender, region, and tradition, all of which were rooted in an African American point of view" (114), Gray writes. His own wistfulness is evident, however, when he calls *Frank's Place* a "moment of displacement, an attempt to push the limits of existing television discourses about blacks" (114). *Frank's Place* lasted for just a moment, and Gray does not assure us that other programming has taken its place or enlarged its contributions.

The viewers who loved the cast and storyline of *Frank's Place*, who were able to hurdle the differences in racial, ethnic, regional, and political culture and enjoy the challenge, do, even now, know what it means to miss New Orleans. The reality of a small African-American business in a working-class community remains largely absent from contemporary American television portrayals of African-American life. That void resonates most for those of us who spent a television season in the warm glow of Chez Louisiane and grew to count on coming home to a place we'd never been before.

Works Cited

Campbell, Richard, and Jimmie L. Reeves. "Television Authors: The Case of Hugh Wilson." *Making Television: Authorship and the Production Process.* Ed. Robert J. Thompson and Gary Burns. New York: Praeger, 1990. 3–18.

Christensen, Mark. "Just Folks: From the Music to the Mortician, *Frank's Place* Captures the Real New Orleans." *Rolling Stone* (March 10, 1988): 37–38.

Collier, Aldore. "Hollywood's Hottest Couple." *Ebony* (January 1988): 70, 72, 74, 76.

Gray, Herman. *Watching Race: Television and the Struggle for "Blackness."* Minneapolis, Minn.: University of Minnesota Press, 1995.

166 *Dangerous Dreams*

Liggett, Lucy. *"Frank's Place."* 15 Nov. 2004. http://www.museum.tv/archives/etv/franksplace.htm.

Moorehouse, Joe. "Black Music and Television: A Critical Look at *Frank's Place." Making Television: Authorship and the Production Process*. Ed. Robert J. Thompson and Gary Burns. New York: Praeger, 1990. 39–47.

Neill, Michael, and Johnny Green. "Host." *People Weekly* (25 April 1988): n.p.

Newcomb, Horace M. "The Sense of Place in *Frank's Place." Making Television: Authorship and the Production Process*. Ed. Robert J. Thompson and Gary Burns. New York: Praeger, 1990. 29–37.

Reeves, Jimmie L., and Richard Campbell. "Misplacing *Frank's Place:* Do You Know What It Means to Miss New Orleans?" *Television Quarterly: The Journal of the National Academy of Television Arts and Sciences* 24.1 (1989): 45–57.

Spotnitz, Frank. "Tim Reid." *American Film: Film, Video, and Television Arts* (October 1990): 20–22, 24–25.

Timberg, Bernard, and David Barker. "Interpreting Television: A Closer Look at the Cinematic Codes in *Frank's Place." Making Television: Authorship and the Production Process*. Ed. Robert J. Thompson and Gary Burns. New York: Praeger, 1990. 19–27.

White, Mimi. "What's the Difference*?: Frank's Place* in Television." *Wide Angle* 13.3/4 (July-October 1991): 82–93.

Chapter Twelve

"American Life Is Rich in Lunacy": The Unsettling
Social Commentary of *The Beverly Hillbillies*

Soon after the nouveau riche Jed Clampett (Buddy Ebsen), his mother-in-law Granny (Irene Ryan), and the rest of his family move to their palatial residence in Beverly Hills, homesickness strikes, and they return to the mountains they love for a winter visit. Encouraged by banker Milburn Drysdale (Raymond Bailey) to take their first airplane flight instead of driving for several days, the Clampetts think they are on a "fancy bus" and begin to fear that the pilot will take "an all-fired fancy shortcut" or that their bus will go "lickety-split" and begin moving so fast that it will leave the ground. (Of course, it does.)

Upon their arrival at the family cabin, Jed Clampett's daughter Elly May (Donna Douglas) goes alone into the woods, wearing a fur coat given to her by Drysdale. To her surprise, Elly May's animal friends flee when they see her. Gradually, Elly May begins to suspect that if she divests herself of the coat, the wildlife that once trusted her might return, so she gives the coat to Cousin Pearl Bodine (Bea Benaderet). Elly May tells her father that the coat "makes my friends in the woods kinda skittish. They must reckon I'll be wearin' them next." When she returns to the woods without the coat, natural balance is restored and the animals return to her side.

The intersection of these two scenes in *The Beverly Hillbillies* (1962–71)—one of the most critically despised and publicly acclaimed situation comedies in American television history—forms the thematic center for this study. The Clampetts' first trip on a jet suggests the fear and suspicion with which the Clampetts and much of America faced technological development, increased industrialization, and economic materialism during the 1960s. Elly

May's discovery in the woods suggests the instinctive sensitivity and strength with which she and Granny respect the natural world and live in balance with it. Granny, whose real name is Daisy Moses, rants about Elly May's "critters" out by the "cee-ment pond," but she also makes individual breakfasts for the animals, speaks to them by name (Elmer the raccoon, Duke the hound, Bessie the chimpanzee, and Rusty the cat are examples), and praises them for fulfilling their responsibilities (Earl the rooster is complimented for crowing, even though he often wakes Granny from a sound sleep: "I know you're just doin' your job"). When a scene that depicts the Clampetts' unfamiliarity with and distrust of technology collides with a scene that depicts Elly May negotiating with wild "critters," what results is the central conflict and the primary didactic message of "The Beverly Hillbillies": Those who live close to the land and who protect nature have a superior moral sensibility, a sensibility that is lost on those in the urban wasteland.

Although this agrarian mantra was anything but revolutionary in American popular culture, *The Beverly Hillbillies* argued for a way of life that many Americans embraced enthusiastically, and because of his clever use of ironic humor, creator Paul Henning would write almost a decade of critiques of contemporary culture and validate a way of life that was disappearing—without offending the viewers who watched *The Beverly Hillbillies* for escape and for a chance to laugh at modern life. Henning's comic appeal may be traced to several traditions in American popular culture, most importantly Old Southwestern humor (1830–60) and "Li'l Abner" (1934–77). Relying upon characteristics from each, this study will suggest ways in which *The Beverly Hillbillies*, often considered one of several formulaic and seemingly vapid ruralcoms of the 1960s, functioned as surprisingly deft and often doubled-edged social commentary.

The popularity of *The Beverly Hillbillies* is indisputable. David Marc and Robert J. Thompson write that in the mid-1960s, several episodes of *The Beverly Hillbillies* gained Nielsen ratings "comparable to those of Super Bowls" and that the show was "arguably the most popular comedy produced in any medium in the history of American culture" *(Prime*, 30). As late as 1982, nine episodes of the series "remained among the fifty most watched hours in television history," according to Marc, and *The Beverly Hillbillies* is still in syndication *(Demographic*, 40). However, according to Christopher Geist, *The Beverly Hillbillies* was "universally despised by critics and totally neglected in Emmy Award considerations" (946).

Although the phenomenal popularity of the situation comedy among viewers does not prove its quality, it does suggest that *The Beverly Hillbillies* gripped the national imagination in a singular way. By focusing on roles played by Elly May Clampett and Granny, this study explores both the

primary theme of the situation comedy and its possible historical antecedents. It also argues that *The Beverly Hillbillies* is, in fact, part of a rich tradition of American comedy and social satire. Although *The Beverly Hillbillies* did not have the scathing satirical edge of "Li'l Abner," Henning might well have agreed with cartoonist Al Capp when Capp said that he found humor "wherever there is lunacy, and American life is rich in lunacy everywhere you look" (104).

Old Southwestern Humor

As Hennig Cohen and William B. Dillingham write in the introduction to *Humor of the Old Southwest*, women are "conspicuously absent" (xviii) from the list of antebellum Southern humorists during the first half of the 19th century. Old Southwestern humorists are male; educated; interested in politics, medicine, the military, the press and other professional fields; devoted to honor, the South and secession; and ambitious and often hot-tempered (xx). According to Cohen and Dillingham, their favorite subjects included hunting; fighting; courtship; contests with other men; elections; religion; stories about naïve country boys in the big city; rogues and swindlers; drinking; and dandies, foreigners, Yankees, and city slickers (xxiv). They liked physical comedy and action. They feared losing the backwoods and the frontier (xxv). By writing comedy, they could forget hardship and believe in the civilized nature of man (xxxviii).

The comedy of *The Beverly Hillbillies* is most certainly "male" humor, and its connections with the characteristics listed by Cohen and Dillingham are obvious. Plots often deal with hunting, fighting, courtship, and competition. At the heart of the story line is the naïve country family confronting urban life. Many of the plots include rogues and swindlers, often outsmarted by the Clampetts, and the dandies and city slickers of Beverly Hills, often overmatched by the goodness and generosity of the Clampetts. Furthermore, Granny is a hot-tempered Confederate sympathizer. In one episode, "The South Rises Again," she confuses the shooting of a Hollywood film about the Civil War ("The War of Northern Aggression") with an actual skirmish. She arms herself, shoulders a Confederate flag, and demands that her family accompany her into war.

The Beverly Hillbillies also adheres to the frame of Old Southwestern humor by encouraging the comparatively sophisticated viewer to identify with the creators of the situation comedy. Like the readers of sketches by Old Southwestern humorists, television viewers are able to enjoy the foibles of

the uneducated subjects of the farcical storyline and to celebrate their own cultural superiority. For example, in one scene, the Clampetts leave their mansion for the hills, and Jed says there is no reason to lock the front door after them because they are taking all their belongings on the trip. As he and Jethro Bodine (Max Baer Jr.) pull out of the driveway, this conversation ensues:

> **Jed:** "I don't know what ever happened to the key to that door, but I reckon with our stuff out of there there ain't nothin' left that anybody'd want to take—'cept them old pictures."
> **Jethro:** "Oh, Miss Hathaway says a couple of them pictures is Rembrandts."
> **Jed:** "Okay, after Christmas we'll see he gets 'em back."

Viewers understand the allusion to a great painter and feel superior to the Clampetts; simultaneously, however, they realize that a knowledge of the arts is not the most important quality—kindness is. It would be honest to return the paintings to "Mr. Rembrandt," and Jed will no doubt try to do so when he returns. More sophisticated and knowledgeable than the Clampetts, viewers find the Clampetts' ignorance humorous and distance themselves from the "hillbillies"; however, they also realize they share (or want to share) the goodness and compassion, the love of family, the appreciation of nature, and the value system of the Clampetts.

Old Southwestern humorists wanted to pay tribute to and yet stand apart from rustic life and rural characters. Cohen and Dillingham write:

> As the youngest and most untutored region of the country, the South was keenly self-conscious...Accused of both crudity and cruelty, Southerners felt the need to let the world know that they were proud enough of their colorful, rustic homeland to want to write about it with the express purpose of preserving in literature its scenes and customs. But at the same time, these men, more than they themselves perhaps realized, wanted to be recognized as gentlemen. Therefore from their detached position as narrators, they contrasted themselves with the common folk they observed and wrote about. They liked the folk but maintained their distance and their status. (xxxix)

The viewer who enjoys *The Beverly Hillbillies* also must negotiate "otherness." The Clampetts' lack of education and knowledge of the world set the viewer comfortably apart from the characters; although he or she might identify closely with the gentleness of Elly May or the honesty of Jed Clampett, there is relief in being more clever and more worldly wise than they.

Alluding directly to the tradition of Old Southwestern humor, Marc acknowledges the longtime American obsession with "hillbillies": "The ethical as well as the physical superiority of the backwoodsman to his city slicker cousin has been a popular theme in America since immigrants began leaving European civilization to live in the wilderness of the New World" *(Demographic*, 42). Henning, Marc writes, was "unabashed and hyperbolic in his idealization of backwoods folk" *(Demographic*, 43), as were humorists of the Old Southwest including Mark Twain, Thomas Bangs Thorpe, and Augustus Baldwin Longstreet. From the theme song at the beginning of *The Beverly Hillbillies* to the enthusiastic farewell that the Clampetts offer the viewers at the end of each episode ("You're all invited back next week to this locality/ To have a heapin' helpin' of their hospitality"), the importance of character and compassion are emphasized, and the "hillbilly" as the embodiment of strong American values is celebrated. Clearly, American television viewers appreciated the invitation to tune in again ("Ya'll come back now, hear?") and enjoyed the opportunity to "set a spell" with people more displaced than they.

The "Ballad of Jed Clampett," a bluegrass tune that hit the top of the country-western charts at the same time that *The Beverly Hillbillies* first aired, was written by Henning and recorded by Lester Flatt and Earl Scruggs. Marc notes the song's connection to American folklore and acknowledges its references to Henning's own "Missouri-rags-to-California-riches story." In the narrative about an unwitting backwoodsman who stumbles into a fortune, the link to Old Southwestern humor is clear:

> Come and listen to my story 'bout a man named Jed,
> A poor mountaineer, barely kept his family fed,
> Then one day he was shootin' at some food,
> When up through the ground come a bub-a-lin' crude—
> oil that is; black gold, Texas tea.
>
> Well, first thing you know old Jed's a millionaire,
> The kinfolk said, "Jed, move away from there!"
> They said, "Californie is the place you ought to be!'
> So they loaded up the truck and they moved to Beverly—
> Hills that is; swimming pools, movie stars.

Although critics such as Russel Nye and M. Thomas Inge are correct when they suggest that much of the satire and comedy of "Li'l Abner" and later *The Beverly Hillbillies* lie in Old Southwest humor, this study focuses primarily upon the ways in which the images of Daisy Mae Scragg and Mammy Yokum of "Li'l Abner" and Elly May Clampett and Granny of *The*

Beverly Hillbillies provide comic critiques of gender roles at the same time that they reinforce the status quo. The study also argues that the images of women created by Old Southwestern humorists and by Capp and Henning were tied inextricably to a celebration of the land and traditional values. Furthermore, this study relies on other characteristics of Old Southwestern humor—such as its tendency toward the grotesque (in part a representation of those who appear foolish but who secretly safeguard the highest human values), an appreciation of an agrarian economy, and the use of the vernacular both to provide comedy and to highlight the connection of the speakers to the land.

Although they are portrayed as iconoclastic buffoons, the characters in "Li'l Abner" and *The Beverly Hillbillies* (as well as in *The Andy Griffith Show, Mayberry R.F.D., Petticoat Junction, Green Acres* and other rural-coms) are often heroic in their war on corporate greed; their commitment to family, community, the land, unions and democracy; and their determination to live by the standards of individualism articulated in the writing of Old Southwestern humorists and in the 1930 classic *I'll Take My Stand*, a celebration of the values of the Deep South.

As critic Ed Piacentino observes, women were treated as secondary figures in Old Southwest humor (116) and were ordinarily stereotyped as "pious, pure, passive, submissive, and humble" (126), but they possessed two traits that were often employed by Henning and other creators of American situation comedies as well. First, they are often strong-willed; second, they often gain their power and influence in the family and the community through the use of language, what Piacentino calls "a weapon of verbal empowerment" (127). Granny, especially, uses her voice to inspire fear and to gain obedience. As Regina Barreca writes in her introduction to *Last Laughs: Perspectives on Women and Comedy*, "Women have traditionally been considered objects of comedy because they are perceived as powerless" (12). Humor by women, she adds, can be "dangerous," "de-centering," "dislocating," and "de-stabilizing" (15). While there is nothing "dangerous" about the humor employed in *The Beverly Hillbillies*, it does, however, allow for Granny to maintain her role as an intimidating matriarch. Furthermore, Granny, like the characters in the sketches by Old Southwest humorists, is conservative, devoted to backwoods habits and folklore, and loyal to the Deep South and to the Confederacy. She also symbolizes what Cohen and Dillingham consider the "masculine" nature of the frontier (xxxix), and she is a human repository of folk tales and tall tales as well as a master of herbs and potions.

In spite of Granny's strong nature and stern sense of values, though, it is important to recognize the masculine roots of Old Southwestern humor as

they affect the portrayal of young single women in "Li'l Abner" and *The Beverly Hillbillies*. In "Ring-Tailed Roarers Rarely Sang Soprano," Jane Curry describes young women portrayed in Old Southwest humor as primarily "inveterate man-chasers, as people devoid of any personal status unless affiliated with that of a man" (130). In fact, Curry suggests that women in comic texts "nearly always" are "vain, scolding, capricious, coquettish, unpredictable, curious, impractical, loquacious, gullible, muddle-headed, gossipy, gushy, back-biting, jealous, or vindictive" (129). However, in spite of the fact that Curry concludes that most women in the tradition of Old Southwestern humor possess at least one of these negative characteristics and are usually "comic objects of sexual pleasure for men," she does argue that many of the women in the sketches possess a "sexuality of their own" (137). References to female sexuality are largely absent from *The Beverly Hillbillies*, except in the character of Jane Hathaway (Nancy Kulp), and although Miss Jane is sexual and interested in men, she is ridiculed for her lack of femininity and desirability.

William E. Lenz correctly states that the sketches of the backwoods that characterized the humor of the Old Southwest were written by "professional men who enjoyed adopting the title of 'Correspondent' to record the manners, morals and odd customs of the inhabitants of the Old Southwest—Georgia, Alabama, North and South Carolina, Louisiana, Mississippi, Tennessee, Kentucky, and Arkansas" (589). A hard-edged, masculine tradition—as noted by numerous critics including Lenz, Walter Blair, Inge and others—Old Southwestern humor may be a "complicated phenomena" (600) that is too easily passed off as misogynistic, according to Lenz.

In his article "The Function of Women in Old Southwestern Humor," Lenz argues that women are powerful because they are often located in "familial, domestic, or social situations" in which men "feel alien or unsure." Certainly, this is true of Granny in *The Beverly Hillbillies*. In an episode entitled "Women's Lib," Jed and Jethro begin doing chores and, predictably, fail at their efforts; in another, "Lib and Let Lib," traditional order is restored. Although Lenz is correct that women such as Granny have dominion over the kitchen, use herbs and tonics with ease and skill, and make big men tremble, one might ask if this is the kind of power a woman wants or if this is the power she takes because it is the only power afforded her.

Most importantly for this study, Lenz also suggests that as "professional men of culture and breeding," Old Southwestern humorists recognized a "province of women" (598), and rather than admit the power women had over them, they turned instead to "idealized portraits of innocent female beauty" (598). In *The Beverly Hillbillies*, the innocent woman is none other than Elly May, who is sexualized but not sexual and enticing but innocent. It

is in Elly May that the creators of *The Beverly Hillbillies* locate beauty, submissiveness, and humility. Ironically, though, Elly May stops short of the passivity present in so many of the women in Old Southwestern sketches; in fact, Elly May remains single and stubbornly prefers the company of Miss Jane and of her "critters." Her strength is not in language but in an attitude of resistance.

The Beverly Hillbillies illustrates other characteristics of the humor of the Old Southwest, although to a lesser degree. The humor is occasionally sexual, although it rarely reaches "bawdy" or "racy"—especially when the Clampetts' male guests from "back home" show up to sample the night life of Southern California or when Jethro decides (as he often does) to become a playboy. Also, the humor often depends upon the use of the vernacular and on the Clampetts' strong Southern accents and rural metaphors *(The Beverly Hillbillies* Web sites often include glossaries that explain terms such as "fetch," "git," "tote," "tarnation," "gumption," "yee-haww," "hankerin'," "Land O'Goshen," "goo-mer" (a strange person), "nary," "pert-near," "weedbenders" (country folk), "corn squeezins" (moonshine), "smoke your haunches" (spanking), "ailin'," "cipherin'," and "well doggies"). The characters are often grotesque (one-dimensional and representative of a single trait or belief), and they often exist primarily to highlight the conflict of cultures that lies at the heart of *The Beverly Hillbillies*.

As Ed Piacentino writes in "Contesting the Boundaries of Race and Gender in Old Southwestern Humor," writers of the Old Southwest often made their political views palpable by using liberal doses of humor: "Generally, as we will see, the humorous manner in which these writers handled their material and the usually safe, non-offensive context in which they treated it often camouflaged or provided a buffer or safeguard for what they were doing" (117), he writes. This assessment holds true for what Marc and Thompson call Henning's "hillbilly trilogy" *(The Beverly Hillbillies, Petticoat Junction,* and *Green Acres)*. Although the primary goal of the ruralcoms was to entertain and provide escape from the political conflicts, poor race relations, and class struggles of 1960s America, the easy humor of *The Beverly Hillbillies* often camouflaged its tough-minded thesis: In spite of the chaos of the modern world, the simple, homespun values of people like the Clampetts would eventually dominate the self-serving attitudes of the Drysdales and their ilk. However, the creators of the popular situation comedies also hinted that technology might never improve the world and that the ways of the wicked (or ignorant) might sometimes prosper.

Granny, whom Marc calls the "chief antagonist to modern culture" *(Demographic,* 48) in *The Beverly Hillbillies,* is also a "stubborn partisan of the Confederacy" *(Demographic,* 49). Marc's observation is central to this study

because in addition to a reliance upon characteristics of Old Southwestern humor, *The Beverly Hillbillies* also leaned heavily upon the values and priorities of the regional literature and politics of the Deep South.

Although published decades after the heyday of Old Southwestern humor, the novels, short stories, and essays of William Faulkner and other modern Southern writers of fiction and nonfiction continued to champion certain ideals of Old Southwestern humorists. At the heart of the literature was the destruction of the agrarian values and way of life that the region had committed to with religious fervor. The creators of *The Beverly Hillbillies* might easily have drawn on the literary tradition of Truman Capote, William Faulkner, Carson McCullers, Flannery O'Connor, Robert Penn Warren, Eudora Welty, and Tennessee Williams, as well as on the sketches of Old Southwestern humorists.

The masterpiece of Southern idealism, *I'll Take My Stand: The South and the Agrarian Tradition*, was published in 1930 by 12 disenchanted and well-educated literary Southern gentlemen and reinforced many of the ideals of the Old Southwestern humorists. The writers and historians included in the collection were male, they were tied to a tradition of Southern gentlemen and high manners, they were staunchly agrarian and suspicious of "progress," and, although they rejected racism, they were sympathetic to many of the philosophies that fueled the Confederacy.

At the root of the manifesto was the simple notion that living on and working the land helped to insure the best in human nature and that turning one's back on rural values would cost America its national conscience. In the introduction to the 1991 edition of *I'll Take My Stand*, Louis D. Rubin Jr. writes: "The Nashville Agrarians saw it coming long before most of us. Their critique of 1930, ridiculed at the time by knowing observers who declared smugly that the clock could not be turned back...constituted a prophetic warning of what might be in store if the headlong exploitation of natural resources and the unthinking mechanization and dehumanization that accompanied untamed industrialism were not honestly acknowledged and confronted" (xix).

In articles entitled "Reconstructed but Unregenerate" by John Crowe Ransom and "Not in Memoriam, But in Defense" by Stark Young, the Nashville Agrarians, who included Donald Davidson, Allen Tate, Andrew Nelson Lytle and Robert Penn Warren, shouted their warnings and questioned the allure of "progress." Young wrote about the role of aristocrats in preserving literature and culture, he celebrated the bonds of family, and he encouraged respect for a system of manners that had been revered by gentlemen and gentlewomen in the Old South. Like humorists of the Old Southwest, Ransom argued in his essay for the right to salvage and record the best

of the past: "It is out of fashion these days to look backward rather than forward. About the only American given to it is some unreconstructed Southerner, who persists in his regard for certain terrain, a certain history, and a certain inherited way of living. He is punished as his crime deserves. He feels himself in the American scene as an anachronism, and knows he is felt by his neighbors as a reproach" (1).

The essayists whose work is included in *I'll Take My Stand* questioned the values of the larger society and what Rubin called the "drift" toward "economic materialism": "For there was a southern tradition worthy of preservation, and it had little or nothing to do with racial segregation, Protestant orthodoxy or states' rights: it was that of the good society, the community of individuals, the security and definition that come when men cease to wage an unrelenting war with nature and enjoy their leisure and their human dignity" (xx).

It is this theme in the regional literature of the Deep South at the turn of the century that provides a central connection between the humorists of the Old Southwest and the cartoon strips and television "ruralcoms" that lay ahead. It is no accident that in episodes such as the "The Clampetts Versus Automation"—in which the Clampetts rescue a bookkeeper at Drysdale's bank who has been replaced by a computer—Henning's focus is on the waste and irrationality of commercial "progress."

"Li'l Abner"

A discussion of the portrayal of women and rural life in *The Beverly Hillbillies* must begin with an analysis of both Old Southwestern humor and the cartoon strip "Li'l Abner." Al Capp's "Li'l Abner" evolved into what Nye calls an "inventive social comedy" and later a "relentless, sometimes savage critique of contemporary life" (227). Inasmuch as Daisy Mae Scragg's function was to critique the limitations put on American women during the life of the cartoon strip (1934–77), hers was a positive image; however, inasmuch as her function was to draw male readers because she was what Arthur Asa Berger calls the "'dream girl' of the American sexual fantasy," she was, admittedly, a negative image.

Daisy Mae pursues Li'l Abner from 1934 to 1952, when the courtship finally ends in marriage and a cover story in the March 31, 1952, issue of *Life* magazine. (Their only child, Honest Abe, was "born" in 1953.) In "'It's Hideously True': Creator of Li'l Abner Tells Why His Hero Is (Sob!) Wed," Capp discusses his decision to allow the wedding of Li'l Abner and Daisy

Mae. Although Daisy Mae is "infinitely virtuous," Capp says that she chases Li'l Abner "like the most unprincipled seductress" (102). Even after snaring Li'l Abner and discovering that he is no more attentive to her after marriage than he was before and that he is as lazy as his father, Daisy Mae remains committed to him. As one fan of the cartoon strip wrote, "Like Abner's Mammy Yokum and other wimmenfolk in Dogpatch, Daisy Mae did all the work while the menfolk generally did nothing whatsoever. Despite this near slavish role, Daisy Mae seldom complained, one of her countless virtues" (www.lil-abner.com). The image of women who were not content unless they were married and serving men was both comic and troubling, both humorous and satiric.

Abner Yokum, Daisy Mae Scragg, Mammy Yokum, and Pappy Yokum of Dogpatch, U.S.A., are transmogrified into Jethro Bodine, Elly May Clampett, Granny, and Jed Clampett. The Yokums, a combination of "yokel" and "hokum," were the creation of Capp, a Connecticut native whose real name was Alfred Gerald Caplin (1909–79). The cartoon strip about simple-minded mountaineers was not the only "hillbilly" comic strip of the time, although it was the most popular. During its history, the strip drew 60 million readers in 900 American newspapers and 100 foreign newspapers published in 28 countries. Quoted by Inge in "Comic Strips," Capp's description of the residents of Dogpatch would also be true of the Clampetts nearly 30 years later: "This innocence of theirs is indestructible," Capp said, "so that while they possess all the homely virtues in which we profess to believe, they seem ingenuous because the world around them is irritated by them, cheats them, kicks them around. They are trusting, kind, loyal, generous and patriotic" (914).

Arthur Asa Berger calls Old Southwest humor the "satirical antecedent" of "Li'l Abner" and argues that the roots of the comic strip are found in sketches by Augustus Baldwin Longstreet, George Washington Harris, Thomas Bangs Thorpe, and Johnson Jones Hooper, whose writing can be "characterized as having a fairly accurate rendering of colloquial speech, a considerable amount of exaggeration and fantasy, much distortion, and certain 'mythic' implications," Berger writes. "Capp makes a number of changes but still draws upon them a good deal, especially in his use of dialect and character" (56–57). Like the humorists of the Old Southwest, Capp "relied heavily for his humor on dialect, exaggeration, the grotesque, and lively narrative action" (914), writes Inge.

From the time "Li'l Abner" appeared in the early 1930s until the death of ruralcoms on American television in the early 1970s, an image of a young "hillbilly" woman—who was as gullible and innocent as she was virtuous and beautiful—prevailed. A buxom woman with childlike charm held an

undeniable allure for the heterosexual male audience. Berger argued in 1970 that male viewers of Capp's comic strip even projected themselves into the strip in order to better enjoy its "erotic situations." Berger also suggested that female readers of "Li'l Abner" could "project themselves into the various voluptuous young women in the strip and have vicarious thrills of their own" (138).

While it would be difficult to prove or disprove Berger's theory, it is important to remember that the women who appear in tales of the Old Southwest are secondary figures, and whether they are empowered by language as some critics have suggested or not, they do not drive the action except when they determine the code of behavior in domestic space. It is also important to remember that young, sexually appealing women in cartoon strips and situation comedies in American popular culture are portrayed quite differently from women of their mothers' or grandmothers' generations: No one would ridicule Mammy Yokum or Granny and live to tell about it. In fact, Mammy Yokum, who appeared to be slight of stature, could fight men twice her size and was a tireless champion of goodness: Her favorite slogan was, "Good is better than evil because it's nicer." Small but boasting high principles, Mammy Yokum, the leader of the Yokum clan, had a mean swing, often called the "good night Irene punch." Instead, it is young women such as Daisy Mae Scragg and Elly May Clampett who, even though used to satirize the inequality of women, are also caricatures of institutionalized sexism.

In "Li'l Abner," females are not central to the action, although, as Berger writes, they are "in their own two-dimensional way, sexually stimulating, and help account for much of the popularity of the strip" (138). Berger even states that there is "almost as much 'cleavage' in Capp's country girls as in the nudes in *Playboy* magazine" (139). The stereotype of the devoted, adoring, sexually appealing young woman who was nothing without a man in "Li'l Abner" even helped to make "Sadie Hawkins Day" an American institution. In 1937, Capp introduced Dogpatch's holiday for the "capture of reluctant males by pursuing females" (227), as Nye describes it, and even now "Sadie Hawkins Day" is a national institution. In short, at the same time that Capp made fun of sexual roles, he also helped to reify them.

Social Satire in *The Beverly Hillbillies*

Characterized by wit and an intellectual sleight of hand, satirists attack with humor, ridicule cultural practice, and seek to promote social good. *The Andy Griffith Show, Green Acres, Petticoat Junction, Mayberry R.F.D., Evening*

Shade, and other ruralcoms are unabashedly didactic. In many cases, they also rely upon the intensity of the audience's longing for order, for simple virtues, for an agrarian economy, and for a value system in which a lack of financial success is offset by the attainment of important human qualities.

Ironically, in spite of the institutionalized sexism in these situation comedies, it is often the female characters who most convincingly exemplify the values intended by the creators of the shows and desired by their viewers. The Clampetts confuse airplane seatbelts with "galluses" (suspenders) on their flight and refuse the food the flight attendants offer them, saying they had a "mess o' grits and jowls" before they left home. The audience most certainly laughed at the Clampetts' confusion. But it is Elly May who understands the import of wearing a fur coat as she returns to her tiny Eden. Laugh tracks aside, Elly May's moments of epiphany are not likely to have drawn hearty laughter from viewers; her awareness of an imbalance of power and her sympathy for creatures in the wild are more likely to have made viewers thoughtful.

The image of blonde, buxom, joyful, and innocent Elly May—who grieved the loss of nature and was forced to confront the way that modern life had alienated her from her past—might have been an uncomfortable one for American viewers. By employing the slapstick familiar to storytellers of the Old Southwest, creator Paul Henning was able to ridicule American values and still make viewers laugh. He could reassure viewers that with virtue, honesty, and a connection to the land, they would be safe. And yet in spite of the fact that scenes like Elly May's in the forest were rare, the underlying, unsettling theme of *The Beverly Hillbillies* remained: A consumer culture is driving technology and is alienating us from ourselves. Even Granny, a consummate nonconsumer, could not save the television audience from the commercials that interrupted the situation comedy or from the realization that innocence and gullibility might make the Clampetts invincible but that viewers were not likely to be so lucky.

Satirists often rely on familiar symbols as they undercut the assumptions of a given society, and Henning is no exception. As we have seen, the fur coats that banker Milburn Drysdale gives to Granny and to Elly May become symbols of the corruption of the city and the moral corruption of the banker himself. Viewers understand that Drysdale has befriended the Clampetts only because he values the $25 million they deposited in his bank, and they prefer the uneducated Clampetts to the elitist and hypocritical Drysdale. The women of *The Beverly Hillbillies* identify themselves with the old ways and reject the superficiality of Southern California. When Granny complains to Jed— "Dadblamed Californie. The weather's as mixed up as the people"—she refers in part, of course, to the value system of her new neighbors. Elly May,

pure in spirit, loves her natural surroundings more than she enjoys the accoutrements of wealth. Innocent and courteous, Elly May becomes a prophet of a better way to live.

The father of *The Beverly Hillbillies*, Henning created "hillbilly" characters when he worked on the radio program *The George Burns and Gracie Allen Show*. He was a writer, creator and/or producer for *The Real McCoys* (ABC/CBS, 1957–63), *The Bob Cummings Show* and *Love that Bob!* (NBC/CBS, 1955–62), *Petticoat Junction* (CBS, 1963–70), and *Green Acres* (CBS, 1965–71). Henning also contributed to *Gilligan's Island*, in which Marc and Thompson suggest that Thurston and Lovey Howell mirror Milburn and Margaret (Harriet MacGibbon) Drysdale, and in which Mary Ann Summers (Dawn Wells) of Homers Corners, Kansas, struggles to understand the skewed values of her shipwrecked companions, much as Elly May Clampett of Bug Tussle (near Hooterville) struggles to understand the residents of Beverly Hills *(Prime, 42)*.

Born in Missouri, Henning became interested in the allure of Southern California and the clash of values between the land of surf and sand and his native Midwest. Television viewers shared his interest in that theme, and *The Beverly Hillbillies* became the highest-rated show on television during its first season. As critics have noted, the old truck the Clampetts drive is reminiscent of the Joad truck in *The Grapes of Wrath*, but this time the mountain family is smiling, hopeful, and charmingly naive. Of Jed Clampett, the patriarch of the clan, Henning wrote, "Jed Clampett was to be a tall man of simple, homespun honesty and dignity—the kind of Ozark mountaineer I knew as a boy" *(Prime, 33)*.

Certainly, it is logical to argue that Old Southwestern humor and "Li'l Abner" are the satirical antecendents for Henning's ruralcoms. Henning adheres to characteristics of Old Southwestern humor in his focus on class struggle, his use of episodic structure, his use of grotesque characters who are essentially one-dimensional and allegorical, and his reliance upon adventures. Henning also would explore the values of backwoodsmen in conflict with the modern world throughout his career. The theme is central to *Petticoat Junction*—featuring Hooterville, Pixley, and Kate Bradley's Shady Rest Hotel—as well as to *Green Acres*, an inversion of *The Beverly Hillbillies* (This time, city dwellers Lisa and Oliver Douglas experience dislocation by moving to a rural area). The theme that Marc describes as the "righteous world of country folk" versus the "corrupt, money-driven modern world" *(Prime, 34)* captivated American households during the 1960s.

Marc regards *The Beverly Hillbillies* as a "nihilistic caricature of modern life" but not a satire. "We are mocked but not instructed," he writes. Marc finds the portrait of contemporary society in *The Beverly Hillbillies* to be

"terrifying and funny, but mostly funny" *(Demographic,* 57). He also argues that "just-plain-folks versus pretentious gentility" *(Comic,* 17) was part of the escapism of the 1960s and would not have been particularly disturbing to television audiences. However, this study suggests that—as Marc himself noted—the antagonists in *The Beverly Hillbillies* are not people but cultures. Such a message is didactic and designed to inspire social change, albeit in a less scathing manner than in "Li'l Abner."

Furthermore, the level of social satire achieved in *The Beverly Hillbillies* and "Li'l Abner" cannot be measured in decibels. Instead, one must recognize that the central theme of *The Beverly Hillbillies* would have been de-centering to 1960s viewers, even though traditional order is restored at the end of each 30-minute episode. One-dimensional characters take on allegorical significance in *The Beverly Hillbillies*, and although, as Marc notes, the "golden preindustrial American past" *(Demographic,* 56) the viewers long for never actually existed, believing in it protected American television viewers from the Machine, but only temporarily. While watching *The Beverly Hillbillies* could certainly be called "escape," viewers had only to step outside their homes to understand that the Machine was driving the future and that the changes they feared were a social and political issue demanding response.

Other shows of the time period, such as *The Andy Griffith Show,* also place rural folk in the midst of ethical dilemmas and provide home remedies for their cultural crises. Just as in "Li'l Abner," the object of ridicule in *The Beverly Hillbillies, Green Acres, Petticoat Junction,* and *The Andy Griffith Show* is often modern life, with its harried and unhappy city dwellers. Nye writes of "Li'l Abner": "Abner's world existed (and still does) on two levels: as a burlesque American comedy, pitting the Great American Innocent against the forces of chicanery and hypocrisy; and as a satiric symbol of an irrational, often corrupt society that only the simple, honest, and incorruptible can master" (227). In one episode of *The Andy Griffith Show,* for example, a businessman from a city in North Carolina is stranded when his sleek car breaks down in Mayberry. After numerous delays (and Goober Pyle's filling station being closed on Sunday), the businessman surrenders to the charm of small-town life, exchanges his Type-A personality for his boyhood country temperament, and joins Andy Taylor (Andy Griffith) and Barney Fife (Don Knotts) in singing hymns on the front porch.

As images from America's unconscious, Andy Taylor, Barney Fife, and the Clampetts are powerful antidotes to the upheaval of the modern world. As Geist writes, the "innocence and basic goodness of the Clampetts triumph over Beverly Hills characters who value money and material possessions more than honesty and integrity" (947), even though the Clampetts are

backward "hillbillies." In what Marc calls the "grandest tradition of American dreaming," Jed Clampett, a "poor-but-honest rugged agrarian individual who acquires spectacular wealth" *(Demographic,* 45), becomes a star on American television. What is more subtle, perhaps, is the fact that, as Marc notes, Clampett is a "reluctant emigrant" *(Demographic,* 45), a symbolic reality for many Americans that crossed racial, ethnic, and gender lines in the 1960s.

As Marc writes, "A man would have to be a fool to give up all this," Jed says of his log cabin home, despite its lack of electricity and indoor plumbing. "All this," he knows—and the viewer will learn—is a spiritual and not just a physical place" *(Demographic,* 45). The "spiritual place" the Clampetts symbolize was more than escape. It was a potent satirical tool that harshly highlighted the reality of 1960s America. The antitheses of Jed Clampett and Granny are Jethro Bodine and his mother, Pearl. As Marc notes, they are from town and are more materialistic and status-onscious than their relatives. "Like Al Capp's Li'l Abner, whom he resembles in figure and dress" *(Demographic,* 47), Jethro is what Marc calls a "striking burlesque of American middle-class values": "He is young, strong, handsome, wealthy, a defender of the 'modern' point of view, not to mention white, male, and heterosexually inclined, and yet he is, in effect, a total zero, a nebbish of the most pathetic order" *(Demographic,* 48).

Unfortunately, although Jethro is featured as a central character as often as Granny and more often than Elly May in the *The Beverly Hillbillies,* it is the female characters who best highlight the didacticism of the *The Beverly Hillbillies.* Caricatures of "hillbilly" women in the literature of Old Southwestern humorists and in the television situation comedies that drew on that literature are predictable, earthy, sexual, and humorous, and many of the one-dimensional, burlesque images of women reinforce stereotypes from the 19th and 20th centuries at the same time that they undercut them.

From "Li'l Abner" to *The Beverly Hillbillies,* women in American cartoons and ruralcoms are generally decorative, voluptuous, deferential to men, and committed to finding a husband, but even this stereotype becomes problematized. For example, Nye describes Daisy Mae as "nubile" and "luscious" (227), which she is, but in spite of being exactly what American men are said to want, she is lonely and frustrated. The desirable women in "Li'l Abner" and *The Beverly Hillbillies* rarely find true love; in fact, Daisy Mae is what Berger calls a veritable symbol of "unrequited love" (98). Even after Abner marries Daisy Mae, he is not interested in her, something Berger calls "ludicrous and perverse" (127). Even Capp's character Moonbeam McSwine, who is beautiful but who smells bad, prefers pigs to men; in *The*

Beverly Hillbillies, too, Elly May prefers her "critters," family, and friends to any of the men who pursue her.

During the 274 episodes of *The Beverly Hillbillies* from Sept. 26, 1962, to Sept. 7, 1971, Elly May is the focus of the plot in only 30 episodes. Not surprisingly, when she is featured, the plot often revolves around her finding a husband. One of the reasons the Clampett family moved to Beverly Hills was to help Elly May find a husband, and this theme is central to episodes entitled "Elly's First Date"; "A Man for Elly"; "Dash Riprock, You Cad"; "Luke's Boy"; "The Sheik"; "The Courtship of Elly"; "Sonny Drysdale Returns"; "The Soup Contest" (in which Granny signs Elly May's name to a recipe so that she can lure a husband); "Elly Comes Out"; "Mr. Universe Muscles In"; "Back to the Hills" (in which the family takes Elly May to the backwoods to look for a husband); the "Silver Dollar City Fair" (in which Granny seeks bachelors for Elly May); "Wedding Plans"; "Jed Buys Central Park" (in which the family looks for men in New York City); "Mark Templeton Arrives"; "Don't Marry a Frogman" (in which a Navy lieutenant pursues Elly May); and "Do You, Elly, Take This Frog?" However, Elly May never marries, and Granny often complains loudly to Jed. In one episode, when Elly May arrives home and affectionately greets her chimpanzee, Granny shrieks to her son-in-law, "Even Miss Jane got herself a handsome fella—and there's your daughter, huggin' an ape."

In *The Beverly Hillbillies*, Henning employed one characteristic of what Lisa Merrill calls "feminist comedy" (279) in her essay "Feminist Humor: Rebellious and Self-Affirming." Henning created humor without requiring that television viewers belittle the objects of that humor. The Clampetts behave in ridiculous ways but are not worthless. They seem daft, but they are beloved. "In feminist comedy, we are no longer cast as an omniscient audience laughing at a character [who is] 'unknowingly betraying' herself," Merrill writes. "Rather, the context and the character interact in such a way as to stir our empathy as much as our amusement. It is the situation which is ridiculed, rather than the characters struggling to negotiate their circumstances." Viewers of *The Beverly Hillbillies* laugh at Granny—but in sympathy. What Granny represents is the heart of the conflict raised in most episodes of *The Beverly Hillbillies*, and it is a conflict of large political significance. As Marc and Thompson write in *Prime Time, Prime Movers*:

> [Granny's] apprehensions about dislocation will, in fact, prove to be perfectly justi-
> fied over the span of the more than two hundred episodes that will follow. A spirited
> enemy of postindustrial culture, she is severely displaced in cosmopolitan California.
> Her considerable folk talents as a chef, domestic artisan, and healthcare worker will

go largely unappreciated in a society where the worthiness of the individual is measured by quantity of leisure time rather than quality of work. (34)

Conclusion

During a time of riots, civil rights marches, student activism, and the Vietnam war, Americans were watching *The Andy Griffith Show* (it first aired in 1960), *The Beverly Hillbillies* (1962), *Petticoat Junction* (1963), and *Green Acres* (1965). Familiar and congenial, Andy Taylor, Jed Clampett, Oliver and Lisa Douglas, and Kate Bradley offered escape and a sense that order might yet prevail. Although Nye and other critics claim that *The Beverly Hillbillies* deals in "neither sex, nor issues, nor problems, but only laughter" (412), the show sent a powerful, albeit formulaic message into American living rooms week after week. While not employing the searing social satire of "Li'l Abner," Henning's ruralcoms challenged societal attitudes and mores in ways that are rarely explored.

A technological universe promised much to Americans in the 1950s, but by the 1960s the public was beginning to question whether technology could deliver a better quality of life. The Clampetts never figure out how their doorbell works; someone always comes to the door after they hear the chimes. They never understand their time-saving appliances. A technological world could be terrifying to those more familiar with rural life, and characters in ruralcoms became representative of the old, safe, secure ways slipping through the fingers of an entire nation. As Marc writes, "That such a past ever existed in America or elsewhere is a dubious proposition at best. It is easy to believe in such a past, however, as a relief from the bleak prospects of life in a mechanical world" *(Demographic,* 56).

The class conflicts of the 1960s, too, make *The Beverly Hillbillies* an interesting cultural study. The show makes profound statements about hypocrisy and about artificial boundaries in 1960s society. For example, as discussed earlier, Granny and Elly May wear their fur coats as they board the plane for their mountain home. The flight attendants greet the two women warmly, but when they see Jed and Jethro, still dressed in their "hillbilly" garb, the attendants try to get them off the airplane before Granny and Elly May see them. Miss Jane, who understands both Drysdale's and Jed Clampett's world, intercedes. The moral is not difficult: How well one is treated is related to how well one is dressed, and judgments based on superficial issues are unjust and immoral.

Known for a decade as "The Hillbilly Network" and bashed by critics, the Columbia Broadcasting System decided in the early 1970s to cancel its

ruralcoms, which were not popular enough with advertisers interested in new urban markets. By the early 1970s, CBS executives had canceled the popular ruralcoms and other "country" programs such as *Hee Haw* and *Gunsmoke* in the interest of shows that attracted younger, more affluent, urban dwellers. Julie D'Acci and other feminist critics heralded the appearance of shows such as *Alice, All in the Family, Good Times, The Jeffersons, The Mary Tyler Moore Show, Maude, One Day at a Time,* and *Rhoda* as programs that introduced working women, women of other races and ethnicities, and older, divorced, single, and working-class women to television. The shows also introduced social issues such as abortion, rape, employment, and race.

At the same time, though, other shows introduced from the mid-1970s to the early 1980s were part of what D'Acci calls the "jiggle" phenomenon: They include *Charlie's Angels, Police Woman, Three's Company, WKRP,* and *Wonder Woman*. These programs often reverted to the beautiful, buxom woman longing for relationships with men at least as much as she longed for professional success. D'Acci writes that some critics have seen these programs as examples of backlash against the women's movement; others, she said, have read them "as prime time's way of killing two birds with one stone and capturing both segments of a divided audience" (16). Whatever the case, rural families began to be replaced by families formed in the workplace or by nuclear families wrestling with racism, war, distrust of government, and other issues gaining sway in the 1960s. The gamble by CBS perhaps paid off: After the demise of the ruralcoms, *All in the Family* became the most popular show on television.

With escalating racial and ethnic conflict and class struggles and with the demise of simplistic images of the nuclear family that had been popular in the 1950s, white Americans in the ruralcom decade had to face their loss of innocence and come to terms with both the blessings and curses of progress, wealth, leisure time, and increasing industrialization. The agrarian life that these Americans "remembered"—whether or not they had experienced it— held a powerful sway. *The Beverly Hillbillies* and its popular spinoffs, *Green Acres* and *Petticoat Junction,* dealt with displacement and the loss of traditional values and rural life. They did so cautiously, as Henning employed humor drawn from the tales of the Old Southwest to assuage the fears of viewers and re-institute the status quo at the end of each 30-minute episode.

Farcical and burlesque, the characters in the Henning situation comedies were not to be taken seriously. Or were they? In *The Beverly Hillbillies,* Granny was far more than a taciturn but lovable rural woman who found herself in an alien land of convertibles, beaches, film studios, and commercial institutions. Elly May Clampett was far more than a naïve young woman seeking to please her relatives by finding a husband. It may be that the very

simplicity of the theme and the one-dimensionality of the characters helped to insure the popularity of the ruralcom during its nine-year run and prevented it from being taken seriously enough. Audiences were guaranteed 30 minutes of escape each week. Perhaps decades later, however, critics may begin to acknowledge the satirical edge in one of the most popular situation comedies in American history and begin to analyze why—although often formulaic, too dependent upon stock characters, and too reliant upon slapstick for its humor—*The Beverly Hillbillies* was entertaining, rich in American popular and literary traditions, and all too unsettling for its time.

Works Cited

Barreca, Regina, ed. "Introduction." *Last Laughs: Perspectives on Women and Comedy*. New York: Gordon and Breach, 1988. 3–22.

Berger, Arthur Asa. *Li'l Abner: A Study in American Satire*. New York: Twayne Publishers, 1970.

Capp. Al. "'It's Hideously True': Creator of Li'l Abner Tells Why His Hero Is (Sob!) Wed." *Life* (31 March 1952): 101–108.

Cohen, Hennig, and William B. Dillingham. *Humor of the Old Southwest*. 3rd ed. Athens, Ga.: The University of Georgia Press, 1994.

Curry, Jane. "The Ring-Tailed Roarers Rarely Sang Soprano." *Frontiers* 2 (Fall 1977): 129–40.

D'Acci, Julie. "Chapter 1: Women Characters and 'Real World' Femininity." *Defining Women: Television and the Case of Cagney and Lacey*. By Julie D'Acci. Chapel Hill: University of North Carolina Press, 1994. 10–62.

Geist, Christopher. *"The Beverly Hillbillies." Encyclopedia of Southern Culture*. Ed. Charles Reagan Wilson and William Ferris. Chapel Hill, N.C.: University of North Carolina Press, 1989. 946–74.

Inge, M. Thomas. "Comic Strips." *Encyclopedia of Southern Culture*. Ed. Charles Reagan Wilson and William Ferris. Chapel Hill, N.C.: University of North Carolina Press, 1989. 214–15.

Lenz, William E. "The Function of Women in Old Southwestern Humor: Rereading Porter's *Big Bear* and *Quarter Race* Collections." *The Mississippi Quarterly* 46 (Fall 1993): 589–600.

Marc, David. *Comic Visions: Television Comedy and American Culture*. 2nd ed. Malden, Mass.: Blackwell Publishers, 1997.

———. *Demographic Vistas: Television in American Culture*. Philadelphia, Penn.: University of Pennsylvania Press, 1984.

Marc, David, and Robert J. Thompson. *Prime Time, Prime Movers*. Boston: Little, Brown and Co., 1992.

Merrill, Lisa. "Feminist Humor: Rebellious and Self-Affirming." *Last Laughs: Perspectives on Women and Comedy*. New York: Gordon and Breach, 1988. 271–80.

Nye, Russel. *The Unembarrassed Muse: The Popular Arts in America*. New York: The Dial Press, 1970.

Piacentino, Ed. "Contesting the Boundaries of Race and Gender in Old Southwestern Humor." *Southern Literary Journal* 32 (Spring 2000): 116–40.

Ransom, John Crowe. "Reconstructed but Unregenerate." *I'll Take My Stand: The South and the Agrarian Tradition*. Baton Rouge, La.: Louisiana State University Press, 1991. 1–27.

Rubin, Louis D. Jr. "Introduction." *I'll Take My Stand: The South and the Agrarian Tradition*. Baton Rouge, La.: Louisiana State University Press, 1991. xi–xxxv.

Chapter Thirteen

Grits and Yokels Aplenty:
Depictions of Southerners on Prime-Time Television

"Come and listen to my story 'bout a man named Jed..." So begins the theme song to *The Beverly Hillbillies*, a television show that, although scorned by critics, became the longest-running and most popular situation comedy in American television history. Those who grew up watching the series probably can sing each of the remaining stanzas.

We also can whistle the theme song to *The Andy Griffith Show*, as we remember Andy Taylor and son Opie (Ron Howard) strolling down the dirt road toward the ol' fishin' hole. We remember "New York is where I'd rather stay/ I get allergic smelling hay/ I just adore a penthouse view/ Darlin', I love you, but give me Park Avenue" from *Green Acres*. And we remember Uncle Joe, "he's a movin' kinda slow at the Junction" *(Petticoat Junction)*.

Logically, "'American Life Is Rich in Lunacy': The Unsettling Social Commentary of *The Beverly Hillbillies*" precedes this essay, but *The Beverly Hillbillies* is far from alone in its didactic intent. It is not accidental that some of the most popular series in television history are shows set in the South or that they promote homespun wisdom. They include *The Andy Griffith Show*, *The Beverly Hillbillies*, *Carter Country*, *Designing Women*, *A Different World*, *The Dukes of Hazzard*, *Evening Shade*, *Gomer Pyle U.S.M.C.*, *Green Acres*, *Mayberry R.F.D.*, *Petticoat Junction*, and *The Waltons*. The return of Americans to Southern comedies and dramas with simple problems and tidy resolutions was a logical reaction to a world in which fear and social unrest dominated the news.

From the days of Al Capp's "Li'l Abner" (1934–77) to country music variety shows to the ruralcoms of the 1960s to the present, the South has been

portrayed as a reservoir of homely virtues, including a young hero or heroine facing initiation experiences (Opie Taylor, John-Boy Walton, etc.); a tendency toward the grotesque, a representation of those who appear foolish but who secretly safeguard the highest human values; and an appreciation of an agrarian economy that makes poverty tolerable by focusing on human values forged in adversity (Southern playwright Tennessee Williams writes in the preface to *A Streetcar Named Desire* that without struggle, a man or woman is a "sword cutting daisies").

From Carol Burnett's satirical treatment of *Gone with the Wind's* Scarlett O'Hara, as she swings down a spiral staircase wearing velvet curtains still on the curtain rods, to the portrayal of daffy Hooterville residents, the South is caricatured with ease. George B. Tindall explains the predictable modern depictions of the South when he writes, "It is a romanticized moonlight-and-magnolias world, which yields all too easily to caricature" (Wilson and Ferris 1097). And Jonathan W. Daniels (1902–81), former editor of the *Raleigh* (N.C.) *News and Observer*, writes, "We Southerners are a mythological people, created half out of dreams and half out of slander, who live in a still legendary land" (Wilson and Ferris, 1097).

Even while they ridicule Georgia drawls, Americans come back week after week for another shot of Southern hospitality. The importance of community, family and human values—traditionally associated with the best of the South—are central in programming from *The Andy Griffith Show* to *The Waltons* to *Evening Shade*. Earl Hamner Jr., creator of *The Waltons*, a show that boasted 40 million viewers in 1973, said his show emphasizes "self-reliance, thrift, independence, freedom, love of God, respect for one's fellow man, an affirmation of values" (Kirby, 144).

Curiosity about the region draped in mystery and moonlight never ebbs. Assumptions about the South, contributed by Southern historians such as C. Vann Woodward and W.J. Cash, influence scriptwriters and producers and become part of popular culture:

(1) The South is a distinct region populated by those who may appear foolish but who are compassionate and fair in their dealings with others;

(2) The South is a distinct region endowed with the philosophical and religious perspective that makes it more cognizant of the implications of "original sin" and human failure than the rest of the nation; and

(3) The South is a distinct region that relies on a rural economy and a belief in the value of the land and the importance of family.

The emphasis on human values in Southern ruralcoms complicates the caricatures of buxom belles and stumbling bumpkins living in a land of

azaleas. Although it is easy to laugh at the ignorance of the traditional breed of Southern heroes, viewers admire their honesty and good will. Images of Southerners fighting for the Populist agrarianism and against corporate greed; committed to family, community, the land, unions and democracy; and living by the standards of individualism articulated in the 1930 *I'll Take My Stand*, the political-literary document penned by the Vanderbilt New Critics, go hand in hand with the images of iconoclastic buffoons.

Popular culture critic Christopher D. Geist has examined television portrayals of the South and has found that most show the region as "backward, somewhat uncivilized, largely rural, simple, and rather monolithic" (Wilson and Ferris, 943). He breaks down the themes of television shows about the South into six categories, examining programs such as *The Real McCoys* (ABC, 1957–62; CBS, 1962–63); *Hee Haw, Mayberry R.F.D., Carter Country* (late 1960s and early 1970s); and *The Dukes of Hazzard* (1980s). His categories include 1) young, buxom country belles; 2) pathetically inept bumpkins; 3) bearers of Southern folk wisdom; 4) corrupt Southern bosses; 5) shiftless "no-counts"; and 6) harmless good ol' boys (Wilson and Ferris 943).

Examples of Geist's caricatures could include Uncle Joe Carson (Edgar Buchanan) of *Petticoat Junction*, who serves as both a "shiftless no-count" and a "harmless good ol' boy." Andy Taylor (Andy Griffith), of course, is the quintessential "bearer of Southern folk wisdom," as are Jed Clampett (Buddy Ebsen) of *The Beverly Hillbillies* and Wood Newton (Burt Reynolds) of *Evening Shade*. "Pathetically inept bumpkins" are personified by Barney Fife (Don Knotts) of *The Andy Griffith Show*, and *Evening Shade* capitalizes on the perceived eccentricity of small-town Southern folk. However, all are benign, kind people, whom we both laugh at and admire.

It is worth noting that during a time of riots, civil rights marches, student activism, and the Vietnam war, Americans began watching *The Andy Griffith Show* (1960), *The Beverly Hillbillies* (1962), *Petticoat Junction* (1963), and *Green Acres* (1965). Andy Griffith, Buddy Ebsen, Max Baer Jr., Eddie Albert, Eva Gabor, and Bea Benaderet offered escape and a sense that moral order might prevail.

The Beverly Hillbillies

One of the best examples of a Southern situation comedy is *The Beverly Hillbillies*, a show in which Abner and Daisy Mae and Mammy and Pappy Yokum of Dogpatch, U.S.A., are transmogrified into Jetro Bodine (Max Baer Jr.), Elly May Clampett (Donna Douglas), Jed Clampett (Buddy Ebsen), and

Granny (Irene Ryan) of *The Beverly Hillbillies*. Al Capp, a Connecticut native whose real name is Alfred Gerald Caplin, created the popular cartoon strip about Southerners from the mountains of Kentucky. M. Thomas Inge points to the connection between "Li'l Abner" and *The Beverly Hillbillies* when he writes of Capp's creation:

> This innocence of theirs is indestructible so that while they possess all the homely virtues in which we profess to believe, they seem ingenuous because the world around them is irritated by them, cheats them, kicks them around. They are trusting, kind, loyal, generous, and patriotic. (Wilson and Ferris, 914)

In *Demographic Vistas: Television in American Culture*, David Marc explores the popularity of *The Beverly Hillbillies*, which ran on CBS from 1962–1971. As late as 1982, Marc says, nine episodes of *The Beverly Hillbillies* remained among the 50 most-watched programs in television history—ratings, Marc says, that are comparable to Super Bowls (40).

Creator of *The Beverly Hillbillies*, *Green Acres*, *The Andy Griffith Show*, and other Southern situation comedies, Paul Henning—like Linda Bloodworth-Thomason, creator of *Designing Women* and *Evening Shade*—was born in Missouri and grew up valuing community, family, and the land. From the earliest days of *The Bob Cummings Show*, Henning developed his favorite theme, what Marc calls "the ethical as well as the physical superiority of the backwoodsman to his city slicker cousin" (42).

Like poets William Wordsworth and Samuel Taylor Coleridge, Henning and others espoused the philosophy that there are "spiritual benefits of life in a natural setting" and that independence and self-sufficiency counter the "pretentious affectations" (Marc, 42) of synthetic life in the city. Marc develops his theory about the importance of *The Beverly Hillbillies* by focusing on the "poor-but-honest rugged agrarian individual who acquires spectacular wealth." He writes: "'A man would be a fool to give up all this,' Jed [Clampett] says of his log cabin home, despite its lack of electricity and indoor plumbing. 'All this,' he knows—and the viewer will learn—is a spiritual and not just a physical place" (45).

In one episode of *The Beverly Hillbillies*, the viewer understands that Elly May Clampett's true wealth is her relationship with the animals near her family's cabin in the Ozarks. She calls the animals by name and feeds them out of her hand. When Granny and Elly May sport new mink coats given to them by Milburn Drysdale (Raymond Bailey) and Jane Hathaway (Nancy Kulp), Elly May learns that the coats "make her friends in the woods kinda skittish."

The coats thereby become a symbol of the corruption of the city and the moral corruption of Drysdale himself, who values the Clampetts only because he worships the $25 million they deposited in his bank. Elly May, pure in spirit, loves her natural surroundings more than she enjoys the accoutrements of wealth. Not only are Southerners reputed to love the land, but Southerners such as Andrew Lytle of *I'll Take My Stand* also warn others about the empty allure of money. In an essay entitled "The Hind Tit," Lytle writes of Americans:

> [They] should know that prophets do not come from cities, promising riches and store clothes. They have always come from the wilderness, stinking of goats and running with lice, and telling of a different sort of treasure, one a corporation head would not understand. (206)

Strong spiritual values, he believes, are not compatible with financial excess, a theme readily subscribed to by Henning in his ruralcoms.

Week after week, Americans got a "heapin' helpin' of their hospitality" and came back for more. In one episode, Granny complains about the weather in California, which she says is as mixed up as the people who live there. Her comment, of course, really means that she considers her neighbors in Beverly Hills unnatural and inhuman. The family packs to visit their cabin in the hills for Christmas; hearing about their plans to leave, Drysdale and Miss Jane buy the Clampetts first-class tickets and send them on their first airplane flight. Having never heard of a jet, the Clampetts think they will be traveling by bus. What follows is a dialogue that sets the Clampetts apart from the residents of Beverly Hills in a classic clash of cultures. Preparing to leave, the family finds Granny loading wood for the trip:

Elly May: "How long do you reckon' it'll take us to get home, Pa?"
Jed: "Jethro figures about six days, hard drivin'. Where you goin' with that wood?"
Jethro: "Granny wants it in the truck."
Jed: "Put it down. With all that wood we've got back at the cabin, we sure ain't gonna haul none from Beverly Hills."
Jethro: "Oh, she says it's for on the way."
Jed: "On the way? Granny, what in the world are you doin'?"
Granny: "I'm makin' sure we don't freeze to death."
Jed: "It's warm here."
Granny: "It won't be when we get in the mountains."
Jed: "You figure to keep it burnin' for six days?"

Granny: "And six nights. Don't forget. Dadblamed Californie. The weather's as mixed up as the people."

Pulling out of the driveway, Jethro and Jed talk about the paintings in the mansion, illustrating another cultural clash. The viewer inevitably identifies with the residents of Beverly Hills, who are sophisticated and educated enough to find the Clampetts' ignorance funny. However, with that identification comes an awareness that knowledge of great art is not the most important quality—kindness is.

Jed: "I don't know what ever happened to the key to that door, but I reckon with our stuff out of there ain't nothin' left that anybody'd want to take—'cept them old pictures."
Jethro: "Oh, Miss Hathaway says a couple of them pictures is Rembrandts."
Jed: "Okay, after Christmas we'll see he gets 'em back."

Boarding the plane, Granny and Elly May are dressed in expensive coats. The flight attendants treat them warmly, but when they see Jed and Jethro, they try to get them off the airplane before Granny and Elly May see them. The moral is not difficult: How well one is treated is related to how well one is dressed.

Once on board, the Clampetts are set apart even more from the Beverly Hills residents and the viewer. None of them has ever flown before. Once again, their ignorance is the heart of the comedy, but while the viewer might not identify with Jed, Granny, Jethro, or Elly May, she or he appreciates the friendliness and openness of the four. As the Clampetts settle into their seats on an airplane they have not seen from the outside, the following conversation occurs:

Flight attendant: "Now, fasten your belts."
Jed: "I ain't wearin' one, ma'am. Just my galluses."
Flight attendant: "I meant your seatbelt."
Jed: "Well doggies! Isn't this a fancy bus!"
Granny: "Now we'll see if this bus driver knows an all-fired fancy shortcut."
Jethro: "Elly, let's you and me watch the road so's we can remember it."
Elly May: "Okay, Jethro."
Jed: "If you ask me, this bus driver of ours is lost. He just keeps a'circlin' and a'turnin'."
Jethro: "I didn't notice no shortcut yet."

Elly May: "Me neither."

Jethro: "Listen to him a'racin' that engine."

Jed: "Yeah. But the wheels must be spinnin' in the mud. We ain't mov-in'."

Jethro: "He got her out of the mud."

Granny: "We's movin' now."

Elly May: "Yeah. Lickety-split, too."

Jed: "By doggies! If he gets to goin' much faster, this thing's gonna leave the ground."

Granny: "Don't look now, but it *is* leavin' the ground."

When others on the plane seem relaxed, the Clampetts decide not to ask the "bus driver" to turn around, lest other passengers think they have never ridden on a bus before. Offered food by the flight attendants, Jed tells them the family had a "mess o' grits and jowls" before they left. Elly May thinks the flight attendants are nice, since they offered strangers their own "vittles." As a kind of omniscient spectator, the viewer understands that the Clampetts would share their "jowls and possum simmerin' in gopher gravy" with anyone who might need food.

Jed, Granny, Elly May, Jethro, and Miss Jane become representative of a cultural perspective antagonistic to the viewpoint exemplified by Drysdale. As Marc notes, Granny becomes the "chief antagonist to modern culture," a "stubborn patriarch of the Confederacy" (48). As the family matriarch, she stands strong as a "conspicuous nonconsumer" (Marc, 50), although the commercials sprinkled throughout the show remind viewers that she is not real and that the capitalistic American world order relies on them to be untiring consumers.

Green Acres

When the "urban utopia proves sterile" (46), as Marc puts it, Oliver Wendell and Lisa Douglas move from New York City to Hooterville in another of Henning's popular shows, *Green Acres*. The dislocation the Douglases experience makes the viewers identify with Oliver and what Marc calls his "faith in a rational order" (52). However, he is duped in episode after episode, and the object of ridicule ultimately is, of course, modernity itself.

The central theme of the situation comedy is the same as that of *The Beverly Hillbillies*, although instead of moving to the big city, the Douglases have moved to rural America for fresh air and the smell of hay. Both the

Clampetts and the Douglases are displaced, as were many Americans during the 1960s, and the cultural clash continues week after week with the implied promise of eventual resolution.

In one episode of *Green Acres*, Lisa Douglas (Eva Gabor) and Oliver Wendell Douglas (Eddie Albert) become involved with a local merchant who passes off yellow barrels as coffee grinders, sports cars, whirlpools, and washing machines. Fred and Doris Ziffel (Hank Patterson and Barbara Pepper) buy what they think is a new washing machine from Mr. Haney (Pat Buttram), although Fred doesn't think they need one since he recently moved a rock down by the creek for the laundry.

Mr. Ziffel discovers that Mr. Haney has duped him and says, "Haney will pay for this. Where's my gun?" (Arnold Ziffel, the pig, drags the gun to his master.) Oliver cannot restrain himself and begins to preach: "Mr. Ziffel," he says forcefully. "Violence is no answer. You can't take the law into your own hands. If you've got a grievance, take it into the courts. This country was founded on the principle of justice for all." His voice rising dramatically, Oliver continues, "The very backbone of our democracy depends on the courts—where wrongs can be righted."

In the "real world" of the 1960s, righting wrongs in the courts, in the universities, or in the streets was unlikely and increasingly frustrating, and the viewer understands both Oliver's passion and his discouragement. The Camelot years are over, children are divorced from their parents, and Americans have lost hope in the military action called Vietnam. The Clampetts reassured America that Jed's values would triumph, but the Douglases reminded them that what Wallace Stevens called the "blessed rage for order" ("The Idea of Order at Key West," 292) would not be satisfied in what had become an increasingly irrational universe. Oliver, who tried to force order through institutional methods, was the biggest buffoon of all.

The Andy Griffith Show

Like *The Beverly Hillbillies*, *The Andy Griffith Show* places rural folk in the midst of ethical dilemmas and provides home remedies for all ills. Again, the object of ridicule and pity often is modern life, with its harried and unhappy city dwellers. In one episode, a businessman from Charlotte is stranded when his sleek car breaks down in Mayberry on a Sunday. After numerous delays, he exchanges his Type A personality for his boyhood country persona, joining Andy Taylor (Andy Griffith) and Barney Fife (Don Knotts) in singing hymns on the front porch.

The most poignant episodes of *The Andy Griffith Show* involve Sheriff Andy Taylor and son Opie, as lessons of kindness are passed from one generation to another: Don't shoot at living things, always tell the truth, don't play practical jokes that hurt others, etc.

In one such episode, Andy is a beauty contest judge, and his girlfriend Ellie Walker (Elinor Donahue) is a contestant. In typical homespun style, Andy tells the assembled townspeople, "Folks, in order to judge a beauty contest, I think it's good to know what beauty really is. Now, they's outside beauty—I guess we can all see that—then they's inside beauty." In the final scene, Andy chooses an elderly woman who helped coordinate the pageant as the winner. Bedlam breaks loose; Ellie hugs the judge and reassures him about his decision.

Like *The Beverly Hillbillies*, *The Andy Griffith Show* had a long television life (CBS, 1960–1968), and it enjoys both reunions and a healthy rerun schedule. Jed Clampett and Andy Taylor are the authorities for viewers in an industrial world; their homespun wisdom solves problems and mends relationships in 23-minute segments. Geist explains the significance of the Mayberry microcosm where all battles are won:

> Mayberry, and by extension the small-town, rural South it represented, was a bucolic haven in which nothing ever happened. Most of the individual episodes centered on the difficulties and misunderstandings that arose among the friends and neighbors in the community. Andy used his considerable charm and homespun wisdom to settle these disputes and to return Mayberry to a state of peacefulness and order at the conclusion of each tale. (Wilson and Ferris, 945)

The Clampetts never figure out how their doorbell works; someone always comes to the door after they hear the chimes. They never understand their time-saving appliances. Life in a technological world was terrifying to the agrarian South, and rural Southerners became representatives of the old, safe, secure ways slipping through the fingers of an entire nation. As Marc writes: "That such a past ever existed in America or elsewhere is a dubious proposition at best. It is easy to believe in such a past, however, as a relief from the bleak prospects of life in a mechanical world" (56).

Southern ruralcoms take television viewers to a place that many of them have never been but are sure they remember. That trend continues. According to popular culture critic Charles Wilson, networks targeted Southern audiences more than ever before during the 1990s. The reason, he suggests, was that Southerners had less access to cable TV in the South's rural areas and also because the South was still the poorest region in the United States (Cleveland, 14).

This study, however, argues that the networks continued to produce shows set in the South, not because of demographics alone, but because of a continuing interest in the myths and artifacts Southern culture made accessible to all Americans. Creators of other Southern situation comedies modified several of the early stereotypes and parodied others. For example, although Jasmine Guy of *A Different World* played a buxom, spoiled Southern Belle, she is black. The Atlanta decorators of *Designing Women* and the college students of *A Different World* burlesque the Southern belle and the mannerly gentleman, and both shows incorporate black characters and struggle to reveal a New South with egalitarian aspirations.

Evening Shade

Television critics in a 1990 issue of *Newsweek* praised *Evening Shade* for disdaining "corn-pone stereotypes" of the South and refusing to "sanitize the South's special blend of earthiness and quirkiness" (Waters and Wright, 64), yet inherent in this compliment is the notion that Barney Fifes, Jethro Bodines, and Gomer Pyles are more numerous in Birmingham than in Detroit—that "quirkiness" works best with a Southern accent.

Although contemporary shows featuring the South have become more sophisticated and more urban-oriented, many of the early thematic threads remain. For example, in *Evening Shade*, Wood Newton (Burt Reynolds) returns to his hometown in Arkansas to coach high school sports. Again, Southern eccentrics populate the town, and parents worry about the materialism of their children. The message, as in the Southern ruralcoms of the 1960s, is that money corrupts and a great deal of money corrupts absolutely.

The 1990 *Newsweek* article, "A Winner Made in the Shade: A Southern-Fried Comedy Straight from the Heart," features writer-producer Linda Bloodworth-Thomason, creator of *Designing Women*, and what *Newsweek* reporters call the "new TV season's most deserving success" (64). *Evening Shade*, a "lovingly crafted comedy about a dot on the map somewhere between Mayberry, Fernwood and Walton's Mountain," concerns Evening Shade, Arkansas:

> [Evening Shade is] the kind of town where there are no burglar alarms and lots of front porches, where the parents and grandparents of best friends are best friends, where the daily paper is delivered from a hand-drawn wagon, where a civic crisis means a loss by the high-school football team and where everyone gathers on Saturday nights at the Barbecue Villa to cluck over the jukebox's most risqué number. (Waters and Wright, 64)

Bloodworth-Thomason exploits the nostalgia Americans feel about the rural world of their real or imagined past by saying: "I'm choosing to do these Southern shows because the area I come from personifies the best parts of Americanism. Like decency and forthrightness and loyalty and love of family. There's nothing corny or hillbilly about it" (Waters and Wright, 64).

In the episode that aired before Christmas in 1990, Coach Newton and his wife, Ava Evans Newton (Marilu Henner) take drastic steps when their children seem unusually selfish and ungrateful: they take the presents from under the Christmas tree and give them to a poor family in town. Worried about stereos and $150 shows, the children fail to send their grandfather a Christmas card as their mother asks, and they tell their father that since they will live longer than he, they "need stuff": "All my kids talk about is what they're going to get for themselves for Christmas," says Newton. "I just don't want to hear 'gimme, gimme, gimme' anymore." When Ava wonders if they have done the right thing, her husband holds firm. Concerned that the children "have nothing under the tree," the mother suggests a compromise. Newton responds, "They don't have anything, honey; they have everything. I want them to realize that."

In the world of situation comedies, all is well in the end. The underprivileged children thank the Newtons for the gifts, the Newton children seem at least comfortable with the involuntary sacrifice, and the community gathers to light the town Christmas tree and sing carols. Homer Bedloe, the railroad efficiency expert trying to buy Kate Bradley's (Bea Benaderet) land in *Petticoat Junction;* Milburn Drysdale, the banker counting Jed's millions in *The Beverly Hillbillies;* and Scrooge himself are defeated in the fantasyland that television makes possible.

American television viewers continue to long for escape, normalcy, laughter, and a moral center. Judith Williamson writes in *Consuming Passions: The Dynamics of Popular Culture:*

> We are consuming passions all the time—at the shops, at the movies, in the streets, in the classroom: in the old familiar ways that no longer seem passionate because they are the shared paths of our social world, the known shapes of our waking dreams. Passions born out of imbalance, insecurity, the longing for something *more*, find forms in the objects and relations available; so that energies fired by what might be, become the fuel for maintaining what already is. (11)

The thesis of Williamson's *Consuming Passions* is that what we cannot attain is what we must have; failing to gain it, we resort to myth and legend to preserve what we never knew. Her theory, of course, is not new. References to dreams and the lost Eden drive American literature, creating the timeless

appeal of texts such as *The Great Gatsby* and fueling the desire for rural-coms.

To understand the passion that the viewing public has for the myths of the South in popular culture, one might rely on several hallmark studies of the Southern mindset, including *The Burden of Southern History* by C. Vann Woodward and *The Mind of the South* by W.J. Cash. In his preface, Cash describes the Old South of popular legend:

> It was a sort of stage piece out of the eighteenth century, wherein gesturing gentlemen move soft-spokenly against a background of rose gardens and dueling grounds, through always gallant duels, and lovely ladies, in farthingales, never for a moment lost that exquisite remoteness which has been the dream of all men and the possession of none. (ix)

Furthermore, because of its support for slavery and its economic devastation during the Civil War, the South does not share the myths familiar to the rest of America. The "national legends of opulence and success and innocence" (25), Woodward writes, have no place in Southern mythology.

Since the 1990s, when 98 percent of Americans first owned television sets and watched more than seven hours of television per day, critics recognized the power of television as a purveyor of myth and cultural awareness. As a symbol of agrarianism, Christian values, love of the land, reverence for family, and admiration for the common people, the South was and is an engaging region of paradoxes.

As Americans continue to watch programs set in the South—such as *Dallas* and *Hart of Dixie*—the region remains a reminder of a society's brighter days, days of porch swings, spelling bees, fireflies, and honeysuckle, days of dusty roads and church socials and picnic blankets beside quiet streams. Our nostalgia is for days and times we only imagine we knew.

Works Cited

Cash, W.J. *The Mind of the South*. New York: Vintage Books, 1941.

Cleveland, Jim. "Southerners Still Distinctive on TV but Stereotypes Softer." *The Southern Register* (Winter 1990): n.p.

Kirby, Jack Temple. *Media-Made Dixie: The South in the American Imagination*. Athens: University of Georgia Press, 1986.

Lytle, Andrew. "The Hind Tit." *I'll Take My Stand: The South and the Agrarian Tradition*. New York: Harper and Brothers, 1930. 201–245.

Marc, David. *Demographic Vistas: Television in American Culture*. Philadelphia:University of Pennsylvania Press, 1984.

Stevens, Wallace. "The Idea of Order at Key West." *The Norton Anthology of American Poetry*. Ed. Richard Ellmann and Robert O'Clair. 2nd ed. New York: W.W. Norton, 1988. 291–92.

Waters, Harry F., and Lynda Wright. "A Winner Made in the Shade: A Southern-Fried Comedy Straight from the Heart." *Newsweek* (17 Dec. 1990): 64.

Williamson, Judith. *Consuming Passions: The Dynamics of Popular Culture*. New York: Marion Boyars, 1986.

Wilson, Charles Reagan, and William Ferris, eds. *Encyclopedia of Southern Culture*. Chapel Hill: University of North Carolina Press, 1989.

Woodward, C. Vann. *The Burden of Southern History*. Baton Rouge: Louisiana State University Press, 1960.

Section Four

Portrayals of Women in Film and Television

Chapter Fourteen

From *Great Expectations* to *The Bachelor:* The Jilted Woman in Literature and Popular Culture

Jennifer Aniston is known for her roles in *The Good Girl* (2002), *Derailed* (2005), *Rumor Has It* (2005), *The Break Up* (2006), *He's Just Not That Into You* (2009), and other films. Television viewers recognize her as the beautiful, effervescent, and resilient Rachel Green in *Friends* (1994–2004), a role for which she won Emmy, Golden Globe, and Screen Actors Guild awards. Those who enjoy *Entertainment Tonight* and read celebrity magazines also know she was married to—and left by—actor Brad Pitt; in fact, it is difficult to find a contemporary article about Aniston that does not refer to Pitt and his wife Angelina Jolie, a star whose talent and commitment to social issues have earned her international acclaim. Part of the appeal of stories about Aniston, Pitt, and Jolie is their box office success, but another compelling issue is Aniston's split from Pitt, the megastar to whom she was married from 2000–2005.

Aniston is not the only popular contemporary image of a jilted woman, of course. The cover of the March 15, 2010, issue of *People* magazine shouts: "'I Didn't Make a Mistake!': His Shocking Pick." The subhead reads: "Jake and Vienna come clean about their wild romance, those scandalous rumors and their plans for the future." This story introduces Jake Pavelka, 32, and Vienna Girardi, 23, who floated "On the Wings of Love" and became the darlings of the television reality show *The Bachelor* during the 2009–2010 season.

Having selected Girardi from "25 young women vying for his affections," Pavelka states in the article: "Vienna is everything that I have ever wanted and more...I made the best choice. Tenley is such a wonderful

woman, but my heart just didn't go all the way for her" (106). The woman to whom Pavelka refers is Tenley Molzahn, the other finalist. Pavelka's selection of Girardi, though, is particularly pertinent for this study about twosomes in the popular sphere. As 15 million watched the season finale of *The Bachelor*, Pavelka turned his back on the majority of his viewers and even his family and picked Girardi over Molzahn: "My parents loved Tenley like crazy," he said, although eventually "they saw how happy I was with Vienna" (106).

Fans of *The Bachelor* had made their feelings known in interviews and on blogs throughout the season; in the end, many were not certain Pavelka had chosen his future bride wisely. Understandably enough, Molzahn said during the show that aired March 1, 2010, that she believes Pavelka made a "mistake": "Jake will see the mistake he made. And I feel bad for him...I don't think he knows what he wants." Pavelka told her that "something just doesn't feel right. I don't know why." Molzahn replied, "I don't know what you think is missing"—and sobbed. In *The Bachelor: After the Final Rose*, the host introduced Molzahn as "the woman Jake sent home in tears," and Molzahn said again, "I don't understand what was missing." But the ABC blockbuster reality show was finished for the season. Pavelka and Girardi were moving to Dallas, where Girardi said she had never visited, and Pavelka performed on *Dancing with the Stars*—along with another jilted woman, Kate Gosselin of *Jon and Kate Plus 8*—during its next season.

In spite of purportedly brokenhearted women such as Aniston, Molzahn, Gosselin and others, the world spins on, of course. Pitt and Jolie take care of their family, act in new films, travel broadly, and battle the paparazzi. Aniston's love relationships remain the stuff of contemporary popular drama. *The Bachelor* ended one of its most controversial seasons, and *The Bachelorette*, Ali Fedotowsky, 25, became the rage. A photo of Pavelka and Girardi adorned a double-page spread in the March 15, 2010, issue of *People* next to the headline: "I Never Thought I Would Find Love Like This." In the short term, the couple contemplated marriage and tried to appease some of their more disappointed fans. Gosselin underwent a "makeover," took care of her children, and dated again.

Suffice it to say that books, articles, television programs, and films about an insatiable desire for companionship, sexual connection, and marriage continue to proliferate. Films that deal with the intricacies of marriage—such as *Father of the Bride* (1991), *Four Weddings and a Funeral* (1994), *My Best Friend's Wedding* (1997), *Runaway Bride* (1999), *An Ideal Husband* (1999), and *Sweet Home Alabama* (2002)—testify that the desire to live happily ever after is not likely to ebb. With a wink and a nod, we laugh at those in film or

on the television screen who need someone too much—perhaps while asking ourselves what we might be missing.

"Something Not Given Back"

Images of women who have been betrayed by their lovers, partners, and husbands have peppered literature and popular culture since the beginning of time. Although the word "jilted" customarily refers to a woman left on the day of her wedding, this study employs the term to describe any woman abandoned, betrayed, rejected, or "sent home in tears." In Katherine Anne Porter's "The Jilting of Granny Weatherall," the dying protagonist, floating between memory and the flesh-and-blood visitors at her bedside, remembers a lost love. She thinks:

> Yes, she had changed her mind after sixty years and she would like to see George. I want you to find George. Find him and be sure to tell him I forgot him. I want him to know I had my husband just the same and my children and my house like any other woman...Tell him I was given back everything he took away and more. Oh, no, oh, God, no, there was something else besides the house and the man and the children. Oh, surely they were not all? What was it? Something not given back. (74)

A woman left at the altar or abandoned by a husband or lover is a compelling cliché because loss and betrayal are universal experiences. In many popular and literary texts, the significance of this loss is tied to the historical dependence that straight women have had on men for financial security, cultural acceptance, children, and protection from an often hostile patriarchal system. It is also tied, though often secondarily, to a woman's genuine grief at the loss of a love that was ultimately unreciprocated.

Furthermore, the terms "old maid" and "spinster" effectively eliminate from view those women who are left or overlooked by men. In her foreword to *Old Maids and Radical Spinsters: Unmarried Women in the Twentieth-Century Novel*, Nina Auerbach dissects the term "old maid." She writes that "'maid' turns her into a perpetual virgin and humble servant, while 'old' mocks the grotesquerie of her preadult status" (x). Laura L. Doan, too, emphasizes the cultural need to dismiss the "spinster":

> The persistence of the spinster stereotype, when the sociocultural order has changed so significantly and the notion of the spinster appears so hopelessly unfashionable, irrelevant, and anachronistic, is a testament to its pervasiveness and strength. The self-identified woman has posed—and continues to pose—an immense threat to patriarchy, a threat culminating in the emergence of a controlling myth in the guise of the spinster stereotype. (15)

Because women and men are taught to view marriage differently, female and male authors sometimes differ in how they adopt the theme of a woman's being jilted, whether the woman is left at the altar or at another time and place. As readers, too, men and women enter a text in different ways. Writing about Susan Glaspell's "A Jury of Her Peers," Judith Fetterley says simply, "Thus it is not simply that men cannot read the text that is placed before them. Rather, they literally cannot recognize it as a text because they cannot imagine that women have stories" (147–48). Although she here is referring to specific characters in a specific fictional sign system, we can expand her analysis to deal with two distinctly unsympathetic and stereotypical portraits of jilted women, Charles Dickens' *Great Expectations* and William Faulkner's "A Rose for Emily." Fetterley also notes, "Forced to read men's texts, women are forced to become characters in those texts" (159), while male readers are unaccustomed to such demands. In both *Great Expectations* and "A Rose for Emily," the primary female characters—like the narrator of Charlotte Perkins Gilman's "The Yellow Wallpaper"—go insane rather than confront their abandonment by men.

It is no surprise that one of the most sympathetic portrayals of a jilted woman is by a female author, Katherine Anne Porter. Porter does not mask the deep loss an elderly woman feels in remembering her lost love; instead, she creates a realistic and representative character. Granny Weatherall has spent her life fencing and tending 100 acres, loving a husband whom she survived, and rearing and financially supporting her children. The loss she confronts is real and overwhelming, but her legs do not buckle, even as she equates the loss of the man she once loved to the failure of Christ—the New Testament bridegroom—to comfort her at her deathbed. Granny Weatherall is obsessed and devastated by the moment at the altar when George does not stand beside her, but she prevails.

The Jilted Woman in American Popular Culture

Lest one believe that portrayals of betrayed and near-suicidal spinsters are restricted to bygone days, it is important to address the prevalence of images of jilted and unmarried women in media texts in the 1980s, 1990s, and 2000s. The portrayal of heterosexual women as desperate for husbands (and the wealth and stability that men ostensibly provide) is evident in a wide range of American cultural texts, even complex ones such as *Sex and the City* and *Desperate Housewives*. These television series both reify and dismantle dominant attitudes about prescribed heterosexuality and the perfect marriage, making them the subject of enthusiastic critical inquiry.

The link between marriage and financial stability in popular culture is decades old. Terms such as "gold digger" also refer almost exclusively (and disparagingly) to women. In his 1986 book *Why Men Are the Way They Are*, Warren Farrell argues that the primary fantasy of the American woman is security via marriage and a man's financial success. A sociologist, psychologist, and media critic, Farrell supports his contention with numerous excerpts from news stories, film scripts, and print advertising, but one of the most blatant examples is an ad for a self-improvement course that appeared in 1985 in *Access to Learning Catalogue*. The ad, entitled "How to Marry Money," suggests:

> "It's as easy to fall in love with a rich man as with a poor one." The fantasy can come true if you're willing to pay the price in planning, patience, and persistence. We'll look at where the wealthy are and how to decide if you have what it takes, prepare for the search, and develop your strategy, make connections, and enjoy the whole process. (45)

The course coordinator advertises herself as a "human relations and communication consultant, a researcher into upwardly mobile marriages, and an astute observer of the social scene" (45). In another example of women who are obsessed with the money someone else earns, the May 7, 1990, issue of *People* magazine features Marla Maples ("hoping the Trump slipper will fit") with a headline proclaiming: "Listen Up, Marla! Here's HOW TO MARRY A BILLIONAIRE." The magazine then introduces the reader to "seven determined Cinderellas who found true love—and true loot" (cover).

Susan Faludi, Pulitzer Prize-winning journalist and author of *Backlash: The Undeclared War Against American Women* (1991), discusses books such as Tracy Cabot's *How to Make a Man Fall in Love with You;* magazine articles in women's magazines such as "How to Close the Deal," "If I'm So Wonderful, Why Am I Still Single?" "The Sad Plight of Single Women," "The Terminally Single Woman," and "Single Shock"; and workshops such as "How to Marry the Man of Your Choice." In a section of her book entitled "The Spinster Boom: The Sorrow and the Pity," Faludi blames the media for going from a message of single women in love with independence in the early 1970s to the opposite message in the 1990s. Single women of the 1990s are depicted as "scowling scullery maids who couldn't go to the ball" (96), she writes.

Everything and nothing have changed since the fictional portraits of lost and lonely women created by Charles Dickens and William Faulkner in *Great Expectations* and "A Rose for Emily," respectively. The feminist movement in the Western world altered profoundly our perceptions of social

institutions, and yet the American popular media continue to promote images
of women as dependent on males for marriage, acceptance, children, and
protection (largely ignoring, of course, the divorce rate and the documented
violence women are subjected to in their own homes). Depictions of women
as calculating gold diggers would be troubling enough without the realization
that such portrayals proliferate in American film, advertising, television, print
media, and popular fiction. Furthermore, the audience is complicit in its
enthusiasm for such images.

Marriage as a means to financial security is not a recent concept. In *Marriage as a Trade*, Cicely Hamilton wrote in 1909 that young women are
"trained to make themselves pleasing to men because marriage is the primary
way for women to earn their living" (1). Only men, she writes, can afford to
be truly romantic. A woman, on the other hand, must never lose sight of the
fact that marriage for her does not mean a relationship with one whom she
adores but is a reality necessitated by economic concerns. In her novel *Just to
Get Married* (1911), Hamilton's heroine (Georgina Vicary) says: "Either I go
to a man who is willing and anxious to keep me, or I stay as a burden and a
failure with people who are longing to be rid of me. There is no other
alternative" (2). A man in love is, consequently, "single-hearted; a woman,
double-motived," writes Hamilton. A woman simply has "no bargaining
power in choosing the mate who is also her economic lifeline" (2), she adds.

However, neither Miss Havisham nor Miss Emily marry for money; in
fact, both of them inherit substantial wealth from their fathers. Hence, the
descent of both characters into the abyss must be explained in other ways.
Only Porter's protagonist in "The Jilting of Granny Weatherall" could
possibly be affected financially by the loss of her beau, and she is too self-
sufficient to stoop to conquer a bank account. At no point, in fact, does Porter
mention Ellen Weatherall's loss of George's money. So, while the signifi-
cance of a woman's remaining single can be linked to a lower income,
Dickens and Faulkner rely instead on society's pity for a woman left alone.

As we have seen, portrayals of desperate spinsters also dot the screens of
America's favorite storyteller, television. They remain in reruns of *The Dick
Van Dyke Show*, which features Laura Petrie as the proud middle-class
possessor of a suburban home equipped with a loving husband and son, and
Sally Rogers as "one of the guys," eternally and unhappily obsessed with
finding a mate. The portrayals existed decades later as well, as the children of
the women's movement find Hope Steadman juxtaposed with her angst-
ridden single women friends in *Thirtysomething*. Longing for marital
paradise, the unhappy spinster is alive and unwell. "In *Thirtysomething*, a
complete pantheon of backlash women is on display—from blissful home-
bound mother to neurotic spinster to ball-busting single career woman,"

Faludi writes. "The show even takes a direct shot at the women's movement: the most unsympathetic character is a feminist" (162).

Western culture equates marriage for women with normalcy and fulfillment. Farrell—who believes a woman's primary fantasy is to be married to one man who is able to provide financial security and complete emotional fulfillment—analyzes television shows such as *Dynasty*, in which, he says, "It now makes no difference whether the husbands are older and about to die or half a woman's age—as long as they've already made it big" (37). According to Farrell:

> Women's primary fantasy is of marriage to one man who is able to provide security, in which she has the option to devote energy to work, home, children, or a combination thereof, as she chooses. Ideally she wants her secondary fantasy as well: excitement, passion, respect, attention, romance, gentleness, and firmness from this one man. Often, however, the man is too busy providing her primary fantasy to fulfill her secondary fantasy. (56)

Similar observations have appeared throughout recent history in popular magazines. In the April 23, 1990, issue of *Newsweek*, two reporters note the 25-year anniversary of *Cosmopolitan*, referring to its history as "A Quarter Century of Cleavage." The thesis of the short piece is that "today's Cosmo girl is still getting tips on using sex to snag a man" (57). *Cosmopolitan* promotes heterosexuality, marriage, and women as seductresses through headlines such as "How to Attract a Man Like Crazy" (February 1989). Rolling one's shoulders and spilling a glass of water, wine, or other liquid down the front of one's dress are offered as ways to entice a man and, presumably, to guarantee marriage to the best possible male candidate. For decades, other women's magazines also have played on a woman's fears with headlines such as "Men and Marriage—What They Want, Why They Wait" (*Glamour*, May 1989) and "It's 10 p.m.—Why Haven't You Been Rejected Yet?" (*Mademoiselle*, August 1989).

Negative portrayals of single women appear in films as well as magazines and other forms of popular culture. In *Fatal Attraction* (1987), for example, Dan Gallagher (Michael Douglas) cheats on his wife Beth (Anne Archer) but manages to retain his family, his lavish lifestyle, and his career. Alex Forrest (Glenn Close), the other woman, is so devastated by Gallagher's rejection that she peers into the living room, which is lit by a roaring fire, and longs to replace Beth. In *Backlash*, Faludi talks with writers, directors, and actors and concludes that they collaborated in creating an unsympathetic single woman in the film. For example, she quotes director Adrian Lyne, who told her he researched "the single women of the publishing world" and found

their lives and apartments "a little sad, if you want me to be honest. They lacked soul" (120). Auerbach, too, discusses Forrest in her foreword to *Old Maids to Radical Spinters:* "As we see her, though, she never goes to work (she is too busy hovering wretchedly around the hero's family), and her nicely furnished apartment is set in Hell (no one else lives on her street; we see only diabolical workmen who pack animal carcasses while smoke and flames belch out from a mysterious source)" (xii).

Eventually, like Miss Havisham of *Great Expectations*, Alex Forrest boils a rabbit, kidnaps a child, and tries to murder her rival. Adding insult to injury, she lives in a sterile flat in the meat-packing district, while her beloved enjoys a warm and inviting country home with a family photo in the entryway. *Fatal Attraction*, writes Auerbach, "should remind even women who hate it that we *have* set ourselves outside conventional norms and that our most vibrant role is that of the outsider" (xiii). In summary, the 1980s and 1990s were not the optimum time period for images of independent women in popular culture, but the decade of Jennifer Aniston and Brad Pitt and Jake Pavelka and Tenley Molzahn did not shape up much better.

The Jilted Woman in Literature

For Charles Dickens and William Faulkner, the unmarried woman is a grotesque figure unable to function after having been left at the altar. For Katherine Anne Porter, the sense of abandonment and loss a woman might suffer at the hands of a man does not impede the woman's accomplishments. All three texts about women abandoned at the altar illustrate that the "something not given back" is not, in fact, simply the bridegroom himself. It is society that robbed the women by telling them that their happiness or worth depended upon marriage. The loss of the culturally supplied image of the perfect life is what costs them their selfhood and prevents two of them from being able to function in the world.

In addition to advertising, film, magazines, and television, this study relies upon a novel and two short stories in which women are betrayed directly and obviously by men who abandon them at the altar. It also deals with women who are injured indirectly and symbolically by a society that sanctifies marriage and canonizes the bride (not the wife) and that minimizes and ridicules the unattached woman. Whether women are lesbian, bisexual, or heterosexual, social institutions depicted in popular culture or in modern literature do not readily make way for the "uncoupled"—those who choose to

be alone and have the poor judgment to consider themselves happy. Marriage thereby becomes a ritual of necessary, prescribed connectedness.

Occasionally, literature allows characters to question the institutions that, one suspects, they will succumb to soon enough. One such work is D.H. Lawrence's *Women in Love*, in which sisters Ursula and Gudrun Brangwen discuss marriage as something that might provide protection, money and emotional connection with one's lover—or that might require a woman to buy the first two by forfeiting the last. The following dialogue demonstrates their fears that marriage will not guarantee happiness in a world and a time that promises it will:

> "You don't think one needs the experience of having been married?" [Gudrun] asks.
> "Do you think it needs to be an experience?" replied Ursula.
> "Bound to be, in some way or other," said Gudrun, coolly. "Possibly undesireable, but bound to be an experience of some sort."
> "Not really," said Ursula. "More likely to be the end of experience." (1)

And yet, even if marriage proves to be the "end of experience," Ursula and Gudrun admit that they might consider a "highly attractive individual of sufficient means" as a marriage partner, especially one who could put them in what Gudrun calls a "better position" (2). In spite of the cultural message that marriage is the answer to one's quest, Gudrun says of her inclination not to marry: "Isn't it an amazing thing how strong the temptation is, not to!" (2). So, while Lawrence initially provides an ideological challenge to heterosexual marriage contracts, he then allows his characters to concede that they, too, would be tempted by a man with sufficient means.

The preconceptions and assumptions that fuel *Great Expectations*, "A Rose for Emily," and "The Jilting of Granny Weatherall" are worth note, for what follows the betrayal of the women in the first two texts is emotional and spiritual emptiness and death, while in the third text, the woman, though wounded, endures. In "The Jilting of Granny Weatherall," the protagonist has "weathered all" except the loss of her first love. She has succeeded mightily during her long life, having fenced her own land and having had a "good house too and a good husband that I loved and fine children out of him" (74). Only at almost 80 when she is facing death does Ellen Weatherall succumb momentarily to her sense of loss.

Miss Havisham of *Great Expectations*, however, longs desperately for marriage to the man of her dreams, a man not identified until late in the novel. The reader understands from the beginning of the text that Pip is in search of his great expectations, but it is the aborted great expectation of

marriage and a lifetime love that drives Miss Havisham mad and energizes the novel itself. When a young Pip meets Miss Havisham, he faces an almost ghostlike visage, standing in a room furnished (like Emily Grierson's in "A Rose for Emily") as a bridal. Miss Havisham is dressed in white and is wearing a veil and bridal flowers. We see the specter through the male child's eyes:

> But, I saw that everything within my view which ought to be white, had been white long ago, and had lost its lustre, and was faded and yellow. I saw that the bride within the bridal dress had withered like the dress, and like the flowers, and had no brightness left but the brightness of her sunken eyes. I saw that the dress had been put upon the rounded figure of a young woman, and that the figure upon which it now hung loose had shrunk to skin and bone. (67)

This portrait of a woman jilted at the altar is eerie, especially when the reader realizes that she is quite mad. *Great Expectations* was published in 1861, and Dickens cannot be said to have written a realistic novel, for his description of the moors, the Havisham estate, and the country cottages at dusk rely far more on the Gothic and romance traditions than upon realism. However, he was in many ways bound by the cultural experience in which he lived. Miss Havisham's incapacitating grief is presented as being logical. In *Women, Marriage and Politics (1860–1914)*, Pat Jallard writes that chaperones for women, keeping diaries of love conquests, ornate meeting rituals (parties and balls), and the terror of spinsterhood were realities women could not avoid during Dickens' time. "Marriage," Jallard writes, "was the most important social institution for the great majority of women in Victorian and Edwardian Britain" (67).

Burned to death in her yellowed wedding dress and despairing of happiness, Miss Havisham is a hideous symbol of the plight of women abandoned by the men they loved and needed to fulfill society's formula for the well-lived life. Like Emily Grierson, Miss Havisham resorts to revenge but gains only remorse.

Having been told of an "immensely rich and grim lady who lived in a large and dismal house" (60), Pip is sent to play on the Havisham estate and entertain the elderly eccentric. The female reader must encounter the events of the tale through his point of view, a point of view in which Miss Havisham is monstrous. The surprise and horror Pip feels upon his first meeting with Miss Havisham are intensified when he notices the bridal cake and the clocks in the room. The clocks and even Miss Havisham's watch are stopped at 20 minutes until nine, and the bridal cake is almost unrecognizable:

An epergne or centre-piece of some kind was in the middle of this cloth; it was so heavily overhung with cobwebs that its form was quite indistinguishable; and, as I looked along the yellow expanse out of which I remember its seeming to grow, like black fungus, I saw speckled-legged spiders with blotchy bodies running home to it, and running out from it, as if some circumstance of the greatest public importance had just transpired in the spider community. (96)

The cake, clocks, and bridal attire are, of course, symbolic of Miss Havisham's lifetime disappointment of being abandoned at the altar at 20 minutes until nine many years before. Later, in a frenzy, Miss Havisham describes the love she felt for the absent groom to Pip: "I'll tell you...what real love is. It is blind devotion, unquestioning self-humiliation, utter submission, trust and belief against yourself and against the whole world, giving up your whole heart and soul to the smiter—as I did!" Miss Havisham has not described love but obsession, an obsession tantamount to self-annihilation.

Wealthy and spoiled, Miss Havisham and her half-brother had "ample means" (197) after their father died. In a betrayal by a male member of her family, Miss Havisham's brother covets her inheritance and befriends and coerces a man to court her. Dickens writes:

This man pursued Miss Havisham closely, and professed to be devoted to her. I believe she had not shown much susceptibility up to that time, but all the susceptibility she possessed certainly came out then, and she passionately loved him. There is no doubt that she perfectly idolized him. He practised on her affection in that systematic way that he got great sums of money from her, and he induced her to buy her brother out of a share in the brewery (which had been weakly left him by his father) at an immense price, on the plea that when he was her husband he must hold and manage it all. (198)

On the day of the wedding, the bridegroom sends a letter and disappears. In retaliation, Miss Havisham lives for revenge, which she accomplishes vicariously through Estelle, a young woman who is haughty, seductive, and cruel. As a child, Estelle refuses to play with Pip, saying, "With this boy! Why, he is a common labouring-boy!" Miss Havisham whispers to Estelle, "Well? You can break his heart." Later in the novel, Miss Havisham tells her, "Break their hearts, my pride and hope, break their hearts and have no mercy!" (69, 108).

Miss Havisham's life of vicious loneliness culminates in a hideous and painful death. While Pip watches, Miss Havisham, sitting next to the fire, suddenly is engulfed in flames as the ragged and old wedding dress catches fire: "In the moment when I was withdrawing my head to go quietly away, I saw a great flaming light spring up. In the same moment I saw her running at me, and soaring at least as many feet above her head as she was high" (431).

"A Rose for Emily" begins with the description of a decaying mansion that rivals Miss Havisham's:

> It was a big, squarish frame house that had once been white, decorated with cupolas and spires and scrolled balconies in the heavily lightsome style of the seventies, set on what had once been our most select street. But garages and cotton gins had encroached and obliterated even the august names of that neighborhood; only Miss Emily's house was left, lifting its stubborn and coquettish decay above the cotton wagons and the gasoline pumps—an eyesore among eyesores. (119)

Again a part of the Gothic tradition, the house represents the aging woman within. And as with Miss Havisham of *Great Expectations*, Miss Emily has no authentic voice. The male narrator speaks for a community that watched Miss Emily from a distance and requires the sacrifice of her happiness in order to preserve its Southern patriarchal system. Miss Emily is at the mercy of a male author, a male narrator, an oppressive father, and a brutal beau. Portrayed as a fierce man standing with "his back to her and clutching a horsewhip" (123), Mr. Grierson dies, and Miss Emily keeps the body until the townspeople break in, overpower her, and take the corpse. A Yankee foreman named Homer Barron comes to the small Southern town, and he and Miss Emily pass by on Sunday afternoons "in the glittering buggy, Miss Emily with her head high and Homer Barron with his hat cocked and a cigar in his teeth, reins and whip in a yellow glove" (126).

The two men with their whips leave little room for Miss Emily to venture confidently into a rigid community. The narrative voice, always detached, always representative of the status quo, tells the reader: "Then we were sure that they were to be married. We learned that Miss Emily had been to the jeweler's and ordered a man's toilet set in silver, with the letters H.B. on each piece. Two days later we learned that she had bought a complete outfit of men's clothing, including a nightshirt, and we said, 'They are married'" (127). The townspeople see Homer Barron disappear into Miss Emily's house at dusk, and a druggist sells Miss Emily a bottle of arsenic, labeled "for rats." The story, told in flashback and foreshadowing, ends when a servant reports that Miss Emily has died, and the townspeople enter the house to bury her. In a style and of a subject reminiscent of Dickens, Faulkner writes:

> Already we knew that there was one room in that region above the stairs which no one had seen in forty years, and which would have to be forced. They waited until Miss Emily was decently in the ground before they opened it.
> The violence of breaking down the door seemed to fill this room with pervading dust. A thin, acrid pall as of the tomb seemed to lie everywhere upon this room

decked and furnished as for a bridal: upon the valance curtains of faded rose color, upon the rose-shaded lights, upon the dressing table, upon the delicate array of crystal and a man's toilet things backed with tarnished silver, silver so tarnished that the monogram was obscured. Among them lay a collar and a tie, as if they had just been removed, which, lifted, left upon the surface a pale crescent in the dust. Upon a chair hung the suit, carefully folded; beneath it the two mute shoes and the discarded socks. (129–30)

When Miss Emily realizes that Homer Barron is not planning to marry her, she buys the arsenic and poisons him. Horrified, the townspeople stare at Barron's skeleton on the bed, "looking down at the profound and fleshless grin" (130). They look at his decaying body and notice that on the pillow beside him was the "indentation of a head": "One of us lifted something from it, and leaning forward, that faint and invisible dust dry and acrid in the nostrils, we saw a long strand of iron-gray hair" (130). Miss Emily, lost and lonely, has been sleeping with the corpse of her former lover. The necrophilia is horribly symbolic of Miss Emily's efforts to find life while living in the shadow of death, in the shadow of decaying houses, a decaying way of life, and the stifling patriarchy of her town. The reader can only surmise with the townspeople that Homer Barron abandoned Miss Emily before the wedding and paid a price that could only be exacted by someone as desperate and rejected as she.

In a provocative essay, "A Rose for 'A Rose for Emily,'" Fetterley correctly deduces that Faulkner's story is about the patriarchy of both the North and South and that it is a "story of a *lady* and her revenge for that grotesque identity" (35). Miss Emily quietly repays her father and the oppressive and unforgiving community in which she lives by murdering Homer Barron. However, the murder is an act of insanity, born of desperation and unbearable loneliness, not the act of a strong woman rebelling against the forces of a patriarchal system. Although Fetterley argues that "A Rose for Emily" is a "story of a woman victimized and betrayed by the system of sexual politics, who nevertheless has discovered, within the structures that victimize her, sources of power for herself" (35), these "sources of power" are a last resort. In creating a spinster whose only recourses are isolation and murder, Faulkner relies on a reader's culturally established set of prejudices to make Miss Emily's behavior appear somewhat believable.

"A Rose for Emily," of course, is not about necrophilia, any more than *Great Expectations* is about Pip's first love or "The Jilting of Granny Weatherhall" is about memory at the time of death. The stories are about the disenfranchisement of women in three cultures: the rural South, mid-19th century England, and the American farmland. Betrayed at the altar, Emily Grierson, Miss Havisham, and Granny Weatherall cope as best they can; one

becomes a murderer in order to "cling to that which had robbed her, as people will" ("A Rose for Emily," 124); the second, a vengeful manipulator; and the third, a rigid overachiever.

In contrast to the authorial and narrative voices employed in *Great Expectations* and "A Rose for Emily," however, Porter lets Granny Weatherall tell a tale that depends upon stream-of-consciousness. Granny Weatherall has suffered the loss of "something not given back," too, but she never compromises or weakens. Facing death, Granny Weatherall thinks of the man she lost, and she fears that God will abandon her at death as George abandoned her at the altar. She remembers:

> But he had not come, just the same. What does a woman do when she had put on the white veil and set out the white cake for a man and he doesn't come? She tried to remember. No, I swear he never harmed me but in that. He never harmed me but in that...and what if he did? There was the day, the day, but a whirl of dark smoke rose and covered it, crept up and over into the bright field where everything was planted so carefully in orderly rows. That was hell, she knew hell when she saw it. (71)

Then, strong and determined, Granny Weatherall sets herself straight: "Don't let your wounded vanity get the upper hand of you. Plenty of girls get jilted. You were jilted, weren't you? Then stand up to it" (72).

In Porter's tale, Granny Weatherall is the superintending narrator of her own life, a life spent achieving and "putting the whole place to rights" (70). "It was good to be strong for everything," says Granny Weatherall, "even if all you made melted and changed and slipped under your hands, so that by the time you finished you almost forgot what you were working for" (70). In familiar imagery for a female reader, Granny measures her life in household tasks. When she looks back on her life, she remembers proudly her organization and strength:

> In her day she had kept a better house and had got more work done...Granny wished the old days were back again with the children young and everything to be done over. It had been a hard pull, but not too much for her. When she thought of all the food she had cooked, and all the clothes she had cut and sewed, and all the gardens she had made—well, the children showed it. There they were, made out of her, and they couldn't get away from that. (69)

When her husband John died, she took over even the typically masculine tasks:

> She had fenced in a hundred acres once, digging the post holes herself and clamping the wires with just a Negro boy to help. That changed a woman...Digging post holes changed a woman. Riding country roads in the winter when women had their babies

was another thing: sitting up nights with sick horses and sick Negroes and sick children and hardly ever losing one…It made her feel like rolling up her sleeves. (70)

The sense that she missed something dominates Weatherall's final moments, and she weeps for an acknowledgment from God that her life has had worth. "God, give me a sign!" she cries. Porter writes:

For the second time there was no sign. Again no bridegroom and the priest in the house. She could not remember any other sorrow because this grief wiped them all away. Oh, no, there's nothing more cruel than this—I'll never forgive it. She stretched herself with a deep breath and blew out the light. (78)

Even while dying, Granny Weatherall is an active force. She must succumb to death, but in the final moments Porter lets her rebel against her fate and blow out the light of her own life. Until the end, Granny Weatherall is engaged, involved. The imagery of the bridegroom and priest in the death scene reminds the reader poignantly of the aborted wedding ceremony, a moment as important in Granny Weatherall's life as childbirth or death. The sense of betrayal is heightened, of course, when Granny Weatherall realizes that God the Father is no more faithful to his promises than George had been. Even at the end of her life, Christ does not appear to comfort her as she believed he would. For the second time, she is surprised, disappointed, and powerless to affect her fate. The male God, like her male lover, cannot be trusted. However, Granny Weatherall's loss does not destroy her or drive her mad. She functions, as women surely do, in spite of the blows dealt her.

Conclusion

Great Expectations, "A Rose for Emily," and "The Jilting of Granny Weatherall" are mysteries with surprise endings. In all three, the reader learns early that a woman has been jilted and changed forever. Because reality is socially constructed, marriage—happy or otherwise—becomes the norm. As different as the three fictional women in this study are, they all long for marriage to men they love, and one settles for marriage to a man she never learns to care for as much as she cared for the one who jilted her. All three spend their lives grieving for what the strong and proud Granny Weatherall calls that "something not given back."

In *Marriage and Inequality in Classless Societies*, Jane Fishburne Collier states that the "glorification of marriage" has always been built into society. "To transform women into wives," she writes, "it has been necessary not only to glorify the status of the wife (despite its actual disabilities) but also to

denigrate the status of nonwife mercilessly. The spinster or old maid has been an object of derision" (11). The prevalent attitude, she confirms, is: "Better dead than unwed" (11).

Sexism is institutionalized in Western culture, and the insistence on heterosexual marriage as normal and fulfilling is one of the strongest rituals of expectation. Alleen Pace Nilsen reveals in her book *Sexism and Language* that women appear last in groups listing men and women, except when the groupings identify family relations and marriage contracts. It is, for example, "Mr. and Mrs.," "he and she," "Sonny and Cher," "Jack and Jill," etc. However, it is "bride and groom," "mother and father," "mother and child," "aunt and uncle" (133), etc. The wedding is the bride's show, and the word "bride" is dominant in everything connected with the wedding: "bridegroom," "bridal attendant," "bridal wreath," "bridal shower" (134), etc.

Marriage continues to be seen as success for women and defeat for men. Women are assumed to love their families; there is no such thing as "family woman," in the same way that society does not refer to men as "career men" (135), Nilsen writes. "At prenuptial celebrations, men look backward while women look forward. It is as if each sex wants to emphasize and honor the state it considers ideal" (134).

Dickens, Faulkner, and Porter seem well aware of the importance of marriage in a woman's life. They deny to their three characters the love, security, and containment promised by society in exchange for marriage; for Miss Emily, Miss Havisham, and Granny Weatherall, the idealistic promise of a perfect marriage remains that "something not given back." Unfortunately, Dickens and Faulkner succumb to the prevailing perspective by creating women whose only response to abandonment is to go mad, and they count on the conditioning of their readers to make such a fate plausible.

Jennifer Aniston and Tenley Molzahn are contemporary figures who seem to arouse pity because Brad Pitt and Jake Pavelka left each of them and fell in love with someone else. Ultimately, though, women in fiction and in life are betrayed in only minor ways by those who leave them standing at the altar or who do not select them at the end of a reality show. In a larger and far more important sense, they are defeated by the society that defines rejected or unmarried women as peculiar or unworthy. That abandonment remains the greatest betrayal of all.

Works Cited

Auerbach, Nina. "Foreword." *Old Maids to Radical Spinsters: Unmarried Women in the Twentieth-Century Novel.* Ed. Laura Doan. Chicago: University of Illinois Press, 1991. ix–xv.

Boeth, Jennifer, and Nina Darnton. "A Quarter Century of Cleavage" *Newsweek* 115.17 (23 April 1990): 57.

Collier, Jane Fishburne. *Marriage and Inequality in Classless Societies.* Stanford: Stanford University Press, 1988.

Dickens, Charles. *Great Expectations.* New York: Penguin, 1963.

Doan, Laura L. "Introduction." *Old Maids to Radical Spinsters: Unmarried Women in the Twentieth-Century Novel.* Ed. Laura L. Doan. Chicago: University of Illinois Press, 1991. 1–16.

Faludi, Susan. *Backlash: The Undeclared War Against American Women.* New York: Crown Publishers, 1991.

Farrell, Warren. *Why Men Are the Way They Are.* New York: McGraw-Hill, 1986.

Faulkner, William. "A Rose for Emily." *Collected Stories.* New York: Vintage, 1977. 119–30.

Fetterley, Judith. "Reading about Reading: 'A Jury of Her Peers,' 'The Murders in the Rue Morgue,' and 'The Yellow Wallpaper.'" *Gender and Reading: Essays on Readers, Texts, and Contexts.* Ed. Elizabeth A. Flynn and Patrocinio P. Schweickart. Baltimore: Johns Hopkins University Press, 1986. 147–64.

———. "A Rose for 'A Rose for Emily.'" *The Resisting Reader: A Feminist Approach to American Fiction.* Bloomington: Indiana University Press, 1978. 34–45.

Hamilton, Cicely. *Marriage as a Trade.* London: The Women's Press, 1981.

Jallard, Pat. *Women, Marriage, and Politics (1860–1914).* New York: Penguin, 1963.

Lawrence, D.H. *Women in Love.* New York: Viking Penguin, 1933.

Nilsen, Alleen Pace. "Sexism in the Language of Marriage." *Sexism and Language.* Ed. Alleen Pace Nilsen and others. Urbana, Ill.: National Council of Teachers of English, 1977. 131–40.

Porter, Katherine Anne. "The Jilting of Granny Weatherall." In *The Old Order: Stories of the South.* New York: Harcourt Brace Jovanovich, 1969. 63–78.

Rizzo, Monica. "I Never Thought I Would Find Love Like This." *People* (15 March 2010): 105–108, 111.

Chapter Fifteen

The Lady Is (Still) a Tramp:
Prime-Time Portrayals of Women Who Love Sex

The proliferation of terms to describe straight women who love sex suggests an unspoken but highly deliberative consensus about how much sex is appropriate. In determining how much sex is reasonable and how much constitutes excess, members of a society enforce their opinions in part by humiliating women who refuse to comply with the majority, using words such as "floozy," "harlot," "hussy," "nymphomaniac," "tramp," "trollop," "skank," "slut," "vamp," "vixen," and "whore" to describe them. If the women are confident enough, they may appropriate the terms themselves, using them as Edie Britt (Nicollette Sheridan) does in *Desperate Housewives* when she describes herself as a "whore" in the episode "Look into Their Eyes and You See What They Know."

These words have distinct etymologies and have appeared throughout the centuries in both high and low culture. Semantic weapons—accepted and wielded by members of the dominant culture—are powerful indeed. Equivalent terms to describe men—who might also enjoy what is perceived to be an inordinate amount of sex—do not exist, although this fact does not seem to dissuade those who advocate particular standards of morality for women and who seek to enforce them.

Of course, women, too, are invested in the discussion of what is appropriate behavior for themselves, their mothers, their sisters, their friends, and those in the larger community. In *Are Men Necessary? When Sexes Collide*, for example, columnist Maureen Dowd expresses horror that it "took only a few decades to create a brazen new world where the highest ideal is to acknowledge your inner slut" (176). Understandably concerned about messages disseminated by media and society, Dowd, however, allies herself

with those who advocate standards of decency and decorum without being specific about how much sex is too much and without clarifying the occasions when sex is appropriate or inappropriate. What, exactly, characterizes a "slut?"

"The Lady Is (Still) a Tramp: Prime-Time Portrayals of Women Who Love Sex" deals with several iconic characters whose behavior polarizes television critics and viewers. The effect of their behavior is debated on line and elsewhere. For example, in 2008 during an ABC News interview, a 22-year-old accused one of the characters included in this study of having encouraged her to become a "slut." When she was 14, she said during the interview, she imitated the behavior of the characters on her favorite television program *Sex and the City* by smoking, by using some of the phrases from the program during sex, and by agreeing to have sex with multiple partners. Certainly, the impact of television images on young people remains an important discussion in media studies.

Further complicating an analysis of decency and television texts is the awareness that celebration of a straight woman's right to express herself sexually has to be balanced by an awareness of why she is doing so: Is she having sex for her own pleasure, to manipulate a man in order to gain something from him, or to feel more free? Does she enjoy sex responsibly, or does she gamble with sexually transmitted diseases and/or risk unwanted pregnancy? How much of her behavior is motivated by her own needs, and how much is the result of media messages and information she receives from her friends, romantic partners, and family? In addition, how well do images of women on television reflect real women, and are the images irresponsible, neutral, positive, contradictory, complex, or simply imaginative and intriguing? And finally, as Samuel A. Chambers asks, can a television program focused on straight suburban women such as *Desperate Housewives* "somehow wind up thwarting or eroding heteronormativity?" (63). If the answer is that the program both reinscribes and undercuts heterosexual ways of being and behaving (and I believe it does), then how much more important is it to consider the portrayals of women on the show in all their rich complexity?

Expressing their sexuality while being ridiculed by others unites several controversial television characters, including Abby Ewing (Donna Mills) of *Dallas* and *Knot's Landing*, Blanche Devereaux (Rue McClanahan) of *The Golden Girls*, Jackie Harris (Laurie Metcalf) of *Roseanne*, Samantha Jones (Kim Cattrall) of *Sex and the City*, and Paige Matheson and Edie Britt (both played by Nicollette Sheridan) of *Knot's Landing* and *Desperate Housewives*, respectively. Because this study does not focus upon lesbians or women of color, it underscores the manner with which straight white women are caricatured when they disrupt suburbia *(Knot's Landing, The Golden*

Girls, Roseanne, and *Desperate Housewives),* a ranch in Texas *(Dallas),* or an urban community *(Sex and the City).* It does not attempt to address social structures in the lesbian and bisexual community or in families of people of color, where sexual attitudes and family structures are complex and varied; informed by numerous cultural, philosophical, and religious forces; and not depicted as often on prime-time television for reasons that merit much more inquiry. It also does not address the class issues prominent in portrayals of middle-class characters such as Roseanne Conner and wealthy women such as Samantha Jones, although this, too, is a topic that deserves more study and surfaces briefly in the discussion of *Roseanne.*

"The Lady Is (Still) a Tramp" suggests that women who subvert unwritten heterosexual codes of conduct must be punished; in fact, their conniving and sometimes narcissistic behavior is the object of humor at the same time that it allows other characters in the television program to bask in a certain moral superiority. Viewers often find their own life choices reinforced by the fictional worlds they temporarily inhabit—unless, of course, they are viewers who identify with the ladies who are (still) tramps. It also argues that women who love sex are often the ones who are most unruly by society's standards; furthermore, although they may be objects of ridicule, they often use wit to retaliate against those who judge them.

Viewers must ascertain how much of the sexual appetite that characterizes Abby Ewing, Blanche Devereaux, Jackie Harris, Samantha Jones, and Edie Britt is harmless and entertaining and how much is malicious and manipulative. In "Images of Power and the Feminist Fallacy," Marjorie Ferguson writes, "*Designing Women, Roseanne, Murphy Brown,* and *The Golden Girls* do offer portraits of female autonomy, confidence, competence, achievement—and dottiness. But the common characteristic of the women shown, in the office or the kitchen, is their ability to *manipulate*" (218). In Ferguson's opinion, the fictional women who populate these television hits "will do anything to get what they want": "Getting the upper hand of men (and of women who are defined as a threat) is achieved through deviousness, lying, sexual blackmail, and assuming passive ('dumb female') or aggressive ('hard bitch') persona as required" (218).

With respect to this study, Ferguson takes particular issue with "sexual entrepreneur Blanche Devereaux" of *The Golden Girls* (1985–1992) and the "bullying" Roseanne Conner of *Roseanne* (1988–1997) (219). "The Lady Is (Still) a Tramp" asserts that the portrayals of Blanche Devereaux, Roseanne Conner, and other television protagonists are far more complex than Ferguson and others might suggest. Kathleen K. Rowe provides one of the most intricate descriptions of the women central to this study in "Roseanne: Unruly Woman as Domestic Goddess." In the essay and the book *Unruly*

Woman: Gender and the Genres of Laughter, Rowe argues that television women who engage lustily in various aspects of life are worthy of appreciation. Women such as Abby Ewing of *Dallas* (1978–1991) and *Knot's Landing* (1979–1993), Blanche Devereaux of *The Golden Girls*, Samantha Jones of *Sex and the City* (1998–2004), and Edie Britt of *Desperate Housewives* (2004–2012) shake the status quo to its foundation and represent what Rowe calls the *"topos* of female outrageousness and transgression from literary and social history" (409). Sexual appetites are only one aspect of their *joie de vivre*, but their rebellion against what they perceive to be arbitrary and discriminatory societal norms is determined and intense— sometimes even relentless. "Whispers follow her like so many eyes," writes Stephanie Rosenbloom about a woman akin to television vixens. "She is the one who will go home with you, the sure bet, the kind of girl you can lie down with and then walk all over. She is ogled, envied and often ostracized. She is the slut" (n.p.).

Whether or not these women are the ones men "walk all over" is a point of some concern, and it is one addressed later in this study. However, women who find that their sexual appetites are simply a part of their general lust for life may not be inordinately concerned with the price they will pay in the esteem of their communities. Ariel Levy, author of *Female Chauvinist Pigs: Women and the Rise of Raunch Culture*, suggests, "I think there are a lot of women who want to have a lot of sex because they enjoy it" (Rosenbloom, n.p.). In addition to the sensuality, eroticism, and physical contact they enjoy during sex, women on television and in real life might also celebrate breaking artificial boundaries, being independent, and/or challenging cultural mores. Rosenbloom writes:

> Indeed, many women admired the fictional libertine Samantha Jones on *Sex and the City* because she had…confidence and an unapologetic attitude about satisfying her desires. Enjoyment was always mutual.
> But viewers often commented that such a woman could not exist in real life. That attitude, [Ariel] Levy said, "goes to show we can't accept a woman who's promiscuous because she wants to be." (n.p.)

Finally, much of this essay deals with single women likely to be judged by their peers and by the larger community; however, married couples such as Roseanne (Roseanne Barr) and Dan Conner (John Goodman) of *Roseanne* and Gabrielle (Eva Longoria Parker) and Carlos Solis (Ricardo Antonio Chavira) of *Desperate Housewives*, who enjoy having sex more often than their friends and family might consider appropriate, also play a role in the study.

Discussing women and sex also requires awareness of the fact that women are the ones who become pregnant and are far more likely to interpret their own sexual behavior as having an impact on whether they marry and whom they marry. Much television programming—perhaps as a reflection of societal values—appears to be far less forgiving of women who are promiscuous than of men who enjoy a similar series of sexual relationships. "Women still have a script for their future that involves marriage, that involves children," writes Susan Freeman, assistant professor of women's studies at Minnesota State University in Mankato. "It governs a lot of choices they make, how sexually active they can be, what risks they are willing to take in terms of alienating a possible marriage partner" (Rosenbloom, n.p.). Whether or not the attitudes toward male and female sexual activity are fair or equal, women seem to have more to lose if they enjoy sex without establishing careful personal boundaries, and they are often the ones who must articulate their reasons for engaging in sex. "There seems to be a mysterious line between being experienced and being a slut, and no one can put a number on it" (n.p.), Rosenbloom writes.

"The Lady Is (Still) a Tramp" is divided into several sections, beginning with a brief overview of the history of women on American television and followed by a discussion of the place of humor in television texts about women. Both suggest that being highly sexual is not a socially acceptable role for women but that the role remains prevalent over time in art, literature, and popular culture. Discussion of several television characters—a few of whom use their sexuality to get what they need and want—follows these two sections.

Not incidentally, actresses with strong opinions about women's equality often play the characters in question, so the impact of these characters stretches beyond the television screen and into popular entertainment magazines and talk shows. For example, Kim Cattrall, who plays Samantha Jones on *Sex and the City*, and her husband Mark Levinson co-wrote a book provocatively entitled *Satisfaction: The Art of the Female Orgasm*. In addition, featuring a "scantily clad Cattrall," a Manhattan billboard campaign advertised an interview with Cattrall in *FHM* (Akass and McCabe, 197). Eva Longoria Parker, who plays Gabrielle Solis on *Desperate Housewives*, also has posed provocatively for Victoria's Secret fashion shows and ad campaigns.

Women and American Television

Before we acknowledge the complexity of portrayals of women who enjoy sex, it is necessary to acknowledge the obvious: women in television have had a long and sometimes undignified history. *Father Knows Best* (1954–1960), *Leave It to Beaver* (1957–1963), *The Dick Van Dyke Show* (1961–1966), and other television programs of the 1950s and 1960s established a precedent of women as devoted mothers and wives. Later, Roseanne Conner parodied the female characters who were devoted to hearth and home, inviting several of the actual actresses from *Lassie* (1954–1973) to *The Jeffersons* (1975-1985) into her unkempt kitchen.

The feminist movement ushered in a different—albeit equally limited—prototype for women. Popular media's "version of 1970s feminism was that it sent women into the workplace to find their self-worth," writes Bonnie J. Dow. "Thus, examples of feminist fallout that received extensive treatment in the 1980s media include the ticking biological clock, infertility woes, and the shortage of marriageable men for women who put off marriage and mother-hood to pursue their careers, as well as the second shift and toxic daycare endured by women who were combining motherhood and work for wages" (121).

Referring to "popular professional serial dramas of the 1980s," including *Hill Street Blues*, *L.A. Law*, and *St. Elsewhere*, as well as dramas such as *Thirtysomething*, Dow discusses women in their 30s who dealt with "evident anxieties related to being taken seriously at their jobs, to their lack of satisfy-ing personal lives, and to their desire for children." The shows also featured a "healthy number of sensitive new age guys (SNAGS, for short), often the love interests of postfeminist female characters, who not only love and respect these alpha women for who they are, but are deferent to and support-ive of their ambitions." She concludes that in a great deal of 1980s television programming, "men had learned the lessons of feminism; it was women who found them difficult" (122).

Years before *Sex and the City* and *Desperate Housewives*, television au-diences welcomed *That Girl* (1966–1971) starring Marlo Thomas, "the first show of the new period to feature a young, unmarried girl living on her own" (Press, 142). *The Mary Tyler Moore Show* (1970–1977) was the "next major departure from the early images," Andrea Press writes, providing the "first true 'career woman'" (142). Television through the 1980s and 1990s repre-sented women making choices; in some shows such as *L.A. Law* (1986–1994) and *Thirtysomething* (1987–1991), the choices between family and career were impossible, while in *The Cosby Show* (1984–1992) and *Family Ties* (1982–1989), the difficulties appeared surmountable, according to Press.

Criticizing contemporary television programs such as *The Man Show*, *Girls Gone Wild*, and *The Bachelor* for their stereotypes of women "as sex objects obsessed with romantic love and pleasing men" (285), Susan J. Douglas also grieves the demise of representations of working-class or middle-class women who rear children and who focus upon earning a living, such as the main characters in *Roseanne*, *Grace Under Fire*, *One Day at a Time*, *Kate and Allie*, and *Cagney and Lacey* (285). Her concern is rooted, first, in the historical preference for portrayals of wealthy women on television and, second, in her concern that the portrayals highlight the obsession women with money might have with physical beauty (fashion, make-up, spa treatments, plastic surgery, etc.). The nostalgia for *Roseanne* stems from more than being sorry to lose Roseanne Barr or being sorry that upper-class angst is overly available to television audiences; it is also the result of understanding that a particularly powerful social critique is missing.

Of course, although poor and lower middle-class women on television in the 21st century might suffer from a lack of representation, images of women who celebrate sex are common. Blanche Devereaux *(The Golden Girls)* and Jackie Harris *(Roseanne)* are particularly representative of characters who preceded Samantha Jones and Edie Britt. Certainly, neither is the epitome of motherhood or the image of the perfect career woman featured during the early years of American television.

The Golden Girls features three heterosexual women who have chosen to live together. The new family order provides them with financial and emotional support. M. Carole Pistole and Gia Marson suggest that *The Golden Girls* is a clear representation of "volunteer family relations" (11): "In depicting a creative family structure that is adaptive and developmentally functional, the show illustrates that purpose and meaningful family can be developed even after the loss of a life partner and after the traditional family, organized around children, ceases to be a viable biologic or economic option" (12).

Although to some extent *The Golden Girls* reinscribes the roles of women as mothers and wives, the characters have lost lifetime partners through death and divorce. The central characters are the heart of the situation comedy; biological family members move in and out of their lives (and, of course, in and out of episodes). One of the central characters is Blanche Devereaux (Rue McClanahan), a highly sexual object of light-hearted ridicule. Beneath her sassy veneer is a woman who enjoys sex and longs to remain desirable to men. Often denying her age, she teases her roommates and flaunts her beaus with a charming Southern accent. Blanche Devereaux's love for her former husband runs deep; in fact, her devotion to him after his

death makes it possible for viewers to enjoy her numerous sexual escapades without judging her behavior too harshly.

The same cannot be said for Jackie Harris, played by Laurie Metcalf, whom critics describe as having had a "string of failed relationships" (Spangler, 170) and unfulfilling jobs. Jackie Harris is critical of herself and is often chastised by Roseanne and Dan Conner and by her mother for her inability to find a suitable husband (at one point, she does marry and have a child, but the marriage ends in divorce). In *Television Women from Lucy to Friends: Fifty Years of Sitcoms and Feminism*, Lynn C. Spangler writes of Jackie Harris: "Having a man is important to her, even if it means going to bars and having one-night stands" (171). As Rowe notes, her primary role is to provide Roseanne with a confidante *(Unruly Woman*, 84). Jackie Harris becomes an object of pity—to a large extent precisely because she engages in sex easily and with great enthusiasm.

Of course, Jackie Harris is not the only character on *Roseanne* who revels in sex, although her enjoyment is less hampered by everyday responsibilities to children and a spouse. Roseanne herself is as bawdy and voracious as the "Wife of Bath" in Geoffrey Chaucer's *Canterbury Tales*, and in most ways she serves as the antithesis of June Cleaver. The central character is a working-class woman who does not worry about vacuuming and is not what Press calls the "typical, slim, white [or in the case of Clair Huxtable, black], and glamorous television woman" (146). Committed to her marriage and devoted to her children, Roseanne nonetheless is a parody of early television women and even of some who followed in hits such as *Desperate Housewives*. "Both in body and speech, Roseanne is defined by *excess* and by *looseness*—qualities that mark her in opposition to bourgeois and feminine standards of decorum" (413), Rowe asserts.

Humor as Subversive

Lovable and vulnerable, Blanche Devereaux and Jackie Harris are classic representations of women who enjoy sex. In spite of the perception that women are not allowed to enjoy sex with the exuberance that men do, they and other television characters provide audiences with largely sympathetic and often comedic representations of highly sexual women. In some episodes, the joke is on them; in others, the female characters employ humor as a tool to remind the world that they are in charge of their own decisions and destinies. As numerous critics have noted, humor is a great leveler—a technique used in playful as well as deeply serious attacks on cultural assumptions. Even in Roseanne Barr's description of her life and motivation

for becoming a stand-up comic and protagonist in her own television situation comedy, she pays tribute to the role of comedy in helping her to survive and succeed. "Co-existing with the pain of her childhood and early adulthood was a love of laughter, the bizarre, a good joke" (412), writes Rowe.

Unfortunately, of course, humor and bravado often are defenses born of difficult life experiences that require disarming those who might attack us. In the case of the television characters in this study, humor fuels confidence as confidence drives the plot. Although Jackie Harris is often plaintive and questions her decisions, Abby Ewing, Blanche Devereaux, Samantha Jones, and Edie Britt almost always maintain their swagger. Of course, women such as Blanche Devereaux, Samantha Jones, and Edie Britt might appear invincible, but their brave exterior often is undercut by their vulnerabilities; in fact, their fictional friends and family members (and, not incidentally, their viewers) often learn to forgive their questionable judgment and sexual proclivities by identifying and/or sympathizing with their fears and personal flaws. In *Sex and the City*, for example, Samantha Jones fears growing older (episodes address her having a chemical peel to avoid wrinkles or panicking when she fears she is menopausal).

These concerns mirror Edie Britt's own fears in *Desperate Housewives*. For example, in season five, Edie Britt's son Travers describes the women of Wisteria Lane as his mother's best friends, when, in fact, each of them has been bested by her and several have unwillingly shared husbands and lovers with her. At one point in the series, they banish her from their lives. After her death, however, the women acknowledge Edie Britt's unique place in their lives and appear to forgive her transgressions. Although Lynette Scavo (Felicity Huffman) responds to Susan Mayer Delfino's (Teri Hatcher) suggestion that they "share memories or tell stories" about their former neighbor by saying, "Why don't you start with the time she tried to steal your comatose boyfriend? That was *fun*," the women also reminisce about times Edie Britt reached out to them.

Her friends also identify with Edie Britt's descriptions of her feelings about aging and the inevitability of death. During a conversation with Gabrielle Solis, Edie Britt speaks in what is essentially a monologue, one punctuated with questions and comments uttered by her neighbor. When Gabrielle Solis suggests that there are pills she can take if she's depressed, Edie Britt responds:

> I'm not depressed. I'm surprised. It's gone by so quickly...My youth. The harder I
> try to hold onto it, the more it just slips through my fingers. And all the make-up and
> dim lighting in the world can't seem to stop it...That's the tricky part. I'm not gonna
> be old...Ever since I was a child, I've known that I was never gonna see 50...Live it

up today because you're not gonna have a lot of tomorrows...It's not a bad thing, Gaby. It's actually a gift. I appreciate my life in a way that most people don't. I just didn't expect it to go by this fast. That's all. ("Look into Their Eyes and You See What They Know")

In spite of their vulnerabilities, women such as Blanche Devereaux, Jackie Harris, Samantha Jones, and Edie Britt face the world without apology and never avoid a stiff headwind. What may be lost in the interpretations of their behavior, of course, is that the women who love having sex are also those who—as Carrie Bradshaw (Sarah Jessica Parker) of *Sex and the City* observes to her three closest friends—"behave like men" sexually and do not need the approval of those around them. For the most part, they are who they are: they are comfortable with their desire for sex and defiant in the face of those who dare to judge them. "Like Medusa," Rowe writes, "the unruly woman laughs. Like Roseanne Arnold, she is not a 'nice girl.' She *is* willing to offend and be offensive" (10).

The ensemble cast in television programs from *Dallas* to *Desperate Housewives* often works together to mitigate the impact of the vamp or vixen on the community. This highly effective reification of social boundaries encourages viewers who have made certain life choices but who might long for the freedom to be more sexually indiscriminate or to use sexuality to gain their personal ends. As we shall see, women who are jealous of the seductiveness of their neighbors or who are concerned about the effect of illicit behaviors on children often act in tandem to control the woman who violates perceived standards of decency. Bree Van de Camp (Marcia Cross) may be a "red-headed ice cube" and a "Puritanical robot bitch" and Lynette Scavo may be a "baby factory," as Edie Britt describes them, but they are faithful to their vows and strive to be good parents. Simply, their priorities reassure viewers who have made similar decisions that their choices are more noble than those of Edie Britt.

In some cases, the behavior of allegedly promiscuous women seems to have its own penalty, which other characters may not celebrate but which they often consider just. For example, in *The Golden Girls*, Blanche Devereaux's three roommates take refuge in the fact that although she goes from bed to bed, she cannot find anyone she can love as much as she loved her late husband; Jackie Harris, Roseanne Conner's hapless sister in *Roseanne*, fails to find fulfillment in her career choices (police officer, trucker, etc.) or in her marriage, and she often returns to the kitchen table to listen to the suggestions that Roseanne, Roseanne's husband Dan, or Jackie's mother inevitably make; and Edie Britt, the sultry seductress of Wisteria Lane on *Desperate Housewives*, pays the ultimate price when she is

repeatedly ostracized by her neighbors and later loses her life. As the objects of derision, these women often are forced to employ humor to hold the world at bay.

Whether the humor is based on one-liners in *Roseanne* or on the wry and dark humor of *Desperate Housewives*, the female protagonists employ it deftly. As Rowe notes, their determination to be at the center of the action makes them strong: "The unruly woman points to new ways of thinking about visibility as power" and the roles provide each woman with an "ability to affect the terms on which she is seen" (11). In *The Unruly Woman*, Rowe "investigates the power" of women's laughter "to challenge the social and symbolic systems that would keep women in their place" (3) and argues that humor can be a "weapon of great political power" (9).

Sex and the City

Winner of the 2003 Golden Globe for "Best Supporting Actress in a Series" and an example of a woman who wields power in subversive ways is Samantha Jones of *Sex and the City*. Owner of a public relations firm, Samantha Jones has been described as a "sexual libertine" (McCabe, 3), as a "spokesperson for sexual experimentation" (Henry, 79), and as "unabashed" (Akass and McCabe, 184). Typically bawdy, loud, and opinionated, Samantha Jones states in one episode: "If you're a successful single woman in this city, you have two choices: You can bang your head against the wall and try and find a relationship or you can say 'screw it' and just go out and have sex like a man." Embodying self-control and autonomy, she is also vulnerable and longs for loyalty and support, while proving herself loyal to and supportive of her three best friends.

Funny and irrepressible, Samantha Jones is the ever-present reminder that societal expectations are destructive to relationships. In one scene, Charlotte York (Kristin Davis) says to Samantha Jones, "Everyone needs a man. That's why I rent. If you own and he rents, then the power structure is all off. It's emasculating. Men don't want a woman who's too self-sufficient." Predictably taciturn, Samantha responds, "I'm sorry. Did someone just order a Victorian, straight up?"

Certain that "Mr. Right is an illusion" (Di Mattia, 19), Samantha Jones engages in numerous sexual relationships, leading some critics to accuse her—understandably enough—of modeling unsafe sex and hedonistic adventures. Astrid Henry writes:

> This focus on pleasure—without much attention, if any, to the dangers of sex—is also the principle [sic] ethic of *Sex and the City*. In episode after episode, Carrie, Samantha, Miranda, and Charlotte are not punished for being sexually active; they are not treated as "fallen women" who must ultimately encounter some horrible fate. Rather, their sexual "selfishness," if you will, is rewarded and praised, which is highly unusual in either film or TV representations of women's sexuality. (75–76)

Criticized for her "shockingly child-like indifference to the potential dangers of sexual expression in the AIDS era" (Greven, 45), Samantha Jones describes herself as "trisexual," meaning she'll try anything. Her exuberant enjoyment of sex worries even Carrie Bradshaw, who argues with her in one episode about her "promiscuity." In another episode, Samantha engages in lesbian sex. When she tells her friends that she's now in a lesbian relationship, Carrie blurts, "Wait a second! You're having a relationship?" (Henry, 79). Clearly, the shock is not that Samantha Jones is sleeping with a woman but that having sex is linked to deep feeling. Called "the most sexually active and sexually satisfied" woman on *Sex and the City* (Henry, 76), Samantha Jones blurts "That's a crock of shit" after Charlotte York argues, "Sex can be great without an orgasm" (Henry, 76).

In her critique of *Ally McBeal* and *Sex and the City*, Press suggests that both television programs depict women with successful careers who are preoccupied with finding the perfect man. "This emphasis is so strong that it undercuts the way the women's careers might be seen to underscore their (and the show's) support for second-wave feminist values," she states. Citing other scholars, Press concludes by saying: "While its portrayal of women and their sexuality has certainly been progressive in many respects, the postfeminist qualities of *Sex and the City* (and its overall adherence to traditional values of glamour and consumerism) tend to mitigate the radical impact the show can have on its eager and committed female audience" (145). However, although Samantha Jones is the slave of consumerism, she is stalwart in her opposition to at least one traditional value: marriage. Unlike Blanche Devereaux, Jackie Harris, and Roseanne Barr, she consistently rejects taking vows, although she demonstrates in the series that she can sustain at least one long-term relationship. "Samantha is an outspoken marriage resister, frequently pronouncing that she has no interest in the institution" (73–74), writes Henry. One of Samantha Jones's most well-known statements is that marriage "doesn't guarantee a happy ending. Just an ending" (Nelson, 89). And when Carrie Bradshaw tells Samantha Jones about her own response to a marriage proposal ("I threw up. I saw the ring, and I threw up. That's not normal"), her friend responds, "That's my reaction to marriage" (Henry, 74).

Most important for this study is that *Sex and the City* illustrates, as one critic writes, the ways in which women are able to negotiate "vicious patriarchal narratives through humour and shared laughter": "This uneasy relationship with the erstwhile myths that shape women's attitudes to fairy-tale romance and the happy-ever-after, the cult of motherhood, and glamour and the pursuit of the perfect body are at the core of what makes us laugh in the show" (Akass and McCabe, 179–80). The ways in which female characters use humor and challenge dominant attitudes are relevant to *Desperate Housewives* as well.

Desperate Housewives

Desperate Housewives hit network television in 2004 with the force of the tornado that would eventually raze Wisteria Lane. With the help of the new blockbuster, ABC netted more than $16 billion in advertising in 2005. Enjoying a viewership of more than 21 million women and men in a typical season, *Desperate Housewives* "presents the intimate lives of five attractive women living in a middle-to-upper-class neighborhood somewhere in America" (133–34), Debra Merskin writes.

Scripts elevate black humor to an art form. According to Nicollette Sheridan, who plays Edie Britt, the show is "touching and it's weird and it's funny and it's witty" (Lancioni, 129). Creator Marc Cherry grew up watching actresses Mary Tyler Moore, Marlo Thomas, and Bea Arthur. As Dow notes, his references are "presumably references to, respectively, *The Mary Tyler Moore Show, That Girl*, and *Maude*," and she adds that Cherry "called the 'desperate housewives' of his series 'their daughters'" (114).

Dow is correct when she describes *Desperate Housewives* as a "black comedy melded with the generic characteristics of a prime-time soap opera" (114). The television program deals with serious themes and employs humor far darker than that in any of the other texts in this study. According to Press:

> Television has even taken a step toward a more honest portrayal of women's choice issues, as seen in the prime-time hit *Desperate Housewives*. A key breakthrough image on this show is the on-again, off-again working mother Lynette, who left a successful advertising career to become a full-time stay-at-home mother. Yet, the portrayal of her role contrasts markedly with families of television's golden era. Unlike the television of an earlier era, motherhood in this instance is not idealized, as Lynette is shown having many regrets about her choice, and then trying to go back to her career and realizing the difficulties involved in this choice as well. In this instance, women's need to choose among motherhood, work, and their combination are fairly and critically portrayed, although it should be noted that like the golden

age of family television, the how has a white, middle-class bias and errs on the side of portraying conventionally beautiful actresses. Nevertheless, in some respects, with *Desperate Housewives*, we travel beyond postfeminist television to family television written with a more overt consciousness of the real social and political issues women now face, in the family, in relationships, and in the workplace. (147)

Feminist criticism about *Desperate Housewives* is mixed. Press compliments the "ambivalence" of the show as it both sustains and undercuts models of "traditional romantic feminine values" (148). Press also expresses hope that Americans "have moved beyond a simplistic nostalgia for 1950s life, so shaped by television family images of the period, to a new sophistication in our ability to consider the choices women continue to make between the roles that family, work, and career will play in their lives. If so, television may be playing a progressive role in facilitating this change of mood" (148). However, Yvonne Tasker and Diane Negra write in "Postfeminism and the Archive for the Future" that the "ability of a series like 'Desperate Housewives' to regularly hit cultural nerves in its depiction of the trials of midlife dating, the struggle to balance career and domestic life, and so on runs the risk of overshadowing its conservative treatment of such issues" (173–74).

Several sexy and seductive straight women dominate the suburban scene in *Desperate Housewives*. Two of the most formidable are Gabrielle Solis (Eva Longoria Parker) and Edie Britt (Nicollette Sheridan). In "Children Will Listen," the narrator tells us, "There were many things Gabrielle Solis knew for certain. She knew red was her color. She knew diamonds went with everything and she knew men were all the same" (140). Merskin describes Gabrielle Solis as "sexy, sultry, promiscuous, sexually experienced...quick tempered, materialistic, devious, desiring, not inclined to work" and argues that she "uses her wiles to manipulate men, wears flashy, brightly colored and tight-fitting clothing she hopes people will notice, because 'she's worth it'" (146). This description also fits Edie Britt, of course, who competes with Gabrielle Solis for her on-again-off-again husband Carlos Solis (Ricardo Antonio Chavira).

In "Three Faces of Eva: Perpetuation of the Hot-Latina Stereotype in Desperate Housewives," Merskin reminds us that Edie Britt is not the only overly sexualized character on the show. Certainly, Gabrielle Solis is beautiful and interested in sex, even planning play days for her daughters so she and her husband can enjoy time together in the afternoon. And certainly, as Merskin also suggests, "Longoria's prime time pinup status and promotional positioning in magazines reinforce the already prominent, oversexed, underdressed decisive and divisive character she embodies on *DH*" (134). However, Edie Britt is labeled as a "slut" when Gabrielle Solis is not: "Despite

committing adultery and statutory rape, Gabrielle is not seen as a slut, while Edie, a single woman and a threat to the other women, is" (Shuler, 185).

However, by the fifth season, Gabrielle Solis has gained weight, has immersed herself in the lives of her daughters, and is less invested in fashion and seduction than she is in motherhood. The "highly sexual" Edie Britt, on the other hand, is who she has always been. She "is single and uses sex to get what she wants in a somewhat mindless and obvious manner," writes Merskin, "whereas Gabrielle is tactical, risky, and sensual (shown in her bra and panties or tiny teddies) and iconicized in the larger-than-life portrait that hangs above the Solis's fireplace" (137).

Called a "serial divorcee" (McCabe and Akass, 3), Edie Britt did not come from privilege. In the first season, she tells Susan Mayer: "Girls like you were always cheerleaders. Clear skin. Honor roll. Popular. In high school, I was the girl that hung out with the freaks at the loading dock. And smoked. Everybody hated us" (Shuler, 186). When her neighbor tries to reassure her that they have left high school behind, Edie Britt replies: "See, I don't think we do...I'm still the outsider that doesn't get invited to the cool parties, and you're still the perky cheerleader who thinks that she can pull the wool over everyone's eyes...we're still in high school. The old rules apply. The cool kids only want to talk to the freaks when they need something" (Shuler, 186–87).

Critics call Edie Britt a "slut" and discuss her role as antithetical to those of other women in the neighborhood. According to Chambers, *Desperate Housewives* reifies the role of wife and mother, setting up Edie Britt as the foil for motherhood:

> Edie is the slut, the abject other that clarifies and shores up the role of "wife" played (or potentially played) by all the other women. Edie, the slut, forms the constitutive outside to the housewives: she is that which they reject and exclude in order to constitute the subject position of wife. (64)

Stacy Gillis and Melanie Waters agree: "Even Edie, the neighborthood 'bad girl,' has a son, though her sexual empowerment casts her as a 'bad,' neglectful mother—a foil to the legions of dedicated maternal figures that populate the Fairview landscape" (201). Sharon Sharp also calls Edie Britt "the neighborhood slut, without the attachment of husband, family or friends and whose self-esteem is derived from male sexual attention" (122).

However, given the popularity of the character played by Nicollette Sheridan, it is inaccurate to suggest that Edie Britt is one dimensional. Certainly, Edie Britt is the outcast, the brunt of cruel humor. Even one of the women to whom Edie Britt has been kind says destructive things about her: "I say she's

easier to get into than community college," says Karen McClusky (Kathryn Joosten). Nonetheless, Edie Britt is not a caricature; she is a complex and compelling figure, evoking sympathy both in other characters and in members of the television audience. For example, in season four, Edie Britt is the epitome of a desperate housewife as she hangs herself in an attempt to lure Carlos Solis back (it is clear she expects him to save her). When Edie Britt is admitted to the hospital after her "suicide" attempt, Solis tells Gabrielle Solis that he needs to wait one or two weeks before moving back in with her. When Gabrielle Solis opposes the delay, he shouts: "Edie's on a ventilator!" This statement, of course, highlights the lack of concern Gabrielle Solis and others have about Edie Britt's condition. Edie Britt's loneliness and genuine affection for Carlos Solis are highlighted later when, visiting a blind Solis in the hospital, she learns he once gave her inexpensive jewelry: "I gave you my heart, and all you could give me was fake jewelry?" The statement is less a reflection of her desire for expensive trinkets than it is a plea that he recognize her genuine love for him.

Of course, Carlos Solis is not the only husband of the neighborhood women whom Edie Britt appropriates. However, the relationships she forms with these men are often more supportive than those they have with their wives (or former wives). For example, when Bree Van de Camp banishes her husband Orson Hodge (Kyle MacLachlan), Edie Britt lets him sleep on her couch. Bree Van de Camp confronts her, saying, "Carlos, Mike, Carl…You do have a way of picking at other women's leftovers." But Orson Hodge, grateful for Edie Britt's kindness and forgiveness, thanks her and says, "You're a good person, Edie Britt."

Seemingly unafraid of anything, Edie Britt is, in fact, terrified that "the chance for love has passed forever," as the narrator tells us while we watch Edie sitting alone near a window of her home. In a flashback, we learn that neighborhood boys amused themselves by scaring her when she was a child, and, in fact, her life as an adult is not much better. Calling her the "devil," the four central characters in *Desperate Housewives* abandon Edie Britt after one of her more destructive exploits: "We're done," Susan Mayer tells her. "You are invisible."

However, in season five, Edie Britt returns unwillingly to Wisteria Lane and in several episodes underscores how sexy, strong, witty, and even happy she is. We are reintroduced to Edie Britt as she washes a Lexus in the driveway. Leaning seductively over the car, she says, "You know someone else my age with a body like this?" She tells Susan Mayer, "I have a husband now." As an indication that not much has changed in Susan Mayer's opinion of her former neighbor, she replies: "Really? Whose?"

No one who followed the development of Edie Britt's character during the series doubts her appeal to men or the fact that she trusts them more than she trusts women. Men, she says proudly, are her "area of expertise." After her death, Gabrielle Solis agrees: "Say what you want about Edie. She really understood men." Karen McClusky replies, "I should hope so after all those years of research."

Although Edie Britt dies in an automobile accident at the end of the fifth season, she dies as she lived—with strength and humor. At one point, she tells Dave Williams (Neal McDonough), the most recent husband who has disappointed her: "There's something you should know about me. I don't stay unhappy for long." With characteristically existential courage, she tells the audience, "Life is brief and mostly sucks. Gotta grab all the good you can while you're on this side of the dirt." When Edie Britt dies, she describes the life she lived by saying: "The good news? I died just like I lived—as the complete and utter center of attention." After her death, her neighbors describe her as "sexy," "perceptive," "strong," and "beautiful." Edie Britt was, as Susan Mayer notes, "one of a kind." Remembering her life, Edie Britt looks down upon Wisteria Lane and says:

> As I looked down on the world, I began to let go of it. I let go of white picket fences and cars in driveways, coffee cups and vacuum cleaners. I let go of all those things which seem so ordinary. But when you put them together, they make up a life, a life that really was one of a kind. I'll tell you something: It's not hard to die when you know you have lived. And I did. Oh, how I lived. ("Look into Their Eyes and You See What They Know")

Conclusion

Certainly, much has been written about the history of women and humor, about female empowerment, and about how women subvert societal rules. This study relies upon scholarship in these areas and critiques the portrayal of selected white heterosexual characters on *The Golden Girls, Roseanne, Sex and the City, Desperate Housewives,* and other television programs. The study suggests that these television characters are representative of a larger social phenomenon. In addition, "The Lady Is (Still) a Tramp" argues that the characters in question (and perhaps viewers who identify with them) pay a heavy price for celebrating their sexuality, for being seductive in order to gain power and prestige or simply to have fun, and/or for enjoying sex (too much). The characters are often ridiculed, and although they might appear to be strong and autonomous, they are treated as pariahs [Edie Britt describes

herself as "exiled from suburbia"], even as their very existence undercuts the status quo.

Although young men often are celebrated when they seek out sexual partners—in fact, sex exists as a rite of passage—women are defiled and vilified for exhibiting the same behavior. The woman who enjoys sex is a "rule-breaker, joke-maker, and public, bodily spectacle" (12), terms that Rowe uses to describe an unruly and endlessly fascinating woman. The woman at the heart of this study "unsettles social hierarchies," and from her we learn what Rowe calls "female resistance—and pleasure" (19).

As we have noted, humor can be a great equalizer, but ridicule masquerading as humor is used to punish women considered deviant and, perhaps more important, unrepentant. When Ella Fitzgerald, Diana Ross, and Frank Sinatra sing "(That's Why) the Lady Is a Tramp" by Richard Rodgers and Lorenz Hart, lines such as "I get too hungry for dinner at eight/ I like the theatre but never come late/ I never bother with people I hate/ That's why the lady is a tramp" suggest a powerful, emancipated person. However, women who long for love and physical intimacy but refuse to sacrifice their own independence have a long history on American television and suffer their own private disappointment and loneliness. These women—who "won't go to Harlem in ermine and pearls" or follow other cultural mandates—sometimes are mocked by those around them and are used as foils for the women who behave appropriately (those who keep their vows, those who are monogamous or at least practice serial monogamy, those who thrive as wives and mothers, etc.). For example, as we have noted, Edie Britt, who has a son, does not behave as mothers are expected to; consequently, she reinforces the maternal attributes of others on *Desperate Housewives*.

Although "The Lady Is (Still) a Tramp" highlights television characters who enjoy the right to pursue and enjoy sexual encounters, it is important to note that most women work long hours and are often too exhausted to think about sex. Although some might argue that we live in communities of actual desperate housewives, the desperation is likely to be rooted in concerns about children, about sustaining a fulfilling marriage, about maintaining friendships, about remaining healthy, and about being financially solvent. It is unlikely that the primary concern among heterosexual women who have opted for marriage and a life in either suburbia or an urban center is the amount of sex that they and their neighbors enjoy.

Because television viewers seek fantasy as well as depictions of real life, this study supports what scholars such as Tasker and Negra suggest: In contemporary television portrayals, feminism is "at once achieved and abjured" (171). It is often difficult to discern whether the portrayals of women such as Blanche Devereaux or Jackie Harris are progressive or

regressive. Is the representation of a woman who enjoys having sex, perhaps "too much," and who defies those who criticize her a progressive image? Are these women courageous and independent or deluded and enslaved by their passions? One thing is most certainly true: Although they may or may not recognize themselves in the characters who populate Manhattan or Wisteria Lane, viewers have made the fictional communities where women such as Samantha Jones and Edie Britt live, love, and seek sexual satisfaction into blockbuster television hits.

Works Cited

Akass, Kim, and Janet McCabe, ed. "Ms. Parker and the Vicious Circle: Female Narrative and Humour in *Sex and the City*." *Reading Sex and the City*. Ed. Kim Akass and Janet McCabe. New York: I.B. Tauris, 2008. 177–98.

————. *Reading Sex and the City*. New York: I.B. Tauris, 2008.

Chambers, Samuel A. "Desperately Straight: The Subversive Sexual Politics of *Desperate Housewives*." *Reading Desperate Housewives: Beyond the Picket Fence*. Ed. Janet McCabe and Kim Akass. New York: I.B. Tauris, 2006. 61–73.

Di Mattia, Joanna. "'What's the Harm in Believing?': Mr. Big, Mr. Perfect, and the Romantic Quest for *Sex and the City's* Mr. Right." *Reading Sex and the City*. Ed. Kim Akass and Janet McCabe. New York: I.B. Tauris, 2008. 17–32.

Douglas, Susan J. "Where Have You Gone, Roseanne Barr?" *The Shriver Report: A Study by Maria Shriver and the Center for American Progress*. 10 Sept. 2009. http://www.americanprogress.org/issues/2009/10/pdf/awn/chapters/media.pdf.

Dow, Bonnie J. "The Traffic in Men and the Fatal Attraction of Postfeminist Masculinity." *Women's Studies in Communication* 29.1 (Spring 2006): 113–31.

Dowd, Maureen. *Are Men Necessary? When Sexes Collide*. New York: Putnam, 2005.

Ferguson, Marjorie. "Images of Power and the Feminist Fallacy." *Critical Studies in Mass Communication* 7 (September 1990): 215–30.

Gillis, Stacy, and Melanie Waters. "'Mother, Home and Heaven': Nostalgia, Confession and Motherhood in *Desperate Housewives*." *Reading Desperate Housewives: Beyond the Picket Fence*. Ed. Janet McCabe and Kim Akass. New York: I.B. Tauris, 2006. 190–205.

Greven, David. "The Museum of Unnatural History: Male Freaks and *Sex and the City.*" *Reading Sex and the City.* Ed. Kim Akass and Janet McCabe. New York: I.B. Tauris, 2008. 33–47.

Henry, Astrid. "Orgasms and Empowerment: *Sex and the City* and the Third Wave Feminism." *Reading Sex and the City.* Ed. Kim Akass and Janet McCabe. New York: I.B. Tauris, 2008. 65–82.

Lancioni, Judith. "Murder and Mayhem on Wisteria Lane: A Study of Genre and Cultural Context." *Reading Desperate Housewives: Beyond the Picket Fence.* Ed. Janet McCabe and Kim Akass. New York: I.B. Tauris, 2006. 129–43.

Levy, Ariel. *Female Chauvinist Pigs: Women and the Rise of Raunch Culture.* New York: Free Press, 2006.

McCabe, Janet, and Kim Akass. *Reading Desperate Housewives: Beyond the Picket Fence.* New York: I.B. Tauris, 2006.

Merck, Mandy. "Sexuality in the City." *Reading Sex and the City.* Ed. Kim Akass and Janet McCabe. New York: I.B. Tauris, 2008. 48–62.

Merskin, Debra. "Three Faces of Eva: Perpetuation of the Hot-Latina Stereotype in *Desperate Housewives.*" *The Howard Journal of Communications* 18 (2007): 133–51.

Nelson, Ashley. "Sister Carrie Meets Carrie Bradshaw: Exploring Progress, Politics, and the Single Woman in *Sex and the City* and Beyond." *Reading Sex and the City.* Ed. Kim Akass and Janet McCabe. New York: I.B. Tauris, 2008. 83–95.

Pistole, M. Carole, and Gia Marson. "Commentary on the Family's Vitality: Diverse Structures With TV Illustrations." *The Family Journal: Counseling and Therapy for Couples and Families* 13.1 (January 2005): 10–18.

Press, Andrea. "Gender and Family in Television's Golden Age and Beyond." *The ANNALS, American Academy of Political and Social Science* 625 (September 2009): 139–50. http://ann.sagepub.com/cgi/content/abstract/625/1/139.

Rosenbloom, Stephanie. "The Taming of the Slur." *New York Times.* 13 July 2006. http://www.nytimes.com/2006/07/13/fashion/thursdaystyles/13women.html.

Rowe, Kathleen K. "Roseanne: Unruly Woman as Domestic Goddess." *Screen* 31.4 (Winter 1990): 408–19.

———. *The Unruly Woman: Gender and the Genres of Laughter.* Austin: University of Texas, 1995.

Sharp, Sharon. "Disciplining the Housewife in *Desperate Housewives* and Domestic Reality Television." *Reading Desperate Housewives: Beyond the Picket Fence.* Ed. Janet McCabe and Kim Akass. New York: I.B. Tauris, 2006. 119–28.

Shuler, Sherianne, and others. "Desperation Loves Company: Female Friendship and the Façade of Female Intimacy in *Desperate Housewives." Reading Desperate Housewives: Beyond the Picket Fence*. Ed. Janet McCabe and Kim Akass. New York: I.B. Tauris, 2006. 180–89.

Spangler, Lynn C. *Television Women from Lucy to Friends: Fifty Years of Sitcoms and Feminism*. Westport, Conn.: Praeger, 2003.

Tasker, Yvonne, and Diane Negra. "Postfeminism and the Archive for the Future." *Camera Obscura* 21.2 (2006): 171–76.

Chapter Sixteen

"This Moment of June": Laura Brown, Clarissa Vaughn, Virginia Woolf, and *The Hours*

Called an agnostic by some and a mystic by others, Virginia Woolf preferred to describe her belief system as a "philosophy." Creating a fictional universe dependent upon epiphany, mystery, and vision—concepts too often associated exclusively with religion—Woolf doubted the existence of God but believed in human potential: "One's life is not confined to one's body and what one says or does" (2017), she wrote in "A Sketch of the Past."

Woolf's conclusions about the nature and purpose of life lie at the heart of her novel *Mrs. Dalloway* (1925), Michael Cunningham's *The Hours* (1998), and Stephen Daldry's 2002 film by the same name. *(The Hours* was the original working title for *Mrs. Dalloway.)* A three-time Academy Award-nominated producer—also known for *Billy Elliott* (2000), *The Reader* (2008), and *Extremely Loud and Incredibly Close* (2011)—Daldry collaborated with Pulitzer Prize-winning author Cunningham to bring the lives and beliefs of three female protagonists to the screen.

Drawn to a novel that immortalizes a summer day in London, Daldry celebrates what Woolf called the "divine vitality" *(Mrs. Dalloway,* 7) of life itself. In *The Hours*, Laura Brown, Clarissa Vaughn, and Virginia Woolf struggle with decisions and relationships, coming to different conclusions about suicide and the value of life but sharing a common secular faith. The film ends with a letter in which Woolf describes her determination "to look life in the face and to know it for what it is...and then to put it away." With these words, Woolf asserts the purpose of human existence and the courage and wisdom that are required in order to be fully alive.

The historic Virginia Woolf repudiated the notion that heroic or even commendable qualities are the result of our having been made in the image of God, and her contempt for dogma was legendary. For example, in a Feb. 11, 1928, letter to her sister Vanessa Bell, Woolf scathingly attacks organized religion by disparaging T.S. Eliot: "He has become an Anglo-Catholic, believes in God and immortality, and goes to church. I was really shocked. A corpse would seem to me more credible than he is. I mean, there's something obscene in a living person sitting by the fire and believing in God" *(Letters,* 457–58). Equally well known is her protagonist's statement in *Mrs. Dalloway*: "Love and religion! thought Clarissa, going back into the drawing-room, tingling all over. How detestable, how detestable they are!" (126).

As incongruous as it might seem to comment on Woolf's belief system by invoking a devoutly Catholic writer from the American South, Flannery O'Connor shared with Woolf a profound respect for mystery, although they described its origin and purposes in radically different ways. O'Connor attributed her reverence for mystery to her devotion to God. In "The Fiction Writer and His Country," O'Connor addresses the charge that a belief system is "a hindrance to the writer," arguing instead that she has "found nothing further from the truth": "Actually, it frees the storyteller to observe," O'Connor writes. "It is not a set of rules which fixes what he sees in the world. It affects his writing primarily by guaranteeing his respect for mystery" *(Mystery and Manners,* 31). Although Woolf most certainly would not link her interest in mystery with a belief in God, her fiction relies upon epiphany and transcendence, what she calls "exceptional moments" ("Sketch," 2017). Analyzing the "mystical quality" of Woolf's writing, Stephanie Paulsell writes:

> A term so laden with religious connotations may seem badly chosen to describe the works of a writer who maintained a thoroughgoing skepticism toward matters religious, and who was the daughter of Leslie Stephen, one of Victorian England's most famous agnostics. Yet Woolf complained that her father and "his agnostic friends" lacked imagination *(Diary,* 3: 246), and her novels seem to many readers to be punctuated by moments of insight into the presence of a hidden reality. (249)

Admittedly on a lesser plane than divine mystery, imagination exists prominently in Woolf's fiction and some of the plays, novels, and films that pay homage to her life and work, such as Edward Albee's *Who's Afraid of Virginia Woolf?* and Michael Cunningham's *The Hours.* For Albee and Cunningham—as for Woolf herself—truth and illusion often are indistinguishable, and, for better or worse, characters in the play and the novel invent everything from a child to the memory of a perfect day as a way

to make daily life more palatable. As T.S. Eliot writes in "The Love Song of J. Alfred Prufrock," without the imagination, reality might be too harrowing to endure: "We have lingered in the chambers of the sea/ By sea-girls wreathed with seaweed red and brown/ Till human voices wake us, and we drown" (3).

Woolf struggled to live without illusions but acknowledged that writing fiction helped her to endure the vagaries of life. In "A Sketch of the Past," for example, Woolf states that her writing "gives me, perhaps because by doing so I take away the pain, a great delight to put the severed parts together. Perhaps this is the strongest pleasure known to me. It is the rapture I get when in writing I seem to be discovering what belongs to what; making a scene come right; making a character come together" (2017). In *The Hours*, Vanessa Bell (Miranda Richardson) celebrates the imagination when she tells her children that their Aunt Virginia "has two lives": "She has the life she's leading and also the book she's writing."

Like George, Martha, Nick, and Honey in *Who's Afraid of Virginia Woolf?* and Laura Brown and Clarissa Vaughn in *The Hours*, human beings long to see the world as it really is, while also recognizing that their individual fictions sustain them and preserve a desire for mystery. Devoting oneself to God or creating a fictional universe provides a construct that guards against madness and despair.

Who's Afraid of the Big Bad Wolf?

In *Who's Afraid of Virginia Woolf?* Martha and George, a middle-aged couple in the throes of marital discord, employ alcohol, anger, detachment, and intellectual elitism to try to assuage their pain. In the third act, Martha both elevates and vilifies George when she describes him as the man "who keeps learning the games we play as quickly as I can change the rules" and accuses him of being someone who is responsible "for having seen me and having said: yes; this will do; who has made the hideous, the hurting, the insulting mistake of loving me and must be punished for it. George and Martha: sad, sad, sad" (277).

Directed by Mike Nichols, the 1966 film drawn from Edward Albee's play starred Elizabeth Taylor as Martha, Richard Burton as George, George Segal as Nick, and Sandy Dennis as Honey. The film was nominated in every possible category and won five Academy Awards, including "Best Actress" for Taylor and "Best Supporting Actress" for Dennis. The film, which lost to *A Man for All Seasons*, is true to Albee's play and captures the tortured relationship of its central characters.

Because they have been married 23 years, George and Martha know how best to antagonize one another, and they create an imaginary son to bind them together and to give them a purpose for living during the times when they are at their most despondent (and, consequently, their most brutal). The son becomes the focus of the verbal games they play, and it is when George announces that their son is dead that Martha is most deeply wounded. Without the fantasy of her son to give her life purpose, the world loses any remaining luster for her and, by implication, for George.

The spirit of Virginia Woolf permeates the play, as the main characters struggle to separate illusion from reality and to find a reason for being. Both George and Martha sing the lyrics "Who's afraid of Virginia Woolf/ Virginia Woolf/ Virginia Woolf?" in a drunken comedy of errors. Albee said he took the title for his play from words written on a mirror in a bar:

> I was in there having a beer one night, and I saw "Who's Afraid of Virginia Woolf?" scrawled in soap, I suppose, on this mirror. When I started to write the play it cropped up in my mind again. And of course, who's afraid of Virginia Woolf means who's afraid of the big *bad* wolf…who's afraid of living life without false illusions. And it did strike me as being a rather typical, university intellectual joke. (Clooney, 85)

Raw and starkly realistic, *Who's Afraid of Virginia Woolf?* becomes even darker after George suggests playing a game called "Hump the Hostess." A guest of George's and Martha's, Honey, agrees to play the game, but her husband Nick understands the reference to his sexual desire for Martha and says to Honey: "Just shut up…will you?" George then says, "You don't wanna play that now, hunh? You wanna save that game till later? Well, what'll we play now? We gotta play a game." George is, of course, acknowledging that he can't deal honestly and directly with his wife; he is also admitting that life is unbearable unless it is punctuated with games. Martha responds—"quietly" and quite venomously—with her idea for a new game: "Portrait of a man drowning." Knowing he is lying to her and to himself, George says to no one in particular, "I am not drowning" (248).

Albee suggests that everyone is afraid of life without illusions, dreams, and fictions, and the interpersonal games that George and Martha play are both annihilating and sustaining. George and Martha avoid reality by creating plays on words, by drinking, and by spinning others into their web of despair. In the most important dramatic moment, Martha accuses George of not knowing the difference between truth and illusion (285), and in a rare flash of self-awareness and intimate connection with his wife, George replies, "No; but we must carry on as though we did." Martha replies sadly and concedes: "Amen" (285).

Although there is little lovable about a couple that will make their guests into pawns and force them to share a humiliating evening, George's and Martha's misery makes it possible to empathize with them. For example, when Martha says, "A drowning man takes down those nearest" (299), we realize that she is aware of those around her—those who might comfort her if she could stop herself from destroying them.

Later, George, too, engages in double entendre when he says, "It will be dawn soon. I think the play's over" (308). The audience understands that both the destructive games and the theater production itself have concluded. The most famous lines in the play occur at the end of the evening, when George asks again, "Who's afraid of Virginia Woolf?" Martha responds, "I ...am...George...I...am." (311). Acknowledging his fear as another tedious and potentially terrifying day dawns, George simply nods.

They Will Buy the Flowers Themselves

In *Who's Afraid of Virginia Woolf?*, Martha and George create illusions and engage in destructive games in order to cope with the absence of God and their failure to find purpose in their own existence. The three protagonists in *The Hours* struggle with the same universal questions. Ultimately, Laura Brown leaves her family and moves to Canada to surround herself with books; Clarissa Vaughn survives Richard Brown's suicide, relying for solace upon her daughter, her partner, and her work; and Virginia Woolf walks into the River Ouse when she believes she is once again falling into madness: "If I were thinking clearly, Leonard, I would tell you that I wrestle alone in the dark—in the deep dark—and that only I can know—only I can understand my own condition," Woolf tells her husband in the film.

However, the clouds occasionally part, and Clarissa Dalloway, Laura Brown, Clarissa Vaughn, and Virginia Woolf find comfort in the beauty and simplicity of a summer day. In these precious moments, the women are invincible: Laura Brown opts not to kill herself and her unborn child, Clarissa Vaughn recommits to her shared life, and Virginia Woolf tells her husband that she chooses "not the suffocating anesthetic of the suburbs but the violent jolt of the capital." The Woolfs understand that the move from Richmond to London may seal her fate, but she demands the right to decide her own destiny. In short, these are women who will buy the flowers themselves.

Alluding often to Woolf's *Mrs. Dalloway*, Cunningham addresses reality and the ways in which a moment can save or destroy us. "It's the city's crush and heave that move you; its intricacy; its endless life," says Clarissa Vaughn, as she also acknowledges "the lunatics, the stunned and baffled, the

people whose luck, if they ever had any, has run out" (14). Like *Mrs. Dalloway* and Woolf's final novel *Between the Acts* (1941), *The Hours* takes place in one day, a microcosm in a person's life. Although both Woolf and the poet Richard Brown commit suicide in *The Hours*, the message of both the novel and the film adaptation is that there are transcendent moments that are worth waiting for: "Still, she loves the world for being rude and indestructible, and she knows other people must love it too, poor as well as rich, though no one speaks specifically of the reasons. Why else do we struggle to go on living, no matter how compromised, no matter how harmed?" (14–15), thinks Vaughn.

Cunningham creates stream of consciousness to allow readers to understand Woolf's deep and persistent sadness and her fear of another painful and disorienting relapse. In one such scene, Woolf thinks to herself: "Her life (already past forty!) is being measured away, cupful by cupful, and the carnival wagon that bears Vanessa—the whole gaudy party of her, that vast life, the children and paints and lovers, the brilliantly cluttered house— has passed on into the night, leaving its echo of cymbals behind, its accordion notes, as wheels roll off down the road" *(The Hours,* 169). The avalanche of signs and symbols replicates the tumult in her mind as she remembers the day with her sister and as she both celebrates and dreads the days to come.

Throughout *The Hours*, Cunningham describes the cruelty and heroism of the human spirit. He writes about Woolf, who leaves suicide notes for Leonard Woolf and Vanessa Bell; Laura Brown, who abandons her children and becomes a librarian in another country; Richard Brown, who throws himself from a window rather than die of AIDS; and Clarissa Vaughn, who reunites with her partner after losing Richard and her dream of the one perfect kiss (and, of course, the one perfect life):

> We throw our parties; we abandon our families to live alone in Canada; we struggle to write books that do not change the world, despite our gifts and our unstinting efforts, our most extravagant hopes. We live our lives, do whatever we do, and then we sleep—it's as simple and ordinary as that. A few jump out of windows or drown themselves or take pills; more die by accident; and most of us, the vast majority, are slowly devoured by some disease or, if we're very fortunate, by time itself. There's just this for consolation: an hour here or there when our lives seem, against all odds and expectations, to burst open and give us everything we've ever imagined, though everyone but children (and perhaps even they) knows these hours will inevitably be followed by others, far darker and more difficult. Still, we cherish the city, the morning; we hope, more than anything, for more. (225)

The Hours is a film about an interior world. Stephen Daldry's genius in appropriating and transforming Cunningham's novel lies in understatement

and in meticulous attention to the rooms and gardens in which women spend much of their time. The first few moments of the film foreshadow what is to be, as Laura Brown (Julianne Moore), Clarissa Vaughn (Meryl Streep), and Virginia Woolf (Nicole Kidman) awaken and prepare to face the day. There are no shootouts or car chases: *The Hours* is an interior world of bedrooms, kitchens, hotel rooms. No thieves break in after dark: in *The Hours*, the terrors are personal, subterranean.

Woolf struggled with headaches and often succumbed to depression, and in 1941 she gave up the fight, committing suicide in Sussex, England. The film *The Hours* begins and ends with Woolf as she walks somberly into the river, her pockets loaded with rocks. The film's 1923 flashback to Virginia and Leonard Woolf and their time in Richmond, England, juxtaposes the artistic life with the pragmatic demands that challenged them. Having moved to Richmond from London to enjoy a quieter life, the couple makes a living by running a small independent press while Virginia Woolf writes *Mrs. Dalloway* in a sunlit room upstairs. But Woolf begins to despise the solitude of her new life. Growing increasingly despondent, Woolf writes her novel and decides that the poet—"the visionary"—will die, just as she herself will one day take her own life.

In the film, Vanessa Bell takes her three children to visit her sister. The two "rambunctious" boys are peripheral to the story, but Angelica Bell (Sophie Wyburd) stays with Woolf and helps her to conduct a funeral for a dying bird. "What happens when we die?" asks the child. "We return to the place that we came from," Woolf responds. The garden tableau—with Angelica, Virginia, and the bird—evokes Woolf's own dark vision. The buoyant Vanessa and her rowdy boys represent the exuberant escape that is denied to her. At the end of the visit, consumed with sadness, Woolf asks her sister, "Do you think I may one day escape?" Vanessa can only say "yes."

The screenplay by David Hare provides subtle links among the women, but it is the shared and mystical experience of the novel *Mrs. Dalloway* that unites them. Virginia Woolf creates Clarissa Dalloway, Laura Brown reads the novel, and Laura Brown's son nicknames his friend Clarissa Vaughn "Mrs. Dalloway." In *Mrs. Dalloway*, Woolf writes poignantly about her protagonist's life in England on a singularly important day in June. *Mrs. Dalloway* begins with a line echoed in Cunningham's novel *The Hours* and in the film by the same name: "Mrs. Dalloway said she would buy the flowers herself" (3). From the first scenes to the conclusion of the film, vases of flowers, the novel *Mrs. Dalloway*, and a desire for independence connect Laura Brown, Clarissa Vaughn, and Virginia Woolf with one another.

The Hours portrays three women who treasure life but struggle with its disappointments. Daily, they are overwhelmed with both the immediacy and

the reminiscences of their individual lives. The rush of experience and memory exhibits itself in a flood of language, both in Woolf's *Mrs. Dalloway* and Cunningham's *The Hours*. Woolf writes:

> For Heaven only knows why one loves it so, how one sees it so, making it up, building it round one, tumbling it, creating it every moment afresh...In people's eyes, in the swing, tramp, and trudge; in the bellow and the uproar; the carriages, motor cars, omnibuses, vans, sandwich men shuffling and swinging; brass bands; barrel organs; in the triumph and the jingle and the strange high singing of some aeroplane overhead was what she loved; life; London; this moment of June. *(Mrs. Dalloway*, 4; *The Hours*, 41)

The film recreates the cacophony of sound and image in occasional cityscapes, but the most notable turmoil is internal to the women themselves.

Linked thematically, the novel and film *The Hours* introduce us to three women who set out on individual quests for meaning and who share a spiritual sensibility. The secular religion to which Woolf ascribes leads her to identify with the "divine vitality" that Mrs. Dalloway cherishes: "To dance, to ride, she had adored all that" (7), Woolf writes. Woolf's own life, characterized by great joy followed by immobilizing sadness, is reflected in the life of her protagonist as well. The immediate moment and the memory of former joy are causes for celebration—in fact, the latter intensifies the former. For example, Mrs. Dalloway suddenly understands the "reward of having cared for people," as their images return to her in a moment of contemplation: "They came back in the middle of St. James's Park on a fine morning—indeed they did" *(Mrs. Dalloway*, 7).

As is also true for Woolf, Clarissa Vaughn's awareness of mortality occurs without any hope of heaven or sense of eternity or divine reward. The present becomes more precious because it is all she has: "Oh if she could have had her life over again!" (10), Clarissa Dalloway thinks. "Did it matter then, she asked herself, walking towards Bond Street, did it matter that she must inevitably cease completely; all this must go on without her; did she resent it; or did it not become consoling to believe that death ended absolutely?" (9), Woolf writes.

Woolf's novel, Cunningham's novel, and Daldry's film are tributes to mystery and to the potential for a life well lived. As Woolf tells her husband in the film, some die so that others might "value life more." For Vanessa Bell, Laura Brown, Clarissa Vaughn, Leonard Woolf, and the others who survive, morning returns, as do the moments of epiphany and despair that define our lives.

For O'Connor and others who believe in a compassionate God and eternal afterlife, faith guarantees a writer's respect for transcendence and

makes it possible, as William Wordsworth wrote, to "see into the life of things" (152). Woolf, on the other hand, relies upon her doubt, which shields her from the possibility of a capricious God and the reality of an uncertain world. While O'Connor insists that God's presence frees her to observe, it is Woolf's disbelief that makes her creative vision possible. The "divine vitality" that Clarissa Dalloway loves is perhaps even more intense when one believes only in the reality of a day, a moment in June.

Works Cited

Albee, Edward. *Who's Afraid of Virginia Woolf? The Collected Plays of Edward Albee, 1958–1965*. New York: Overlook Duckworth, 2007. 149–311.

Clooney, Nick. *The Movies That Changed Us: Reflections on the Screen*. New York: Atria Books, 2002.

Cunningham, Michael. *The Hours*. New York: Farrar, Straus and Giroux, 1998.

Eliot, T.S. "The Love Song of J. Alfred Prufrock." *Collected Poems (1909–1962)*. New York: Harcourt, 1991. 3–7.

The Hours. Dir. Stephen Daldry. Paramount, 2002.

O'Connor, Flannery. "The Fiction Writer and His Country." *Mystery and Manners*. New York: Farrar, Straus, and Giroux, 1989. 25–35.

Paulsell, Stephanie. "Writing and Mystical Experience in Marguerite d'Oingt and Virginia Woolf." *Comparative Literature* 44.3 (Summer 1992): 249–67.

Woolf, Virginia. *Between the Acts*. 1941. New York: Mariner Books, 1970.

———. *Mrs. Dalloway*. 1925. New York: Harcourt, 1981.

———. *The Letters of Virginia Woolf*. Vol. III: 1923–1928. Ed. Nigel Nicholson and Joanne Trautmann. New York: Harcourt Brace Jovanovich, 1977.

———. "A Sketch of the Past." *The Norton Anthology of English Literature*. Ed. M.H. Abrams. 5th ed. Vol. 2. New York: W.W. Norton, 1962. 2010–2019.

Who's Afraid of Virginia Woolf? Dir. Mike Nichols. Warner Bros., 1966.

Wordsworth, William. "Composed a Few Miles Above Tintern Abbey." *The Norton Anthology of English Literature*. Ed. M.H. Abrams. 5th ed. Vol. 2. New York: W.W. Norton, 1962. 51–55.

Index

FRAMING FILM
The History & Art of Cinema

Frank Beaver, *General Editor*

Framing Film is committed to serious, high-quality film studies on topics of national and international interest. The series is open to a full range of scholarly methodologies and analytical approaches in the examination of cinema art and history, including topics on film theory, film and society, gender and race, politics. Cutting-edge studies and diverse points of view are particularly encouraged.

For additional information about the series or for the submission of manuscripts, please contact:

Peter Lang Publishing, Inc.
Acquisitions Department
29 Broadway, 18th floor
New York, NY 10006

To order other books in this series, please contact our Customer Service Department at:

(800) 770-LANG (within the U.S.)
(212) 647-7706 (outside the U.S.)
(212) 647-7707 FAX

Or browse online by series at:

WWW.PETERLANG.COM